Arts Therapies and
Clients with Eating Disorders

DATE DUE

OCT 13 1995	JAN 2 9 1999
NOV 11 1995	NOV - 0 1999
NOV 3 0 1995	DEC 1 4 1999
DEC 1 5 1995	
JAN. 20 1995	OCT 3 0 2000
FEB - 6 1996	
FEB 1 2 1996	DEC 1 1 2000
FEB 2 8 1996	AUG 7 2001
DEC - 4 1996	
FEB 2 6 1997	OCT - 8 2003
SEP 2 7 1997	Rej - 10336994
Oct 11/97	
Oct. 25/97	
NOV 1 3 1997	
MAR 2 0 1998	
NOV 2 4 1998	
Dec 3	

of related interest

Music Therapy in Health and Education
Edited by Margaret Heal and Tony Wigram
ISBN 1 85302 175 X

What Do You See?
Phenomenology of Therapeutic Art Expression
Mala Betensky
ISBN 1 85302 261 6

A Multi-Modal Approach to Creative Art Therapy
Arthur Robbins
ISBN 1 85302 262 4

Art Therapy and Dramatherapy
Masks of the Soul
Sue Jennings and Ase Minde
ISBN 1 85302 027 3 hb
ISBN 1 85302 181 4 pb

Dramatherapy with Families, Groups and Individuals
Waiting in the Wings
Sue Jennings
ISBN 1 85302 144 X pb
ISBN 1 85302 014 1 hb

Arts Therapies and Clients with Eating Disorders
Fragile Board

Edited by Ditty Dokter

Jessica Kingsley Publishers
London and Bristol, Pennsylvania

First published in the United Kingdom in 1994 by
Jessica Kingsley Publishers Ltd
116 Pentonville Road
London N1 9JB, England
and
1900 Frost Road, Suite 101
Bristol, PA 19007, U S A

Library of Congress Cataloging in Publication Data

A CIP catalogue record for this book is available from the Library of Congress

British Library Cataloguing in Publication Data

A CIP catalogue record for this book is available from the British Library

ISBN 1-85302-256-X

Printed and Bound in Great Britain by
Biddles Ltd., Guildford and King's Lynn

Contents

III: Dramatherapy

IV: Psychodrama

V: Dance Movement Therapy

VI: Music Therapy

I
Introduction

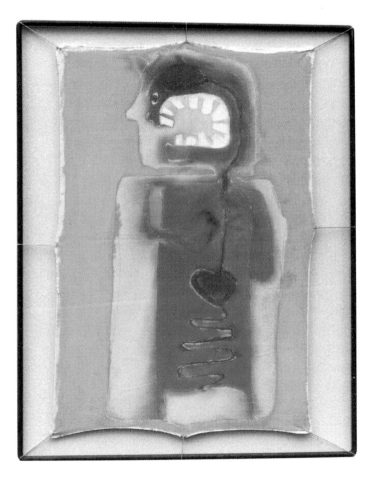

Mirror-image

So there you sit with your chocolate stained smile.
Numb, silent and tired,
as if nothing had happened in the small hours of anger.
The self-inflicted protest falls on silent eyes.
Too many times numbed by the pain of stabbed wounds
hidden by the passage of time.
And then with the ignorance of the first wound
you reach out once again to cover the tracks of forbidden fruit.
Dispelling the inflicted food
and returning once again to the cruel world
where nothing can touch your sacred secret.

Elise Warriner

Introduction

Ditty Dokter

Before outlining the contents of this book, it is important to answer the question: 'What are the arts therapies?'. They take in art therapy, music therapy, drama therapy and dance movement therapy. In this book psychodrama is also included, its slightly separate status due to a differentiation in the professionalization process, which will be clarified later. 'Arts therapists provide for their patients an environment, arts media, and very importantly, themselves – in terms of time, attention and a clearly defined relationship. The aim of the session or sessions is to develop a symbolic language which can provide access to unacknowledged feeling and a means of integrating them creatively into the personality, enabling therapeutic change to take place. The therapist's focus is not particularly on the aesthetic merits of the art work (be this dance, drama, painting, music etc.) but on the therapeutic process – that is, the patient's involvement in the work, their perception of it, and on the possibility of sharing this experience with the arts therapist' (Standing Committee for Arts Therapies Professions 1989).

Art therapy, in this same pamphlet, is defined as a process involving a transaction between the creator (the patient), the artefact and the therapist.

Dance movement therapy is the use of expressive movement and dance as a medium through which the individual can engage creatively in a process of personal integration and growth.

Music therapy, through the non-verbal improvisation on musical instruments allows individuals to express their emotional state and to enter into an interactive dialogue with the therapist. Old patterns of relating can thus be reflected on, explored and reorganized.

Drama therapy makes use of roleplay, voice work, myth, ritual, storytelling and movement. Movement and objects can be used non-verbally as

in the other arts therapies. It can facilitate the individual's self awareness, but particularly offer a creative way for an individual or group to explore personal and social problems (Addenbrooke's NHS Trust Arts Therapies Department pamphlet, 1993).

Psychodrama is the method by which a person can be helped to explore the psychological dimensions of his problems through the enactment of their conflict situation (Blatner 1973). Each chapter in this book provides further in depth definitions and descriptions. A brief outline of the history and professionalization of the arts therapies follows.

The arts therapies in Britain developed in the second half of the twentieth century. They have gone through a rapid professionalization process. They have mirrored the medical profession in its striving for recognition as a profession (Parry 1987). They require professional or academic qualifications pre-training, which is set at a postgraduate level. This limits access and different training courses are now also looking at graduate level training, special entry places and possible widening of criteria to enable easier and more varied access. This may also benefit people from different cultural backgrounds, at present under-represented. Music therapy, for example, is proposing to widen its criteria of a western classical music training to include jazz musicians. The other arts therapies are going through a similar process of re-assessment, for example in the art therapy race and culture committee and the drama therapy equal opportunities committee.

Other aspects of the professionalization process are the founding of professional associations to negotiate for recognition by academic, medical, educational and ministerial departments. The professional associations have formulated codes of practice and disciplinary procedures. The individual associations came into being at different times and tended to operate independently from each other. It is a recent development that they have decided to work more together, although the different arts therapies are at different stages of the process: art and music therapy being the eldest and dance movement therapy the youngest in this country, which influences the co-operation.

The arts therapies are pursuing national registration through the Council for Professions Supplementary to Medicine and the United Kingdom Standing Committee for Psychotherapy (UKSCP). This dual approach shows the debate within and without the profession as to whether arts therapies are a form of psychotherapy or not. At present only psychodrama is accepted by the UKSCP. Within the profession, with varying emphases within the different modalities, there is a debate as to whether the therapeutic nature of the arts therapies should be identified and described solely within the

language and concepts of psychotherapy. In this book, some authors stress the psychotherapeutic nature of the work, others the inherently therapeutic nature of the artform. All stress the importance of the relationship between therapist and client. The theoretical orientation of the authors combine the art modality and psychotherapeutic concepts, the latter mainly in the field of object relations and Jungian symbolism. Anthropological concepts are used to start to address the growing transcultural issues in this field.

In the introductory chapter I outline the aetiology and treatment of eating disorders, as well as providing a hypothesis as to the effectiveness of 'acting out' therapies with 'acting out' clients. Elise Warriner describes her experience of art therapy as a client in Chapter 2. In the art therapy section which follows, Joy Schaverien gives an object relations background to her art therapy work with inpatients suffering from anorexia. Mary-Jane Rust in the different framework of the Women's Therapy Centre gives examples of feminist based art therapy groupwork with sufferers in the community. Paola Luzzatto describes imagery she has particularly found in her inpatient work; her case example of a male anorexia patient adds to the so far female picture. Sue Jennings and Diane Waller use their professional and personal experiences to provide a transcultural perspective on eating disorders; Sue Jennings' client in the fertility clinic suffers from secondary anorexia due to an 'incomplete rite of passage'. The anthropological concepts regarding body experience add to our western perspective.

The other chapters in the drama therapy section look particularly at groupwork and working with staff. Maggie Young's chapter about short term groupwork with women suffering from bulimia, using developmental and story journey frameworks, provides some very useful ideas for outpatient brief therapy work. Astrid Jacobse has developed an inpatient model, based on the Dutch 'creative process' approach in the arts therapies, a wider European perspective. Linda Winn illustrates how dramatherapy techniques can be used in experiential training for staff who work with clients suffering from eating disorders. As her training includes both self-reflective and educational elements, in a modified form it could equally be applied in the cognitive/educational aspects of treatment.

The psychodrama and dance movement therapy section starts with the chapter by Mary Levens. In her art therapy and psychodrama work at the Maudsley Hospital she draws on the object relations theory in the process towards individuation. It picks up on the previous object relations based Chapters 1 and 3 and in the final section Jackie Robarts illustrates how she applies this in music therapy with young children and adolescents. Sandra Jay describes an outpatients' psychodrama group for clients suffering from

bulimia. For those interested in the differences and similarities between psychodrama and drama therapy, it is interesting to read this chapter alongside the one by Maggie Young, both working with similar client groups in similar settings. The dance movement therapy chapters are a good example of focussed ways of working. Sally Totenbier focuses on body image, giving in-depth descriptions of the dance movement therapy techniques used. Helen Payne describes a research project in a community setting, applying her particular method of integrative dance movement psychotherapy. This is the last chapter in the arts therapy or arts psychotherapy debate, where the authors identify themselves as psychotherapists. The appropriateness of that identification can, perhaps, be judged by the reader from the ways of working described in the many case examples. Ann Sloboda provides several, while describing her music therapy work with a variety of clients of both genders, suffering from a variety of eating problems.

To conclude the book, two important further issues are raised in the music therapy section. Penny Rogers investigates the connection of eating disorders to sexual abuse and Margaret Heal describes her work with a young woman with Down's syndrome. As many arts therapists work in this intermediate field of clients with a learning disability, who suffer mental health problems, this chapter provides an insight into the use of music therapy in such a situation.

Different authors use different terminology, depending on the setting they work in and their philosophical orientation. The terms eating disorder, problem and distress all refer to the painful condition Elise Warriner's images and poetry so powerfully illustrate. To alleviate even some of that pain is, for sufferer and helper, the ultimate aim.

Acknowledgements

I would like to thank Sue Jennings for the original idea, Alida Gersie for her encouragement and David Tatem for his support. Clients, staff and fellow arts therapists at Addenbrooke's NHS Teaching Trust ultimately made this book possible.

References

Addenbrookes NHS Trust (1993) 'Arts Therapies in the Mental Health Service' – an information leaflet.

Blatner, H.A. (1973) *Acting In.* London: Croom Helm.

N and J Parry (1976) *The Rise of the Medical Profession.* London: Croom Helm.

Standing Committee of Arts Therapies Professions: 'Artists and Arts Therapists'

Fragile Board – Arts Therapies and Clients with Eating Disorders

Ditty Dokter

This chapter introduces the history, aetiology and treatment of eating disorders. There is, as yet, no definitive description of any of them, but an outline of the major points is given. This is followed by an introduction to the role of the arts therapies in the treatment. A theoretical underpinning, based on object relations theory, aims to provide a possible explanation for the suitability of arts therapies for these particular clients. Case examples are derived from my work as a dramatherapist at the acute psychiatric unit in Addenbrooke's teaching Trust in Cambridge, specialising in providing treatment for clients suffering from eating and affective disorders. While working there I offered a slow open dramatherapy group for clients with eating disorders (for details, see Dokter 1992).

The fragile board of the title refers to Elise Warriner's dinner setting, which represents the fragility and barbed wire atmosphere of the family dinner table – often a western, white and middle class dinner table. 'The efficacy of food refusal as an emotional tactic within the family depends on food being plentiful, pleasing and connected to love' (Brumberg 1988, p.139). Other cultural, social, psychological and economic factors play a role in the aetiology of eating disorders. In discussing the three main models regarding aetiology (biological, psychological and cultural) I will go into this further. First, I want to place eating disorders in their proper historical context. Given the fact that this disease is seen as a modern social dis-ease of society, especially the female half, and is of growing epidemic proportions, it may be surprising to realize that anorexia existed before there was a mass cultural preoccupation with dieting and a slim female body.

Throughout history women have used the control of appetite, food and their bodies as a focus of their symbolic language. Brumberg shows how the understanding of food-refusing behaviour evolved between the sixteenth and nineteenth centuries, in response to new developments in religion and medicine. By the nineteenth century the refusal of food had become transformed from a religious act to a pathological state: from sainthood to patienthood. However, even when an illness is organic, being sick is a social act. Expressions of physical anguish and mental stress are selected quite unconsciously from a repertoire of symptoms which we learn by being part of a culture. When attempting to understand the aetiology of eating disorders, different explanations can and do exist simultaneously. At present there is still no definitive answer to what anorexia nervosa really is, although attempts have been made to define it since the nineteenth century. Bulimia nervosa, as a much more recent concept, was incorporated in the Diagnostic and Statistical Manual of Mental Disorders (DSM III) in 1985, and is even less well defined. That any definition will need to incorporate the biological, psychological and environmental factors, is now generally accepted. Eating disorders are not merely a social construction. They have physical consequences, and involve a level of self-destructive behaviour, which makes them qualitatively different from chronic dieting. They show the reciprocity of biology and culture.

Eating disorders: diagnostic and clinical features

The following diagnostic criteria of anorexia and bulimia nervosa have been formulated (DSM III 1985). These medical criteria focus more on illness than health. They emphasize the biological and, to a lesser extent, psychological factors.

Anorexia Nervosa

1. Refusal to maintain body weight over a minimal normal weight for age and height, e.g. weight loss leading to maintenance of body weight 15 per cent below that expected; or failure to make expected weight gain during a period of growth, leading to body weight 15 per cent below that expected.

2. Intense fear of gaining weight or becoming fat, even though underweight.

3. Disturbance in body image, e.g. the way in which one's body weight, size or shape is experienced. Feeling fat when emaciated, or experiencing one bodypart as too fat, even when underweight.

4. In women, absence of at least three menstrual cycles, when otherwise expected to occur (primary or secondary amenorrhea).

Bulimia nervosa

1. Recurrent episodes of binge eating (rapid consumption of a large amount of food in a discrete period of time).

2. A feeling of lack of control over eating during the eating binges.

3. The person regularly engages in either self-induced vomiting, use of laxatives or diuretics, strict dieting or fasting, or vigourous exercise in order to prevent weight gain.

4. A minimum of two binge eating episodes a week for at least three months.

5. Persistent over-concern with bodyshape and weight.

Anorexia nervosa occurs predominantly in young women in western countries and developed non-western ones. The most common age of onset is between 14 and 16 years old. Studies of incidence and prevalence are beset with methodological problems, but the rate of incidence is clearly rising and is highest amongst students in professions preoccupied with a slim body, for example dance students. Five to ten per cent of anorexia sufferers are male. They are less likely to be diagnosed early and their loss of body weight should be 25 per cent of 'normal weight' as a diagnostic criteria. Other diagnostic criteria are similar to those for women, but men show a higher incidence of overactivity (Margo 1987).

Bulimia nervosa occurs predominantly in women who are older than anorexia sufferers. The social class distribution also tends to be broader. The prevalence of binge eating among the general female population is as high as 21 per cent, but the rate of clinically significant bulimic episodes is unknown and unlikely to be above five per cent. Vomiting is less frequent at three per cent (Fairburn and Cooper 1987).

The clinical features of anorexia and bulimia are an extension of the diagnostic ones mentioned earlier. The weight of an anorexia sufferer is below 85 per cent of the average; in-patients are often severely under that weight. The danger of anorexia has grown, because today's patients are considerably thinner than they were, say, fifty years ago. This is even more

significant in view of the fact that young women are growing taller. The severity of today's anorexia probably reflects the client's zealous commitment to diet and exercise, as well as parental and medical tolerance for thinner bodies (Brumberg 1988). The eating habits include avoidance of 'fattening' foods, 50 per cent experience intermittent loss of control over eating (i.e., binge eating), low carbohydrate diet, no loss of appetite (N.B. 'anorexia' meaning 'loss of appetite' is a misnomer based on historical mis-perceptions) and peculiar eating habits. Examples of the latter may be avoidance of or concentration on particular foods, not being able to eat with others and so forth. Weight control is achieved by dieting, vomiting, laxatives, dieuretics and exercise. Characteristic beliefs and attitudes include overvalued ideas about the importance of weight and shape, the pursuit of a thin bodyshape, an exaggerated fear of weight gain and body image disturbance. The psychological effects of physical starvation are a liability of mood, sleep disturbance, loss of libido and poor concentration. An overriding preoccupation with food can lead to stealing and hoarding of food and a narrowing of all other interests. Other psychopathology include general 'neurotic' symptoms such as depression, anxiety and obsessional symptoms. Eating disorders have also been connected to borderline personality traits (Levens 1990, see also Chapter 11) and other addiction problems. The fact that clients with a borderline personality organization are usually poly-symptomatic may reflect this; the eating disorder may then be considered secondary to a more serious problem of under-structured internal resources (Masterson 1977).

Some of the clients I worked with also had drug and alcohol addiction problems and self-harm tendencies, so might fit this model; however, the question of which comes first still applies. I will address this phenomenon when looking at the aetiology of psychosomatic problems.

Bulimia sufferers are often of average weight; 25 per cent have a past history of anorexia. Eating habits include loss of control over eating and strict dieting. Compensatory behaviour to maintain weight control includes vomiting, using laxatives and dieuretics, dieting and exercise. Beliefs and attitudes are very similar to those of anorexia sufferers, but usually there is no pursuit of thinness, rather an extreme sensitivity to changes in body weight. Other psychopathology focuses particularly on depression and anxiety.

The physical complications are due to starvation, binge eating, self-induced vomiting and purgative abuse. Starvation side effects are amenorrhea, bradycardia, hypothermia and hypotension and gastro-intestinal disturbance. Binge eating causes dilation of the stomach, menstrual disturbance and parotid gland swelling. Self-induced vomiting and purgative abuse can

cause metabolic disturbances, arythmic heartbeat, kidney damage, epileptic fits and dehydration. Self-induced vomiting results in the erosion of tooth enamel, hoarseness and gastric reflux. Purgative abuse also results in rebound water retention (which in its turn reinforces the psychological fear of becoming fat).

Little is known about the longer term outcome of eating disorders, nothing is known concerning bulimia, and follow up studies of anorexia survivors have focussed on severe cases. Hsu (1980) reviewed 16 outcome studies. For those severe cases there is a high rate of poor overall adjustment and a mortality rate of five to ten per cent, mainly due to suicide. Fifteen to twenty-five per cent of survivors are still below 75 per cent of average weight, and 25 to 50 per cent are not menstruating regularly. Infertility clinics find anorexia survivors and clients with current eating disorders amongst their clients (Jennings 1993, see also Chapter 7). Eating habits and attitudes are no longer problematic for one third of survivors; up to 50 per cent still experience bulimic episodes, and up to a third still self-induce vomiting (Hsu 1980). More recent follow up studies suggest that mortality may be as high as 15 to 20 per cent.

The aetiology of eating disorders

As mentioned above, the aetiology of eating disorders is subject to consid-erable debate. It is widely accepted that a combination of biological, psychological and social factors are of importance (Garner and Garfinkel 1985). As the clinical and diagnostic factors tend to emphasize the biologi-cal, I want to focus more on the psychological and social factors.

Predisposing factors for anorexia tend to be a family history of eating disorders and affective disorders, a personal history of affective disorder and a fear of maturity. In bulimia, predisposing factors considered are a family or personal history of affective disorder, and a predisposition to obesity. For both, the social pressure to be slim is a very important factor. It is important to look at the socio-cultural context for reasons for recruitment to fasting behaviour. The subsequent anorexic 'career' includes the physiological and psychological changes which condition the individual to exist in a starvation state. Hilde Bruch (1973 and 1985) subscribes to this when saying that the cultural emphasis on increasing slenderness can never be the sole determin-ing factor. 'Normal' weight control is distinctly different from the frantic obsession with thinness of the anorexia sufferer. Bruch suggests that the changing status of, and expectations for women play a role. The contradic-tory expectations of achievement and dependence create severe personal self-doubt and uncertainty in women, particularly in adolescence. In a

submissive way they 'choose' the fashionable dictum to be slim as a way of showing themselves to be deserving of respect.

This echoes Brumberg's view of historical development in the twentieth century (Brumberg 1988). In the name of health and science, the rules for feeding and eating became codified. Women had a moral responsibility to learn these rules. In this way, feminization of scientific nutrition contributed to women's heightened sensitivity to the body. Women began to internalize the responsibility for weight maintenance and overweight in women became a physical liability, a character flaw and a social impediment. Many women internalized the notion that size and shape of the body was a measure of self-worth. Losing weight would bring spiritual as well as physical transformation. Post World War II there was a popularization of adolescent weight control, with its concern about childhood obesity and a general socialization into concerns about a slim body shape. The recent emphasis on physical fitness has intensified cultural pressures on the individual for control and mastery of the body, and a critique of food processing added to new food theories. The anorexic's devotion to thinness, her elaborate espousal of food theories and the narrowing of the food repertoire to only the lightest of food is part of the general social mentality. The modern symptom constellation confirms the connection between modern dieting and eating disorders. As in many psychological disorders, the behavioural symptoms are an expression of prevailing cultural concerns.

This is reinforced by the fact that the incidence of anorexia and bulimia is different for women from different ethnic groups in Britain. Those with culturally less emphasis on a slender body shape tend to have a lower incidence of anorexia and bulimia. When western cultural values are adopted more, the incidence rises. Amongst Caribbean women there is at present a higher incidence of bulimia than anorexia. The background of the sufferers tends to be of a higher social class and at present it seems that the higher the level of education, the more predisposition to bulimia (Holden and Robinson, 1988). This may be connected to the adoption of the western values of that higher education system. The importance of considering different cultural values concerning food and eating is shown by Bhadrinath (1990) in working with adolescents from Asian extraction. Different attitudes to the body in different cultural contexts are discussed by Jennings in Chapter 7, and some transcultural experiences by Waller in Chapter 6.

The psychological genesis of eating disorders are considered as largely familial and individual. However, the present cultural aesthetic contributes to an acceleration in dieting, which increases the number of people at risk. There is a correlation between the level of exposure and the prevalence of

dependency in the general population. In occupations such as modelling and ballet, where a slender figure is imperative for success and dieting is pervasive, the incidence is significantly increased. The ideal of the superwoman requires a single-mindedness and drivenness which is typical of the anorexia sufferer. In this transactional time, when a new future for women is tentatively charted out, but gender roles and sexuality are still constrained by tradition, young women will feel the pain of transition most acutely.

This dilemma has been most clearly delineated by the feminist psycho-analytic approach. Susie Orbach (1978 and 1985) shows how the successful femininity for adult women today requires three basic demands. The first is that she must defer to others; the second that she must anticipate and meet the needs of others; and the third that she must seek self-definition through connection with another. The consequence of these requirements is that, by denying themselves, women are unable to develop an authentic sense of their needs or a feeling of entitlement for their desires. Women become dependent on the approval of those to whom they give, preoccupied with other's experience and unfamiliar with their own needs. The imperative of affiliation means that many aspects of self are underdeveloped, producing insecurity and a shaky sense of self. Under the competent care giver lives a hungry, deprived and needy little girl, who is unsure and ashamed of her desires and wants. A psychological consequence of the suppression of women's desires for both dependency gratification and autonomy is that women do not feel worthwhile within themselves. This psychology is brought to mothering, particularly the mother–daughter relationship. There is evidence to suggest that these taboos on female desire and the stricture 'not to expect too much' are expressed in the feeding and holding aspects of the mother–daughter relationship. Because the daughter does not receive adequate gratification of early dependency needs, she has difficulty in the separation process, for she still needs an experience of consistent nurturing. Through the idealization and alienation from the female body in modern society, the adolescent girl is learning to develop a split between her body and herself. In her attempts to conform or reject contemporary ideals of femininity she uses the weapon so often used against her; she speaks with her body.

Orbach's view reflects a wider one in which eating disorders are seen as obsessional behaviours, connected with independence versus dependence issues (Lawrence, 1984) and the family as a predominant factor in the development of eating disorders. 'Eating-disordered families' are seen as too controlling, and the only way of control for the client is through control over her body. Sheila McLeod (1981) distinguishes between text and subtext. The text is: 'I am slim, I have won. My body is my own and I do what I want

with it.' In the subtext, however, weightlessness equates with worthlessness, emptiness: 'I am a nobody, not even my body belongs to me.' Even in the Victorian era the family dynamics were recognized and 'remedied' by medical control taking over from parental control. An essential part of the treatment was separation from the family (Brumberg 1988).

The central relationship, focussed on in literature, is the one with the mother. Winnicott (1965) discusses how a child needs to learn that it has a voice. If the mothering is 'too good', the child does not learn this. It can only express itself in its actions and often only learns to do what the parents approve of. For these individuals it is difficult to achieve and maintain a sense of self as a free and autonomous person. This is of relevance to the eating-disordered client; linked to nourishing (Lawrence 1984). The relationship with the mother is often the central idealized relationship. The eating disorder is a return to the childlike state of dependence, the only option available to cope with the bottomless pit of emptiness inside. The mother may be the preferred ideal object, but if she is not available a friend, partner or sibling can fulfil the same function. This was certainly the case for the dramatherapy group members and the dynamics of these relationships were regularly brought to and explored in the group. A particular difficulty was the idealization; ambivalence, the co-existing of positive and negative, were very difficult to acknowledge openly and were instead expressed physically.

So far I have discussed primarily the social/cultural, psychoanalytic and family therapy models of aetiology. What is left is the biomedical model. Initially, since the Victorian era, the biomedical model has focussed on the loss of appetite (as it was seen then) and hormonal imbalances. Physiological treatments focussed and focus on re-feeding and drug treatment. Physicians are justified in their close attention to the body, as eating disorders are characterized by particular physiological abnormalities. The question is whether these symptoms are primary or secondary in the aetiology. Which came first: hormonal imbalance or starvation?

The treatment of clients with eating disorders

The aetiology stresses a combination of social/cultural, physiological, psychological and family dynamic causes. Most modern treatment programmes address the complexity of these aetiological factors. This involves a combination of re-feeding and re-establishing regular eating patterns, a cognitive/behavioural input on body perception and distorted thought-patterns, and psychodynamic treatment on an individual, group and/or family basis. The psychiatric unit where I worked as a dramatherapist offered all these

and added physiotherapy regarding relaxation and body image work. The re-feeding in this particular unit was negotiated with the client and involved intensive nursing care and the involvement of a dietician. The advantage of this multi-disciplinary approach is that the psychodynamic input, which includes arts therapies, can focus on underlying conflicts and emotions. The difficulties around food are seen as a symptom. In the following chapters different treatment emphases will be outlined. The arts therapies usually form one of the psychodynamic forms of treatment following or accompanying weight restoration.

The treatment often has two aims; one focussing on the physical well-being and survival of the client, the other focussing on understanding the issues underlying the difficulties with food. One of the problems with this is that too much focus on physical well-being can reinforce the concept of the disorder as an illness in itself, where underlying factors are not relevant.

Garner and Garfinkel (1985) actually reinforce that nutritional improvement and a resolution of psychological problems should occur in close interaction, because a lasting recovery requires a change of the inner self-image (very poor with extremely high ego-ideal standards). They formulate the therapeutic aim as: 'to encourage the client in the search for autonomy and self-directed identity in the setting of new personal relationships, where what they have to say is listened to and made the object of exploration.' This importance of returning control to the client is not easy when both complying and wanting to please are strong features of the client's psychological make-up. The focus within the therapy is that the clients have a consistent experience of being listened to as important. The therapeutic task is not to give clients insight into the symbolic significance of their behaviour, but to help clients face the realities of their past and present lives. Interpretation as a therapeutic tool is not acceptable. It is a painful re-enactment of being told what to feel and think. It interferes with the development of autonomy and trust in one's own psychological abilities.

In relation to group therapy, a small group is considered more containable (four to six clients). When recruiting, one needs to keep in mind the likelihood of a high drop-out rate, though. In terms of group selection, mixing clients with anorexia and bulimia can be useful. Although the bulimic and anorexic can represent each other's fears, they can also be a good education for each other. For similar reasons, it is important to have at least one member at the desired weight. When working with a group, offering individual sessions is helpful, both to prevent drop out and as preparation for revealing personal material later in the group. Keeping in touch through letters and phonecalls can be helpful for similar reasons (Dokter 1992).

The various chapters in this book provide examples of the role arts therapies have played in the treatment of eating disorders. It is important to distinguish between inpatient treatment, which often follows the above described pattern (especially for anorexia) and outpatient treatment (more usual for bulimia). Arts therapists working in a community setting may need to focus on issues regarding eating (see Young, Chapter 8), as theirs may be the only treatment offered. Whatever role the arts therapies play within the overall treatment, there are some doubts about their use in a psychotherapeutic context. The doubts are related to the use of action as a means towards change, especially with clients who already use action as a means of avoidance or defence. In the following section I will put forward a hypothesis as to the potential usefulness of arts therapies, especially with these types of client groups.

'Acting out' therapies for 'acting out' clients; a hypothesis

The psychotherapeutic and art concepts are sometimes seen as mutually exclusive, using the concept of acting out to dismiss the notion of using the arts as a therapeutic modality. Analysis practises 'suspended' action (Foulkes 1964). The arts therapies practise direct action within their art modality in the therapy. It is important to consider how this acting out can be transformed into a therapeutic form of action, which allows for internal change. This is especially important for acting out client groups such as clients with eating disorders, as they are seen in a psychodynamic framework as acting out through the body their underlying emotional conflicts. Aiming to integrate the group analytic and dramatherapeutic approach I formulated the following hypothesis (Dokter 1988):

> 'Dramatherapy and group analysis in their ways of intervention aim at different levels of thinking. Dramatherapy uses symbols as communication with the primary process thinking, both therapy models use signs and words as communication with the secondary process thinking.' (p.116)

Acting out in the analytic sense can occur in both analytic and arts therapies treatment. It is a reflection of the transference. Clients are opting for immediate need gratification, rather than personal change. From a group perspective this can show in lateness, absences, leakages, outside socialising, scapegoating and so forth (Yalom 1975). From an individual perspective, clients are seen as possessing oral traits. The client repeatedly performs, acts or undergoes experiences similar to past ones in an attempt to find belated gratification, or at least some relief of tension (Fenichel 1946). The group

or individual is not able to recognize the experience in relation to its source, the past, nor its repetitive character. The therapist often sees it as a resistance to reflection and thinking.

Bion's model of thinking provides a developmental explanation of the difficulties for the 'acting out' client (Bion 1967). He stipulates that a capacity for tolerating frustration is necessary to enable the psyche to develop the process of thinking as a means of tolerating frustration. This first development of thinking allows the development of the reality principle. The dominance of the reality principle is synchronous with the development of an ability to think, and so to bridge the gulf between the moment when a need is felt and the moment when this need becomes fulfilled. Fenichel (1946) sees the development of speech as the next step:

> 'The ability to recognize, to love and to fear reality (the reality principle), is developed generally before the learning of speech. However, it is this faculty of speech which initiates a further decisive step in the development of reality testing. Words allow for more precise communication, as well as making anticipation more precise by trial action (rehearsal).' (p.46)

This anticipation of action now becomes thinking proper and consolidates consciousness.

If, on the other hand, there is an inability to tolerate frustration, this tips the scale towards evasion and destroys the development of thinking. The thought becomes a bad object (in an object relations sense), only fit to be evacuated. This has serious consequences for the psyche. Communication is affected by realistic projective identification; it enables us to recognize that both good and bad objects exist in – and outside of – oneself. The psyche also lacks the apparatus to anticipate action. Reality cannot be interpreted, only evaded by fantasy or attack. Thinking is dominated by the primary process. It is a magical, archaic type of thinking, which is represented by symbols. In Bion's model of thinking we thus find the developmental link between thought, action and language as well as an explanation for the need to act out in the analytic sense.

Clients suffering from eating disorders are very well able to think, but whether they are able to use verbal reflection and interpretation for personal change is debatable. Anorexia sufferers are notorious intellectualizers; being in touch with feelings is very difficult. Bulimia sufferers, on the other hand, feel easily overwhelmed. As already stated, feeling out of control and/or controlled by significant others is an important issue for both. Interpretation in therapy is often experienced as a painful re-enactment of being controlled.

It is important to ask why clients act out this control issue through their body. Orbach's explanation places this within the social context of being a woman. Joyce McDougall (1989) explains this further within the intrapsychic context of early infant relationships.

McDougall, like Bion, originates the disturbance in the early developmental stages. In her work with psychosomatic states she makes the following observations: 'I originally believed that in psychosomatic states the body was reacting to a psychological threat as if it was a physiological one; that there was a severe split between psyche and soma (p.9)… However, continuing observations showed me that many patients suffering from grave psychosomatic illness were neither operatory thinkers, nor devoid of knowledge of their affective experiences' (p.11). Freud favoured the role of language in the structuring of the psyche and psychoanalytic treatment. McDougall emphasizes that not all communications use language. In attempting to attack any awareness of certain thoughts, fantasies, or conflict situations apt to stir up strong feelings (painful or exciting) a patient may produce a somatic explosion instead of a thought, dream or fantasy. These psychosomatic problems are often due to too close a fusion between mother and child. McDougall (1985) connects this to a predisposition in the adult towards transitory objects rather than Winnicott's transitional objects (Winnicott 1974). These transitory objects may take the form of addictive substances, relationships and/or sexual behaviour. An addictive psychic economy is sometimes allied to psychosomatic dysfunctioning, since both tendencies have similar origins. Both these psychosomatic and addictive tendencies have been connected to eating disorders; all are seen as characteristic acting out behaviours (p.5).

> 'We are all liable to discharge tension in acting out ways, when events are unusually stressful. But those who habitually use action as a defense against mental pain run the risk of increasing their psychosomatic vulnerability. An affect cannot be conceived as a purely mental or physical event. Emotion is essentially psychosomatic. Thus, ejecting the psychological part of an emotion allows the physical part to express itself as in infancy, leading to a resomatization of affect.' (McDougall 1989, p.95)

Bion's model gives some explanation of the difficulty of using verbal interpretation in the treatment of clients with eating disorders. McDougall provides the additional focus on the body as the medium of acting out. Combined, they provide a possible hypothesis for the effectiveness of arts therapies in the treatment towards psychic change in clients suffering from

eating disorders. In a verbal therapy mode, acting out is a way of avoiding the frustrating reality. Rather than using language and thinking in anticipation of action, action is used as a substitute for thinking. In arts therapies, action is encouraged. Acting out as a resistance to therapy occurs, of course, too, but the intervention is different. Much further research would need to be done, but I wonder whether it could be stipulated that both models of therapy aim at different levels of thinking. Verbal therapy demands the transfer from action into thinking, followed by verbalization. In the arts therapies the intervention can communicate with the primary process thinking through symbols and metaphors. The fact that this communication is through action and can at a later stage be translated into secondary process through verbalization, may demand less of the client's ability to tolerate frustration. Those arts therapists looking for a theoretical framework in working towards insight with clients at the more severe end of the continuum, often come to object relations theory as a guide-line (see Chapters 3, 11 and 15). Other arts therapists may work in a shorter term framework on more focussed goals such as creating greater role flexibility, assertiveness and independence, body image changes and such.

Two important aspects of the arts therapies treatment are the projective potential of the creative medium and the embodiment of the experience. Levy (1988), looking from the perspective of a dance movement therapist, sees the different art modalities as potential developmental stages towards embodiment:

> 'Art, like drama, can act as an intermediary step connecting the intellect (words), with the body (movement). The inherent limitations of the artistic materials place a natural boundary around the psychomotor aspect of the experience, restricting the expression largely to finger, arm, shoulder and upper body movement on a defined space – the paper. These limitations can be helpful to some individuals for whom complete body action may initially be too threatening.' (Levy 1988, p.197)

David Johnson (1982) gives embodiment, projection and role as the three stages in dramatic development. These stages can be used for assessment and as guide-lines for the structuring of sessions. In many circumstances the progression would be progressive, but with certain client groups reversing the order may be necessary, if – as in clients with eating disorders – embodiment may be the most threatening stage. This was certainly the case in my work. I found that projective dramatherapy techniques such as sculpting, poetry and storytelling were experienced as helpful. They pro-

vided people with an opportunity to express how they felt. At times clients felt threatened by the projected material; they felt that it took on a reality of its own. This external reality faced people with underlying emotional issues; flight into the symptom to defend against emotions became more difficult. Projection was an important first stage, before clients could start working with role. In the short term framework of the acute unit in which I was working, once people became outpatients they were referred on; embodiment was not reached. This focus on underlying problems and relationships is often seen as an important role of the arts therapies. The creative work allows personal material to be brought out into the open. This can then be re-framed in the relationship with the therapist. The re-framing is extremely important, otherwise the feeling of being out of control and dipped into chaos can be overwhelming (Dokter 1992). Elise Warriner's account of her art therapy experience (Chapter 2) seems to mirror my clients' account of their dramatherapy experience in this.

Levy's proposal to use the different art modalities as developmental stages, is an interesting one. It requires several arts therapists in a multi-disciplinary team and sufficient resources to all be working with the same patient; in the current financial reality, this is a rarity. The difficulty of building up a relationship with several different therapists can also be too daunting a task for the client, potentially a good argument for an integrated expressive arts therapist. Current arts therapies training courses, with their heavy emphasis on artistic development in their chosen medium by the potential therapist, makes this problematic, although a few integrative courses are emerging. It is possible to select and focus on particular ways of working within one art modality, as the above example shows; further chapters in this book will provide further illustrations. They also show how arts therapies can be a good complement in a multidisciplinary team approach, as well as provide (sole) treatment in a preventative, or curative outpatient setting. Arts therapies are not the final treatment answer to the problem eating disorders present for the 'sufferers' and 'treaters', but they have a useful role to play.

This book will, it is hoped, communicate some of the variety and breadth of application, as well as providing a wealth of further references and sources.

References

Bhadrinath, B. R. (1990) Anorexia nervosa in adolescents of Asian extraction, *British Journal of Psychiatry*, 156, 565–568.

Bion, W. R. (1967) *Second Thoughts.* London: Heinemann Medical Books.

Bruch, H. (1973) *Eating Disorders. Obesity, Anorexia Nervosa and the Person Within.* New York: Basic Books Inc.

Bruch, H. (1985) *Four Decades of Eating Disorders.* In D.M. Garner and P.E. Garfinkel (eds) *op. cit.,* pp. 7–19.

Brumberg, J.J. (1988) *Fasting Girls The Emergence of Anorexia Nervosa as a Modern Disease.* Boston, MA: Harvard University Press.

Diagnostic and Statistical Manual of Mental Disorders (D.S.M.) III (1985) Washington D.C.: American Psychiatric Association.

Dokter, D. (1988) 'Acting out, a dialogue between dramatherapy and group analysis.' In P. Jones (ed) *State of the Art* conference proceedings. Hertfordshire College of Art Design, St. Albans.

Dokter, D. (1992) Tolerating chaos – dramatherapy and eating disorders, *Dramatherapy,* 14, no.1, 16–19.

Fairburn, C. G. and Cooper, P.J. (1987) The eating disorder examination: a semi-structured interview for the assessment of the specific psycho pathology of eating disorders, *International Journal of Eating Disorders,* 6, 1–8.

Fenichel, O. (1946) *The Psychoanalytic Theory of Neurosis.* London: Routledge and Kegan Paul.

Foulkes, S. H. (1964) *Therapeutic Group Analysis.* London: Maresfield Reprints.

Garner, D. M. and Garfinkel, P. E (eds) (1985) *A Handbook of Psychotherapy for Anorexia Nervosa and Bulimia.* New York: Guilford Press.

Holden, N.L. and Robinson, P.H. (1988) Anorexia Nervosa and Bulimia Nervosa in British Blacks, *British Journal of Psychiatry,* 152, 544–549.

Hsu, L.K.G. (1980) Outcome of Anorexia Nervosa; a review of the literature (1954–1978), *Archives of General Psychiatry,* 37, 1041–1046.

Jennings, S.E. (1993) Shakespeare's theatre of healing; dramatherapy in the theatre of life' *Dramatherapy,* 15, no.2, 2–8.

Johnson, D. (1982) Developmental approaches in dramatherapy, *The Arts in Psychotherapy,* 9, 83–90.

Lawrence, M. (1984) *The Anorexic Experience.* London: Women's Press.

Levens, M. (1990): Borderline aspects in eating disorders; art therapy's contribution, *Group Analysis,* 23, no.3, 277–285.

Levy, F. (1988) *Dance Movement Therapy. A Healing Art.* Reston: American Alliance for Health, Physical Education, Recreation and Dance.

McDougall, J. (1985) *Theatres of the Mind. Illusion and Truth on the Psychoanalytic Stage.* New York: Basic Books Inc.

McDougall, J. (1989) *Theatres of the Body. A Psychoanalytic Approach to Psychosomatic Illness.* London: Free Association Books.

McLeod, S. (1981) *The Art of Starvation.* London: Virago Press.

Margo, J.L. (1987) Anorexia Nervosa in males. A comparison with female patients, *British Journal of Psychiatry,* 151, 80–83.

Masterson, J.F. (1977) 'Primary anorexia Nervosa in the borderline adolescent; an object relations view'. In P. Hartocollis (ed.) *Borderline Personality Disorders,* pp. 475–494. New York: International Universities Press.

Orbach, S. (1978) *Fat is a Feminist Issue.* London: Paddington Press.

Orbach, S. (1985) 'Accepting the symptom: a feminist psychoanalytic treatment of anorexia nervosa.' In D.M. Garner and P.E. Garfinkel (eds) *op. cit.*, pp. 83–107.

Winnicott, D.W. (1965) *The Maturational Processes and the Facilitating Environment.* London: Hogarth Press.

Winnicott, D. W. (1974) *Playing and Reality.* Harmondsworth: Pelican Books.

Yalom, I.D. (1975) *The Theory and Practice of Grouppsychotherapy.* New York: Basic Books.

Anger is Red[1]

Elise Warriner

My first experience of art therapy was weekly group sessions during a period of in-patient treatment. As an art student, I saw this more as an opportunity to reaffirm my artistic ability than to explore my emotions through art and therefore used these sessions simply to draw and paint what I saw rather than what I felt.

My first encounter with private art therapy treatment came about through a general inability to express feelings through art. I also felt that as a student illustrator it would be a good idea to learn to get in touch with my emotions and to relay them on paper. At that time I had no idea how art therapy would help my personal and artistic development. Initial one-to-one sessions were based on talking through ideas, feelings and events of the week and then drawing and painting. My therapist and I would then discuss the art work. I was constantly surprised by the amount of seemingly sub-conscious information that was being relayed about these situations which could be interpreted by my use of colour, relationships of figures and so forth. This led on to more talking based on the sub-conscious information and brought out deep rooted feelings of which I had not been previously aware. These sessions also involved acting out dreams, and role play in order to verbalize and deal with events within a safe environment. This activity and supported creative space gave me perhaps the first opportunity to explore emotive and personal areas which had not been dealt with previously. Although I had not learnt to rely on these outward resources to vent my feelings it certainly helped me to become aware of new ways of coping.

1 This piece is dedicated to Margaret McKernon for her help and support during our time together in art therapy sessions from 1992 to 1993.

A change of circumstances led to a change of art therapists, and I started doing art therapy in a day hospital setting. I had the luxury of a large and well equipped art room all to myself. Initially, however, I was unwell during our first sessions and a few weeks after our first meeting I was hospitalized for a period of about five months.

It may be interesting to note that I did not want to do art therapy in the hospital because I was very distressed at the fact that by doing art there I would be contaminating my drawing ability. I wanted to keep my talent outside the hospital to keep it safe. I was not aware of this distress until my art therapist came to visit me, at which time these feelings came to the surface. I returned to art therapy after my discharge and fortnightly sessions were built into my out-patient treatment plan. This was when I feel the true value of art therapy came to the fore.

Strange as it may seem, anorexia and illustration have at least one thing in common. They are both about expressing oneself without words, yet one is destructive and the other creative. Each session would start with a general chat and then a time of solitary creativity and then, about an hour later, my art therapist would return to discuss outcomes.

The real battle during the sessions was to learn to deal with these emotions in a creative way. There was a difficulty, though, since my low self-esteem filled me with the concern that, rather than self-inflicting the anger and pain, which I had done in the past, I was now afflicting others with the distress I felt. However, my art therapist guided me through my difficulties and together we built up a visual dictionary with which to communicate my feelings.

One of the greatest assets of art therapy for me was that I had a creative space in which to explore my emotions. Due to my lack of self-confidence, I had felt unable to share emotions, because I did not believe that they were important. In fact, I saw emotions as weaknesses which I was too embarrassed and ashamed to even recognize, let alone share. This had led to a rather dysfunctional way of life with a highly mastered ability to cut off emotions, and had reached the stage where physical pain itself was hard to acknowledge.

Finding this visual language not only helped me to communicate, but this time and space actually dedicated to them gave my emotions an importance. At the lowest points of my feelings of worthlessness, I would have to encourage myself that my art therapist was at least being paid to be with me! Putting emotions down on paper also helped to make them real. No longer could I reject them as a figment of imagination, invisible and therefore unimportant, because now they were actually down on paper. This also

distanced them from myself and I felt more able to analyze and share their meaning. As time moved on I felt more and more confident to acknowledge their importance, to rely on their interpretations and to accept them as a part of me. Confidence also grew from the subconscious similarity of themes within the drawings.

I think the hardest thing about the therapy was how deep I had to draw my initial emotions from. It was like drawing water from a very deep well. Initially hard work, but very rewarding.

Art therapy was very different from other treatments I had had. I have done family therapy and seen many psychiatrists and psychologists, so I was used to the seemingly shallowness of talk and one-way silence. Yet art therapy was a far deeper experience; tuning into the subconscious was like fumbling about in the dark. It was up to me to draw from within and I had control over how much I kept in or let out.

To a certain extent, if anorexia was used as a numbing agent, art therapy brought the pain into the open. Being a rather analytical person, even though I felt unable to express my emotions, I certainly thought about how I felt a lot more. Art therapy was a bit like Pandora's box; once it was open, that was it. Being constantly fearful of lack of control had meant a total cutting out of all emotions. Accepting them back into my life meant a readjustment.

The only unhelpful part of art therapy, if it can be seen as that, is that it was like coming face-to-face with buried demons. To draw and deal with the visually disturbing imagery unlocked emotions and feelings which were hard to tidy away and leave behind after an hour.

Gradually, I found I had more control over the imagery and I became more aware of the power of my feelings such as anger, fear and pain. The very safe surroundings within the art therapy room allowed me to start to explore the link between hidden emotions and my drawing ability. It seems ironic to me now how unattached I originally felt my art work in the art therapy sessions was, to my art work at college. And yet my degree course in illustration fundamentally dealt with illustrating emotions. As my confidence in my work grew I started to use some of the ideas explored during art therapy sessions in college. This meant that not only was there no longer the necessity to cut off the therapeutic side of art at college, but I could carry on pushing through ideas.

At first I found this quite daunting; I felt as if I was exposing myself to people, almost as if I were turning myself inside out. I felt it was challenging, because at last I was allowing others outside a therapeutic setting into my world; to a certain extent I was letting people know: 'This is me like it or lump it! It was a very revealing time and certainly a time of great readjust-

ment. It also made life a lot simpler. No longer was I leading two different lives, one as an artist doing a degree and another as a person 'in therapy'. I could at last bring all my thoughts and feelings, both good and bad, about myself and my illness, into my art. Not only did it feed my art but it also started to break down the barrier between disability and ability. I used my 'situation' for me rather than against me. The work also helped me to learn to talk to my friends at college about how I felt. They would see my work and ask me about it. Their genuine interest in what I was portraying gave me the confidence to begin to share not only my artwork but my feelings. I used the work almost as an excuse to talk. As my work built up, my confidence increased and my confidence in my work increased; one fed the other.

Therapy became easier too, since I had allowed myself time to think things through during the week rather than burying myself in my work during my time at college, and then having to spend time during therapy to adjust and readjust my mode of thinking. I also gave more value to how and what I felt. This was not easy. For so long I had equated tired with being lazy, hunger with being greedy, pain and illness as weakness, that to let go of these beliefs meant learning to listen to my body and translate those messages in a helpful rather than harmful way.

This time between hospitalization in 1992 and my degree show was a very artistically prolific time. I found that once I had dedicated myself to illustrating my emotions, illness and so forth. I found that the work literally flooded out of me. No longer did I feel guilty about 'wasting' so much time in hospital, especially during the second year, because I was now using the experience to fuel my work. No longer did I feel cripplingly ashamed of what I had been through, because people knew and yet still accepted me. I felt as if I were on a mission, driven by the ignorance of others. I was pretty fed up with comments from other 'dieters' that just increased my guilt even more. They saw nothing of the frustration I felt.

I cannot pretend that everything was rosy from then on. There were downfalls during this year of recovery. I found the necessarily fallow periods of the final year very hard to handle. During busy periods I had allowed myself to eat, seeing food as fuel for my work – an equation which I had finally started to grasp (after many long hours with my dietitian, I might add!). So when work was slow, I found the impetus to eat very hard. I had also buried all my thoughts about my weight and size by reminding myself that in order to work I needed to have muscle and be strong. These fallow periods removed this mask of self-acceptance and I would wake up to my 'fatness'. The difficulty in eating and distorting thoughts started up and I

was again prescribed liquid nutrition. This highlighted the instability of my recovery even then. It could be seen that, ironically, the art work had replaced anorexia as a numbing agent, however positive and productive it had become. However, its enormous value came from the fact that at least it illustrated the thoughts and feelings that I was numbing. It was quite often the case that I would not realize the true interpretation of a piece of work until some time after it was finished, rather like analyzing an emotion after an event.

I also wrote poetry which best illustrated this situation. In one instant, not until many months after writing a particular poem did I realize its true meaning. I sat down and wept. I think this detachment from my work at the time of creation was necessary. I have always loathed the idea of self pity and certainly was not producing work in order to communicate a need for sympathy. Disassociation allowed me to mourn and grieve as it was for someone else.

It was difficult to convey the importance that I attached to art therapy to tutors at college. There was query about the value of so called splashy painting and finger painting that, as far as my tutors were concerned, I must be doing during the sessions because that was what art therapy was about! It was not until I actually brought in these scribbles that my tutors took note.

Making art out of art therapy, as one of my tutors called it, for me was about not only exorcising emotions (art therapy) but communicating them to others (art). The difficulty was, of course, that at first I could not recognize the emotions myself, let alone interpret them! Gradually, though, I found a visual language and developed it to my needs. I was boosted in confidence by the fact that imagery that was seemingly obvious to me was valued as new and exciting by others.

It was all very well doing the work and I had great satisfaction in putting my work up with the help of my twin and her husband, but the trauma of the whole situation of coming out of the closet, so to speak, only really hit me at the private view when the assessment was finished and the work open to the public. The true realization that now any one could enter my space felt as if I was being invaded. It had been less than a year from my discharge from hospital and I was still receiving quite an intensive out-patient treatment and yet here I was exposing my most intimate secret to all and sundry. It was a risk, but well worth taking. The response to my show was pretty incredible, to say the least. Within a week I had been awarded a first class honours degree, a commendation and prize for my dissertation (also on anorexia, called 'Food Is a Four Letter Word') and been interviewed by the BBC for a local news programme.

Looking back at the work now, I see it as a fundamental part of my recovery. Anorexia had replaced the need to communicate my feelings because it had become the answer to all my problems. Art therapy had helped and guided me back to communication with others, although it would not be possible for me to say that there were no other treatments fundamental to my stability, such as the many hours put in by my dietitian, clinical psychologist and physiotherapist. The relevance of producing imagery during therapeutic sessions was a vital link between myself and the outside world.

The art therapy sessions spanned a year and it was easy to see the improvement made just through the sessions themselves. Ironically, this was highlighted at the end by hardly any drawing done during the sessions. They were mainly talking. At last through the visual language I had found my voice and a confidence to communicate.

Yet even then in this time of gentle nurturing of my self-esteem I received a blow to it. I failed my medical for teacher training due to my 'history'. My confidence through the understanding and support of many was shattered by the ignorance of a few. Luckily, a second opinion by an eminent psychiatrist in the field was successful. But it does illustrate how difficult and how scary opening oneself can be, especially where self-confidence relies so heavily on others.

My aim now is to carry on using my ability and experience to break through the ignorance of the less well informed. I also still turn to my sketch book at times when I find it hard to express how I feel. I found the time doing art therapy invaluable, not just as an artist, but as someone who had lost the ability to express feelings outwardly. I sincerely hope that other sufferers could have the same opportunity to find another voice, to break through the silence.

II
Art Therapy

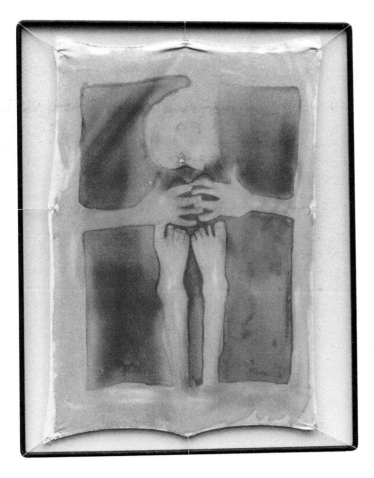

The Enemy Without

You think that you can change my life even in my dying.
You think you know the answer to the silence of my killing,
Yet you know nothing of the weapon I am using
to numb the pain of life, so heavy on my chest.
The questions on your lips are not yours for the asking.
You think that I don't hear the pleading forever in your voice.
I cannot tell the secret that will always burn inside me
and I know that its existance will be my epitaph.
Oh you think that life is precious and you fight to keep me breathing.
Yet you hold me nearer death than the life that I am living.
Don't think that I am sad for all the living I am losing,
I am not crying but for pain that comes from all my being.
Allow me to break free of the chains in which you bind me
and I will find my freedom in the silence of my death.

Elise Warriner

*This poem is about my hostility towards the medical profession
during my hospitalization in 1990.*

The Picture as Transactional Object in the Treatment of Anorexia[1]

Joy Schaverien

The premise of this chapter is that, in the treatment of anorexia, art psychotherapy has a specific contribution to make. In the case of severe eating disorders the client's relationship to food may be understood to be a means of negotiating, and mediating, between the internal world and the external environment. It is proposed that pictures may also mediate between the inner and outer world of the client and so between the client and the therapist. As an object of transference itself the art object may temporarily, and unconsciously, become a substitute for the use of food. It may serve a positive function as a Transactional Object. This view accords with those who consider that anorexia is a borderline disturbance. Thus the anorexic client is considered to be functioning at a pre-symbolic level; she is concretising her experience and acting out through the use of food. If this need for concrete expression can be converted from an obsession with food to a use of art materials, there is a beginning of a movement towards symbolization.

Art can offer a means of bringing the anorexic to a stage where she can relate directly to another person. The art process, mediated within the transference, may facilitate a journey from a relatively unconscious, or undifferentiated, state through stages of concrete thinking, to the beginnings of separation and eventually to symbolization (Cassirer 1955 and 57, Schaverien 1991). If language and art are both considered to be symbolic

1 I am grateful to the *British Journal of Psychotherapy* for permission to reproduce this paper, the substance of which was first published in 1994 in the *British Journal of Psychotherapy, 11(1)*.

forms, we can understand that art offers a significant means of communication. Furthermore, if the patient is unable to speak about the pictures this does not mean that the treatment has been unsuccessful; a conscious relation to unconscious contents may develop through the art medium itself. Later, it may be possible to transform the experience into the spoken word, but this is not essential. The point is that the patient has the experience of making and owning the pictures and the art therapist is witness to this.

The setting

This chapter is based on my experience of working as an art therapist with anorexic in-patients in two different NHS settings. The first of these was an adolescent unit where the approach was, to some degree, behavioural. The second was a psychiatric hospital with a specialist multi-disciplinary team approach to eating disorders. The problems encountered when working within a psychiatric hospital are very different from those encountered in out-patient art psychotherapy. Art therapy is linked with other treatments and this means that communication between the various disciplines concerned is essential to prevent splitting. In-patient admissions for anorexia are often made because there is concern regarding the physical condition of the patient; therefore, attention to this has to take priority in the overall treatment plan. This means that many professionals become involved and 'things' are done to the patient. The newly admitted patient may be in a severe state of malnutrition and dehydration. Even when physical intervention is minimally invasive, such as establishing a regime with clear boundaries, art therapy, like other psychotherapeutic approaches, inevitably takes a secondary role.

Although the focus of the chapter is on anorexia, my hypothesis also applies in a modified form, to bulimia and compulsive eating problems. (See Rust (1987 and 92), and Levens (1987) for discussion of these problems.) The treatment described here is mainly individual art therapy. Although I have worked with anorexic patients in groups I do find that, in general, this client group responds better to an individual approach. This accords with the nature of anorexia, which is a very private expression of distress, in which control is a significant factor. This is rather different from those suffering from other eating problems. These are also private expressions of distress but bulimic and compulsive eating patients often benefit from the relief of being in a group of people with similar difficulties (Dana and Lawrence 1989). The anorexic in a group may be very reticent to engage with others;

alternatively, she may relate with a cheerful false-self presentation which is inevitably reflected in the art work.[2]

In out-patient art psychotherapy open-ended treatment can be maintained even after discharge from hospital. However, in the psychiatric setting I am discussing here, I offered art therapy to all anorexic patients on admission and continued during the in-patient phase. I would work mainly individually with people who were on bed rest; they would be provided with art materials and encouraged to draw or paint in their own time, and in private. The art therapist would then visit for one or two sessions a week. This phase could go on for as long as necessary and in some cases this would be for as long as a year. These people would only join an art therapy group once they had attained a stable weight and were no longer confined to bed rest. Others, who were less physically ill on admission, would come to a group for one or two sessions a week.

The Anorexic

The entire existence of the person suffering from anorexia is centred on food. All her energies are directed to controlling her own intake of food. Her thoughts are constantly concerned with what she will eat, what she can eat, and what she has eaten. She makes bargains with herself, and with others, about what she is permitted to eat and inflicts penance on herself for transgressions of her self-imposed regime, McCleod (1981), Chernin (1981 and 1985). This is a very conscious interest; food and its effects are her sole and usually total, preoccupation. The refusal to take food into herself is a way of controlling her own body, destiny and ultimately her life. Consequently, when she begins to achieve this control, which is a denial of her desires, she comes to feel omnipotent.

The anorexic might be understood as suffering from a form of borderline disturbance characterized by a powerful defence system and distorted relationship to the body. In place of an imaginal world the anorexic has her own symbolic rituals, ideas and actions connected with food. These are a way of concretizing her experience. She exerts control through the ingeniously designed patterns of monitoring intake and excretion of food. Thus, if she eats she will take laxatives to ensure that the food does not remain too long inside her, or she will purge herself by induced vomiting. She will only eat certain foods and any transgression will be atoned for by excessive

2 In this paper I use the pronoun 'she' for convenience. The majority of anorexic patients are female but this is in no way intended to preclude the minority of males who also suffer from anorexia.

self-directed punishments, such as exhausting exercise. The whole effort is directed towards control of the uncontrollable: the body, other people, and ultimately life and death.

The anorexic uses food to mediate between herself and the world. The attachment to, or interest in, food is obsessional. The borderline thought processes which underly anorexia mean that food is often invested with magical powers. Its presence in the body is desired but also experienced as intrusive and disgusting. Terrified of loss of control and so fragmentation, the anorexic is frozen on the borderline between life and death or control and madness.

Family relationships

The infant's omnipotent power in relation to her mother is centred on the need to feed and the reciprocal need of the mother to gratify her; to feed her when she is hungry. As the infant grows and develops her needs change and, gradually, she begins to test her independence; to leave the mother and return on her own terms. The first evidence of this is when the infant is able to crawl away, then to walk and explore the world for herself (Eichenbaum and Orbach 1983). This can only be achieved if the mother can provide a base to which the child may safely return (Mahler *et al.* 1975). The mother, or parenting adult, is needed to provide a good enough holding environment (Winnicott 1971), which allows the child to experience safety, but also a tolerable amount of failure of the maternal environment. The child needs to be nurtured and fed but learns to sustain a certain degree of frustration which would have been intolerable in infancy.

As the child develops, vestiges of this early relationship remain, and are, at times, to be recognized in battles at the dinner table over food; in some cases these last into adolescence and beyond. The anorexic's control of the world, via food, could be understood as an extension of this ability to interest her immediate maternal environment through her refusal to eat. This evokes the mother's primitive anxiety, her need to respond and ensure the survival of her child. The mother's ambivalence regarding the adolescent daughter's impending sexuality and separation from her may be a contributary factor in this anxiety.[3]

Theories regarding the aetiology of eating problems abound. There are sociological factors as well as developmental theories which contribute to

3 The male anorexic is usually given scant attention in the literature. He too is involved in
 similar issues with the mother; these are of a slightly different nature. These will be
 explored in *The Engendered Gaze* (forthcoming Routledge 1995).

understanding (Palmer 1980, Crisp 1980, Bruch 1974, Orbach 1978 and 86, Chernin 1981 and 85). However, it is not my intention to review the literature nor to discuss the diverse theories regarding the origins of these problems. My aim is to draw out the central factors which lead to the efficacy of art psychotherapy as a method of treatment for this client group. The premise of this chapter is that for the anorexic, food is significant; it is a symptom; a means of expressing something else.

The transactional object

The idea that the pictures in art therapy may come to be valued as Transactional Objects is a development from previous work on the Scapegoat Transference in Analytical Art Psychotherapy (Schaverien 1987 and 91) and from an earlier paper on this topic (Schaverien 1989). The Transactional Object which I propose is different from both the Transitional Object (Winnicott 1971) and the Transformational Object (Bollas 1987). The transitional object is the first 'not me' object to which the infant becomes attached. It is an object which mediates between the mother and the environment. The transitional object is an actual object with a physical existence, a teddy bear or a piece of blanket, to which the infant forms an early attachment. Sustained by the transitional object the infant begins to be able to retain a sense of the continued existence of the mother in her absence. Winnicott demonstrates how this attachment gradually disperses and becomes sustained by the whole environment. This leads eventually to cultural life and appreciation of art.

There is clearly a relation here between the transitional object and the picture which has a mediating function in anorexia. The picture mediates in the transitional space and so it may sometimes become a transitional object; it may enable the patient to sustain the relationship to the therapist in her absence. This is the beginning of the ability to symbolize and relate as a separate person and it is one facet of the artist's relation to her pictures; but it is not this function that I am exploring here. I am suggesting a more direct and, in some ways, less complex role for the picture. I am proposing that the picture is an object through which unconscious transactions may be acted out and channelled. Initially an unconscious acting out, it may lead to a conscious attitude and enactment.

Bollas argues that the transitional object is 'heir' to the transformational object (Bollas 1987). The transformational object is a part-object relation, an internal process, which is a result of the earliest attachment to the mother as mediator. 'Not yet identified as other, the mother is experienced as a process of transformation' (Bollas 1987, p.14). The mother transforms

otherwise unbearable anxiety or intolerable feelings; she metabolizes the infant's experience and returns it in a manageable form. Bollas considers that the transitional object belongs to a later stage and is dependent on the satisfactory negotiation of this earlier developmental phase. Clearly, this too is relevant when working with disorders related to food. However, unlike the transitional object and the picture, the transformational object is not a tangible object and it does not actually exist between the mother and the child.

The transactional object that I am proposing offers an additional category. It owes a debt to both of the above theories but it comes from a different root. The idea is based on anthropological explorations of the use of art in different cultures throughout the world.[4] The word 'transaction' implies a category of object which is used in exchange for something else. It is an object through which negotiation takes place. This may be thought to imply a conscious transaction, but the process to which I refer is primarily unconscious and may be magically invested.

Art materials and food

Like food, art materials have a physical presence, and, like the mother offering the child food, the art psychotherapist provides art materials for the patient to use. The concrete nature of this transaction, within the therapeutic boundary, sets up a resonance with the problem. This can be observed in the use made of the art materials; often they are related to in a similar way to food. For example, it may be some time before the anorexic will dare to engage with the art materials. She may be suspicious of them and refuse to use them at first. Then she may tentatively try them out in private, well out of the view of the therapist. She may make her pictures in secret and so the art therapist never sees the process – the mistakes the parts that are covered up. When eating, the anorexic takes a small helping of food and then plays with it; likewise, when offered art materials, she may take a pencil in preference to any of the more sensual materials offered. She may then make a tiny mark and fiddle around, tentatively marking the paper, but never 'biting' into it. This approach of the anorexic echoes her relationship with food. Levens (1987) has shown that the bulimic patient will be more likely to binge on the art materials; going wild and splashing paint around and

4 This is a term to which I am indebted to my colleague Dr Ragnar Johnson for drawing my attention. In exploring the use of art objects in art therapy with our MA students at the University of Hertfordshire, he pointed out the transactional use of artefacts in anthropological studies.

then worrying about the mess she has made. Thus it is evident that the relation to the art materials is significant even before a picture is made.

Once made, the picture becomes an object through which unconscious transactions may be negotiated. The pictures reveal the significance of the role played by food; but the pictures, as objects, may themselves be the medium through which the patient relates to the therapist. This may reproduce elements of the mother/child feeding relationship in the trans-ference. The use of food as a transactional object might be understood to be an unconscious displacement of an anxiety or fear. If this displacement can be channelled through art materials it may be possible to bring the original impulse to consciousness. The pictures, as temporary transactional objects, may facilitate the beginning of movement from an unconscious, fused state, where magical thinking is activated, to separation and differentiation.

Case illustration part 1

The following vignette is offered as an illustration of the beginning of this process. It is an example of the very early stages of engagement in art therapy with an anorexic patient. I offer this here because it shows how the pictures begin to reveal and embody the inner world state of the patient. This occurs even before the patient becomes conscious that it is doing so. With May, as with most anorexic patients, there was a mild resistance to using the art materials. Although she had some facility with them, there was little understanding of the reason she was being asked to draw or paint. I suspect she complied initially because the therapist requested it. Only gradually does the process become meaningful for the patient.

May had made a few decorative pictures in the two weeks since her admission. She was an in-patient on bed rest and, in accordance with my usual practice, I left a selection of art materials with her in her room. At first the pictures she made were all similar to Figure 3.1. This is a very common type of picture for anorexic patients. Although it could be understood to be revealing in several ways, the controlled nature of its execution is typical. Such a picture echoes the transference to the therapist in that it affirms, as does the patient herself, no matter how emaciated, that all is well and she does not know what all the fuss is about. Both pictures, Figures 3.1 and 3.2, are carefully drawn, the use of the material is sparing and they are drawn on very small pieces of paper. This is typical of the relationship of the anorexic to the art materials in the early stages.

Despite the apparently decorative quality of the picture, Figure 3.1, there are several indications in this picture of the problem. For example, the mushroom or toadstool, which I have encountered as a common image from

Figure 3.1

anorexic patients, could indicate food which is experienced as dangerous, or poison. The slim fairy figure which floats above temptation, high in the sky could be understood as in flight from reality. She is not earthed but rather an aethereal creature with the ability to fly. She is the opposite of an embodied and earthed woman. Associated with the crescent moon, this could be understood as the unconscious element in the psyche. Thus, the picture states the problem. The female figure is suspended, neither child nor woman, she is poised between earth and sky. However, the patient was in no way ready for such an interpretation. It was early days and her attitude to it was defensive and protective. For her the picture was no more than it appeared; an attractive image drawn in coloured felt tip pens. This image was apparently

unconnected to her feeling self. It was of little significance to her and, in this way, it echoed the transference to the therapist.

This picture was not a transactional object in any embodied sense. None the less, I suggest it was, because it was the beginning for May of permitting art to mediate between her inner world and her outer self. It was a reflection of her inner state and it was 'out there' for her to see. Subsequently, she showed it to the therapist and so it was the beginning of permitting the art to mediate between her 'self' and the therapist. In contrast to this picture was the tiny pencil drawing which was drawn on the back of this 'pretty picture' (see Figure 3.2). This was the start of engagement in art therapy for May.

Food as a transactional object

For the anorexic, food is empowered. As we have seen the power attributed to it effects the relationships between the anorexic and those people who care most about her. For her, food is a focus on which many bargains are struck; bargains with herself and bargains with others. In this sense food becomes for her a transactional object.

The interest of the anorexic in her food consumption frequently extends to other members of her family. In addition to controlling her own food intake, the anorexic may have a compelling interest in the food consumption of other family members. Often, while starving herself, the anorexic will take an abnormal interest in the diet of her family. Sometimes this becomes manifest in her insistence on cooking food for the family which she will not eat; sometimes it is evident in her obsessional concern that they should eat healthy foods. Thus, her anxiety regarding her relationships can be understood to be expressed in a concretized form through the food. She may attempt to strike bargains with them over food, insisting that they eat what she will not. She may sit at the dinner table eating only lettuce, pushing the rest of her food into piles or hiding it under a lettuce leaf. Meanwhile, the rest of the family becomes increasingly exasperated, angry and worried in turn.

Battles for control of the life of child/woman rage in the family around such behaviour, the symbolic nature of such life and death struggles is vividly expressed by Spignesi (1985). Both intra-personally and inter-personally these are highly emotive and complex methods of relating, with food as the currency and endless focus of attention and concern. For the anorexic, food becomes a medium by which deals with others are negotiated and a distorted independence is achieved . The anorexic structures her social existence and her private world through food; she controls her own body and exerts some

control over others through it. Food, which is essential for life and health, becomes an unconscious way of symbolising conflict. Anorexia could be seen as an unconscious acting out of the splits and stresses of the divided inner world of the sufferer. It is her own unique and self invented solution, which is a symbolization of an internal battle for control of her life, Shorter (1985).

The picture as transactional object

It is here that we can begin to isolate one reason why it is that art psychotherapy is potentially effective in treating such patients. Art offers an alternative; a way of enacting and symbolising the inner conflict and it also provides another potential transactional object. Anorexia could be understood to be a form of acting out. *Acting out* is behaviour which is motivated by unconscious pain; a form of splitting. The relation to food could be understood to be such acting out. Conversely, *enactment* implies that there is consciousness and so the act has meaning. The art work, as a transactional object, might at first be the channel for unconscious acting out; later, it may develop into an enactment.

This transactional object is very different from the other transactions which involve discussion of body weight. Whether the therapist is working as a member of an in-patient team, or with the client as an out-patient, she needs to know about the rest of the treatment programme. It is essential that she is in contact with other workers so that she does not becomes split off and manipulated by the patient. However, she must not negotiate any contract with the client over weight gain or loss or regarding food intake. Art should never become a bargaining counter itself; this can be very destructive. For example, I have known a situation where the patient was only permitted to be engaged in art therapy when a certain weight was attained. Furthermore, weight loss meant foregoing art therapy. In this behavioural approach art becomes a privilege which is gained or withdrawn according to external factors. Art psychotherapy cannot be effective if it becomes part of a bargaining process itself.

The transaction to which I refer is less conscious and less obvious than this. When a picture is made it is private; it belongs to its maker. The content of the imagery may not be conscious, but the artist has the option, at any time during its creation, to obliterate or destroy any part or the whole picture. In practice it is relatively rare that a picture is destroyed, but it is this option which is, for the anorexic patient in particular, so essential. The picture can be viewed in private and then shown. This makes a space between the 'utterance and the performance'. Throughout the process the access of other

people to the picture is controlled by the artist. The picture thus becomes, like food, a private matter. Furthermore, it is an object through which mediation for control may be negotiated without the necessity for verbal intervention.

The picture is less important than food and so it is not as emotive in terms of family dynamics. Parents may be curious to see the picture, but it is not a matter of life and death, as is eating. Thus the patient may find this is one area where she can express herself and yet find a refuge. Here she may explore how she feels without invasive questioning of her motives. The picture offers a forum where unconscious conflicts and conscious concerns may be externalized and the internal theatre of the patient may be revealed. It can then be viewed by the artist herself, and subsequently by others – but only if she chooses. The picture, and the inner constellation which it exhibits, may become accessible for discussion but at a remove from the patient. The picture is 'out there', a third object, a potential transactional object which is not food.

We have seen that the anorexic is preoccupied with controlling her desires and maintaining a distance between herself and the people around her. Her inner world patterns reflect this; so for her the picture may offer a real solution to the problem of maintaining her own space in relationships. A picture creates space and it offers a way of potentially sharing that space by permitting the imaginal world to be viewed. The anorexic does not usually permit herself imaginal space; she does not dare to dream or risk chaos; nor can she permit her vigilance to lapse for a moment. She fears mess and intrusion and by either she may be overwhelmed. A picture, even the first tentative attempts of the anorexic, permits the possibility of contained mess, within the framed space of the picture. Here chaos may be held safely within the boundaries of the paper, separated from its creator, and it may exhibit the imaginal world.

This picture may become a scapegoat in that it may embody the chaos, the feared aspects of the inner world; on the paper these may become 'live' within the therapeutic relationship. Here the client may engage in a way in which she cannot dare to venture to engage with the therapist. The framed and separated nature of the picture serves two functions for the anorexic. It separates the pictured image from her and, in doing so, distances her from her own fears. Paradoxically, it brings the pictured fears and fantasies nearer to consciousness because they are to be seen. Simultaneously, the picture protects the transitional area Winnicott (1971); it keeps the space between patient and therapist. The imaginal world may be revealed in the picture but

there is no automatic right of access to it. No one else has a right to see or even question it.

Food as subject matter

The initial pictures made by anorexic patients are often about food. A skeleton sitting on a huge pile of food which reached to the edges of the paper was the way that one young woman pictured her predicament. The pictures which refer to food are often the first ones, the ones which state the problem. I submit that they also test the therapist. By assessing the therapist's reaction to the *content* of the imagery, the patient measures the therapist's reaction to her attitude to food. The reception of these early pictures is then crucial. If the therapist is able to convey that she accepts these pictures, without getting drawn into negotiations about the consumption of food, she may gain the trust of the patient. Despite her defences, the anorexic is likely to be desperate for her plight to be understood.

It is possible for the therapist, by not showing any particular interest in food, to encourage the patient to relinquish her obsession, at first only in her pictures. This is not an overt ploy, merely that the therapist is genuinely more interested in the person than her food intake. The interest in the person, without the interest in food, is unusual for the patient, who is used to defining herself in relation to her food intake. As soon as she enters hospital, negotiations regarding weight gain and food consumption are formalized. Art permits her to be an ordinary person with ordinary worries; through the making of pictures she may redefine her existence. In finding another means of expression for her conflicted and divided inner world the focus may shift; the patient may begin to permit herself to eat more normally. The problems, fears and fantasies which have been displaced into food are released. The fears which have been frozen with the imaginal aspects of the self may come to the fore at this stage in frightening and powerful images. A freedom and self-understanding develops through assimilation of the pictured image. An understanding of the unconscious meanings of anorexia becomes clearer, and the need to enact the drama of life through food is gradually relinquished.

When the patient is courageous enough to risk picturing food, and her relation to it, the therapist merely accepts this as any other statement, or image, of feeling made by the patient. Overt interpretations of the content of the patient's pictures or behaviour tend to be experienced as invasive. Transference interpretations are rarely useful with the anorexic; the very nature of her transference means that they meet with denial and rejection. However, the picture could be understood to be a kind of visual interpreta-

tion; it is seen by both people and even when nothing is said, the picture has, as it were,'had its say'. The patient who fears intrusion will not find it easy to show the therapist her pictures; she is likely to feel extremely exposed when she has made an image which has any real meaning for her. When the picture gives access to her imaginal world, in however tentative a manner, there may be an overwhelming feeling of risk.

Transference

The transference with this client group presents a rather different set of problems from other client groups. In the transference the therapist is likely to be experienced as 'a parent' and to be expected to relate in similar ways. Thus there is an immediate problem for the development of a working alliance within which a transference may develop. The client will treat the therapist as she does all adults, as a figure of authority, so she may anticipate loss of control. She will need to keep the therapist at a safe distance, in order to maintain her control of the situation. The transference in psychotherapy effects the unfreezing of old patterns. The anorexic has learned to live without trusting imagination for fear that she will be overwhelmed by chaos; similarly, she will not trust another person for fear that she will be overwhelmed in relationship. The imaginal world will thus remain frozen (Spignesi 1985).

The transference to the therapist is likely to be a repetition of the powerful cycle of resistance. Attempts on the part of the therapist to mobilize unconscious forces are likely to be frustrated. The anorexic is the expert at this relational game and she is terrified of letting go. We have seen that there is often a similar resistance to engaging in the art process. However, in my experience, it has become noticable that, like May, she just may permit herself to start to imagine on paper, usually in private, or out of sight of the therapist. She may have been good at drawing at school; alternatively, she may never have any previous abilities in this area but she may have a little confidence in making controlled pictures. These are usually pale pencil or felt tip pen drawings – both mediums which allow for maximum control of the end result – paint is rarely used. This may be the start. Eventually, a transference may be mobilized in relation to the paper; the pictures which were initially decorative, tight and diagrammatic may begin to embody feeling.

By altering the currency and also the nature of the obsession, by the gradual substitution of art for food, the therapist is offering the client a different method of negotiating with the external world. This is a delicate task. The therapist initiates the creative process; in this sense she teaches the client that it is possible for her to use this medium. At the same time she must

maintain a distance from the final picture and from the picture in progress. She accepts but must not be experienced as curious, interested, or enthusiastic. The therapist must be prepared to wait without expectation while the patient is given space to be private and even secretive. The patient needs to have the option to destroy her pictures or to hide them. It doesn't matter if the therapist does not see everything that is made; it is far more important that the patient can find refuge in her art work; that she can begin to explore for herself the constellations of the images of her inner world. If she can begin to do this, then later there may be the opportunity for discussion of content with the therapist. Links and connections may then be made which further the progress of differentiation. This will all follow the initial involvement of the client with the art materials which she can control. The triangular pattern of child–food–parent may be replaced by one in which the picture becomes the apex of the triangle. We then have patient–picture–therapist the concrete element which was food now becomes picture. The potential for a symbolic dimension enters the equation.

Case illustration part 2

For May, the unfreezing began tentatively and, I propose, initially through the image Figure 3.2. I spent a good deal of time with May listening to her story, hearing about her life, and her relationships with her family and looking at the pictures she had made. Before leaving her on one occasion I suggested that she might think about what she had told me and perhaps she could find a way of picturing it. The direction was not specific, but it was designed to give her permission to picture her distressed feelings on paper. It was also intended to affirm the seriousness of what she had told me. This session was the beginning of a real engagement in the process. I was permitted to see, and side with, the real, distressed part of herself.

When I returned to see May in her little room, a few days after the session described above, she showed me first her pretty picture, Figure 3.1, and then, tentatively, she showed me her secret image drawn faintly on the back of the paper. It was a very small pencil drawing of a girl curled up in an oval shape, remniscent of an egg. In its own way this vividly portrayed her situation. It did not need immediate interpretation. The image revealed her regressed state; at this stage words would have intruded in her relationship to the image. The image was hidden on the reverse of the picture Figure 3.1. which she considered to be more acceptable. It showed her something of which she may have been only partly conscious prior to making the drawing. The

Figure 3.2

therapist saw the image without needing to ask for explanations; it is an eloquent image; an exemplification of a feeling rather than an explanation (Henzell 1984). May knew that I understood that she was showing me how withdrawn, little and regressed she felt. In this way she was starting to let me into her world, to show it to me; she could not find words to tell how she felt but she did not need to because it was evident from her picture.

This tiny doodle on the back of what she considered, at the time, to be her more important picture was an 'embodied image' (Schaverien 1987, 1991). It was the first tentative step in admitting to herself, and to the therapist, how she felt. This very small picture engaged her feelings on a real level in contrast to a performance level. She was permitting a public expression of her private experience. In so doing she was admitting, only partly consciously, that her pretty picture world was an act; a false-self construction. I submit that this change occurred because trust and a positive transference was beginning to become live in the therapeutic relationship. After our previous meeting she was prepared to allow herself to experience, in a tightly controlled, and safely small, pencilled image how she felt. The

tiny picture, which risked admitting feelings of vulnerability, was a tiny picture but a very large potential step.

The picture was the medium through which a transaction could begin to take place between us. The patient could experiment with relating to the therapist but without actually facing her. Both could regard the picture while talking about the feelings. This enabled May to test the triangular space. Perhaps she was, unconsciously, testing whether the space between us would remain once her inner world was exposed. To use a feeding analogy – she was nibbling, testing whether, if she took a small bite, interpretations would be stuffed into her. By showing the picture she was using an object to mediate between herself and the therapist. Thus this picture was a transactional object that was not food.

Conclusion

In discussing the role of the picture as a transactional object, the focus has been the object nature of the art work. However, the images which emerge in a series of pictures, in long term work, are highly significant. In this chapter, the aim has been limited; I have attempted to highlight one facet of the ways in which pictures offer the anorexic patient a medium for entering into relationship. The pictures facilitate a relationship, first to the self, and then to another person; in this way they begin to embody some of the power which was previously invested in food and so they become transactional objects in place of food. The therapist is present as witness; and so it is likely that the relation to the therapist may repeat some of the power which was invested in the parents. Thus, there are two ways in which the transference may begin to come live into the present of the therapeutic relationship. First, through the transference to the picture, in place of the relationship to food, and, second, through the transference to the therapist in place of the parent.

References

Bollas, C. (1987) 'The Transformational Object'. In *The Shadow of the Object*. London: Free Associations.

Bruch, H. (1978) *The Golden Cage*. London: New York: RKP.

Cassirer, E. (1955 and 57) *The Philosophy of Symbolic Forms*. New Haven, CT: Yale University Press.

Chernin, K. (1981) *Womansize*. London: Women's Press.

Chernin, K. (1985) *The Hungry Self*. London: Virago.

Crisp, A.H. (1980) *Anorexia Nervosa: Let Me Be*. London: Academic Press.

Dana, M. and Lawrence, M. (1989) *Women's Secret Disorder: A New Understanding of Bulimia*. London: Grafton.

Eichenbaum, L. and Orbach, S. (1983) *What do Women Want*. London: Penguin.

Henzell, J. (1984) Art, psychotherapy and symbol systems. In T. Dalley (ed) *Art as Therapy*. London: Tavistock.

Levens, M. (1987) Art therapy with eating disordered patients, *Inscape*, summer pp. 2–7.

Mahler, M. *et al*. (1975) *The Psychological Birth of the Human Infant*. New York: Basic Books.

McCleod, S. (1981) *The Art of Starvation*. London: Virago.

Orbach, S. (1978) *Fat is a Feminist Issue*. London: Hamlyn.

Orbach, S. (1986) *Hunger Strike*. London: Faber and Faber.

Palmer, R.L. (1980) *Anorexia Nervosa*. London: Pengiun.

Rust M.J. (1987) 'Images and Eating Problems'. In M. Lawrence (ed) *Fed Up and Hungry*. London: Women's Press.

Rust M.J. (1992) 'Art therapy in the treatment of women with eating disorders'. In D. Waller and A. Gilroy (eds) *Art Therapy A Handbook*. Oxford: Oxford University Press.

Shorter, B. (1985) The concealed body language of anorexia nervosa. In A. Samuels (ed) *The Father*. London: Free Associations.

Spignesi, A. (1985) *Starving Women*. Dallas: Spring.

Schaverien, J. (1987) The scapegoat and the talisman: Transference in Art Therapy. In T. Dalley *et al*. (eds) *Images of Art Therapy*. London: Tavistock.

Schaverien, J. (1989) Transference and the Picture: Art Therapy in the Treatment of Anorexia, *Inscape* Spring.

Schaverien, J. (1991) *The Revealing Image: Analytical Art Psychotherapy in Theory and Practice*. London: Routledge.

Winnicott, D.W. (1971) *Playing and Reality*. London: Penguin.

Bringing 'The Man' Into the Room
Art Therapy Groupwork with Women with Compulsive Eating Problems

Mary-Jayne Rust

In this chapter I will be drawing on my experience of facilitating three one-year analytic art therapy groups for women with compulsive eating problems at the Women's Therapy Centre, North London.

I would like to set the scene by describing the context in which this work took place, as The Women's Therapy Centre (WTC) is a very specific setting in which to work. It is an all-women environment and it is well known, amongst other things, for its work with women with eating problems. This began with the publication in 1978 of *Fat is a Feminist Issue* by Susie Orbach, who co-founded the WTC with Luise Eichenbaum in 1976. They have published many books and articles on women's psychology. Together with material published by other members of the WTC and the workshop and education programmes, their work has reached thousands of women who come in search of a feminist psychotherapy, in the hope that it can offer a different understanding of their lives from the more traditional psychotherapies. For many women their past experiences with men make it impossible for them to speak to a man in a therapeutic setting.

One of the features that sets the WTC approach apart from other therapies is the interweaving of internal with external influences in women's lives. It takes into account the fact that many of the difficulties that women experience spring from the different positions that men and women hold in today's society. These influences get channelled through the family so that sons and daughters are raised in different ways.

In my experience women come to the WTC with tremendous expectations that at last here is a place where, not only will they be finally understood, but that things will not be like they are when men are around. There are hopes that this will be a warm, cosy and nurturing environment where the groups are supportive. In one sense these hopes and expectations are very helpful in aiding the therapeutic work: building the therapeutic alliance and nurturing the positive transference perhaps goes more smoothly under these circumstances when hopes are high. Difficulties begin when conflict starts to emerge, when women get angry with one another, hurt one another and experience feelings similar to those which have dogged their relationships with men.

This is one of the central issues, amongst many others, I wish to address in this chapter, as I believe it is a key issue for a woman in the working-through of her eating problem. Art therapy is one way of bringing these issues to light, of helping conflicts to move from being locked in the concreteness of the body to a place where they can be imagined, expressed, thought and spoken about.

Culture, gender and the recent increase in incidence of eating problems

The scene needs to be set in another way. To talk about a difficulty such as an eating problem without pointing to the fact that it is gender, culture and time specific is tantamount to talking about the increase in incidence of heart attacks in men without looking at its relation to stress at work, living in the 20th century and all that a western lifestyle entails.

Of course there have always been different ways in which people have experienced difficulty around eating. I am here referring to the particular problems that we are facing today, known as anorexia nervosa, bulimia nervosa and compulsive eating, of which only one in ten of the sufferers are male. Furthermore, these symptoms are known only in western culture (although as western culture spreads more into other parts of the world these symptoms are appearing elsewhere) and have rapidly increased since the 1960s. Today we see an alarming situation where it is the norm for a woman to be permanently worried about her body, to be on a diet. In my experience there are extremely few women who have not, at some point in their lives, had a problem around eating and/or body image.

I would support Orbach in her claim that it has its roots in the gender imbalance of today's society (Orbach 1978). We live in a patriarchal culture where men hold more power than women. Men are taught to have more of a voice in the external world and to act OUT their feelings whereas women

tend to internalize their feelings, to act IN. For example, a woman would tend to be violent to herself rather than towards another, hence the high proportion of women in mental institutions as opposed to prisons. It follows that a woman would be more likely to use food as a means of swallowing her feelings.

There is gender difference in who carries the baby, who feeds it and who continues to be in charge of feeding the family. According to Orbach and Eichenbaum (1982) mothers relate to girls and boys in different ways. A mother unconsciously prepares her daughter not to expect too much as an adult woman by limiting the amount of care she receives as a baby. Indeed, the evidence is that girls spend less time at the breast, are fed less and weaned earlier. It also suggests that a mother may unconsciously believe that her baby daughter can meet some of her own needs for longing and care. The outcome of this is that a girl never quite gets enough, from her earliest experience onwards, and leaves home still hungry, so to speak. Little wonder that she should then turn to food, in a variety of ways, as a mother substitute. She feels guilty for her longing and copes by splitting off these feelings, which only re-emerge in a less conscious form as an eating problem. The whole drama with mother – the wanting, the feeling guilty for wanting and the pushing away – is then re-enacted in the form of taking in food and throwing it up.

In the therapy relationship the task is then to uncover the split-off longing, for it to be felt in all its rawness, so that finally that woman can be in touch with what it is she longs for, and can make some moves to find some of it. Again, this is played out in terms of food. The food is always eaten surreptitiously and as a result the hunger is never really satisfied. If the physical hunger can be laid bare and differentiated from the emotional hunger, the woman has a chance of knowing when to eat, what kind of food she wants, how much and when to stop.

The situation is made far more complicated when it is not just a case of care being withheld but when there has been an inappropriate response to what is needed. Take, for example, the case of feeding when what is really needed is to be physically held. A more extreme example is when a father abuses his daughter. She experiences love and abuse all tangled up together. She feels that it is her desire that has brought this about and often tries to resolve the situation by a refusal to take things in at all or an unconscious determination to rely on food rather than people to meet her needs. It is a long job to unravel this situation to a point where taking things in from the therapist can be experienced as satisfying rather than abusive – to where she can begin to see that she is simply repeating this long held pattern of abuse

by putting things (e.g. food) inside her that she does not really want. The eating problem is an abuse of her body. Because she is not in touch with her own needs she cannot distinguish what she wants from what she doesn't want. The anorexic copes by starving herself and saying 'no' as much as possible to everything. The bulimic woman wavers, eats and vomits, wanting to take things in and then not wanting them. The compulsive eater says a blanket 'yes', eating continuously or bingeing regularly and then going on diets as a means of mildly purging her system.

In the therapy setting the task is to try to uncover the needs that have been split off, which have been felt to be overwhelming or wrong, to take the conflict away from the arena of the body into an area where it can be expressed in images and in words. Art therapy can be particularly helpful here in providing a means of expression which is more physical than a verbal exchange. This is especially useful in an area of difficulty which could be termed as psychosomatic, where the sufferer is already using a physical means to express the underlying difficulty in an unconscious way. (See Rust 1992 for more detail.)

Setting up the groups

There are many different types of therapy offered at the WTC – individual and group work, brief and open-ended work, therapy aimed at a particular client group and week-end workshops. A one year closed group for women with eating problems offers some thing in between a workshop and open-ended therapy. This type of time limited closed group is a place for women really to get a taste for what is on offer without feeling committed to a longer term venture. For some women this can serve as a preparation for open ended work, whilst for others it might be sufficient in itself.

There are separate groups at the WTC for compulsive eaters and for bulimic women. Women who do not make themselves sick can find the bulimic experience too disturbing to hear about. It is therefore necessary to create spaces where women with different difficulties feel safe to talk about the range of their experience.

A waiting list is formed from phone and letter enquiries. Some women are self-referred and have heard about the work of the WTC through the media, literature or through friends. Others have been referred through their GPs, hospitals or social services. They are then assessed for their suitability for such a group with the aim of selecting eight women altogether. Questions are considered such as whether the woman will benefit from once weekly group therapy – does she need more than this, does she need individual work, how will she cope when the group comes to an end.

The balance of the group is considered carefully in terms of issues that might set one person apart from the others, such as age, race, class, sexual orientation and size. Generally speaking, for a woman to be 'one of a kind' in a group can place her in a very difficult position. Of course, in one way or another, we are all 'one of a kind'. However, there are some instances when this situation is particularly difficult. When being 'one of a kind' ties into being part of an already oppressed minority in our culture then this person is likely to receive some difficult projections from the rest of the group. Take, for example, the issue of size in a group where eating and body image is the focus. Many of the women seeking help are not necessarily overtly overweight, although of course they feel themselves to be unacceptably large. They long to be thinner than they are. Fat is the place of loathing, disgust and depression which they yearn to get away from. For one woman in the group to be noticeably much fatter than the others might set up a situation where she is carrying these loathsome feelings for the others. This might become unbearable for her to the extent that she leaves. To have two large women in the group helps to spread the load of feelings and makes it easier for the projections to be challenged.

Something similar might happen for the only lesbian in a group of heterosexual women, for the only black woman amidst a white group, for the lone working class woman or for a woman much older than the rest of the group. Racism, homophobia, class discrimination and ageism are as much in the group as they are in our culture. Having 'two of a kind' helps to prevent the possibility of scapegoating.

Setting boundaries

I ran three groups, all of which started in October and ran through until the end of July, with about 40 sessions in each.

In the first group the sessions were two hours long. I introduced the materials to the group, letting the women decide how and when to paint and talk. This proved to be rather an excruciating experience for them. Just as with their dilemma of whether to eat, how much and what it was that they wanted, they found it equally difficult to know when to start and stop painting, what and how much to paint. They would spend a great deal of time deliberating over making the boundaries between talking and painting and frequently left the painting to the end. There was then not enough time really to involve themselves in the process and no time at all to bring the images into the group afterwards.

Whilst this was an interesting process in itself, for it so reflected dilemmas about decision-making in their lives, it seemed that in such a time-limited

group they could never get to the point of being able to use the images in the group. They were cast away at the end of each session, not talked about or reflected on together. The creative nourishment of the group never got digested and taken into the group body as if the painting was the surreptitious after dinner feed, eaten so guiltily that it never has time to be savoured and made use of.

As a result of this, in the second group I decided to make more definite boundaries for painting and talking and to lengthen the group to two and a half hours. I invited them to paint for the first hour, which left us an hour and a half to talk. Despite my fears of this being a somewhat controlling move, this appeared a better solution in that it settled the group into a rhythm of painting and talking in a way that soon allowed them to start making use of the images. This could be seen as reminiscent of the way some women with eating problems need the help of a structured eating pattern imposed by an external party which helps their own rhythm of eating to develop. However, one of the complications was that there was no initial contact. The painting was done in isolation at the beginning of each session. Some members of the group found it much harder than others to make use of the painting time and, as the group developed, these were the people who arrived late each week.

After much deliberation I decided to say in the first session of the third group that painting for about an hour near the beginning of the session might be a useful structure. However, it was their decision whether to continue with this. Providing them with a little structure that they could use flexibly seemed to work well for this client group. For them to be plunged into something so unboundaried seemed too paralyzing, despite the useful parallels with their eating problems.

Beginnings and middles

Although each group has its own particular atmosphere, the beginning of the group is always an anxiety-provoking time. One of the things I have noticed about this particular client group is the reluctance to just jump in, to make a mess. There seems to be a tremendous fear of getting tangled up together without being able to get out again intact. This makes the use of the art materials a difficult experience, initially, where the paint needs to be controlled. Often the women prefer to use dry materials on small pieces of paper. There is not a sense that if something is unintended it can be used as a slip of the brush, transformed or repaired. Alternatively, at the other end of the spectrum some women embark on copious amounts of art work, filling the paper with a mass of material as if bingeing.

This seems to be reflected in the family backgrounds which, roughly speaking, fall into two types: either the difficult feelings have been kept firmly under wraps and not expressed at all, or they have got very out of control, with violent outbursts where people get hurt emotionally and/or physically. In either case there is no room, for example, for anger or grief to come and go, being a useful and natural part of being alive. As a result, food is used as a means of quelling the feelings to stop them from erupting uncontrollably. Understandably, there is a fear of the feelings coming out on the paper, of producing something that might be too revealing or interpreted by others in a way that feels uncomfortable. The images are often kept outside the group circle to begin with. Gradually, as they are brought in, there is a reluctance on the part of most of the group to make any comments about other people's work. The feeling I am left with is that it would be extremely intrusive to remark on any piece of work and certainly if I do I must not 'get it wrong'. Without this feedback between one another there is little satisfying nourishment within the body of the group and the women leave each session feeling somewhat starved. At this stage there is often mention of bingeing before or after the group, indicating the lack of a good feed during the session. It is as if the fear of crossing over one another's boundaries, entering into one another's space, keeps each person separated off. Without this penetration there is no cross fertilization and nothing new can be conceived.

Clearly, there is a link here with the experience of abuse. Much has been said recently of the connection between eating problems and sexual abuse: that there is an unusually high percentage of women with eating problems who have experienced some kind of sexual abuse in their childhoods. Although my experience seems to bear this out, to make the connection in the sense that the abuse is the cause of the eating problem is too simplistic. Rather, I would suggest that abuse of the child goes on in a much wider sense, where boundaries are overstepped in all sorts of ways. For example, even if the father is not sexually abusing the daughter, he might be seeking things from her which are inappropriate. He might be touching or looking at her in a certain way which feels more like a partner's touch or look. He might be seeking emotional comfort from her that he should be getting from his partner.

Alternatively, father might be absent from the home a lot, whilst mother seeks consolation from the daughter, taking her into her bed at night as a substitute for father, using her as a partner in talking things over. Daughter becomes in effect a close friend. 'Abuse', or the 'inappropriate use of', can take many forms, some of which are subtle and can only be identified later on. When there has been no definite violence or clear sexual abuse it can be

very confusing for a woman to try and articulate that something was clearly not right.

If what has been taken in feels out of place or wrong or bad, the solution is to maintain a very tight boundary, to keep strict control over what comes in. To be intruded upon or to intrude upon another's space can only lead to discomfort. This is like the taking in of food which then needs to be purged because once inside it can feel quite indigestible. It is small wonder that there is such difficulty in digesting the images within the group.

In some of the images parts of the face are covered or erased, particularly the eyes, mouth and ears. One woman, who had had a particularly prolonged experience of abuse at the hands of her father, repeatedly scratched out these features. Later, when she was able to describe these images, she discovered that these are the parts of the visible body which penetrate and take in other people – seeing into, speaking and listening. Without eyes, ears and mouth there is safety from penetration.

Another particularly vivid instance of this was in one of the groups where seven out of eight of the members had experienced either physical and/or sexual abuse as a child. As usual, the group had formed a close bond at the beginning by talking about their relationships with men who were the abusers, the ones who raped and who committed the violence. We could be safe in here at the WTC without men.

One of the group members stopped bingeing quite soon after the group had begun and as a result her bottled up feelings were spilling out everywhere in her life. She was no longer putting up with situations she had been in. This had a ripple effect on the rest of the women who began to take more risks in their lives. Slowly, the feelings began to creep into the room. As anger and frustration came bubbling to the surface a woman was doing a series of snake images in clay. One of the images was a container full of snakes crawling out, echoing the feelings spilling everywhere; the can of worms had been opened.

In a session following on from this, she did a particularly large snake with a knot in its tail sitting up like a cobra. It was placed in the middle of the group, squarely facing me. When we sat down together I waited with baited breath, sensing the volcano about to erupt. The woman described the snake as a 'dick' and the knot in its tail she linked to the can of worms which she had also seen as a vagina. The group seemed to be enthralled, frightened and outraged; the 'man' had come into the room without a doubt. They spent a good deal of time looking at this object and talking about it. So much was contained in this image. They felt as though things were being dredged up

from the bottom of a pond like monsters from the deep. They likened the snake to the creature 'Alien' in the series of films Alien, Aliens and Alien 3.

In the first of the Alien films a group of people land on a strange planet and, whilst investigating a collection of eggs in a cocoon state, a creature leaps out almost imperceptibly into one of the travellers. The group return to their space ship and, some time later, after this creature has incubated inside the stomach of this person, it breaks out through his stomach wall. It grows larger and larger, terrorizing the crew. They also talked of tapeworms in the stomach, alien creatures living inside them, feeding from them, needing more and more food, leeching the body of all good nourishment.

They seemed to be saying something of the poisonousness of penetration in any form: that which gets inside becomes like a parasitic monster which eventually threatens to destroy its host like a father or mother who uses the child for his/her own ends, to the point where the child is leeched of all identity.

As the group facilitator, I seemed to be experienced as two things: a penetrating and leeching parent, my words being the only valid comments within the group therefore leeching them of their identity. But I was also the person who they imagined could lead them through, to show them the way out of their eating problems. The snake was facing me, threatening me with its deadly bite.

Suddenly, one of the group said she was sickened by this and wanted to stamp on the snake's head. The woman who made it gave her permission and, to the amazement of the group, she got up and did just that.

There was some relief that this threatening creature had been destroyed until they realized that at the same time as destroying the poisonous part of the snake they had also destroyed its capacity to eat, to talk and to listen. In their musings on this event they began to talk of their own capacity to penetrate, to hurt and sometimes their capacity to abuse one another and themselves. Certainly their own desire to eat until it became painful was, they realized, a repeat of the original abuse.

To navigate this part of the group where the women begin to acknowledge the perpetrator within as well as the victim feels like walking in a minefield. For them to see how they continue to abuse themselves is to admit to a part of themselves being like the abuser who has been so hated and kept away at all costs. For these issues to be broached too early on in the group, before the group as container is strong enough, can feel too persecutory and group members are likely to feel very unsafe and leave. For it to be left too long in a time-limited group leaves no time for the issues to be worked through, for the angry and destructive feelings to be survived. Group

members leave without a sense of being able to repair any damage that has been done.

In my experience, these explosions of anger usually come to a head about mid way through the group. There is then enough trust between group members to expose and survive the very strong feelings, and enough time for reparation to take place.

For the abuse not to continue, they have to find the ability to draw a line, to state a boundary between what was and what was not acceptable. As children, they had not known this boundary and, even when they did, it had been too frightening to say 'no'. As adults, they needed to recognize the hurt taking place and to stop it continuing, to say 'no' when necessary: to recognize the hunger, to eat, to stop when full.

It is interesting to note here how many times there were intruders into the room during the course of the second group, when so many of the group members had had the experience of abuse and of mothers who could not protect them. For a while I became caught in the powerful counter-transference feelings and found it hard to think of a way of protecting the group space.

The room we were using was on the ground floor of a large community health building. The WTC is on the top floor and does not suffer from intrusion in this way. It took me some time to think my way into putting up adequate notices to ensure that people did not wander in asking for information. Of course I had thought to do this from the beginning, but clearly my initial attempts were not good enough. It was not until I realized how powerfully this tied into the material of abuse that it became crucial for me to know how to draw the line for the group in protecting the space. I had become the mother who was turning a blind eye, unable to prevent the abuse from taking place.

However, my main point here is to illustrate the usefulness of the image in enabling these angry feelings to emerge. From the beginning of the group there is a space, however unconscious, for the violence to be seen without these feelings entering into the verbal exchange. When there is such fear surrounding the violent feelings within, an all or nothing situation arises. If conflict erupts too early before there is enough sense of containment some women feel too unsafe and will leave the group. If the conflict is suppressed altogether, the feelings emerge outside of the group, leading to the continuing self-destructive behaviour such as bingeing.

The image making provides a space for the individual within the group to have a dialogue with herself which is seen, unlike an internal dialogue. This can give each woman a chance to allow difficult and frightening feelings

to surface in a more contained way until it is bearable for them to be expressed openly, thereby risking the entanglement of conflict between members of the group.

Another important function of the image in this context is that it allows for the inherent paradoxical nature of feelings to be expressed. Together with the destructiveness of the anger is also a profoundly empowering force. The snake was both enthralling and frightening, poisonous and powerful. That which penetrates has both the capacity to abuse and the seeds for new life, creativity and destructiveness all in one place.

Inherent in the experience of abuse is the notion that it is caused by the desire of the child. In order to escape further abuse, all desire must be dampened, which of course includes the desire for life, the desire to create. Unlocking the door of creativity is like opening Pandora's Box: all kinds of images spring forth, but essential for this client group is the discovery that they own their own desire and that it can lead to both creative and destructive ends. Their abuse was the result not of their desire but of another's destructive desire. Their compulsive eating is, paradoxically, a means of both attempting to satisfy their desire in a non-harmful way and keeping the lid on their internal Pandora's Box firmly shut. Opening it through the use of art is a route which is perhaps a little softer and more connected to the body than a purely verbal interaction.

Endings

Towards the end of the group, the images are useful in bringing to light the impending finality. A woman with compulsive eating problems has difficulty in feeling the separation. Her tendency will be to deny the pain of loss and separation, being reminded of painful endings and/or deaths in the past, of never having had enough and not being ready to leave. More painful is perhaps the very early experience of the absence of what was needed, of mother not being there enough, at a time when verbal articulation was not at hand. As the end of the group approaches, her dependency on food is likely to increase to help blot out the pain and stifle her rage. To acknowledge and feel the forthcoming loss is to acknowledge her dependency on others and their capacity to leave, to hurt and to be out of the sphere of her control. Food is relied on as a stable form of dependency which is in her control. Not coming to the group is an alternative way of evading these painful issues.

A common theme in the images throughout the groups, but particularly towards the ending, is the recurring image of a black hole, a vortex, similar to the image of a black hole in space where objects are sucked in and disappear into a vacuum. Again, the image is a very useful means of

expression here when this particular internal experience of terror, of complete absence, of literally disappearing as a person, mirroring the experience of the absent mother, is so very hard to put into words.

Towards the end of the group I experienced a similar sense of all pervading hopelessness. What could we do or say in the face of these overwhelming black holes? How can words help in the face of such hopelessness and despair? In particular, I faced the frustration of being in a time-limited situation with them, to watch them having to leave when yet again they felt they had not had quite enough. With the help of supervision I realized the usefulness of being faced with the opportunity of a separation where it might be possible to FEEL through the process, to express the feelings and to make the all important links to food and body image. As well as the eating being a means of protection, so was the extra weight on their bodies. Moreover, it was important to be able to recognize what they HAD got in the face of their frustration about the complete cure not having been effected. For example, their eating problems may not have disappeared entirely, but they may be leaving with a new perspective on how they use food and their bodies.

The images were useful in holding the extreme feelings that could not be felt or spoken about until enough trust had been built up between group members. They were also containers for paradoxes which, for women who are so used to swinging around in an all or nothing situation, is invaluable.

References

Orbach, S. (1978) *Fat is a Feminist Issue.* London: Paddington Press.

Orbach, S. and Eichenbaum, L. (1982) *Inside Out, Outside In.* Harmondsworth: Penguin.

Rust, M-J. (1992) Art therapy in the treatment of women with eating disorders. In D. Waller (ed) *Art Therapy: A Handbook.* Buckingham: Open University Press.

Art Therapy and Anorexia

The Mental Double Trap of the Anorexic Patient.
The Use of Art Therapy to Facilitate Psychic Change

Paola Luzzatto

Introduction

One of the most striking features of the anorexic patient is what appears as a desperate unwillingness to change. It may be presented as denial of the illness, or as resignation to a nearly dead state of mind, or as a belief in the survival value of the symptom, or as a deep paralyzing ambivalence about it; yet the basic position is the same: 'Don't ask me to change'. Two opposite impulses, either of abandoning the patient to his/her destiny, or force-feeding him/her, are often there, in the carer's mind. Psychotherapy is not about forcing a patient, but about giving the patient the freedom to change (Freud 1923, p.50). The question is: what kind of interventions may help the patient to regain that freedom?

In this chapter I illustrate one possible approach to anorexia, based on two major steps: within a good therapeutic alliance, helping the patient to visualize the mental Self-image, and working with the patient to explore the internal dynamics of the Self-image and the potential for change in the patient.

I will start with some definitions. By 'mental double trap' I mean a self-representation based on the image of a special trapping situation, which I will describe later on. By 'anorexic patient' I mean a patient who has been diagnosed anorexic according to current psychiatric criteria, although, for the therapist, anorexia is a symptom rather than a diagnosis, and the therapist looks for the psychic reality behind the symptoms. By 'art therapy' I mean here a form of psychotherapy, based on both verbal and non-verbal expres-

sion and communication, whose aim is to facilitate positive change in the internal world of the patient, and in his/her interactive capacity with the external world. Finally, by 'psychic change' I mean a change in the pattern of internalized object-relationships that characterize the internal world of the patient. From this point of view, I work within the psychoanalytic framework of the Object-Relationship School. I work with the assumption that there is a two way relationship between internal and external world: our experience shapes the internal world, and our internal world shapes our experience.

Definition and structure of the double trap

Towards a visual image of the self

In the psychoanalytic literature, the internal world is often presented in visual terms: it may be an internalized pattern of relationships (Fairbairn 1958), a picture of a relationship with an object (Hinshelwood 1991) or an internal space contained inside a boundary (Gaddini 1987), or a membrane which separates an inside from an outside (Winnicot 1988, p.68). Following Winnicot very closely, a basic visual representation of the self may be conceived, in a two-dimensional drawing, as an outline which separates Self from World/Others (Figure 5.1).

Figure 5.1 The mental self-image

There are many ways of arriving at a picture which represents a basic self-image, or a core object-relationship of the patient. It depends on the symbolic capacity of the patient, on the approach of the therapist, on the relationship between the two. Sometimes the image may be the result of an unconscious process, like a dream, or the result of the interaction with art material (Rust 1992, p.163). Sometimes patients need to be actively helped to become able to convey their experience to the therapist through mean-ingful symbolic images (Killick 1993). Anorexic patients in particular may take a long time before making self-revealing images (Levens 1987). It may be important for the therapist to trust that the patient's ego may have a role in bringing unconscious material to a conscious level (Weiss 1971).

The concept of a visual representation of the mental self led me to devise an art therapy session, which I call Self-image, or Self-World Image (Luzzatto 1987). I help the patient to move into a symbolic attitude, and to see the white paper as a symbol of their 'world'; then I encourage them to visualize, using abstract shapes and colours: (1) the boundaries of the self; (2) the space inside the boundaries (= inner world of thoughts and feelings); (3) the space outside (= the world they interact, or do not interact with). I have used this session with a dozen anorexic patients, and they have all responded well, usually with a feeling of surprise, at the moment of looking back at their picture, for becoming aware of something new about themselves. Sometimes, with very negative or withdrawn anorexic in-patients, this has been the session they remembered most, at the time of being discharged from hospital.

From my clinical experience, considering both the results of the Self-World Images, and other pictures made in art therapy sessions, one type of self-image seems to be recurrent among anorexic patients, and may well illustrate the basic pattern of relationships, or the core issue, in many of these patients. I describe it as an image of a double trap.

The three elements of the double trap: the self, the prison, the persecutor

Graphically, the image of the double trap could be described as in Figure 5.2, with three basic elements: (1) **The Self.** The self is visualized as something quite small, vulnerable, often precious (it may be a little dot, or a foetus-like shape, or a little animal like a skinny bird, or a small goldfish, or a mermaid). (2) **The Prison.** The self is contained inside a prison, or imprisoned by somebody, or by a group of objects. The prison has at the same time a negative and a positive meaning: negative because it is a prison, positive because it is also a protective barrier against an external persecutor. (3) **The Persecutor.** There is something threatening or persecutory in the external world (it is often visualized as an aggressive shape, or a threatening

colour, or a devouring animal). The persecutor is ready to attack the self, in case the self should escape from the prison. The presence of the persecutor justifies the immobility and hopelessness of the self inside the prison.

Figure 5.2 The double trap

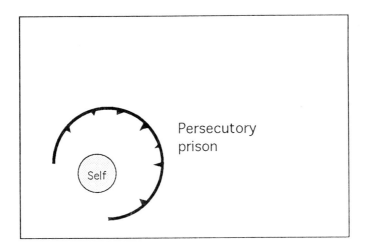

Figure 5.3 A variant of the double trap – I

Variations on the theme of the double trap

For some anorexic patients the Prison and the Persecutor are merged into one and the same symbol: either the persecutor is also imprisoning the victim, or the prison is also actively persecutory. The two functions, of imprisoning and persecuting, may alternate in time (Figure 5.3). Sometimes there is in the picture also something that looks like a 'good object', but either it does not protect the victim from the persecutor, or it is unreachable. Unreachable happiness becomes a mental persecution. Happy people keep their happiness for themselves without sharing it, and make the victim feel left out. The basic pain may be experienced not as being attacked, but as being betrayed (Figure 5.4).

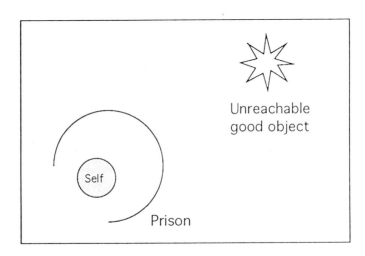

Figure 5.4 A variant of the double trap – II

The meaning of the double trap

The double trap may be seen as a graphic illustration of what Guntrip (1982, p.425) calls 'a static closed sado-masochistic system of internal bad-objects' which starts with the helpless child who finds himself in a hostile environment, becomes terrified and identifies with his bad objects who seem so powerful. Thus the 'bad object inside' takes the place of both object and ego. Once that is done, the child is caught in an internal situation from which he feels he cannot escape.

The little self and fear of nothingness

I understand the basic fear of the anorexic patient as a fear of ego-weakness more than a fear of persecution. The presence of the persecutory object in the internal world prevents the development of personal relationships, and therefore prevents a solid ego-formation. 'There are no fears worse or deeper than those which arise out of having to cope with life when one feels that one just is not a real person, that one's ego is basically weak, perhaps that one has hardly got an ego at all. These are the ultimate fears in our patients.' (Guntrip 1982, p.424).

The persecutor and anxiety of destruction

I understand Persecution as an image of a relationship with a bad object, which is still better than 'no object at all'. The feeling of persecution may become an obsession in the patient's mind. In an adolescent, it may take the form of feeling disliked at school, or being jealous of a sibling, or being unwanted by a parent, with an intensity which does not seem justified by the real life situation. When there has been a traumatic experience, the real trauma becomes entangled with a phantasy persecutory object outside space and time. The internalization and identification with a persecutory object may become a sort of defence against the fear of non-existing. This is why this image is so hard to give up: it would leave the anorexic patient in the terror of the void, the nothingness of no object and no ego.

The prison as refuge

Quinodoz (1990) explored the concept of the prison-as-refuge as a problem of separation/individuation. There is either a separate object that is rejecting, or a non-separate object with which there is fusion. Both are threatening. The result is a feeling of 'vertigo', which is an alternation of claustrophobia and agoraphobia. Or else, immobility and lack of communication:

> 'The refuge might rob the patient of his liberty. He then has the urge to flee from the prison, in order to be able to breathe again by himself…but there he once again encounter Difference, and so he looks for his prison again, from which his one idea was to escape.' (p.57)

The paradoxical communication

Pictures may be made to hide, not to reveal (Mann 1990). The image of the double trap may not be a real communication to the therapist of feelings of

persecution, or fear of disintegration: rather, it may be recognized as a wish not-to-communicate, because the outside world is too threatening, or because there is nobody out there, as in the narcissistic or autistic mental state. There is no real 'message' if there is no recognition of an 'other' as the recipient of the message (Maldonado 1987). In this case, the communication could be described as 'paradoxical' and it may be resolved only through making the lack of communication a subject of communication, and so stepping out from the paralyzing paradox (Watzlawick 1967, p.197).

The therapeutic work on the mental double trap

Objectification and distancing

When a symbolic image reflects a core object-relationship, it becomes a precious tool in the therapeutic process. The peculiar quality of the visual image of the double trap is that the three elements (the vulnerable self, the prison-as-refuge, and the persecutor) are all in the same picture, and they are connected with each other.

While the symbolic image is made, the patient often seems to be merged in it. This first stage of merging is important, as it allows the patient to project part of him/herself on to the picture, and the image to become a real part of the total transference (Schaverien 1989). We reach a second stage when the picture can be looked at. The 'looking at' is the first form of separation of the patient from his/her image. It must happen in the presence of the therapist, who becomes a witness, a mirror, a potential helper. This distancing of the picture from the patient is a symbolic action, and the patient may participate in this process consciously. It may be useful sometimes to place the picture at the same distance from both patient and therapist, and to look at it in silence for some time. The patient is often surprised, as some unconscious elements may have emerged. More may emerge during the silence. The third stage is the separation of the patient from the image through words. The verbal elaboration, as much as the image-making, can never be forced, it may only be encouraged. Some anorexic patients, after having made their Self-World Image, told me they wanted to look at it with me, but did not want to talk about it. Nevertheless, they always asked for my feedback, which usually triggered their own verbal elaboration, afterwards. The linguistic dimension is a social, temporal dimension. When the patient has agreed to talk about the picture, the image becomes part of shared space and shared time, instead of being a secret personal phantasy. Space and Time are expanded. The perspective has changed.

Working with the double transference

Work on this type of image must be done with respect, caution, and loving attitude towards the patient, if it is possible to use this word within its professional meaning. The anorexic patients are not used to facing a persecutor, and they are not used to face their fear of non-existing. They need a strong ally to be able to do that, not a confrontational, judgemental, or bullying counterpart. The specificity of the art therapy method can be very useful here: one aspect of the internal world of the patient may be projected on to the image, while another side may be projected on to the therapist. This leads to a 'working with the double transference', which I consider the most specific tool of art therapy. This process may be used in a variety of ways within the therapeutic relationship. The primitive dysfunctional side may be projected and contained in the picture, while the more functioning part of the patient – the observing ego – may be engaged in the therapeutic alliance (Silverman 1991, p.87). Inevitably, the primitive feelings will be projected on to the therapist, too, who needs to rescue the functioning side of the patient again and again. The anorexic patient may transform the therapist into a persecutor, as well as into a victim. If the therapeutic alliance is re-established, the effect on the patient will be an increase in the awareness of the self, which will modify the image of vulnerability, which in turn will affect the role of the persecutor.

From image to imagination

Once the image has become a symbol, patient and therapist can work symbolically on the image. This is not possible until the image is fixed, and the patient is identified with it. Now that the image is separate, the patient – supported by the therapist – can go back to it, both emotionally and mentally. It is a property of images, in fact, that they allow an emotional response to something that is not present (Arieti 1967, p.83). The philosopher Sartre (1983) has described some principles of imaginative work which I find important as an art therapist: one may imagine that something that was not there, *is* there; or that something that was there, is *not* there any more; or one may imagine a *movement*. The aim is to explore what happens 'if', and what happens 'if not', and how the patient feels about it. The patient may start to connect, free-associate, explore alternatives.

As the mental trap is 'double', so the therapeutic undoing of the trap is a double process: on one hand, the persecutor must lose its power as an internal object; on the other hand, the little self must gain strength. The need for the prison will then decrease. The therapeutic process becomes a bit like a

table-tennis game and the ball moves all the time from one end of the table to the other: from the persecutor to the self, from the self to the persecutor; from the present to the past, and from the past to the present; from phantasy to reality, and from reality to phantasy.

I have found some techniques based on the concept of *space* very useful in working with an image of a double trap. (1) **Focusing on the self:** helping the patient to experience more internal space (e.g. 'zooming in' inside a self that was visualized as a little dot). (2) **Focusing on the whole image:** helping the patient to experience more relational space between the self and the persecutory – or the unreachable – object; encouraging the patient to identify with the various elements in the picture and to explore the relation-ship between them. (3) **Focusing on the three-dimensional space** be-tween the patient-in-the-picture and the patient-who-is-observing-the-picture, in alliance with the therapist. The patient may then be able to tolerate the pain of the little self without switching off into anorexic behaviour.

An illustrative case

Introduction to the 21-year-old anorexic young man

Francis was referred to art therapy by his consultant psychiatrist, with the diagnosis of anorexia nervosa. He was almost 21 years old, the second of three children, and was living at home with his parents and younger sister. After being successful with his 'O' Levels in secondary school, Francis started to lose interest in school and to be obsessed with his diet, until he dropped out and said he wanted to stay at home, to 'help his mother', and to 'write a novel'. His weight came down to Kg 36, and his doctor wanted to admit him to hospital, but he refused. His doctor saw him as an outpatient for a few months, then he referred him to individual art therapy.

I saw Francis for brief individual art therapy, within the NHS, and the therapy was structured in the following way: (1) a long assessment over five sessions, to allow his mental self-image to emerge, and to find a focus for therapy; (2) twelve individual art therapy sessions, to work around what had been accepted by both of us as the focus of therapy, plus one follow-up session, a month after termination of therapy. Altogether, I saw him for 18 one-hour individual art therapy sessions, over a period of six months.

This case illustrates some major dynamics and themes of anorexia, present also in anorexic females. It is not a case to discuss anorexia in males, but an opportunity to present specific art therapy interventions.

This has been a short term therapy, with a good outcome, where change has developed both in the imagery and in the life-style of the patient, and

positive outcome has been confirmed by a follow-up through his GP three years after termination of therapy.

Emergence of the core relationship... the image of the double trap

Francis's self-image seems to belong to what I have described in Figure 5.3: the Self is imobilized inside a fist, which is both Prison, and Persecutor.

The image was made during the third session, which started with a long silence. Probably this was a negative reaction to a previously good session, when a good therapeutic alliance seemed to have been established. Francis made a comment about resenting people who are happy. He is never satisfied with what he has, so he is never happy. 'It is as if I am tied down, my soul tied down inside my body, and my body tied down somewhere... I feel trapped'. I suggested he could visualize his feeling of *being trapped*. Francis drew a black fist (Figure 5.5). I placed the picture on the wall in front of us,

Figure 5.5 The Fist: I can't breath... I will suffocate... I must not move

so that we could look at it together from the same distance. I encouraged him to 'move in' inside the fist. Then he explains: 'I am trapped inside that fist. It is dark. I feel imprisoned... There is no space. There is no air. I can't breath. If I stay there, I will suffocate... But if I move...the hand gets tighter...the more I try to get out, the tighter the hand becomes, and I get crushed, so... I'd better stay still, I must not move... I plead Let me go.'

('What happens then'?) 'I get angry... I turn my anger against myself...I provoke pain to myself...I become the fist.'

'How is it to be the fist?' – I ask. 'If I am the fist, I want to remain very tight, so much that I feel pain... It is like if I want to feel pain, I need to feel

pain, so I do not think of what is behind the pain. I keep tight and I say NO'. 'No to what?' – I ask. 'NO to letting go… I think that if I let go… I would disintegrate…'

Francis began to understand that this trap is at the same time a destructive device, and a protection against disintegration. He understands that his way of provoking pain in himself is in order to feel alive, to build up a pain-skin around himself. We connected the metaphor of the fist with his life situation and with the transference. He feels imprisoned in the family setting. He describes a violent father who used to beat his brother, and who now threatens his mother. He needs his father's attention, but he also wants to kill him. He needs to protect his mother, but he also wants to leave her. When he protects her, he is afraid of father's anger. In the transference, he now feels trapped in therapy, he is not sure it is useful, it may be damaging, and he is not sure he wants it.

During the fifth session, Francis said that the image of the fist had remained very much in his mind. I put the drawing on the wall and we looked at it again. I repeat that the message seems to be that if he stays there he will die by suffocation; if he tries to get out he will be crushed. The real message – I say – is that he must not move, and that there is no way out. Or is there any alternative? After having visualized the image, and having looked at it, and talked about it, another point of view has been created. This is probably what allows Francis to say: 'Maybe I could try to open the hand'. This is a very important moment: from image to imagination.

Francis made a new drawing, which exposes the very fragile little self, in a foetus-like position, in the centre of the palm of the hand. (Figure 5.6)

Figure 5.6 The Open Hand: I feel cold and exposed… I will fall down

Francis identified quite easily with the small creature: 'Now I feel cold… I feel exposed… There is too much light. It's strange, I have remained in the same position as when the fist was closed… I can't move because I need to keep myself warm; it is very cold…' ('What would happen if you manage to get up?') 'I could try to walk, but I am afraid I will fall down from the hand, I will slip down from one of the sides.'

I commented that maybe he felt so afraid and so cold that he almost wished the hand could close again on him. Francis said 'Yes, it is true'; then he admitted that he often provoked his father. He also provokes other people, like saying he is Jewish, or homosexual, which is not true, just to see how they react. He expects to be attacked, or rejected. He has also started to come late to therapy. He wants me to get angry with him.

It becomes clearer to both of us now that he can take any of the three positions: (1) he may be the little creature inside the fist, victim of violence; (2) he may be the fist, attacking and damaging himself; (3) he could provoke somebody else to be the fist. Now he is aware that his feeling of persecution and his obsessions in some strange way protect him against a much more frightening feeling, the ultimate anxiety: the fear of being dropped and left to fall forever and to disintegrate.

His attention has now moved from the persecutory fist, to the very vulnerable naked and cold little self that emerged as the creature inside the fist. When I suggest we decide the focus for the short-term therapy, Francis says: 'I could work on the idea of the open hand…maybe freedom will not kill me…'

The process of change

Whenever it was possible, whenever it was appropriate, we kept connecting the various elements of the trap, so that Francis could gain a new perspective.

Sixth session. The attention is on being persecuted. Francis made an image from a dream, in which he was beaten up and tortured. It is very Christ-like. He had ropes around his wrists and ankles, and swords inside his chest. He is trapped. 'What about if somebody would loosen the ropes?' I ask. Francis began to free-associate. 'To imagine myself without the rope, is like to imagine a coat without its hanger. The coat falls down on the floor. The coat becomes a puddle of water on a field. There is sun in the sky. The sun makes the water evaporate. I do not exist any more…' The fear of non-existing is the primary fear.

Seventh session. Now the attention was on being vulnerable. Francis drew a hand that comes out from black mud. The hand is asking for help. Francis uses his imagination to explore different possibilities: (1) 'somebody is

pulling me out'; (2) 'my hand grasps something solid'; (3) 'somebody pulls me up…then that person laughs at me, and drops me'.

The theme is 'I cannot trust anybody'. Not his parents. Not his therapist. Therapy is going to fail. He had arrived to the session quite late. He admitted he wished to go back to anorexia, and to the nice feeling of almost dying, where 'nothing matters'.

Eighth session. The feeling in this session is that Francis does not want to communicate. I suggested he closed his eyes, and moved the pencil on the paper, freely, to relax, in a blind drawing. His hand moved slowly all around the paper. Then he opened his eyes, and said that he had made a wall all around the paper, and he felt imprisoned inside it. He is very surprised that he has used his freedom to build up a prison for himself.

Ninth session. Francis said he had become less obsessional. It is possible that the attention he receives in therapy helps him to value his thoughts and feelings more. He thinks many of his obsessional thoughts were conflicts about whether to do what he wanted to do, or what other people wanted him to do. Now he has decided that, when he is in conflict, he will give a priority to what *he* wants to do. The idea that he can find a priority is for him a great relief.

Tenth to Fourteenth sessions. Francis was able to make images – and to talk about – the most painful feelings of jealousy and envy. His intense jealousy towards his brother and his sister is understood by Francis as a fear of being ignored, which triggers an anxiety of nothingness. Francis described his father beating up his brother, and being loving with his sister. He is in the middle, and he feels ignored, and non-existing. Francis would then do anything: to be beaten, or to beat himself, to take drugs, to burn his skin with cigarettes, to cut himself, to starve. The pain is real and makes him feel alive. An Oedipal preoccupation that his parents should not be together is very strong. In this respect, there are two extreme feelings: either his parents hurt each other, which is terrifying or they are happy together, and leave him out, which is equally terrifying. About other relationships, he is ever between two extremes: if he is with people, it becomes too much, he feels upset; then he wants to be in peace by himself, and he becomes too lonely. He is afraid of intimacy, he is afraid of loneliness, he does not know which is worse. Francis starts to realize the meaning of his relationship with food: if he eats, he cannot stop and eats too much; the only way not to eat too much is to stop eating. He may be using food to express his conflict about relationships.

Fourteenth to Sixteenth sessions. Separation/Individuation. Francis began to think that he can cope with leaving his parents to their relationship.

He was able to relinquish his need to control them. Now he does *not* know whether – when mother and father are together – this is good for them, or not. They have told him that he has spoiled their relationship and their family life. He says their relationship is unpredictable, basically unknown to him, and he can now accept it. This makes him ready to separate and to give more attention to his own interests and to his own growth. Within two weeks, Francis actually moved out, and got a job. In the process, the persecutor had become weaker, and the little self stronger. Francis made an image in which, after having destroyed the phantasy of the little self inside the persecutory hand, he walks out as an adult (Figure 5.7). Francis says that there is a *new space*, around him, which allows him to breathe and to move, even if the world is still perceived as dangerous; and there is a *new feeling*, that he can describe only for what it is not: it is not love, and it is not hate; it is not need to merge, and it is not wish to attack. He calls it 'a form of indifference', and he is intrigued. It makes him feel free to be himself.

Figure 5.7 Walking out as an adult: A new space and a new feeling

This short term therapy has been only the beginning of a personal process of separation and individuation, which fortunately he has not interrupted, and he has continued in his own way.

Conclusion

The mental image of the 'double trap', where a vulnerable self is imprisoned, but cannot escape, because a persecutor is out there, and no reliable good

object is around, seems to be recurrent among anorexic patients. The awareness of this mental image may help both patient and therapist to give a meaning to what would seem otherwise a meaningless behaviour, and to think about what seems to be unthinkable pain. In psychoanalysis, this process is carried out mainly through the use of transference and interpretation. But when the persecutory element is very strong in the internal world of the patient, the use of transference as the main tool may trigger dropping out from therapy (Gunderson *et al.* 1989). Other agents for psychic change may have to be considered (Klein 1990; Stewart 1992). It is now clear that the two points of view, of change brought about only by interpretation, or only by the therapeutic alliance, are both naive and inadequate. It seems more likely that therapeutic change comes about when the patient is exposed to a new identification with the therapist's way of dealing with conflict, and gains a new perspective, which enables him/her to visualize a possible new outcome (Rangell 1992). This theory of change is not exclusive to psychoanalysis, yet the three-dimensional feature of art therapy may facilitate this process. The process is based on several steps, and in this paper I have focused on some of them: (1) Objectification of the core mental image; (2) Distancing from it; (3) Re-experiencing it within the therapeutic alliance; (4) Working with the Double Transference; (5) Moving from Image to Imagination.

In this way the patient's awareness of Space and Time may be amplified, and a new perspective on the internal image of Self–World relationship is made possible. The patient may gain some freedom to change, and the wish to step out from the deadly anorexic trap. Many other factors intervene at this point, and the presence or absence of internal and external resources may obstruct, or facilitate this process.

Acknowledgments

I thank Dr H.Oakeley for referring this patient to me, and Dr M.Bernstein and Dr A.Molnos for useful comments. I feel grateful to this patient, who shared his struggle with me, and who allowed me to show some of his pictures.

References

Arieti, S. (1967) *The Intrapsychic Self.* New York: Basic Books. Italian edition (1969) Il Se' Intrapsichico. Torino: Boringhieri.

Fairbairn, W.R.D. (1958) On the Nature and Aims of Psycho-Analytic Treatment, *International Journal of Psycho-Analysis, 29, 374–85.*

Freud, S. (1923) *The Ego and the Id,* Standard Edition, 19, p.50n.

Gaddini, E. (1987) Notes on the Mind-Body Question, *International Journal of Psycho-Analysis*, 68, 315–329.

Gunderson, J. *et al.* (1989) Early discontinuance of Borderline Patients from Psychotherapy, *Journal of Nervous and Mental Disease* 177 (1).

Guntrip, H. (1982) *Personality Structure and Human Interaction. The Developing Synthesis of Psychodynamic Theory.* London: The Hogarth Press.

Hinshelwood, R.D. (1991) Psychodynamic Formulation in Assessment for Psychotherapy, *British Journal of Psychotherapy*, 8, (2).

Killick, K. (1993) Working with Psychotic Processes in Art Therapy, *Psychoanalytic Psychotherapy*, 7, (1), 25–38.

Klein, J. (1990) Patients who are not ready for interpretations, *British Journal of Psychotherapy*, 7, (1), 38–49.

Levens, M. (1987) Art Therapy with Eating Disordered Patients, *Inscape*, Summer 87, 2–7.

Luzzatto, P. (1987) The internal world of drug-abusers. Projective pictures of self-object relationships, *British Journal of Projective Psychology*, 32, (2), 22–33.

Maldonado, J.L. (1987) Narcissism and Unconscious communication, *International Journal of Psycho-Analysis*, 68, 379.

Mann, D. (1990) Art as a Defence Mechanism Against Creativity, *British Journal of Psychotherapy*, 7(1).

Quinodoz, D. (1990) Vertigo and Object Relationship, *International Journal of Psycho-Analysis*, 71, 53.

Rangell, L. (1992) The Psychoanalytic Theory of change, *International Journal of Psycho-Analsis*, 73, 415.

Rust, M.J. (1992) 'Art Therapy in the Treatment of Women with Eating Disorders'. In D. Waller and A. Gilroy (ed) *Art Therapy. A Handbook.* Buckingham: Open University Press.

Sartre, J.P. (1983) *The Psychology of Imagination.* London: Methuen.

Schaverien, J.(1989) Transference and the Picture. Art Therapy in the Treatment of Anorexia, *Inscape* Spring 89, 14–17.

Silverman, D. (1991) 'Art Psychotherapy: An Approach to Borderline Adults'. In H. Landgarten and D. Lubbers (ed) *Adult Art Psychotherapy. Issues and Applications.* New York: Brunner/Mazel.

Stewart, H. (1992) *Psychic Experience and Problems of Technique.* London and New York: Tavistock/Routledge.

Watzlawick, P. (1967) *Pragmatic of Human Communication. A Study of Interactional Patterns, Pathologies and Paradoxes.* New York: Norton & Co.

Weiss, J. (1971) The emergence of new themes: a contribution to the psychoanalytic theory of therapy, *International Journal of Psycho-Analysis*, 52, 459.

Winnicot, D.W. (1988) *Human Nature.* London: Free Association Books.

The Power of Food

Some Explorations and Transcultural Experiences in Relation to Eating Disorders

Diane Waller

In anorexia nervosa we see yet another form of Eve's defiance, although one that may not perhaps be so immediately apparent. Eve refuses the apple and the knowledge of the world that goes with it in a gesture that can be understood as a rejection of that world and of that knowledge. While at first glance it might appear that the anorectic's refusal to eat is an act of conformity, a taking-up of the commandment, the act of refusal contains its dialectical response: I shall not partake of that which is offered for it is not sufficient/not for me at all. The food is the symbolic representation of a world that has already disappointed the anorectic. Entry into it is not the answer. (Orbach 1986, p.63)

This quote of Orbach's, taken from *Hunger Strike* supports a theory about eating disorders, and in particular anorexia, that I have found very convincing: that is, the central feature of the condition is one where the sufferer is locked into a pattern of defiance, defence and ambivalence (Jeammet 1980). Jeammet points out that in the treatment of anorexia, the defiance must be recognized and understood, so as to avoid entering into a power struggle where the therapist tries to defeat the patient and so increases her resistance. If this should happen, she could feel like a sacrificial lamb, defeating both the therapist and herself. Maintaining the terrific defence system is ultimately a life or death matter – to be or not to be. It is hardly surprising, then, that so many therapists report feeling confused, helpless and angry when working with eating disordered patients.

Although anorexia and eating disorders in general are increasing among males, the condition is one which mainly affects women, hence my use of 'she' in this chapter. There are numerous speculations in the literature about why this should be so – social, psychological, anthropological, medical/biological explanations are offered. Most eating disorders (with the exception of bulimia) are obvious because the sufferer is either very much fatter or very much thinner than 'the norm'. It cannot be denied that we, in western Europe, live in cultures where leanness in both sexes is much valued, but for women it is especially desirable. In *Fat and Thin: A Natural History of Obesity* (1977), Beller comments that the fact that females are, from birth onward, fatter than males might seem to be a biological injustice as undeserved as any social or economic injustice exercised upon women by a male-dominated social system. She adds that the ideal of feminine beauty has, within the span of the past half century, increasingly reflected a male ideal model in preference to a typically female one. Indeed, the hipless and flat chested mid-twentieth century model or female cult figure, for example Twiggy or Princess Diana, more resembles an adolescent boy. For reasons which may be to do with women's struggle for acceptance, the present model is one that has, by and large, been imposed on women by women:

> The status assumptions implicit in this choice are interesting. People tend to ape their betters, and women's aspirations to the unmodulated physiques of men express unvoiced, and until recently probably largely unconscious, judgments about the nature of male status and privilege as compared with their own. But from an anthropometic point of view the trend is a dubious one: Female fleshiness is a fact of biological life and one that has every appearance of having been programmed into the species long ago by nature. (1977, p.58)

Not all societies produce an obsession with body shape among women, although it seems that in 'westernized' countries, the trend is set. For many years I have had the experience of living in and visiting parts of the Balkans, where until recently leanness in women was not considered desirable, nor, indeed, attractive at all. Nevertheless, women were strongly identified with provision of food and care, which was, in its own way, extremely oppressive, as I shall try to show later when describing some powerful personal experiences I had in the Balkans.

Beller also discusses the strong connexion between obesity and depression, but adds that it is unclear whether the obese get fat because they are depressed or they get depressed because they are fat, bearing in mind all the negative connotations fatness has acquired in our society. There is an irony

in the fact that food may be self-administered as a treatment for depression in this and other affluent societies, despite its obvious side effects – not to mention the vicious circle which it manages to set in motion. But, Beller says:

> If food is the cheapest and most abundant mood-altering drug on the market, psychoanalysis is undoubtedly the scarcest and most highly priced. (p.181).

Nor, unfortunately, is there much evidence to suggest that 'traditional' psychoanalysis is very helpful in the treatment of eating disorders. Bruch, a prominent writer in the field of eating disorders feels, however, that a modified version of psychoanalysis, emphasising better functioning of self concept in the patient and attempting to repair the underlying sense of incompetence, disturbed self-concepts and lack of autonomy may well prove of value (Bruch 1974, p.335–337). Art psychotherapy is one such 'modification' that seems to help. For example, Schaverien (1989, p.14) describes how the anorexic experiences any transference interpretation as an intrusion and thus a threat, and how the image may become a most important mediator between the client and the therapist. (See also Waller 1983, p.14–21; Murphy 1984: Levens 1987; Rust 1992, p.155–172 for other examples about the way in which art therapists have worked with eating disordered clients.)

Of course each individual's situation is very different and the therapist's approach will reflect this. It is, though, essential when considering any group of 'disorders' which affect one group in such a striking way to look for a sociological as well as psychological explanation. In this respect, Orbach's work provides us with useful multi-dimensional explanations. For example, in *Hunger Strike*, she discusses the socialization of women, pointing out the wide range of skills and achievements required of and by contemporary women (the products of late twentieth century capitalism) – from the feeding of infants to taking care of the daily food needs of family members, to the role of the hostess with flair, to the high level executive (and prime minister). It is mothers, though, who are still charged with responsibility for bringing up their daughters to adopt a version of their own social role. Identification with the mother is central to the construction of a daughter's personality, and of course there is no such thing as a personality constructed outside culture or without reference to its mores.

The power of food in women's lives cannot be underestimated. Orbach puts it vividly:

Food for literally millions of women – and here I wish to stress that, horrifying as it is to confront this reality, I do mean millions of women – is a combat zone, a source of incredible tension, the object of the most fevered desire, the engenderer of tremendous fear, and the recipient of a medley of projections centring round notions of good and bad. In the midst of the most extraordinary plenitude the Western world has ever witnessed in regard to food, women in North America, England and Europe are engaged in a battle voluntarily to restrict their food intake, frequently to a point below the actual requirements of their bodies' physiological needs. Whereas once women's preoccupation was with getting enough food to feed the family, now it is with limiting their own food intake. (p.62)

In selecting food through which to express a major conflict, women with eating disorders have, then, given it immense power – indeed, life or death power.

At this point I would like to introduce a cross-cultural dimension, through reference mainly to Macedonia, Bulgaria and Romania, countries in which I have spent a lot of time and which have had a strong influence on me throughout my life, including in my professional work with clients and especially eating disordered women. Briefly, I participated in a research project in the early 1980s, to examine the possible benefits of group art therapy on women referred from a community mental health centre (see Waller 1983, p.14–22 for details). All the women had suffered or were still suffering from an eating disorder and had not responded to 'conventional' treatments. I was astonished by the power which resided in these women, but which they persistently failed to acknowledge, seeing themselves as victims and others as oppressors, and by the mechanisms they employed to avoid therapy while appearing to request it. Their self-images were so low that they could not conceive of achieving any of their goals in life. It was a despairing group, but one which contained enormous resources and potential for change. Gradually, through making and discussing images together, the women were able to examine their current situations, get angry and begin to take some action. As the therapist, I felt constantly under seige, alternating between being bad mother/father and idealized and envied parent. I was often unfavourably compared (indirectly and subtly) with their (male) doctors. My experience in the Balkans had, though, given me tremendous respect for their painful feelings and especially the anorexics' fear of treatment programmes where women are obliged to consume high calorie food several times a day. This was, I believe, useful in withstanding the feeling of being

devoured, which most of the therapists I have supervised seem to experience in this work.

Given that anorexia and bulimia have been mainly perceived as problems of affluent western societies, I was interested to learn that young women in Bulgaria are increasingly affected. I am grateful to Marina Boyadjieva, Professor of Psychiatry at the University of Pleven, for an interview in which she discussed this issue and her findings. It appears that rapid changes in the until-recently rural society have produced severe stress for all the population and in particular young women, whose roles and expectations are very different from those of their mothers. Likewise, in Macedonia, a region which has experienced many changes due to rapid industrialization, the pressures on women have been extreme. Women are an important element in the work force. They have often had to maintain the family whilst the males went abroad as 'guest workers', and have not had the support of their extended family. The massive influx of village dwellers to the towns has produced many social problems, not least among families split up and moved to blocks. The women are alone with their children, or are obliged to leave the children with neighbours, while they work. Social networks are severely disrupted, producing depression of an often serious nature which may well go undetected. Daughters raised in such circumstances could not gain a very positive identification with their mother. They are also deprived of the modifying influence of aunts and uncles, cousins, and grandparents.

The economic problems of many areas of the Balkan peninsula have, then, often been disastrous to family life. Under the still paternalistic (despite the move towards socialism) governments of Bulgaria and Romania, emphasis on industrialization led to the creation of new, often ugly and impersonal conurbations and a certain contempt for rural life. In some parts of ex-Jugoslavia men were obliged to work abroad, often living in very poor conditions but earning reasonable wages for their hard labour. They at least had the satisfaction of earning, camaraderie, and sending the money back home: very important to male pride. The status of 'gastarbeiter' was, on the other hand, not very desirable: these workers had no protection and were the first casualties of the European recession. The women usually stayed at home with the children, and if they had moved to the towns, had no support systems. When the women accompanied their husbands abroad, they would be even more isolated in countries where they could understand neither the language, nor the culture. It is not uncommon to find, for example, Albanian women who have lived for many years in Australia, doing menial work in factories, speaking no English and unable to relate outside a narrow circle

of Albanian speakers, or Turkish women isolated in industrial towns in the Netherlands.

These are precisely the social and economic factors which lead to frustration, despair, anger and isolation – the very conditions in which anxiety and depression flourish. That is not to say that these are the 'causes' of eating disorders, but for vulnerable people, it may be the trigger which sets off disturbances in bodily functions, including the relationship to food.

In societies in which food is powerful, either because there is too much of it or too little of it, and where a family's identity and a woman's role is closely bound up with it, it is not surprising that it can acquire a negative as well as a positive significance. Experiences which I had during periods of living in, studying, working and holidaying in the Balkans taught me more than I could ever have believed about the power of food and the energy which would be required to cope with its management. I started out as someone whose attitude towards food was reasonably uncomplicated, and who shared with most young women in the 1960s bombarded by fashion images, a desire to remain slim: but like Jean Shrimpton rather than Twiggy. In the next part of this chapter I will give some illustrations taken from my diaries, letters and notebooks compiled between 1966 and 1973, which included a year in Macedonia on a Leverhulme scholarship. My aim in these visits was to study the role of the traditional arts (dance, textiles and costume in particular) in a rapidly changing society.

Macedonia, 1967

The 'old' habit of pressing food on guests came from times when guests travelled long and hard to reach their destination, and when food was very scarce. Balkan hospitality demands that guests be given the best, for as long as they stay. However distant a member of the family or friend of the family, one could arrive any time of day or night and receive total hospitality.

This important role of food and hospitality was well illustrated during a visit by my friend Beverley and I to Ohrid, a town near the Albanian border having a mixed population of Bulgarians, Macedonians Greeks, Turks, Gypsies and Albanians. We were travelling and living very basically, hence we were delighted to be able to stay with a family whose young son I had met the previous year, and who was studying English in the hope of becoming a doctor. Their house was decorated in traditional Albanian style, with home-woven carpets and embroideries and carved wooden furniture. When we arrived a meal was prepared and we quickly understood that we were living in a family which adhered strictly to the laws of Islam. We were honoured by eating with Mr Z a 'hodzja' (priest) in the local mosque,and

the boys, while Mrs Z and the girls served the food, only eating theirs separately, later.

They waited by the table, watching while we ate, which felt very uncomfortable and I lost my appetite immediately. This was disastrous as they expected us to eat a very large meal. We anticipated that, as the first meal after arrival, this would be a one-off and subsequent meals would be lighter or we would fend for ourselves. This was wishful thinking and incorrect. Although of medium build, both Bev and I were considered unhealthily thin by Mrs Z and in need of being fed continuously. We found ourselves devising schemes to escape for the day to avoid food.

One way was to visit villages in the mountains near Ohrid, where there was a rich folklore tradition. On the evening before the first visit, we told Mrs. Z. that we had to catch the 5 am bus from the bus station in town and that we would not be back until late. She got up at 3am on that morning to make, in her summer kitchen in the garden, food enough for six people, carefully wrapped and packaged for travel. We took this with us and shared it all with the numerous children who accompanied us up the mountain paths. In this way we could stem our guilt feelings about trying to escape from her feeding us but we did not waste the food either. This happened on the three occasions that we went on whole day trips. For the rest of the time, we were obliged to eat four times a day, quantities which were intolerable. Our protests were ignored as being merely politeness. We resigned ourselves to the situation. If we refused the food it would be an insult to her role as a woman, and by that token to the whole family. The laws of hospitality obliged them to feed us until we were satiated, and obliged us, as women, to conform.

The following year, I visited Ohrid with Dan, my partner, and we stayed for two nights with the Zs in Ohrid. I would like to have stayed in Ohrid longer but it was impossible to do this without staying with the Zs – it being a small town they would have known and been very hurt and insulted. I did not want to hurt them, nor did I want to suffer the same stuffing process as before. We again ate with Mr Z and the boys but Mrs Z and the girls did not appear in Dan's presence and the youngest boy served the food. The younger sister helped in the kitchen but the elder, D, having reached puberty, was obliged to remain upstairs, out of sight of male guests. In fact, she was already betrothed and had become very fat – which was considered necessary and desirable. When married, she and her husband would join his brothers,

and D's elder brother in Australia.[1] Whenever I went up to see her, she pinched me and said you are too thin, why are you so thin! I had never considered myself thin, so it was interesting to have everything turned upside down.

During the first meal, Dan finished eating quickly and put his knife and fork on the plate. All the plates were then removed immediately. We had discovered that whenever Dan finished a course, it was the signal for everyone to finish. Normally this would have made me angry, but here it was a relief, for as long as Dan colluded, I did not have to eat everything or risk offending. It did, of course, reflect the clear power balance in male–female relationships in this society.

On returning to Ohrid a few years later, we found the walled garden turned into a building site for the elder son's new house, to be used whenever he returned from Australia, the summer kitchen gone, and the house bereft of its traditional furnishings. Mr Z told us about his recent trip to Medina. He also spoke about Albania and regretted the decline of religion there. He was clearly homesick but he could not go back. It was a very sad occasion and I could only imagine how traumatic these changes must be to Mr and Mrs Z, and indeed to all the many families in their situation. Mrs Z was complaining of stomach pains and looked unwell. I had a feeling that she had completely lost her role, along with her summer kitchen.

Bulgaria

In 1967 Beverley and I had made our way back from Ohrid to Skopje, with many adventures on route, and had taken a bus from Skopje to Sofia in Bulgaria. Arriving late, we found a private room where the hostess immediately suggested that she feed us during our stay in return for bras and make-up. Bev did have some spare bras and said she would think about it next day. We then went out to explore the town and have a meal. We quickly realized the importance of this gesture from our hostess because there was nowhere to eat so we went back to the house, hungry. Mrs A was waiting for us when we got back and boiled some eggs. Bev said she could try the bras on and have them if they fitted. Mrs A said they certainly would. A good bargain was had by all. We remained friends with Mrs A for years after, until she moved out of Sofia.

1 By the end of the 1960s, there had been a mass emigration of young families from the Balkans to Australia. This was a source of great sorrow to those left behind, so much so that the folk song, 'Cursed Australia', which featured a mother lamenting the loss of her sons to this country, could be heard all over Macedonia for many years.

Our next destination was Varna, on the Black Sea coast, from where we intended to take a train into Romania. We arrived at one o'clock in the morning after a horrendous hitch-hike on roads which were not, or barely asphalted, and during which we had ended up in an all-male 'kafana' (taken in by our lorry driver chauffeur) where we tried to eat kebabs under the astonished gaze of several dozen men. We eventually got to Varna, completely exhausted and anxious.

At that time, tourist bureaux were open all night and we were offered a room nearby. Our host collected us and took us to to the family home, where chocolate, biscuits and tea awaited. The next day the family took us to their peach orchard on a hill overlooking the sea. The picnic we had was extraordinary, with a range of food prepared and served with minimal equipment. When we left, we were each given about five kilos of peaches in string bags which we carefully carried onto the 'putnicheski vlak' (slow train) which chuntered through the scorching countryside to the Romanian border. We dispensed peaches to all who wanted them for by the time we changed to a more sophisticated Romanian train, they were ripening rapidly and peach juice was everywhere. We found ourselves unable to throw them away as they had been a precious gift, symbolizing the open friendliness and generosity of the family, so we ate as many as possible and gave the rest to surprised fellow travellers.

On arrival in Constanza, we were met by friends and given a huge meal. We were, by that time, feeling uncomfortable and not like ourselves. Our bodies had changed, our clothes did not fit and we were constantly wondering how to avoid the food that was so generously offered. To some extent, we resigned ourselves, kept just loose fitting dresses and swopped the rest of our clothes for rugs and pots.

Oxford

On return to Oxford and friends in the Serbian community, I understood that they had experienced the same problems while visiting friends and relatives in Belgrade. They were overwhelmed by hospitality to the extent that they had contemplated an old Roman habit of vomiting after one meal in order to cope with the next. It was reassuring to know that my feelings were shared. Serbs who had lived such a long time in England had found it equally hard to cope. However, my landlord, who had very little contact with non-Serbs in Oxford, left me every weekend enough dishes of rice pudding and pancakes to last the week, and frequently brought me food even when I had finished my supper. In return, I helped him shell nuts for the nutcakes he made for many and various festive occasions. Whilst shelling nuts, we

spoke mainly of food and Balkan politics. It is with great sadness that I recount this incident now, knowing the misery and deprivation faced by those involved in the current civil war.

Skopje

During a year spent in Skopje, I found that it was impossible to visit a Macedonian family without eating, whatever time of day. I learned only to sample a small amount for if I finished the food, more was brought. I remembered the Slav custom of offering more three times: if the guest refuses three times, plates are removed.

Not to eat would have been to insult the family, but to eat when not hungry is unpleasant for oneself. It was important never to visit after eating a meal, and never at a time which could possibly be construed as a meal time, which restricted our ability to meet people. The exception were families who had lived in the West, who had changed their perceptions of the role of host and guest and never forced food upon us. I began to experience the insistence on giving food as aggressive and for a time I found it hard to eat at all. One felt trapped when visiting a family to see costumes or be shown a particular dance step and nothing could happen until a large meal had been consumed! Even though I knew perfectly well that the pressing of food was a normal aspect of Macedonian cultural life, and the family did not experience a conflict, I experienced the panic which I later acknowledged as present among eating disordered women and became preoccupied by thinking about food. The overwhelming feeling was of being trapped, leading to feeling angry and rejecting of those who are offering it.

I thought perhaps I was becoming obsessional: Dan didn't have the same problem because he was not obliged to eat (as a man, he could push his plate away and this would be accepted). It was as if, as a male, he was allowed to recognize and and act on his needs but I, as a woman, was not. Yet I could identify with the woman whose role would be undermined if food was refused. The only way was to stay with non-domestic situations, such as going to rehearsals of the dance groups to learn steps and turning down invitations to people's homes. This was sad but necessary.

We could not reciprocate because we lived in one room in someone else's house. We could, though, get things from Greece, as we often went there at weekends, thus placing ourselves immediately in a privileged position and becoming targets for envy. Eventually we acquired such long shopping lists from various families that we spent all our time looking for objects as disparate as a bride's veil and a spare car wheel. Sometimes we were not able to find the required objects and on one occasion we bought nothing, being

too overwhelmed by it all. This sense of not being able to move freely was increasingly strong. We started to feel resentful and guilty, as we kept our departures to Salonika secret. To refuse to look for something would be construed as very offensive. The request might be made by a friend of people we had visited and the expectation would be on us to meet it. Once again it was an all or nothing situation.

Conclusion

I have chosen to include the above anecdotes because they illustrate situations which were very unexpected and overpowering. The experience of the power of food and the feeling of oppression it produced in me taught me much that was useful when, several years later as an art therapist, I encountered women with eating disorders. I recognized the panic, the feeling of being overwhelmed, the need to control one's environment, the wish to escape and the everlasting preoccupation with eating or not eating. The reader might well look sceptically at my experience and ask, but why didn't you just say no, insist on not eating when you didn't want to? Say that you couldn't spend all the time in Salonika buying things for people you didn't know? It is a good question. I only know that the pressure to conform was so powerful that it took drastic measures (such as not visiting, not telling people anything) to escape from it.

I have to say that despite the good medical intentions behind behaviour-ally-oriented treatment programmes, and while recognising the dilemma when faced with a dangerously ill client, I cannot but question their long-term effectiveness. I had witnessed the willing stuffing of a young girl in readiness for marriage – she did not question this because all young girls were so stuffed and perhaps she didn't see a choice. She seemed proud of her fatness and scornful of my lack of it. No battle of wills would take place as long as she accepted her situation. What happens, though, when a woman cannot argue against the status quo openly and without fear and when she chooses food as a means of making a protest? So often one hears: …they are wilful, they are defiant, (they are making *me* feel useless). Worse, they are tempting fate, they are courting death, they are walking a tight-rope…they are rejecting, controlling, deliberately harming themselves… They become the centre of negative attention, dominating the family, hurting the parents. They are hateful. They are compelling, asking for help only to reject it. Above all, they are miserable and confused and cannot enjoy themselves.

I have found working through art therapy with women in this state has been positive mainly because the women themselves have sought this approach, having become bored with their situation, in which they actually

limit their own freedom. I use the word 'bored' advisedly: they are literally 'sick' of the situation and they are angry about it. But how to change it? This is clearly the work to be discussed in other chapters. I hope that my personal experience of living with what almost became an obsession about food, entirely unexpected and at times frightening, through being in a culture where it has enormous symbolic power, has given an insight into some of the feelings, albeit in a much milder form, which women who are really in the grip of an eating disorder might be experiencing.

References

Beller, A. Scott. (1977) *Fat and Thin*. New York: Farrar, Strauss and Giroux.

Bruch, H. (1974) *Eating Disorders: Obesity, Anorexia Nervosa and the Person Within*. London: Routledge, Kegan Paul.

Jeammet, P. (1980) Anorexia Nervosa. Paper given at Association for Psychiatric Study of Adolescents Conference, July 1980.

Levens, M. (1987) Art Therapy with eating disordered patients, *Inscape, Journal of Art Therapy*, Summer. London: BAAT.

Murphy, J. (1984) The use of art therapy in the treatment of anorexia nervosa. In T. Dalley (ed) *Art as Therapy*. London: Tavistock.

Orbach, S. (1986) *Hunger Strike*. London: Faber.

Rust, M.J. (1992) Art Therapy in the treatment of women who have eating disorders. In D. Waller and A. Gilroy (eds) *Art Therapy: A Handbook*. Buckingham: Open University Press.

Schaverien, J. (1989) Transference and the picture: art therapy in the treatment of anorexia. *Inscape*, Spring.

Waller, D. (1983) Art Therapy as a treatment for Eating Disorders. Report of a research project. In J. Henzell (ed) *Proceedings of the British Psychological Society International Conference 'Psychology and the Arts'*, Wales: University of Cardiff.

III
Dramatherapy

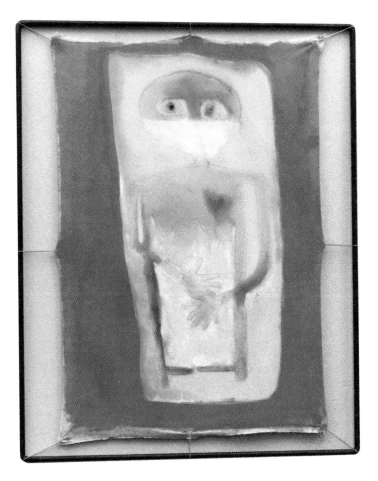

The Deadly Blue

Clinging onto ice to find internal warmth, to fight against
the cold that numbs my body, spirit and soul.
The silent tears I'm shedding are the quiet screams of frustration
as my body lies exposed surrounded by deadly blue and cold.
I can see others playing in the shadows of the blazing sun
yet I cannot bear the coldness that bites below my skin
layer upon layer of clothes that surround me
are like traitors to my body, a shiver down my spine.
I cannot tell of all the pain that is biting at my body
because I know the answer but it's just beyond my reach.
and so I sit here quietly still wishing to feel freedom
to once again breathe summer air and leave the ice to melt.

Elise Warriner

This poem is about how cold I felt whilst I was unwell.

A Dramatherapy Case History

An Anorectic Response to an Incomplete 'Rite-of-Passage'

Sue Jennings

In this chapter I consider a single case history of an Asian woman who presented at an infertility clinic for medical investigation. She and her husband were concerned that after a year of marriage there had been no conception. After a preliminary out-patient's appointment, she was referred to me for dramatherapeutic assessment and counselling.

There is now extensive literature on the aetiology of 'eating disorders' and *anorexia* in particular. Most of this writing has concerned both clinical and feminist interpretations, many of which are addressed elsewhere in this book. My current concern is the social and cultural context of what we choose to term 'eating disorder'. Although there is an attempted move towards a more generic approach in which eating disorder comes within the wider view of 'weight-related problems', nevertheless the most frequent primary analysis concerns clinical dysfunction. Women, more frequently than men, are referred for various therapeutic interventions because their weight and eating patterns prevent healthy functioning. This may be in relation to their fertility, since people who have a body mass that is too low or too high, stop ovulating; or it may be in relation to other medical conditions, such as heart stress. Eating disorder may be seen as a psychological or psychiatric condition that prevents a person's well-being and optimum achievement in the adult world. Most therapists would agree that psychotherapeutic and behavioural intervention is frequently unsuccessful, with therapists often complaining that clients will not stay in therapy. Indeed, many say that such people are unable to sustain long-term therapy and

suggest that the client is somehow at fault. However, perhaps we should appraise the therapeutic intervention and look at whether inappropriate theory and methods are being used, especially when we are working cross-culturally. Quite apart from the cultural dimension of the presenting 'problem', have we also taken into account the cultural dimension of who has the trust and confidence of the client in order to make an intervention; indeed, do we understand a cultural concept of therapy? (d'Ardenne and Mahatni 1992; Kareem and Littlewood 1992).

My task, therefore, is twofold: to consider briefly the therapeutic context of transcultural therapy, as well as looking at the wider cultural context of belief and ritual in relation to the human body, and eating in particular, and suggest that a cultural understanding of the 'societal body' may enable a change in patterns, even after brief therapy.

Healers and therapists

Until comparatively recently, psychotherapeutic intervention has stemmed from theory and practice amongst white western society (Dokter 1993) and attempts have been made to draw universals in relation, not only to practice, but also to meaning. Imagery and symbol and the workings of the unconscious have been interpreted from a universal model of the human psyche, even when there is evidence to suggest that the data has been skewed, for example through reportage and analysis of the Temiar people's 'dream culture' (Jennings 1992, 1994). Many of these approaches and practices are not only white western, but also middle-class, and the idea that a complete stranger outside of the familial and social network can be useful in personal problem-solving, is an alien concept to many other social and cultural groups.

As if to challenge this approach, there has been a move in western societies to incorporate shamanic approaches from other cultures and to superimpose them onto our own, without an understanding of the cultural context of the shamanism (in order to clarify my own practice, whereas I used to refer to a 'shamanic model' of dramatherapy (Jennings 1992), I have changed this to a 'metaphysical model' in order to distinguish theory and method). So, cultural confusion ensues, with various practices addressing groups of people for whom the therapy has no cultural meaning. *Both the therapist and the practice need to address the cultural meaning of the client.* Sadly, this has sometimes meant that non-white families end up with stereotypes, and it is not unusual to hear people say: 'It's a typical West Indian marriage' or 'That is the norm for Greek mothers'.

Most radically, we need to consider whether a 'professional therapist' is in fact the most appropriate person to intervene. I continue to be impressed

by the quality of intervention given; for example, by the Asian health aides at the London Hospital. These are women with a very brief training in counselling skills who, although usually called upon to translate for the doctors and nurses, also give counselling support to many individuals and couples from their own ethnic background. They are seen as an extension of the family, and it is within the extended family that much counselling traditionally takes place.

I cannot over-emphasize the need for some basic training in social and medical anthropology for practising therapists of all kinds and, happily, several of the dramatherapy training programmes are addressing this very question.

Social and cultural bodies

Anthropologists have long been aware of the medium of the human body to express meaning about society. The shape of the body; its clothing and decoration; the emphasis of one body-part over another; the grooming and feeding of the body – all make powerful statements about the value system of the society concerned and the relationships between people. Polhemus (1978) states:

> Our bodies and our perception of them constitute an important part of our socio-cultural heritage. They are not simply objects which we inherit at birth, but are socialized (uncultured) throughout life and this process of collectively sanctioned bodily modification may serve as an important instrument for our socialization (unculturation) in a more general sense. That is, in learning to have a body, we also begin to learn about our 'social body' – our society. (p.21)

Many of these values are expressed through bodily rituals, performed at specific ceremonies or during *rites-of-passage.*

Rites-of-passage are those rituals which accompany changes in social status throughout human life. Rites-of-passage accompany us from birth, through coming-of-age, adulthood, parenthood and death, to name but some. These rites always involve the three stages of, separation, transition (liminal) and re-incorporation (Van Gennep 1962), when people are separated off from their group and go through a period of instruction and learning and then are re-incorporated with their new status into their appropriate social group.

During the liminal time – the transition between one state and another – there is usually a marked contrast of bodily ritual. There may be special food or a period of abstinence; clothes will change and may become plainer

or old or neutral; hair may be cut or combed or braided. *It is not uncommon for the time of transition to be a time of 'self-denial'*, before the re-entry into society in the new status.

Parkin (1992) draws our attention to the importance of bodily statements over verbal statements in rituals and rites-of-passage. Although he agrees that speech is part of social action and that there is an inseparability between word and deed, nevertheless he says:

> But I would suggest that anthropological ideas of ritual contrasted with myth constantly threaten to reverse this premise: it is often part of the alleged special character of ritual that it *does* presuppose an action or series of actions which does not need speech. Thus, while myth is rendered as privileging words, ritual is held to privilege physical action; but it is an action that can only be understood as bodily movement towards or positioning with respect to other bodily movements and positions. If such movements are a principle feature of ritual, then it must be through them rather than through verbal assertions that people make their main statements. (p.12)

Therefore an effective *rite-of-passage* has an emphasis on bodily action, together with other ritualized bodily expression, in relation to other bodies.

Can this give us any clues, therefore, to an isolated period of starvation of a young woman in an alien culture?

Case history

Mr and Mrs D attended an out-patient infertility clinic having been referred by their GP for primary infertility. The Consultant Gynaecologist asked me to assess them for possible counselling, as he was concerned at the high levels of stress and the preliminary tests (such as blood and sperm tests) had not yet commenced. They came into my room very quietly, at my suggestion that perhaps there were things to talk about. He was dressed in western shirt and trousers and she was wearing traditional clothes. She spoke little English and he did most of the translating for her. He said that they had been married for a year and he was worried that they did not have a baby. His parents were putting great pressure on them to start a family and he thought his wife was very stressed. Mrs D was then asked to go for a medical examination, and he stayed to talk to me. He was concerned at the stress on his marriage, which had been arranged a year previously. He hinted at his mother's impatience, especially since his brother and two sisters had already got children: 'You know how it is with mothers – you are not always what they want'.

He then went on to discuss his wife's homesickness: he said she would sit and not talk to anyone, and listen to Indian music. He thought this was unhealthy as it made her even more depressed, so he had stopped it. When his wife returned, I suggested that we meet again to talk things over further. He said that he thought she ought to come and see me on her own and it might help her to adjust to her new life. When I asked her what she thought of the idea, she said she would like to come back and talk.

I needed some time to think this one through, and asked them to wait. Meanwhile I went for an update with the doctor. I shared with him my concern at how thin she was (not immediately apparent because of her flowing clothes); however, we calculated her Ponderal index and she was well under the limit for regular ovulation. Was this to be a question of an eating disorder – *anorexia* being masked as infertility?

I agreed to see her on a regular basis and suggested that he came once a month. I said that she was free to discuss anything that she wanted with her husband, and I also said that perhaps the Indian music could be reinstated as it could well be reassuring. Mrs D looked immediately brighter-eyed at this suggestion, and Mr D agreed to the arrangement.

First session

Mrs D attended very promptly and seemed eager to see me. I thought it was important to be direct with her about her weight and explained that she would not conceive while she was so thin as her body would not release the eggs. She said she was scared of getting fat. When I said that pregnancy would make her even fatter, she then said: 'I am only a little girl – I am not a woman yet', and showed me her stomach which she said she thought was fat and that her husband would not like her if she was fat.

I suggested that she told me her story, starting from before she got married. Her English was very halting and we both used pictures and cartoons to illustrate points and I repeated summaries back to her, in order to be clear about what she was saying and also to make sure that I had understood it.

She told me that her marriage had been arranged between the two families: her husband's uncle had gone to India to find a suitable family from which to choose a wife for his nephew. The two families had long discussions and correspondence, and she had seen a photograph of him but that was all. They had not met prior to her journey to the UK.

She said that she lived in a small village far away from the town. Her father had taken her to Delhi and then put her on an aeroplane to England where her new family met her at the airport. She felt very sad at leaving her

village and thought she would never see her family again: she missed her grandfather in particular as they were very close. Her eyes misted at these recollections and she hastily wiped her eyes, saying that people got cross if she was upset. I asked who 'people' were, and she said mainly her mother-in-law who expected her to keep busy and be a good wife. She said her husband got upset when she was depressed, which is why he stopped the Indian music; however, he had agreed that she could play it since our discussion in the previous meeting. I suggested that, next time, we could do some drawing or painting and talk again about India.

Second session

Again, Mrs D arrived very promptly and seemed eager to see me. However, she said that she was not sleeping well and felt very sick if she tried to eat very much. She said that she had tried to eat more because the doctor had said she was too thin, but she looked anxious again and said: 'Do you think I am getting fat? I think that I am getting fatter.'

She looked over my various toys and art materials, and her eye caught my set of nesting dolls in Indian dress. She immediately picked them up, took them apart, and arranged them in a row. She was absolutely intrigued by them and said that I knew a lot about India. Without any prompt from myself, she began to talk about her family in India and used the dolls to illustrate who everyone was. There was her mother and father and several children; the youngest daughter was still at home. Her sister and both her brothers had been married in India and lived nearby. Her grandmother was dead, but her mother's father lived with them and was a very special person for her. She felt closer to him than to her own father but he was getting very old now and she was scared that he would die. (Although I did not pursue this point, I have come across examples whereby women are scared to have a baby in case a parent or grandparent may die 'in exchange'.)

She was upset that her family, apart from one brother, were not at her wedding. She had hoped that all her relatives could attend, as they would have done if she had been married in India. She was very engaged with the dolls and became more eloquent in English as she talked about her extended family. Her animation was in sharp contrast to the subdued self that I had witnessed previously.

Third session

Again, she arrived promptly and immediately asked if she could talk about her village. I offered her felt pens and paper and asked her if she wanted to

draw her village. After a little hesitation she said that she would. She drew several houses in the village, and palm trees and the vegetable garden, using vivid colours. She said how she loved the colours; they were all bright and cheerful, and how grey it was in London. She became very animated and started to talk about life in the village, about the girlfriends she had that she was able to chat with: she had been at school with some of them, and they all shared things together. Everyone in the village knew each other and she was able to visit other people's houses. She then started to cry and said that she missed everyone so much and perhaps they would all forget her. She felt sad that she had no group of friends here and could only go out of the house with a member of the family.

I suggested that we could use the sessions to say 'goodbye' to her family in India; not in a final way, because she would see them again one day, but perhaps in a way that made it possible for her to let go of them and allow herself to live here.

Fourth session

We placed all the toys on the desk: animals, landscapes, people, buildings. She selected enough to create her village with houses and people and moved them around describing what life was like there. She then 'told them' that she was going on a journey and would not see them for a long time as she was going to a new country, but that she would write to them and send them pictures. She still looked sad, but did not cry. I asked her if she had written and sent pictures and she said that she hadn't. They had pictures of the wedding, but she had been too sad to write again. We discussed that perhaps she could keep a diary of the things she did, and send it occasionally with photographs, in order to keep in touch with her family. Maybe they would also write and tell her any news, and perhaps her girlfriends might write to her.

I asked her to create the house that she had come to in London and she drew a very grey tall Victorian building.

'It's very grey and dark', she said: 'It doesn't have the colour we have at home.'

She then, on impulse, took the finger-paint, which she had previously been very reluctant to use because it was messy, and created blobs and splats of colour all around the house. She seemed to enjoy making a mess of colour and said that it made the house look a lot better. I said that I would expect her to come with her husband to the next session.

Figure 7.1

Fifth session

She and her husband attended, and he said that he thought she was less depressed than she had been before. He commented on the fact that she was not sleeping well and that she said she had pains in her neck and back. I

suggested that he helped her with some relaxation exercises which would be similar to exercises that they did in their own culture.

I used the hospital examination couch and demonstrated a basic shoulder-massage followed by a 'tension-relax' routine (starting with the feet and working up to the head), and suggested that they could both do it together. Then I used a piece of 'guided imagery' where one pictures a comfortable place where it was warm and one could relax; 'see' the colours, and so on; taking her gently into relaxation and then out again. I suggested to her husband that he could help her by doing this exercise for her each night before they went to sleep. They both left looking a little less burdened.

Sixth session

She arrived at this session saying that she felt a lot better. She was looking very merry and a vestige of a giggle escaped. She said that her mother-in-law had been a lot nicer to her and was not so critical. When I asked her if she knew the reason, she said that she thought her husband had spoken to his mother. She seemed pleased that he had spoken on her behalf to his mother, rather than colluding with her criticism of her.

I asked her whether she still felt fat and she said that her body felt much better and that she did not have the pains in her shoulders and back any more. She giggled and said that her husband had tried to do the relaxation routine with her; he was very good at the massage and breathing, but could not do the guided imagery. She started giggling again and said that he thought of such boring places that she just did that one herself. However, she added that it was good because she could now *go to her village in her imagination* and see all the colours and have the restful feelings that she felt there. She said that she played the music some of the time and no-one complained, but she didn't need to play it all the time: 'I have found a way of remembering everyone and everyone: nothing is going to disappear'. She added that her brother had arrived with letters from home and was going to take her letter and photos back for her family and friends. She had also been able to tell her husband that she wanted to meet some women of her own age.

Seventh session

Mrs D arrived in very thoughtful mood and said that she wanted to play with the finger-paints. She drew a picture of a woman with a baby inside her (Figure 7.2) all in blue paint, and said: 'I like this picture – maybe it is me'.

Figure 7.2

I asked her whether she was less frightened now of having a baby and she said that she was beginning to think that she looked forward to having her own child. She said: 'I think I have grown up now. I would like to have a baby and care for it. My grandfather would be very pleased too.' Her Consultant came to see her and expressed spontaneous surprise at how she looked, to which she said: 'I am a grown-up woman now. When I first came here I was a little girl.'

He welcomed her to the adult world, at which she smiled with an air of acknowledging the great changes that she had undergone. He suggested that she came back to see him for a further check up. Then she said: 'But I can still come and see you if I need to, can't I?'

Eighth session

She came to see me after her medical appointment and her doctor came with her. She said: 'I've got some news – I'm pregnant!' The doctor stood there grinning from ear to ear and, like me, was not quite able to take it all in. He remarked on the changes that had come about in a very short space of time. She said: 'Well, I told you that I was grown up now.' Of course, she could not wait to tell her husband, and we talked about what her family in India would say when they knew she was going to be a mother. She was a little sad when she realized that her mother would not be there when her baby was born.

We spent the remainder of the session consolidating what we had done in the previous sessions and 'letting go' of each other from what had been a very intensive relationship. She said how important it was to be able to come and talk about her previous home and it was important that I understood something about India. I suggested that they both came to the final session.

Ninth session

They attended together. She was looking radiant and he was behaving in a very protective way. She had virtually no sickness; felt very fit, and was sleeping well. She said she had no more pains like she had before. He was delighted and said that he knew that coming to the sessions had helped them both. They both talked about the brother coming over and being the messenger with the letters, and they were able to talk about her feeling cut off from her homeland.

I suggested that it was not a good idea to forget India, even though his wife seemed much more settled and happy here: perhaps they could both go there when the baby was a little older and he could meet all her family. He said that he realized she needed to have friends here and his family were helping with this; also that she was going to attend English classes.

Mrs D did come to see me from time to time when she was attending the out-patients' antenatal clinic. She wanted me to promise to be there at the birth, to which I said that I would try, but could not promise, since I lived two hours' away from the hospital.

I had a 'phone call in the early hours of the morning some months later and, by the time I got to the hospital, the baby was born. Both the doctor and I were taken in by the family and treated as if we were members of it. Classical photos of three generations were taken round the hospital bed, and I remembered the colourful picture she had drawn of how she would like it all to be. Both the doctor and myself had been made members of the extended family and were invited to the child's naming celebration.

Discussion

In a previous brief description of the above case history (Jennings 1993) I suggested that

> Mrs D appeared to be suffering from secondary anorexia in relation to keeping control over her identity after leaving home, and the anxieties she felt arriving in a strange country and being in a demanding family. (p.6)

I want to elaborate on these ideas now, and place them more in a cultural context than in a clinical view.

In reviewing this material I have been very struck, first of all by the brevity of the intervention, and secondly by the content that Mrs D engaged with which Mrs D engaged. As can be seen from the above, she did not follow any conventional anorectic patterns and readily engaged in the therapy. If we consider it from the point of view of an incomplete rite-of-passage, we can perhaps understand more clearly Mrs D's brief eating disorder.

Mrs D was expected to make a literal journey into married life with little preparation or anticipation of it. Her own family was not at her wedding apart from her brother, and she mourned the fact that her mother and grandfather, in particular, were not with her. However, she was not only making a rite-of-passage without the accompanying traditions into her married state, she was making a journey to a European society where she had no roots, and was also moving from a close-knit rural environment to a capital city with only the relatively small network of her husband's family. It appeared to me that there had been no satisfactory transition from one state to another and that there had been no ritual closure. Mrs D was still in a state of transition between cultures, between being single and being married, between girlhood and adulthood, between adulthood and parenthood. By taking control of her body through controlling intake of food, she was making a cultural statement about her liminal status. This, as we know, often involves abstinence. Her relationship with me was not so much based on a conventional 'transference', but designated me rather as a village

midwife for whom it would be appropriate to attend the birth and naming. In fact, I think it was important, in terms of my completion of her rite-of-passage of birth, that I was able to be there for her on both these occasions.

My understanding of Mrs D's liminal state was first triggered by her eating pattern which went with a complete change in expected norms of behaviour – not going out; dressing less brightly; sleeplessness; vague pains – all things that we could suggest were depressive symptoms.

If she had only been seen by a clinician, she might well have been put on anti-depressants and perhaps referred to an eating disorder group. However, I would suggest in this case that it would have been quite inappropriate.

It was crucial to address the 'missing ritual' in Mrs D's new situation, which she was able to do symbolically through the use of dramatherapeutic projective media. *She created a theatre of the past and a theatre of the present and a theatre of the future through pictures, models, stories, of which she was both director and performer.* It was important for her to be able to re-establish her previous rooted past and symbolically make the journey in order to establish her new roots in her married family. It was also important for her to be able to create the role that she wanted me to play, within this rite-of-passage – that of liminal specialist – who would allow her to revisit her past in her own way and then move into her new future.

This case presentation illustrates how an understanding of social and medical anthropology can facilitate therapeutic intervention that is appropriate to the context and culture of the client. Certainly, the outcome would have been very different if more conventional therapy had been undertaken, but then I doubt if this couple would have attended.

Dramatherapy is possibly the only approach that can assist people to create the rituals that they need to process, and allow meaning to emerge within the bodily and spatial patterning that makes major statements about our values and beliefs.

Dedication
This chapter is dedicated to Mr Ovrang Djahanbachch, whose trust and vision allowed this dramatherapy programme to start.

References
d'Ardenne, P. and Mahatni, A. (1992) *Transcultural Counselling in Action.* London: Sage.

de Coppet, D. (ed) (1992) *Understanding Rituals.* London: Routledge.

Dokter, D. (1989) Dramatherapy Across Europe – Cultural Contradictions An Inquiry into the Parameters of British Training and Practice. In H. Payne (ed) *One River Many Currents: A Handbook of Inquiry.* London: Jessica Kingsley Publishers.

Jennings, S. (1985) Temiar Dance and the Maintenance of Order. In P. Spencer (ed) *Society and the Dance.* Cambridge: Cambridge University Press.

Jennings, S. (1992) The Nature and Scope of Dramatherapy: Theatre of Healing. In M. Cox (ed) *Shakespeare Comes To Broadmoor: 'The Actors are Come Hither' The Performance of Tragedy in a Secure Psychiatric Hospital.* London: Jessica Kingsley Publishers.

Jennings, S. (1993) An Operating Theatre of Healing? *Journal of Dramatherapy,* 14, No.2.

Jennings, S. (1994) *Theatre Ritual and Transformation.* London: Routledge.

Kareem, J. and Littlewood, R. (eds) (1992) *Intercultural Therapy.* Oxford: Blackwells Scientific.

Parkin, D. (1992) Ritual as spatial direction and bodily division. In D. Da Coppet (ed) *op cit.*

Polhemus, T. (ed) (1978) *Social Aspects of the Human Body.* Harmondsworth: Penguin.

Turner, B.S. (1992) *Regulating Bodies.* London: Routledge.

Van Gennep, A. (1962) *The Rites of Passage.* Chicago: University of Chicago Press.

Dramatherapy in Short-Term Groupwork with Women with Bulimia

Maggie Young

This chapter is concerned with models: both models of groupwork for clients with bulimia and approaches within dramatherapy best suited to this work. The chapter is based upon my experience of facilitating therapeutic groups for women with bulimia over the past four years. I define my practice of groupwork as falling within the insight or psychotherapeutic model of dramatherapy (Jennings 1983). Relationships and events which occur in the group are explored as well as individual issues; thus participation in the group process is an important factor in bringing about change and personal growth. Within this model I have experimented with the use of two different dramatherapeutic approaches: the embodiment–projection–role paradigm (Jennings 1990, p.10) and the group journey structure (Lahad 1992, p.157, Gersie 1990, 1992, Jennings 1987, p.13 and Jennings and Minde 1993, p.172). The focus of this chapter will be on describing how these two approaches were applied in two separate closed groups for women with bulimia, which followed each other sequentially. The two frameworks will be evaluated and the benefits and limitations of each identified and compared. In the conclusion, questions will be raised about how dramatherapy can most effectively be used in the context of short-term groupwork for women with bulimia.

Group therapy and bulimia

Bulimia nervosa is an increasingly common disorder characterized by a chaotic binge–purge eating pattern and over-preoccupation with body shape

and weight.[1] The problem is often accompanied by intense feelings of conflict, low self-esteem and emotional ambivalence. Such difficulties predominantly, but not exclusively, affect women and occur in societies in which western values are prevalent (Dolan 1991). Three broad approaches to the treatment of bulimia are described in research literature (Fairburn *et al.* 1991 and Garner *et al.* 1993). These are interpersonal therapy, cognitive behavioural therapy, and an integrated approach exemplified by the work of Lacey. I originally based my work on the model developed at St. George's Hospital, London by Professor Lacey for use in short-term outpatient work with clients with bulimia (Lacey 1983, 1986). The unique aspects of this ten week programme are a combination of individual and group therapy and a combination of behavioural and psychodynamic approaches. Individual sessions utilize behavioural and counselling techniques to bring disordered eating under control. Verbal psychotherapy is used within the group session to explore new ways of dealing with feelings and the emotional and social factors associated with an eating disorder.[2] The rationale behind the approach is that, as disordered eating is brought under control, 'intense feelings of anger and depression can be declared or unmasked' and these can be addressed through a psychodynamic approach. The eye of the dramatherapist immediately focuses on the word 'unmasked' and asks whether dramatherapy techniques could be used as a medium for the exploration of intense feelings. I have introduced dramatherapy into this model in place of verbal psychotherapy in the group session. Individual sessions are no longer offered in our programme (see section on structure). This fundamental change, whereby dramatherapy is integrated into a groupwork programme for women with bulimia, forms the focus of this chapter.

My work has also been informed by the theory and practice which has emerged from the London Women's' Therapy Centre, much of which relates to the use of active methods of therapy with women with eating disorders (Ernst and Goodison 1981, Orbach 1986, Lawrence 1987). I have also found *Experiential Therapies for Eating Disorders* an invaluable text (Hornyak and Baker 1989).

1 The disorder was named bulimia nervosa in Britain by Russell but is known as bulimia in the USA. There are two slightly different sets of diagnostic criteria: those of Russell (1979) and those of DSM-IIIR (1987). I am using the American term for simplicity and to refer to American criteria.

2 Much of the therapy in this programme has been carried out and developed by occupational therapists, namely Rose Stockwell and Anne Harte as well as Bridget Dolan, Psychologist. Anne Harte has extended the programme for use on a self-help basis in conjunction with the Eating Disorders Association in Norwich.

Why dramatherapy and eating disorders?

Dramatherapy is an active, experiential therapy which uses the body and voice as tools for self-expression. The following are some of the key strengths of dramatherapy as an approach to work with eating disorders. Dramatherapy can:

1. facilitate the release and expression of feelings

2. work directly with distress focused on and around the body

3. enable an exploration of both individual and social roles.

With its strong links with the cultural, dramatherapy is ideally placed to facilitate an exploration of role models of women and how these may impact on an eating disorder. These points will be developed in the descriptions of actual groups later in the chapter. The use of dramatherapy in groups enables members to disentangle and decode the very many confused attitudes and behaviours which they have adopted in relation to food and the body. Members of a group have much to offer each other, and the use of dramatherapy offers both a vehicle for the expression of feelings and the creative exploration of group processes.

Group selection, context and structure

The majority of women referred to the group suffer with bulimia or closely related difficulties and the group is focused around their needs. The women are referred primarily by GPs and Community Mental Health Teams and a proportion of these are students. Each person referred is interviewed for an hour prior to any decision about their future membership of the group. Motivation and commitment to tackle the eating problem as well as willingness to look at it from a psychological point of view, are important criteria in the selection procedure. An understanding of the development of an eating disorder in terms of predisposing, precipitating and perpetuating factors is useful in the assessment phase. Such a model (see Figure 8.1) helps both therapist and client to identify problem areas and establish aims of treatment.

After experimentation with various length of groups we have found that twelve to fourteen weeks is the optimum length for a short-term closed group. The majority of members can sustain a regular commitment over this period of time. The sessions take place in a group room in a psychiatric out-patients department which is part of a general hospital. There is no stigma attached to attendance at this unit and this appears to be an important factor. The dramatherapy group is a stand alone treatment for the majority of members and not an adjunct to other therapies. For this reason it appears important

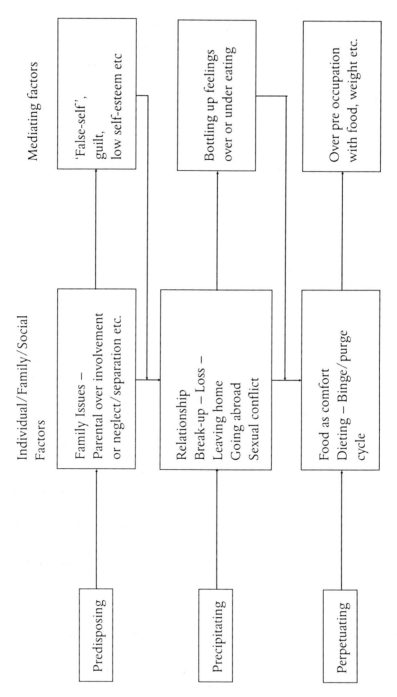

Figure 8.1 Development of an Eating Problem
(loosely based on Yellowlees 1992)

that there is a framework for tackling eating behaviour, as well as an exploratory approach provided in the dramatherapy sessions. Individual sessions are not offered but, instead, the first half-hour of a two hour group is allocated to practical issues around food and eating. A personal notebook/diary is provided so that members can record their progress and many suitable books and self-help manuals can be recommended.[3] This session is followed by the dramatherapy group which follows the standard format of warm-ups, main theme or development phase and closure. Within this overall model, two different dramatherapeutic approaches were used, and these are described in the following two sections.

Embodiment–projection–role paradigm

The embodiment–projection–role paradigm is a developmental approach to dramatherapy practice elaborated by Dr. Sue Jennings (Jennings 1990, p.10). In Jenning's writings these three terms are defined primarily in terms of children's play. Embodiment is the pre-play stage where the child is preoccupied with bodily senses and physical activities; projection is the gradual ability to project outside of oneself through the symbolic use of toys and objects; and role is the development of the ability to take on imaginary roles. This paradigm has much in common with developmental approaches in dramatherapy as described by Johnson (1982). With reference to developmental psychology, Johnson uses the terms sensorimotor, symbolic and reflective to refer to broadly equivalent stages. He proposes that the media of movement, drama and verbalization correspond to these three stages and encompass a progression from bodily expression, through the use of imagery and symbols, to the ability to take on a role and to put thoughts into words.

The developmental perspective is useful for clients who have come to a halt or blockage in development and have difficulty in verbalizing problems. Many women with eating disorders have experienced a block as a result of rejection or inconsistent parenting. A significant proportion have been sexually abused as children, which can seriously interfere with development and the ability to play. Women with bulimia often engage in a secretive and obsessive ritual around food and the body, which can be perceived as an avoidance of emotional and physical maturity. Kim Chernin, writing from a feminist perspective (1986), introduces a collective dimension into this discussion through her understanding of eating disorders as a 'profound developmental crisis in a generation of women still deeply confused about

3 See French, B. *Coping With Bulimia*. Cooper, P. *Bulimia Nervosa A Guide to Recovery* and
 Treasure, J. and Schmidt, U. *Getting Better Bit(e) by Bit(e)*.

what it means to be a woman in the modern world' (p.17). In view of the above factors, a developmental perspective was selected.

The application of the Embodiment–Projection–Role paradigm

In terms of work with adults, the framework implies that early sessions focus on physical activities, for example trust exercises and ups, moving on to an intermediate stage of projective activities which may involve an element of 'as if' metaphorical thinking. The final stage is enactment, which may be a dramatization of a past, present or future scene from a member's own life. The paradigm works against premature disclosure, a particular problem for sufferers with bulimia, who often disclose significant emotional distress before the safety of the group has been established. The framework guides the therapist in the selection of exercises at each stage in the life of the group and seeks to ensure that work is well structured. The progress of this group fell into three distinct parts and activities used at each stage were consistent with the overall framework.

Group composition

I used the embodiment–projection–role paradigm in a twenty-week group with six women with bulimia. The women were between the ages of twenty and thirty-two. In terms of occupation, two were employed, two were students, one was engaged in voluntary work and one was a single mother. They came from a variety of socio-economic backgrounds and one member came from a mixed race background. A high degree of severity of eating disorder was noted as well as factors associated with a poorer prognosis, for example a previous history of anorexia. Two members disclosed childhood sexual abuse at initial interview and a third disclosed this during the group. The average length of time which members had had the eating disorder was eight years. Using a standard measure, all but one member began the group with a severe bulimic eating disorder.[4] At the end of the group, severity of eating disorder was reduced for all members and three no longer had a binge–purge eating pattern.

1. Embodiment (week 1–8)

The primary aim of the embodiment stage for the therapist is the building of an atmosphere of trust and safety in the group. In practical terms this

4 The standard measure used was the 'BITE' A Self Rating Scale for Bulimia. Henderson M.
 and Freeman C. (1987) *British Journal of Psychiatry*, 150, 18–24.

means enabling members to make eye contact, and to speak and participate without undue anxiety. A subsidiary aim of this stage is that work is being done on redefining body-image without this being an explicit aim. In this group standard warm-ups and ice-breakers were used, for example Trust Fall, Trust Walk, Eye-Contact/Swap Chairs, Group Tangle (Jennings 1986). Such exercises were enjoyed by some members, while for others they raised an insurmountable degree of anxiety. Anxiety appeared to relate to self-consciousness, fear of exposure and fear of allowing others emotionally or physically close. Embodiment activities facilitated an exploration of the barriers and guards which members had built as a defence against being hurt. For some, these had been built physically by means of layers of weight or loss of weight. A disturbance of body boundaries became apparent after an exercise related to giving and receiving compliments. All agreed that anything positive allowed in, had immediately to be rejected or rubbished afterwards. This emotional response echoed current eating behaviour. There was a fear of dependency and a need to maintain a separation between the inside and outside of the self.[5] Members of the group agree that they experienced a body-boundary a few inches outside the skin, beyond which others were not allowed to penetrate. This discussion was followed by a series of exercises where body-boundaries were explored.[6]

EXAMPLE: BUBBLE EXERCISE

> In pairs A and B, the active partner, A, imagines herself surrounded by a bubble of protection. B outlines the bubble shape using her hands, taking care not to burst the bubble. The exercise can be developed to include movement. A moves within the bubble, while B outlines the shapes she is making. The distance of the outline can be varied and A is encouraged to state non-verbally what distance feels safe. Reverse roles and discuss.

Such an exercise was found helpful in reassuring members that they are in control of the speed at which they lower their defences. In a useful discussion which followed, members talked of the loneliness and isolation of having a secretive eating disorder. They are not accustomed to allowing anyone close or letting genuine emotions past their outer defence. Throughout the group

5 For an excellent discussion of the concept of boundaries in women with eating disorders see Dana, M. (1987) Boundaries: One Way Mirror to the Self in Lawrence M. (ed.) *Fed up and Hungry, Women Oppression and Food.* London: The Women's Press.

6 For a discussion of parallel themes see stark A. Aronow, S. and McGeehan T (1989) Dance/Movement Therapy with Bulimic Patients, p.129 in Hornyak L & Baker E (eds) *Experiential Therapies for Eating Disorders.* New York: Guilford Press.

sessions members gradually became more comfortable with physical contact, asking for a hug, or to end sessions holding hands. It became apparent that barriers may need to be lowered to leave the eating disorder behind and that the group may be a useful place to begin this process.

2. Projective stage (week 9–13)

In this stage, the main themes explored were both self-esteem and roles played inside and outside the group. The main techniques used were sculpting and what is referred to as visual dynamics, whereby an issue of importance for the group is explored by visual means (Jennings 1986, pp.143–172). Members create the equivalent of a photograph or diagram that enables a specific theme to be explored in a direct way. Either miniature or life-size variations of such exercises can be used (Jennings 1993). In the following example a miniature sculpting exercise was used to explore the theme 'My Life as it is Now'. Members select a variety of small objects, in this case buttons, to represent the self and significant others. Relationships between these are portrayed by how the buttons are placed in relation to each other on the floor. Members share this button sculpt with the group and decide on changes they wish to make. This exercise invariably creates very strong emotions and predominant individual and group themes are revealed. It is therefore useful as a diagnostic tool and helps in setting aims for the individual and the group. In this particular group the themes were of over-involved or inconsistent mothers, absent fathers and, common to many sculpts, a desire to change the self. Dull grey or beige buttons were initially chosen to represent the self. These were changed for brightly coloured, flamboyant buttons, highlighting the importance of the issue of self-esteem.

Such work, which explores the self in context, can easily be developed into its life-sized counterpart: family or group sculpting. In family sculpting, a member positions other group members to represent her family and this work can lead to a powerful exploration of family themes as documented by Root (1989). The aim of group sculpting is to clarify the dynamics in the group and enable each member to explore the role she is taking on and how this relates to her role outside the group.

EXAMPLE: THE GROUP AS A HUMAN BODY

A life-sized body including facial features, bones and internal organs was drawn on a large sheet of paper placed on the floor. Each member stood in turn on the part of the body which represented the role they had taken on, so far in the group. It emerged that we had a group of

carers – soothing hands, listening ears and so forth. One member saw herself as the womb of the group, in other words, 'the Mother'. When asked to re-position themselves (according to the role they would like to play), all placed themselves in more powerful positions, many near the voice or throat. A productive discussion developed about how members find it difficult to voice their own needs and give expression to their own feelings. The 'Mother', speaking on behalf of all, said she had given enough and now it was time for each to take something out for themselves and get to the 'nitty gritty'.

3. Role

In the role stage of the group, members were encouraged to enact past, present and future scenes. Warm-ups used related to breathing, and voice-projection exercises, as a preparation for the expression of feelings. Many psychodramatic methods were used, including mirroring, doubling, role-reversal, and members of the group were selected to play subsidiary roles. Predominant themes addressed included anger, loss, sexuality and the effects of childhood sexual abuse.[7] Scenes were often played on two levels, first to allow the protagonist to explore her own feelings and second to rehearse or practice an actual scene. A common difficulty was in the expression of strong emotions, especially anger and sadness, which many experienced as particularly threatening. This further seemed to emphasize the disturbance which members felt around the throat and chest area and their desire to learn to express emotions instead of pushing them down with food. An invaluable exercise to explore the link between bingeing and feelings is 'The Clock Exercise' (Callahan 1989 p.107). In this exercise a clock face is imagined on the floor and members walk around it, stopping at specific times when food typically becomes a problem for them. They are then asked to speak about their actions and feelings in the present tense. Powerful material for further individual work usually emerges from this exercise.

Evaluation

The group was led within the embodiment–projection–role paradigm and, developmentally, the group had made great progress. Towards the end of the group, many buried issues came to the surface and members reported personal changes in addition to a decrease in severity or cessation of eating

7 See Bannister, A (1989) The effects of Child Sexual Abuse on Body and Image. *Journal of the British Association for Dramatherapists* Vol 12 (1). This paper explores the links between bulimia and childhood sexual abuse.

disorder. These changes in the words of the members included: daring to begin a new relationship, being able to glance in mirrors, taking my big coat off in public, buying clothes for myself. Members felt less guilty and appeared able to express feelings more directly, both inside and outside the group. Within the group, members learned to ask for what they needed and deal with conflict and these changes were associated with an improvement in eating patterns. The embodiment stage was definitely experienced as the most difficult part. The underlying difficulty with this stage may link to the fact that many women with bulimia have experienced inconsistent parenting and childhood play may have been disrupted. Half the members of this group had experienced abuse, and control is a central issue for people with eating disorders. For these reasons, careful thought must be given to the selection of these exercises and each member must be in charge of how much or how little she participates.

The assumption implicit within this framework is that physical activities, that is, ice-breakers and warm-ups, are somehow an easy starting point. However, my initial conclusion was that this assumption may have to be turned on its head in respect of clients with bulimia. Johnson (1982) puts forward the view that the developmental principle may need to be re-evaluated for higher functioning client groups, for example people with obsessive neurotic problems. He notes that

> 'Many people operate at higher developmental levels though often in a rigid or stereotyped way, in an attempt to structure their sense of self. But they cling to these structures and are thus threatened by earlier modes of relating, as if they would fall back or be pulled back into a more infantile state. They have lost access to these earlier levels of expression and communication with which they need to make contact before they can proceed further. Here Dramatherapy in a sense should work backwards, supporting the security of the person's self as she expands the range of expression.' (Johnson 1982)

This quotation seems particularly appropriate to clients with bulimia who, in addition to functioning at a higher level, are often out of touch with and deeply afraid of both the body and the inner child. Consequently, a different starting point, which did not initially focus on the use of movement based warm-ups, was selected for the following group.

Group journey structure

I was originally introduced to the six piece structure of story-making or bibliography by Dr. Ofra Ayalon, colleague of Dr. Mooli Lahad in a workshop at Derby University, Summer 1991. The notion of a metaphorical group journey is well documented in dramatherapy literature (Lahad 1992, p.157, Gersie 1990, 1992 Jennings 1987, p.13, Jennings and Minde 1993, p.172). My initial motivation for using this structure was twofold: as a tool to increase commitment between members, and to focus the group process around change. I also anticipated that, by introducing a fantasy element early in the life of the group, images and symbols could be introduced and worked with. In the dramatherapy literature the point is made that, by using a journey, 'a paradoxical structure is created whereby people are brought closer to their life experience by being distanced from it' (Jennings and Minde 1993 p.182). In addition, the story our group were to create illustrates the point that this type of journey often has a mythic structure.

Application of the group journey structure

I used the group journey structure as a basis for work in a ten-week group for seven women with bulimia. The very short length of the group was dictated by university holidays, as a larger proportion than usual of the group were students. The theme was introduced in the context of a discussion of group commitment and of journeys and the repercussions should fellow-travellers leave an actual journey without explanation. The notion of the group's starting point and direction was developed by means of a guided fantasy on this theme. Each member was given a large sheet of paper which was folded, but not cut, into six squares. The six squares were identified in terms of the key features of the guided fantasy as follows: that each story/journey has a starting place and central character; an item taken on the journey for practical or personal reasons; an environment to be crossed; an obstacle to be overcome; how the obstacle was overcome; and a final destination.

Prior to the guided fantasy, we did some deep breathing exercises which members found difficult but beneficial. Afterwards each person filled in the six squares according to the contents of their fantasy and then individual stories were shared. A group story was created by combining elements from each individual story. The story, shared with permission of the group, fell into three sections and is included in the text, followed by a description of how I structured creative drama around various elements of the story. The

creation of a story, in itself brought the group closer together and created feelings of release and elation.

1. *The train station drama and the pile of rubbish (weeks 2–4)*

> Each individual started the journey alone on a railway station. The station is built on a pile of rubbish and everywhere is completely covered in litter. Someone is in the lavatory with her head down the toilet. We can get on the train at any time; it is up to us. We took with us family and friends and left the rubbish behind.

In the week following the creation of the story I invited members to create the beginning scene of the story. I watched (in some amazement) as rubbish bins were emptied, paper venomously torn and screwed up and a great deal of energy was put into creating a pile of rubbish in the corner of the room. The train was depicted by means of chairs and this, too, was strewn with litter and empty cans. Members were asked to position themselves in terms of their own starting point for the journey. I anticipated that most members would be on the train and the task of the session would be to explore feelings around 'leaving an eating disorder behind'. However, the reality was that there was an uncomfortable split in the group, with some members on the train, some on the platform and one sitting on the pile of rubbish. The scene was brought to life but it was not possible to resolve it at this stage. In the processing that followed, it became apparent that all the group had found the scene powerful and for some it had 'touched a raw nerve'. A collective group image emerged of a jar with a screw down lid with contents which suddenly popped out, which were understood to represent powerful feelings in the group. We discussed what the train represented and all agreed that it was a symbol of motivation and willingness to face the eating problem and make the journey. The group began to see that although they would all like to be together, maybe they were at different stages of readiness to tackle the problem.

The following week's session focused on the idea of rubbish and what this meant for each person. Each member was asked to draw their image of rubbish and how it was contained, prior to expressing this through the body. Some members found the exercise difficult, saying that rubbish could not be drawn or represented as 'rubbish is inside me and I am the rubbish'. This alerted me to the importance of further work on 'externalization of feeling through movement, physical expression and accompanying imagery' (Stanton Jones 1992, p.209), an important theme for clients with bulimia.

2. Facing the monster (weeks 5–7)

> In the middle stage of the journey the terrain is hard-going, covered with enormous boulders. We keep trying to get up but never succeed. An enormous monster appears over the horizon and it requires the whole group standing on each other's shoulders to overcome it. We overcome the monster and rest at the oasis, a peaceful blue pool of water.

Prior to beginning work on the middle stage of the journey we spent one week on sculpting 'My Life as it is Now', using buttons. Themes of problematic relationships with mothers, fathers, husbands, boyfriends and also abuse emerged. A predominant theme for this group was unresolved feelings regarding the effects of parental divorce. Remaining true to the story, we did some preparatory drama work on climbing boulders and asking a partner for support if needed in order to get up. This work was essential to establish trust and cohesion in the group prior to facing the monster. Each member was asked to identify what the monster meant for her. Monsters were identified as abusers and absent fathers, as well as 'the monster in me' or the bad side of the self. One member held a lot of anger about her father. She had adored him when young but 'when he divorced mother, he divorced the whole family'. This member had 'act hunger' and a scene was enacted where she confronted her father with the feelings.[8] In subsequent weeks feelings were explored regarding how a member felt about a man who had abused her, and we looked at how members experienced the sides of the self.

Remembering the place of safety at the blue pool, each session was ended with relaxation, deep breathing, music, or a winding down activity.

3. The exit from the maze (weeks 8–10)

> We have been in a dark maze for as long as we can remember. Suddenly it begins to get lighter and we see the exit. W are hurrying towards the exit, getting quicker and quicker. There is a roar of cheers and everyone is clapping as we emerge. Each one of us is doing exactly what we want, dancing and laughing, and there are spotlights on us. We each feel OK and we have a feeling of belonging.

The work in the final three weeks of the group again took its lead from the story. Movement and dance was introduced into the group as the main

8 Act hunger is a psychodramatic term which implies a drive towards fulfilment of 'desires and impulses at the core of the self'. See Blatner H. (1973) p.68 for a discussion of this point.

warm-up activity, which raised many issues related to touch, early experience of parenting and sexuality. Themes from the middle section of the group were picked up, relating to how members saw themselves split into sides, a coping side and a negative angry side. Masks were used to identify characters associated with these two sides of the self and work was done on trying to initiate a dialogue, negotiation or middle position. These two extremes also represent the dichotomy between bingeing and purging behaviour. The focus of the work was on integrating these splits, deciding or rehearsing how to handle situations on a reality level and increasing self-assertion and coping strategies. We did a final sculpt related to each member's progress and final position in terms of the journey. Members placed themselves at various stages on the journey ranging from 'finally ready to get on the train after struggling to free myself from my anorexic side' to 'having completed the whole journey, I feel ready to take my bow with the spotlight on me'.

Evaluation

The group was led within the group-journey structure and the reader may be struck by the richness of symbolism and metaphor contained in the story. On this occasion the group were able to relate to such imagery, that is the train to relate to motivation, rubbish to represent what needs to be left behind, the monster to represent a feared person or object and the exit from the maze to represent a way out of cyclical preoccupations. The story in fact contained some powerful and core issues in working with clients with eating disorders and was used as a creative vehicle to explore such themes.

The group story had provided a coherent framework for the group and a framework that all members could understand, not only the therapist. The story was precious to the members and something over which they all had ownership. Furthermore, members appeared to live parts of the story between the weekly sessions, reporting back that they had seen themselves in relation to an aspect of the story. The story provided a shape and several reference points for the group. However, on the basis of experience with subsequent groups, it is not always possible to move quickly towards a shared group story, without losing too much of the individuality of the separate stories. Certain clients with tendencies to concrete thinking have difficulty with the use of the imagination and therefore find it difficult to relate to the fantasy ideas. One possibility which I have not yet explored is to structure the group journey specifically around the theme of a personal journey of healing from an eating disorder.

An advantage of this approach is that clients were able to move into imaginative drama work with very little preparation, and to work creatively with imagery and metaphor. The story structure provided a protective element, enabling members to work on frightening themes, for example confronting a monster, without necessarily identifying all aspects of their personal monster. In the previous group, drama work had usually been reality-based whereas in this group, where there was a stronger emphasis on the use of fantasy and metaphor, creative drama was more easily accessible to all members.

Conclusion

In this chapter, I have discussed therapeutic models in relation to the treatment of eating disorders. I have illustrated how I have used dramatherapy in the context of an integrated group therapy programme for women with bulimia. Owing to limitations of space, I have not discussed some of the difficulties of combining practical and exploratory approaches and the implications of the above for the transference relationship. Neither have I discussed therapeutic outcomes in any detailed way (although this will be the subject of a future study). I have focused on the use of two different dramatherapeutic frameworks; the embodiment–projection–role paradigm and the group journey structure. The two frameworks are not mutually exclusive and I would argue that both have relevance for work with this client group. A developmental model is extremely relevant because of the strong evidence that bulimia, in common with other eating disorders, is linked to both individual and social developmental issues. However, a developmental approach in dramatherapy implies beginning with physically-based drama work. This can be a problematic starting point for clients with bulimia, who have so many difficulties with body-image. The embodiment stage may, in fact, be considered the culmination rather than the starting point for the work. Enabling clients to participate in such work which increases their range of physical and emotional expression is crucial to effect change in both body and self-image, two key areas in work with clients with eating disorders.

The group journey structure was seen as an extremely valuable tool for bringing imagery and metaphor into the group. The effect of this was that members were able to participate in creative drama with minimal preparation. The story structure provided a creative and protective element, allowing members to work through powerful issues in a relatively short space of time. The journey could be adapted specifically to represent 'a symbolic journey of healing from an eating disorder'. Whether this structure is used or not,

such an approach sensitizes one to the use of metaphor in the group. Such imagery, often suggested by members during the session, may provide powerful clues to understanding the group process and invaluable pointers for the development of creative work.

Although the two frameworks can inform how a dramatherapy group for this client is structured, because of the therapeutic nature of the work, each group will be different. There can be no definitive blueprint for how such a group should be led. However, one possibility is that early sessions can be used as a diagnostic phase including the use of life-maps and small object sculpts, as well as an assessment of members' preferred working methods. The therapists could make a formulation about the key themes and aims for both individuals and the group as a whole, after the first two or three weeks. The formulation could be shared with the group and, on the basis of this, a flexible outline of what issues will be covered, negotiated and clarified.

The model of groupwork I have described is short-term and, as such, shares many common features with brief therapy interventions.[9] Most important, I would emphasize the need for the therapist to take an active and facilitative role and to maximize client involvement within the programme. It is also important to establish clear, realistic and limited aims and to maintain a positive and hopeful atmosphere in the group. A positive therapeutic alliance is essential to the work.

Groupwork with women with bulimia uniquely combines personal, familial and social issues. Dramatherapy has enormous potential to address these and a multiplicity of related themes. It provides a creative vehicle for the exploration of both individual and social roles, body and self-image. Dramatherapy, with its strong links with the cultural and the theatrical, is ideally placed as a therapy to explore the interface of personal and political issues which surround what is now understood to be a largely culture-bound syndrome. Body-image disturbance and body-disparagement can be largely understood as resulting from the pervasive pressure to conform to negative and unrealistic female role models, for example Superwaif and Superwoman. Dramatherapy has the fictional world and the world of scripted and unscripted drama at its disposal to explore such themes, leading to an extremely versatile and flexible approach. However, the very flexibility of the approach should not compromise a clear focus for therapy. This is essential if aims and goals of therapy are to be achieved leading to positive outcomes from the therapeutic intervention.

9 See Koss and Butcher in Research on Brief Psychotherapy in *Handbook of Psychotherapy and Behaviour Change*, Chapter 14, pp.662 & 663.

Currently, a multi-dimensional approach to eating disorders which focuses on both developmental issues and societal values is recommended.[10] Creative and arts-based therapeutic approaches are ideally placed to respond to the challenge of providing accessible, non-stigmatized but effective therapy for increasingly common disorders which are inextricably linked with contemporary cultural and social values.

Acknowledgements

I would like to express my thanks to the following people who have either influenced or supported me with this project:

Dr Sue Jennings and Mary Levens, practitioners, Noelle Leyshon, O.T. and Carole Birkett, O.T., co-therapists, Sue Bateman, Dramatherapist and Sarah Cook, Lecturer, for supervision, and Rosemary Lawson, Val Barley, Dr. Tim Kendall and Geraldine Shipton. I also thank all group members both past and present who have both shared and taught me so much and the staff at Nether Edge Psychiatric Out-Patients Department, Sheffield for their supportive approach. Thank you to Andrea Long and Bridget Strong for typing the manuscript and to all members of my family for support.

References

Bannister, A. (1989) The effects of Child Sexual Abuse on Body and Image, *Journal of British Association for Dramatherapists, 12,* 1.

Blatner, H.A. (1973) *Acting-In. Applications of Psychodramatic Methods.* New York: Springer.

Callahan, M.L. (1989) 'Psychodrama and the treatment of bulimia.' In L. Hornyak and E. Baker (eds) *Experiential Therapies for Eating Disorders.*

Chernin, K. (1986) *Women. Eating and Identity.* London: Virago.

Cooper, P.J. (1993) *Bulimia Nervosa. A Guide to Recovery.* London: Robinson.

D.S.M. III R. (1987) *Diagnostic and Statistical Manual of Mental Disorders 1987.* Revised edition Washington DC: American Psychiatric Association.

Dana, M. (1987) Boundaries: one-way mirror to the self. In M, Lawrence (ed) *Fed Up and Hungry, Women, Oppression and Food.* London: The Women's Press.

Dolan, B.M. (1991) Cross cultural aspects of anorexia nervosa and bulimia nervosa: a review, *International Journal of Eating Disorders, 10*(1), 67–69.

Ernst, S. and Goodison, L. (1981) *In Our Own Hands. A Book of Self-Help Therapy.* London: The Women's Press.

Fairburn, C.G., Jones, R., Perder, R.C., Carr, S.J., Solomon, R.A., O'Conner, M.E., Burton, J. and Hope, R.A. (1991) Three Psychological Treatments for Bulimia Nervosa, *Archives of General Psychiatry,* 48, May.

10 see Newton T, (1993) Editorial, *Eating Disorders and Medical Education.* – Vol 1 – No3 p142

French, B. (1987) *Coping with Bulimia*. Northamptonshire: Thorsons.

Garner, D.M., Rockett, W., Davis, R., Garner, M.V., Olmstead, M.P. and Eagle, M. (1993) Comparison of Cognitive Behavioural and Supportive Expressive Therapy for Bulimia Nervosa, *American Journal Psychiatry*, 150, 1.

Gersie, A. (1990) *Storymaking in Education and Therapy*. London: Jessica Kingsley Publishers.

Gersie, A. (1992) *Earthtales: Storytelling in Times of Change*. London: Green Print.

Hornyak, L. and Baker, E. (eds) (1989) *Experiential Therapies for Eating Disorders*. New York: Guilford Press.

Jennings, S. (1983) Models of Practice in Dramatherapy, *Journal of British Association for Dramatherapists*, 7, 1.

Jennings, S. (1986) *Creative Drama in Groupwork*. London: Winslow Press.

Jennings, S. (1992) *Dramatherapy, Theory and Practice 2*. London: Routledge.

Jennings, S. (1993) An Operating Theatre of Healing? *Journal of British Association for Dramatherapists*, 14, 2.

Jennings, S. (ed) (1987) *Dramatherapy, Theory and Practice for Teachers and Clinicians*. London: Croom Helm Ltd.

Jennings, S. and Minde, A. (1993) *Art Therapy and Dramatherapy – Masks of the Soul*. London: Jessica Kingsley Publishers.

Johnson, D.R. (1982) Developmental Approaches in Dramatherapy, *Arts in Psychotherapy*, 9, 183–189.

Koss, M. and Butcher, J. 'Research on brief psychotherapy.' In S, Garfield and A. Bergin. *Handbook of Psychotherapy and Behaviour Change*. New York: John Wiley and Sons.

Lacey, J.H. (1983) Binge Eating Psychological Vomiting – A Controlled Treatment Trial and Long Term Outcome, *British Medical Journal*, May.

Lacey, J.H. (1986) An Integrated Behavioural and Psychodynamic Approach to the Treatment of Bulimia, *Journal Review of Bulimia and Anorexia Nervosa*, 1, 19–26.

Lahad, M. (1992) 'Story-making in assessment method for coping with stress.' In S. Jennings (ed) *Dramatherapy Theory and Practice 2*. London: Routledge.

Lawrence, M. (ed) (1987) *Fed Up and Hungry: Women Oppression and Food*. London: Women's Press.

Newton, T. (1993) Editorial. *European Eating Disorders Review*, 1, 3, Dec.

Orbach, S. (1986) *Hunger Strike: The Anorexic's Struggle as a Metaphor for our Age*. London: Penguin Books.

Root, M.P.P. (1989) 'Family sculpting with bulimic families.' In L. Hornyak and E. Baker *op. cit.*

Russell, G.F.M. (1979) Bulimia Nervosa – an ominous variant of anorexia nervosa, *Psychological Medicine*, 9, 429–448.

Schmidt, U. and Treasure, J. (1993) *Getting Better Bit(e) by Bit(e)*. Hove: Lawrence Erlbaum Associates.

Stanton-Jones, K. (1992) *An Introduction to Dance Movement Therapy in Psychiatry.* London: Tavistock Routledge.

Stark, A., Aronow, S. and McGeehan, T.O. (1989) 'Dance/movement therapy with bulimic patients.' In L, Hornyak and E. Baker (eds) *Experiential Therapies for Eating Disorders.* New York: Guilford Press.

Yellowlees, A.J. (1992) Eating Disorders – A Crisis of Self Esteem, *Holisitc Health,* Autumn.

The Use of Dramatherapy in the Treatment of Eating Disorders
A Developing Dutch Method

Astrid Jacobse

Introduction

This chapter describes a developing Dutch method in the treatment of anorexia nervosa and bulimia nervosa patients. First, the perception of dramatherapy in the Netherlands is described, followed by the work situation of the author at the University Hospital of Utrecht, where dramatherapy is one of the elements in the multidisciplinary treatment of anorexia nervosa and bulimia nervosa. Subsequently, a theoretical framework comprising the four basic elements of dramatherapy is presented, and the general observations with anorexia nervosa and bulimia nervosa patients are described. The observations concerning eating-disorder patients are summarized in a table. Then, a concrete dramatherapy task is presented, with the observations of an anorexia nervosa patient performing this task. After discussing these observations, general recommendations for dramatherapy with anorexia nervosa patients are given. A second dramatherapy task is used to illustrate the observations in bulimia nervosa patients, and to formulate general recommendations for this patient group. The chapter concludes with a description of the possibilities and advantages of using groups comprising both anorexia nervosa and bulimia nervosa patients in dramatherapy.

Throughout the paper, patients will be referred to as 'she', because about ten times as many women than men suffer from eating disorders.

Dramatherapy in the Netherlands

In the Netherlands, dramatherapy, music therapy and art therapy are the three specialisms of creative therapy, for which the umbrella organization is the Dutch Society of Creative Therapy. New and developing specialisms within creative therapy are garden therapy and dance therapy, but these have not yet been recognized by the Dutch Society of Creative Therapy. There are four institutes for creative therapy in the Netherlands.

The Dutch Society for Creative Therapy defines drama therapy as follows: 'The objective in drama therapy is to establish processes of change and acceptance in the client by means of a treatment, directed at the individuality of the client, and using drama materials' (NVKT 1989). Central in this definition is the medium of drama.

Dramatherapy is a therapeutic method based on different psychotherapeutic theories, such as gestalt therapy, creative-process theory, social-system therapy and client-centred therapy (Cimmermans 1993). Creative-process theory can be used by all four specializations of creative therapy, and forms a particularly important part of the training programme in all four Dutch institutes. In this theory, a creative process is described as 'a process which enables somebody to extricate himself from the rigid relationships with his environment, and to develop new and significant relationships with his environment by active involvement' (Smitskamp 1988). In order to enable this creative process to occur, two conditions have to be met:

1. Cues should suit the needs of the individual patient.

2. The environment should be emotionally secure to enable the client to respond to cues.

The multi-disciplinary team approach

The University Hospital of Utrecht has a specialized unit for the treatment of bulimia nervosa and anorexia nervosa. The units for inpatient and day-patient treatment have mixed treatment groups, comprising both patients with bulimia nervosa and patients with anorexia nervosa. However, in addition, there is one day-patient treatment group with only bulimia nervosa patients.

A multidisciplinary team approach for the treatment of anorexia nervosa and bulimia nervosa is indicated, because of the very specific and complex needs of these patients. This multidisciplinary approach combines the treatment of cognitive distortions, misperception of body image and abnormal eating habits, and consists of the following elements: cognitive behav-

ioural treatment (e.g. monitoring behaviour, planning of weekend) and verbal and non-verbal group psychotherapy (Hoek 1993).

As one of the non-verbal group psychotherapies, dramatherapy is part of the treatment package provided by the multidisciplinary team for different wards of the hospital. Weekly, patients have 75 minutes of dramatherapy.

In anorexia nervosa and bulimia nervosa, patients have a negative body image and a feeling of inferiority about their ideas and feelings (Bruch 1978). Often, this negative self-image already shows at the first dramatherapy session. Dramatherapy concerns the individual as a whole. Because a negative body image is a part of a negative self-image, dramatherapy can offer a lot of possibilities for the treatment of anorexia nervosa and bulimia nervosa: in anorexia nervosa and bulimia nervosa, patients tend to divide their body from their head; in other words, they do not consider themselves as a whole. Some anorexia nervosa patients even believe that they only exist of a head. Dramatherapy does not support this division between head and body, but concentrates on the patient as a whole. This may explain the resistance against dramatherapy in patients with anorexia nervosa and bulimia nervosa.

A framework for dramatherapy

In dramatherapy, patients are confronted with their problems by playing fictitious scenes. The dramatherapist chooses the working method and setting, according to the development of the patients. The patients generally decide on the concrete subject matters. A framework consisting of four basic elements of dramatherapy is used to describe the development of the patients, and thus to help to choose the working method (Jacobse 1993). The different aspects of behaviour – emotions, cognitions and transactions – might come out within each element of the framework, depending on the working method and the scene chosen.

The framework comprises the following four elements.

1. acting as such

2. means of communicating

3. role choice

4. functioning in the group.

All elements are inherent to group dramatherapy. *Acting as such* is the first element of the framework. Five basic stages of coming to *acting* are distinguished, which should be mastered to some extent before somebody can truly benefit from dramatherapy. Therefore, a progression through these five stages has to dominate the beginning of treatment. The *means of communicating*

refers to the possibilities and limitations that each individual has in communicating, and thus in acting. In dramatherapy the means of communicating should be recognized and, where possible, extended. The latter two elements of dramatherapy, *role choice* and *functioning in the group* are elements of social interaction. Dramatherapy can help to recognize patterns in social behaviour and provides an access point to changing them, where required.

In the following, each of the elements of drama therapy are described, as well as the general observations in anorexia-nervosa and bulimia-nervosa patients.

1. Acting as such

The author distinguishes five aspects, describing the stages in the process of coming to acting:

(i) to be on stage

(ii) expression

(iii) sculpting

(iv) imagination

(v) emotional involvement.

(I) TO BE ON STAGE

Patients act on a play area which is well marked out, using, for example, lighting or a stage, to distinguish acting from reality. By entering the play area, the patient attracts attention, and literally and figuratively, comes 'into the spotlight'. Thus, being on stage emphasizes the presence of the patient and increases her approachability.

> Anorexia nervosa patients who are gaining weight are increasingly dissatisfied with their body, as a result of which it becomes more difficult for them to be on stage. They interpret the fact that the group members are looking at them as a sign that they are not beautiful. Hence, being on stage confirms their negative self-image. In the debriefing, the patients tend to give rational explanations for their acting.

> Bulimia nervosa patients often have little self-confidence and consider themselves not interesting enough to appear on stage. They will only step into the spotlight because they are asked to. The patients are insecure about their acting and will explain in detail what they acted in the debriefing.

(II) EXPRESSION

Expression refers to the ability to show emotions or a way of thinking, and especially to show these spontaneously. People can express themselves verbally or non-verbally. In dramatherapy the emphasis is on non-verbal expressions, on action, although verbal expressions are not excluded.

Patients with eating disorders prefer verbal to non-verbal expressions; the latter are experienced as more frightening.

> In anorexia nervosa patients a division is seen between head and body; some patients even state that they consist only of a head. This division is a hindrance for non-verbal expression, which involves the person as a whole. Anorexia nervosa patients use measured words for their expressions. They make high demands of themselves, which inhibits them from being spontaneous.

> Patients with bulimia nervosa let their expressions be subject to what others will think about it. Often they are afraid of taking too much space. Their negative self-image inhibits them from responding to first impulses. They find it difficult to express their emotions, especially feelings of anger and fear, which make them feel more vulnerable. This is related to the fear of losing the other.

(III) SCULPTING

Sculpting refers to articulation, giving shape to, or developing a shape for feelings and thoughts. Sculpting can be done verbally and non-verbally.

> Anorexia nervosa and bulimia nervosa patients generally prefer to use language, and find it very threatening to use their body for sculpting.

> Anorexia nervosa patients keep the shape of their body tight and small by starvation. In dramatherapy a similar tendency is observed: tight and small shapes are chosen for sculpting. Anorexia nervosa patients spend little time on stage; they do not move much, they talk softly, and they hardly use their fantasy. In general, anorexia nervosa patients use very precise and unambiguous sculpting.

> Patients with bulimia nervosa prefer to use shapeless material, and use the material in a very flexible way: anything could be everything, and can easily change to anything else. Forms may disappear or change just as suddenly as they were introduced. As a result of this, bulimia nervosa patients tend to 'melt' into situations and roles. Furthermore, they are very insecure about their sculpting and often look for reassurance from the group.

(IV) IMAGINATION

In order to establish reciprocity of communication, it is important that somebody can imagine a situation, that somebody can put herself into someone else's shoes. In this paper, the term *imagination* refers especially to the level of cognitions and actions; thus, one can imagine a part, environment, time or situation. Imagination implies leaving day-to-day reality, which might result in loss of control. The less familiar the situation, the more difficult it will be to keep control. This is very frightening for some patients, and they might even try to avoid such situations. Therefore, to allow a patient to enter into a role, it is important that this role provides enough safety. If a patient is able to enter into a certain role, the therapist can ask her to select another role in the same scenery to invite her to new expression and sculpting.

> Patients with anorexia nervosa prefer well-known situations because of their fear of losing control.

> Patients with bulimia nervosa are either restrained if boundaries between imagination and reality weaken, or transfer too easily and too completely in their roles.

(V) EMOTIONAL INVOLVEMENT

Emotional involvement with a part allows a patient to get in touch with emotional and behavioural aspects which are less familiar to her. To become emotionally involved, the patient has to allow herself to experience new or unconscious feelings. Such inner movement (the emotion) influences the external movements (action and behaviour). Becoming emotionally involved is a very slow process. Emotional involvement, like imagination, brings the patient to a less controllable situation. This is well described by Stanislavski (1985) in his book *An Actor Prepares*, in which a very precise psychological analysis of the different roles in drama is presented. Stanislavski had a natural way of acting in view and stressed the importance of the 'inner creative state':

> They draw life from the fiction which is the play and make it seem more real, its objectives better founded. All this helps them to feel the role, its innate truthfulness, to believe in the actual possibility of what is happening on the stage. In other words, this triumvirate of inner forces takes on the tone, colour, shadings and moods of the elements they command. They absorb their spiritual content. They also give out energy, power, will, emotion and thought. They graft these living particles of the role onto the 'elements'. From these grafts there gradually grow what we call the 'elements of the artist in the role'.

Patients with eating disorders find it difficult to enter emotionally into a part, because keeping control forms part of their coping strategy. Therefore, with these patients it is important to provide enough safety to allow them to let go of their control. Emotional involvement is difficult to achieve; it asks a lot from the patients. Often it is reached only in the final part of their treatment. Patients need to have the courage to be in the spotlight and feel free to express themselves and to sculpt their thoughts and feelings. These appear to be preconditions for actual imagination and emotional involvement in new and less familiar situations.

Patients with anorexia nervosa and bulimia nervosa both have problems with getting emotionally involved in a role; however, this problem has a different origin in the two groups. In anorexia nervosa patients, getting emotionally involved is inhibited by the fear of losing control. To overcome this fear, they have to learn to start a dialogue with their roles, and they should aim at an extension of their role repertoire. In contrast, bulimia nervosa patients are inclined to 'melt into their role', and should learn to avoid this. Therefore, bulimia nervosa patients should rather aim at giving more depth to a small number of roles.

The first three aspects of acting: *to be on stage*, *expression* and *sculpting* go hand in hand with one other. When somebody is on stage, she will have to express and sculpt her feelings and thoughts, even if these are – for example – feelings of hesitation or embarrassment related to being in the spotlight; everything presented on stage has an intention that might be expressed, restrained, or covered up. *To be on stage*, and to *express* and *sculpt* feelings and thoughts demand confidence (Jacobse 1994). The latter two aspects of acting (*transference* and *imagination*) demand flexibility, as well as the ability to let go.

The aspects of *acting* will dominate in the beginning of treatment. Patients initially have to get used to acting as such: to *being on stage*, to *expressing* themselves, to *sculpting* (giving form), and to putting themselves in somebody's place (*imagination* and *emotional involvement*). A patient who is not familiar with acting as such, will be restricted in *communicating* (for example, the use of the voice) or in her *role choice*.

2. Means of communicating

The means of communicating refers to the technical means that an individual patient has available for communicating, and thus for acting: her voice, language, posture, mimetic art, movement and perception. These aspects

influence the total action (external movement), and allow the patients to differentiate in their roles. An individual's performance depends on the arrangement of aspects such as timing, tension, dynamics, and the use of fantasy, concentration and creativity. When playing different characters and situations, the patients are encouraged to vary in using these aspects, and encouraged to develop their flexibility. In dramatherapy, patients can explore their specific limitations and increase their communicative possibilities.

> Patients with eating disorders generally make little use of the oppor-tunities of voice, movements and facial expression for communicating: their means of communicating appear to be limited. As a result of this, there is little differentiation in their acting or in the different roles they play.

3. Role choice

The dramatherapist should try to recognize patterns in role choices and the motives behind such pattern. Role choice refers not only to the part somebody plays in the scene, but also to the position somebody takes with the parts that she plays. In this context, it is relevant to evaluate the patient's role repertoire, the way a patient selects a role and the grounds for this choice. During dramatherapy the role repertoire should gradually be extended.

At the beginning of the treatment, especially when the patients are unfamiliar with drama, they should be encouraged to play roles in which they feel comfortable, because such roles will enable them to get used to *being on stage* and to learning to *express* themselves. Most patients who start dramatherapy choose the more familiar roles spontaneously, as they try to hold on to situations or roles they recognize or know. Therefore, patients should be encouraged to select their own roles.

> Eating disorder patients who have just started dramatherapy, some-times show deviant behaviour by selecting roles with which they do not feel comfortable at all, especially roles in which they have to expose their bodies. They might, for instance, choose to play a whore, a photographer's model or a mannequin. The patient usually intends to please the therapist with this role choice, thus, the role choice may have its root in fear of rejection and perfectionism. When playing such uncomfortable roles, the patients have to switch off their feelings, which can be observed from their mechanical way of acting and the total absence of emotional involvement: 'They act as if their body and behaviour were a product of other people's influences and actions' (Bruch, 1973, p.55). They might cross their boundaries to such extend

that in the debriefing they are unable to recall what they have just played, as if they suffer from a black-out. Their perfectionism, their wish to please the therapist, their aim to avoid conflicts, and their fear of rejection, have overruled their need to observe their own boundaries and limitations.

Patients with anorexia nervosa or bulimia nervosa generally have difficulties in creating their own role. This may be related to their family background. The families of the patients are often characterized by strong solidarity of the family members with each other. Often, the boundaries within these families are weak, overt leadership is lacking, and a positive attitude is observed towards sacrificing individuality for the purpose of preventing family problems (Vandereycken *et al.* 1989).

4. Functioning in the group

The functioning of a patient in the group refers to her role and position in the dramatherapy group, and the function and consequences of this role for the group; in individual dramatherapy this element can be seen as the interaction between patient and therapist. The dramatherapist should recognize these interactions and respond to them.

The function somebody has in the group is related to the *role choice* in the scene. The scene to play and the roles are generally chosen by the patients during a discussion preceding the play. The position of a patient in the group will be one of the factors determining the choices made in this preparatory discussion. For example, somebody who acts as leader by providing the group with ideas and summarising the outlines for the scene, will usually play the leading role in the scene as well. Thus, the role played in the scene is often a reflection of the role somebody has in the preparatory discussion. In dramatherapy it is important to take these group processes into account and respond to them; if the functioning of a patient in the group changes, her *role choice* might change as well.

The group-process can be controlled in different ways, depending on the group members and the view of the ward. The position of patients in the group should be one of the topics in the preparatory discussions of a scene or in the debriefing. This point can be raised by the therapist, but the therapist can also stimulate the patients to make each other aware of these interactive processes. If patients become more aware of the processes involved in the distribution of the roles, they can learn to choose more consciously and broaden their repertoire. Furthermore, if patients start alerting each other

on these processes, they also work on their functioning in the group and broaden their real-life roles.

> Patients with anorexia nervosa often take positions which allow them to keep control. They like to be loved, and they care and feel responsible for everybody. Bulimia nervosa patients also like to be loved. They tend to adapt to the others.

In the table on the next page, the general observations of anorexia nervosa and bulimia nervosa patients are summarized, following each of the elements of the framework for dramatherapy. The table can help to explain the differences in acting between these two patient groups, and provides suggestions for working methods and tasks which could be used in dramatherapy with eating-disorder patients.

Summary of general observations in dramatherapy with anorexia nervosa and bulimia nervosa patients.

Element	Anorexia nervosa patient	Bulimia nervosa patient
1. *Acting as such*		
a. to be on stage	• prefers to be invisible • is on stage as little as possible or covered up as much as possible • has a negative self-image • explains in debriefing why she acted the way she did	• is on stage because it is being asked • takes either a central position or not • has a negative self-image • explains in debriefing what she acted
b. expression	• strongly prefers verbal expression • head and body are divided • ignores first impulses, because of her strong need to keep control • has difficulty with expressing anger	• shows little expression, because she dislikes her ideas and is afraid to be overrun by ideas • is restrained by fear of taking to much space • has difficulty with expressing anger

c. sculpting	• uses small, rigid and univocal forms • is over-articulated • looks for reassurance • sets great store by appearance • is very precise	• prefers shapeless material • articulates little or not at all • looks for reassurance • is hardly differentiated
d. imagination	• prefers well known situations	• is either restrained if boundaries between imagination and reality weaken, or transfers too easily and too completely in her role
e. emotional involvement	• is restrained by fear of losing control • acts without being in touch with her feelings	• is restrained by fear of 'melting into her role'
2. Means of communicating	• uses little movements • talks much but softly	• varies little in movement and voice-work
3. Role choice	• prefers a central position, guaranteeing her to keep an overview and to stay in control • chooses caring roles • avoids conflicts • is not flexible in her role choice	• prefers roles to which she can adapt easily • tries to please others with her role choice • avoids conflicts • is flexible in her role choice
4. Functioning in the group	• takes charge in order to stay in control • takes responsibilities • likes to be loved • cares for everybody	• contributes little, because of fear of taking too much space • adapts to the group • likes to be loved • takes everybody into account

From observation to specific recommendations

In this section, the observations in an anorexia nervosa patient and in a bulimia nervosa patient are described, taking two specific dramatherapy tasks as an example. A connection is made with characteristic themes in both patient groups, and recommendations for dramatherapy with anorexia nervosa and bulimia nervosa patients are given.

Anorexia nervosa

Anorexia nervosa patients are characterized by their need to be in control. They will try hard to take the lead in the preparatory discussions of dramatherapy scenes, and during the scene they might even leave their roles to act as a director. Generally, they either take a central position or are almost invisible during the scene. In their attempts to play their roles as perfectly as possible, they may eliminate their feelings. In the debriefing, they tend to explain their acting in a very rational way, leaving little or no space for their experiences and feelings. This has been described by Hall (1985): 'The implication is always that feelings must be avoided rather than experienced and increasingly coped with.'

THE TASK

The patients are asked to select a certain type of family (Jacobse, 1993) and to choose a role in that family. The task is to play a dinner setting. In this example, the group has selected a 'Dynasty'-type family. The anorexia nervosa patient described below chose the role of the mother.

THE OBSERVATION

The dinner table is situated exactly in the middle of the stage. Mother is laying the table, arranging the knives and forks very neatly, dusting the plates before placing them on the table, and folding all the napkins in exactly the same way. She continues her work while the other family members, father, daughter and son, appear on stage. When the whole family is seated, mother puts much effort in keeping the family together: she sighs when father gets up. She helps her daughter to make a decision on a suitable evening dress, meanwhile keeping an eye on father, who is on the 'phone. In addition, she imparts some table manners to her son. When father has finished his telephone conversation, mother asks him for money to join the weight-watchers.

In the debriefing, the patient explains to the observers what she has just acted.

DISCUSSION

This example illustrates acting by anorexia nervosa patients very well. By selecting the role of mother in the scene, the patient takes a position in which she can care for the others. She keeps control of the scene by being the first character on stage: this enables her to choose freely where she wants to sit. Her position, at the head of the table, enables her to see the others entering the scene, which again helps her to keep control over the situation. Further-more, being seated at this position makes the lower part of her body invisible

for the observers. She bends the scenery to her will. The materials used for the scenery are unambiguous: table, cutlery and napkins are represented by a real table, real cutlery and real napkins. She lays the table methodically, almost compulsively. In this way, she can initially avoid contact with the other players and keep control of her own role. As mother she is the key figure who keeps everybody together. She tries to comfort everybody, probably because of fear of being rejected. Her wish to join the weight-watchers is related to her preoccupation with eating and losing weight. In the debriefing, the patient rationalizes her experiences.

RECOMMENDATIONS

1. The time available for the preparatory discussion should be limited, and the preparatory discussion should include the beginning, the middle and the ending of the scene. Too much detail should be avoided, to encourage patients to act spontaneously. If too much time is spent on the preparatory discussion, acting is postponed and the resistance to acting increases.

2. When setting the scene, attention should be paid to the participation of each individual patient. Anorexia nervosa patients need to learn to balance their contribution over the course of the scene: roles and stories do not have to be clear from the first minute onwards; they should rather develop during the scene.

3. All patients should be involved in the distribution of the roles; in this discussion the patients can learn to negotiate.

4. If a patient develops her role, she should be made aware of the different aspects and possibilities of this role. For example, a mother not only looks after and cares for the other family members, but she also has her own feelings, emotions, interests, hobbies, etc.

5. Patients with anorexia nervosa prefer roles in which they can keep control, nurture, rule, efface themselves, have a good appearance, be business like, precise, well-arranged and distant. In particular, the therapist should be aware of their tendency to perfectionism, and the choice of roles in which they have to exhibit their body. Patients should be alerted to patterns in their role repertoire, and encouraged to try different roles.

6. The time available for setting the scene should be limited. Anorexia-nervosa patients are inclined to set the scene as realistic as

possible. This is very time consuming, and also limits the use of imagination and fantasy.

7. Voice-work, facial expression, posture and movement should match the role. This helps the patient to get emotionally involved with the scene, and to differentiate between different roles. The patients suppress their feelings when they are talking a lot; therefore, talking should be restrained in favour of action. Furthermore, the patient might start talking in order to break a painful silence, and thus to help and to care for the others.

8. In their need to keep control, anorexia nervosa patients tend to play solo. Dissociation enables them to keep control over their own role and to safeguard themselves against unexpected situations. They have to learn to develop a role by communicating with the others.

9. In the debriefing, rationalizations should be curbed so that patients can learn to experience their feelings.

Bulimia nervosa

Bulimia nervosa patients are characterized by their inability to set clear boundaries, and by their problem of regulation of impulsive behaviour (Vanderlinden 1989). In dramatherapy a bulimia nervosa patient often will play a role because she was asked to do so; she tends to pay little attention to her own limitations and boundaries. A bulimia nervosa patient generally prefers to work with shapeless material (plastic, textile). The nature of her roles evolve quickly; small influences can change the thread of the story drastically, leading to a divergence from the plans made during the preparatory discussion. When acting, the boundaries between reality and drama become blurred and the bulimia nervosa patient tends to 'melt into her role'. Within the dramatherapy group, she is trying to become popular with the others, by adapting herself to the others.

THE TASK

The patients are asked to construct the wall they experience at this moment, using any material available in the dramatherapy room. Thus, on stage they construct the figurative wall with which they set their boundaries in various situations.

THE OBSERVATION

A bulimia nervosa patient chooses the rack with clothes to symbolize the wall she experiences. The rack contains about forty dresses, varying from evening dresses to police uniforms.

Figure 9.1 by Astrid Jacobse

Figure 9.2 by Astrid Jacobse

The patient uses this wall to protect herself: from behind the rack she carefully observes the passers-by, then she selects the dress suitable for situation and person, and finally she appears on stage.

With one passer-by this patient dresses herself in a fur coat. She feels distance and chilliness towards this person. She uses the fur coat to hide these feelings, because of her fear of rejection.

Figure 9.3 by Astrid Jacobse

When another person passes by, she takes two boas from the rack and wraps them around her neck. She has obtained the impression that this person has problems. The boas are chosen to invite the other to open up, so that she can offer her help.

More people are passing by. The scene with the rack lasts a long time and the patient appears to be unable to terminate the scene. Only with help of the therapist is the scene finished. In the debriefing, the patient recapitulates in detail what she just has played.

DISCUSSION

This example, the scenery and the selection of a rack with clothes to represent the wall, gives a good illustration of dramatherapy with bulimia nervosa patients. A dress is material with a shape; however, by using a rack of dresses as a wall, the patient can change the shape of this wall and her own

appearance continuously. The variety of dresses offers the patient the opportunity to adapt herself to the different situations and different persons. The patient has created a role with many options and different characters, who resemble each other in their tendency to adaptation.

The patient did not terminate the scene herself, and the scene would have continued if the therapist had not interfered. Bulimia nervosa patients lack confidence in acting. In particular, they are insecure about their ability to get their intentions across. This is clearly illustrated by the example, in which the patient continues to play new encounters with people passing her wall. The detailed description and explanation she gave of her part during the debriefing was rooted in this lack of confidence as to whether her acting had been clear.

Furthermore, in the debriefing it appeared that the whole scene was improvized. Although one might appreciate the courage and inspiration needed to act without initial preparation or structure, this way of acting has the big disadvantage that the patient can deny her responsibility for the scene. In the debriefing, the patient used the fact that everything was made up during the scene as an excuse, by saying that everything had just happened to her, and that the scene was out of her control.

RECOMMENDATIONS

1. The scene has to be well prepared and the debriefing should include an evaluation of possible deviations from these plans. Important questions for the debriefing are: 'Did the scene correspond to the initial plans' and, if this was not the case: 'Where did you deviate from your plans and what was the reason of this deviation'. This will urge the patient to take responsibility for acting. Furthermore, it can improve her understanding of her own limitations and difficulties, and show her how to set boundaries.

2. In the preparatory discussion of a scene, attention should be paid to the termination of this scene. Every scene should have of a clear beginning and ending, or, in other words, clear boundaries (the scene presented above has a clear beginning, but lacks a clear ending). Taking responsibility for the termination of a scene gives patients the opportunity to practise setting her boundaries.

3. The therapist should observe carefully how the roles for a scene are divided. Patients should be encouraged to select their own role, because this will urge them to take full responsibility for their way of playing.

4. Each patient should first concentrate on a single role and develop her ideas about this role. Thereafter, the actors can build the scenery together. If this order were reversed, roles might easily be adapted to the scene, which would result in vagueness of roles.

5. The patients should be made aware of patterns in their role repertoire. Bulimia nervosa patients tend to choose roles in which they can be pliable, adapt to others, please everybody, avoid conflicts, take no responsibility, efface themselves, be absent minded, follow the others and be sneaky. Many bulimia nervosa patients are familiar with these characteristics in everyday life. By acting roles with these characteristics, they will confirm and perpetuate this behaviour.

6. In the construction of the scene the materials should be well described, to avoid, for example, a table cloth changing into a curtain during the play.

7. The therapist should observe and respond to technical aspects of communicating. Voices should be loud and easily heard. Furthermore, verbal expressions and sculpting (words and tone) should correspond to body language.

8. The patient should act within her own role as much as possible.

9. In the debriefing, the patient should be curbed if she starts explaining what she played.

Anorexia nervosa and bulimia nervosa patients together in one group

Groups comprising both anorexia nervosa and bulimia nervosa patients offer specific possibilities for drama therapy. From the observations in both patient groups, described earlier in this chapter, it can be seen that these groups show similarities as well as differences. Both patient groups are characterized by a negative self-image, which is reflected in their difficulties with being on stage, expressing themselves and sculpting their feelings and thoughts. Another similarity between these two patient groups is that they do not negotiate; however, their reasons for not negotiating are different: in anorexia nervosa, the roots of this behaviour lies in the fear of losing control, whereas in bulimia nervosa, the underlying problem is the fear of rejection. These characteristics influence all elements of the framework for dramatherapy.

In dramatherapy with eating-disorder patients, an important aim should be that the patients learn to negotiate about roles; furthermore, attention should be paid to the negative self-image. If these aspects are not taken into account appropriately, the behavioural patterns will be reinforced: the

anorexia nervosa patient will continue playing her caring role and try to stay in control, and the bulimia nervosa patient will continue adapting herself to the situation. Patients generally tend to adhere to the behavioural patterns they are familiar with.

The combination of anorexia nervosa and bulimia nervosa patients in a dramatherapy group is especially useful for the dynamics of the group, because of the contrasts between these two patient groups. For example, bulimia nervosa patients prefer to use shapeless material, whereas anorexia nervosa patients prefer to use unambiguous material. Furthermore, the groups have to develop the way they set their boundaries into an opposite direction: anorexia nervosa patients have to learn to set their boundaries less rigidly, and bulimia nervosa patients have to learn to set clearer boundaries. By setting less rigid boundaries, the anorexia nervosa patient will extend her role repertoire. By setting clearer boundaries, the bulimia nervosa patient will learn to avoid 'melting' into her role, the scenery or other actors. These contrasts in particular between the two patient groups, mean that the two groups have a lot to offer to and learn from each other.

Group dramatherapy offers the patients a good opportunity to experiment psychologically and physically – as a whole person – with their newly obtained roles.

Acknowledgement

The author is grateful to Dr. C.J.K. Spaaij for translating this article and for helpful comments.

References

Bruch, H. (1973) *Eating Disorders. Obesity, Anorexia Nervosa and the Person Within.* New York: Basic Books.

Bruch, H. (1978) *The Golden Cage.* Cambridge, Massachusetts: Harvard University Press.

Cimmermans, G. and Boomsluiter, J. (1993) *Handboek Dramatherapie.* Nijmegen: Hogeschool Nijmegen.

Hall, A. (1985) Group psychotherapy for Anorexia Nervosa. In D.M. Garner and P.E. Garfinkel (eds) *Handbook of Psychotherapy for Anorexia Nervosa and Bulimia.* New York: The Guilford Press.

Hoek, H.W. (1993) Groepstherapie bij Bulimia Nervosa, *Tijdschrift voor Psychiatrie,* no.10, p. 702–714.

Jacobse, A. (1993) Spelen tussen de marges, dramatherapie met anorexia- en bulimia-nervosa patiënten, *Nederlands Vereniging voor Kreatieve Therapie Tijdschrift,* no.3, p. 74–81.

Jacobse, A. (1994) Dramatherapie in een groep met anorexia en bulimia nervosa patiënten. *Tijdschrift voor groepspsychotherapie*, in press.

NVKT (Nederlands Vereniging voor Kreatieve Therapie – Dutch Society for Creative Therapy) (1989) Functieomschrijving Dramatherapie, p. 6.

Orbach, S. (1986) *Hunger and Strike, The anorectic's structure as a metaphor for our age.* New York: Avon Books.

Smitskamp, H., te Velde, H. (1988) *Het Kreatief Proces, Toepassingen in therapie en onderwijs.* Culemborg: Phaedon.

Stanislavski, C. (1936) *An actor prepares.* New York: Theatre Arts.

Vandereycken, W., Kog, E. and Vanderlinden, J. (1989) *The family approach to eating disorders: Assessment and Treatment of Anorexia Nervosa and Bulimia.* New York: PMA Publishing corp.

Vanderlinden, J., Norré J. and Vandereycken W. (1989) *Debehandeling van Boulimie, een gids voor de therapeutische praktijk.* Deventer: Van Lochum Slaterus.

Experiential Training for Staff Working with Eating Disorders

Linda Winn

The training workshops described in this chapter arose due to the increase in demand for therapists to work with people eating disorders. Many practitioners who find this client group challenging wished to increase their understanding of the issues involved and consequently their effectiveness as therapists.

In addition to being aware of the aetiology and symptomology described in the introductory chapter, it is necessary for the therapist to develop an insight into their own attitudes regarding self image, body image and food issues, or there is a real danger of their own unresolved conflicts being projected onto the client or group. I have also found that prejudices and myths surround the person with an eating problem and practitioners need to explore these.

The groups are held in a large room, either within a hospital setting or a community hall. It is important that the venue is free from interruptions and that privacy can be assured. The groups consist of 8 to 18 people both female and male, (although female staff tend to be in the greater ratio). The knowledge of the nature of Eating Disorders varies and Session 1 facilitates expression of the knowledge base and a sharing of information. The participants are committed to attend the four training session. The workshops last between two and a half and three hours depending on the size of the group and the existing knowledge base of the participants.

I use the following exercises in multi-disciplinary staff training groups (including nurses, GPs, occupational therapists, social worker, psychologists, art therapists, and so on). The aim is to educate and increase self awareness. These methods are also suitable for women's groups and at some stages in groups and in individual work with people with eating disorders:

Staff training workshops

Session one

KNOWLEDGE BASE / CHILDHOOD IMAGES

This session is aimed at discovering the extent of the staff's knowledge, based on matters described in the introductory chapter and assisting them to fill in any missing information.

A helpful diagram is shared, so that we have a shared picture of the cycle people may be trapped in.

The following cycle commonly occurs

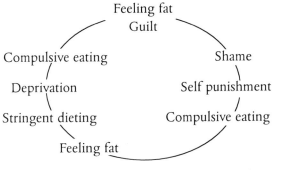

(Hutchinson 1985 p.27)

In order that the workshop does not remain theoretical but moves on to look at how issues, surrounding image affect us personally, I then introduce three dolls.

THE DOLLS

Doll A is a popular blonde-haired model with an improbably proportioned 'perfect' body.

Doll B is a doll in traditional dress with some extra padding added underneath to add some dimension to her waist and hips.

Doll C is a muscular male doll

I provide pieces of paper to each pair in the group with the following words printed on them:

Strong Independent Lover Capable Beautiful Lonely Successful
Sensible Caring Clumsy Happy Kind Depressed Wealthy
Poor (*This list can be altered or contributions invited from the group*)

The workshop participants are invited to confer with their partner and then to place the labels with the dolls of their choice.

The results of this are fairly predictable, with glamour equating with success and happiness. This opens up a group discussion on how we can all be influenced by well-targeted marketing. It surprises some participants that they have carried images given to them in childhood and that, never having had cause to question or alter them, they have remained buried but intact, possibly influencing their responses to people with body image/self image problems. Further questions are invited from the participants and they are given handouts of the information about Eating Disorders, the symptomology and aetiology.

GROUP REFLECTION

The group is multidisciplinary, made up of 12 members (4 male and 8 female) from social work, occupational therapy and nursing background, with knowledge ranging from theoretical only to theoretical and practical experience of working with people with eating difficulties.

The group began with the nursing members more versed in the symptomology of eating disorders with the other disciplines expressing a wish to look at the practical issues surrounding treatment of suffers. There was some disquiet when the participants realized they were going to begin the session by exploring their own attitudes to body/self image and food rather than looking at 'case studies'. They found it helpful (in addition to agreeing that what was experienced and expressed in the group should remain within the group, unless it were agreed by all that it would be shared in a wider arena) physically to mark out safe places within the room to return to. This also served to mark the transition from the theoretical part of the session to the practical.

They gave me further feedback that the production of the dolls (which caused some amusement and recall of childhood aspirations and envy for those who had the right doll!), helped them to explore in a deeper and more meaningful way what the differing images represented to them. Someone commented how the visual also helped to conjure up recall of the session (a further aid to learning). The use of the dolls demonstrated the paradox that distancing allows for exploration at greater depth. The participants are less likely to 'censor' their responses to the subject as they feel less threatened.

Session 2

COLLAGES

The participants are asked to make collages using a large selection of magazines – (women's, photography, colour supplements, etc) using anything that is of particular significance to them and this workshop. They are

given 30 minutes to do this. When the 30 minutes are up they return to the circle and, after being reminded again about confidentiality within the group, invited in turn to share with the group anything they feel able to about the collage and what it means to them. This usually opens into a larger discussion about opposing images the media give us – one particular image, I recall, had on one page an advertisement for an enormous cream cake and on the next an article on how to lose weight and have the body of a certain super model, with the promise that it could lead to success in love and work.

These images are those which bombard us all, workers and clients, and we need to be aware of them so that we can then decide our response to them.

IDEAL WOMAN

I then invite the group to create society's ideal woman – based on what they have gleaned from the earlier exercise.

MATERIALS:

1. Large range of coloured fabrics (1 metre x 2 metres) – these provide stimulation and therefore aid creativity.

2. A mannequin or model head (similar to those that wigs are displayed on)

3. Selection of cardboard boxes and similar

4. Safety pins

5. Adhesive labels

6. Wigs

7. Jewellery

8. Loaded camera (preferably one that produces instant photographs)

The group is encouraged not to spend too much time in discussion but to begin to create the woman. This exercise needs to be time limited and 30 minutes is usually sufficient with the facilitator reminding the group of the last 5 minutes.

When the participants have completed the model they are asked to fill in the adhesive labels and attach them to any specific areas, further describing attributes or power associated with certain aspects of her. They are also asked to fill in a card each describing the character of this ideal woman. A photograph is taken of the creation.

The group share some of their thoughts and feelings about this woman. If there are two mannequins or heads available, and sufficient silks and so on, this model is left intact; if not she is dismantled by the group and the materials used – de-roled by, for example, saying 'this red cloth is no longer a clingy ballgown that gives the wearer great power but a piece of red fabric' and so forth. De-roling is important in that it means no lasting association remains with the particular objects used.

The cards and labels, also the photograph if available, are placed to one side and the group now construct their own 'ideal woman' in the same time span and using the same labels and card as before. A photograph of this 'woman' is taken. I have never seen the creation of 'society's ideal woman' and 'the group's ideal woman' that are closely similar.

The different story cards are shared and then I check out with the group if they think their perceptions and awareness of body and self image have been heightened or changed between now and the start of the training. This is an opportunity for people to express their difficulties or conflicts – in a safe place – and acknowledgement of these will help them to be freer when working with clients requiring assistance in overcoming these difficulties.

If the first model has not been dismantled and de-roled this is now done. The second model is dismantled in the same way.

The participants are asked to sit back to back in pairs and, if they are able, to close their eyes and reflect on the session – seeing in their mind's eye a video replay of what has taken place, pausing over anything they want to understand or explore further; images, words, feelings and to take them away with them. They then slowly turn to face their partner, making eye contact with them and then return to the circle and acknowledge the rest of the group. They are asked to think about how they would use this exercise with a group or individual and some ideas are shared with time given for questions. They are given the opportunity to take their collage with them or leave it behind. If they choose the latter I ascertain whether, if their identity is protected, it can be displayed or used in other training or whether they want it destroyed or kept in a locked cupboard.

GROUP REFLECTION

In one psychiatric nursing staff group with members who had some experience in the use of creative methods in therapy there were five females and three males present. One male expressed some difficulty with the creation of the ideal woman in discussion with the group over the labels used to describe society's 'ideal woman'. He acknowledged that she was perfect but wondered what was wrong with aspiring to perfection! The group opened

this out to a useful debate on whether we are totally unswayed by physical beauty or give it a greater weighting than some other attributes such as a sense of humour or spirituality. It was decided that these group members would be influenced by their cultural background, personal philosophy or religion, social background and individual experiences. The important thing was that the differences were acknowledged and wrestled with, leading, one could hope, to a greater insight and sensitivity to the dilemmas when in a client setting.

Early on in my career I was facilitating an Eating Disorder Group and told I would have a co-facilitator who had asked to join in. This was many years ago when it was just not the thing to ask your co-facilitator personal questions about self/body image and attitudes to food, (of course this does not happen now, does it?). The result was a painful learning experience and at the least some confusion for the attenders (who survived despite us). It turned out that my co-facilitator had many unresolved conflicts concerning food and issues of control. The first session it manifested in her being very challenging and directive about how much food people within the group should eat and, prior to the next session, taking them out for a fried breakfast, although not eating herself. It would have been immensely preferable to have worked through this conflict in attitudes in a staff training group as happened in the one described, rather than in the therapy setting.

The male mentioned has gone on to develop his awareness and sensitivity to women's issues and to do some good therapeutic work. He also caused his colleagues to be more aware of the difficult transition this can be for some people and that is part of a learning process.

Session 3

The issue of control/loss of control is central in the development and maintenance of eating disorders, so the aim of this workshop is to explore this with the participants. The treatment of Eating Disorders rarely, in my experience, focuses on food and body; I want to encourage the therapists to explore the dynamics involved.

PUPPETS

The group are asked to get into pairs and are reminded of the need to keep their partner safe. They are asked to find a space within the room and decide who will be the puppet and who the puppeteer. The puppeteer attaches 'invisible strings' to the puppet who lies on the floor and, by using non-verbal movement, the puppeteer gets the puppet to a standing position and then, after five minutes of controlling the puppet, the 'strings' are cut and the

puppet comes alive and free to move and do what he/she wants. Roles are then reversed. The group then comes back to the circle and each person takes a turn to say one word or gesture associated with being in control.

SPECTOGRAM

They are then introduced to sand trays and spectograms. The sand tray measures 57cm x 72cm x 7cm. There is a large selection of figures, such as dolls, farm and jungle animals, clowns (there is always a useful selection of miniature figures available in Cake Decorating shops), shells, buttons, string, or vehicles. Group members are again asked to work in pairs and one person of each pair spends 20 minutes using a sand tray and selecting figures and so forth to show themselves in relation to significant others; whilst they were doing this they were to consider to themselves the issue of who is exerting control or power and whether it was a shifting element or not. When it was complete, they had a further 15 minutes to tell their partner a story of the figures in the sand tray. The partner was to encourage them to tell the story of the figures and not relate it in the first person (the purpose of this is to keep the use of metaphor and distancing) the partner was not to interpret but could check out some things with the story teller, for example 'I see the rhino has his back turned to the tiger – is that how it is?'.

When the 35 minutes is up there is a further 10 minutes to 'de-role' the figures, for example 'this clown is no longer my partner but a figure of a clown' (to prevent any unfortunate lasting associations!). Roles are then swopped and the story teller becomes the listener, with new figures and a new story. During this time the facilitator should be available to help with any difficulties or confusion over carrying out the activity.

When both partners have used the spectogram they return with the rest of the group and have the opportunity to share something of their experience. The use of sand trays can have a powerful effect in the insight it can give someone into their particular situation – so I strongly believe that therapists who plan to use them should experience this themselves beforehand; they will then also see the need to de-role the figures used.

Some time is spent within the group discussing whether it feels safer to be in control or controlled, issues surrounding power and how this relates to someone with an eating disorder and how, when faced with the feelings of powerlessness in their life, they think that at least they can control something (their intake of food or absorption of it into the body) and how it gradually takes control of them and the battles that ensue to gain control or towards self empowerment.

MIRRORING

The session ends with some mirror work. In pairs, one person mirrors the other and then the person taking the lead relinquishes it to the other; after a few minutes of this the sub-groups are asked to become aware of the others in the room and to take on their movements. Within a few minutes the whole group should be moving in unison and moving closer together. The facilitator asks them to slow their movements down and gradually to do some small movement separate from the rest of the group and begin to move away to a space they have identified in the room. When they reach it they can choose to sit or stand or lie and reflect on what has take place for a minute. They are then asked to make eye contact with each person in the room quickly. Before leaving the session they are told that it may take a while to 'process' their experience and any further comments can be brought to the next and final training session in this series of workshops.

GROUP REFLECTIONS

The group commented on here is the same group described in Session 2. All group members commented on the puppet exercise that they felt happier in the role of the puppet than the puppeteer as it had felt easier to obey instructions than give them. (There was some discussion over whether as psychiatric nurses they were sensitive to any 'custodial or hierarchical image, or whether it was that working within the National Health Service they had become accustomed to taking orders – it was certainly a point to think on – as with so much metaphor).

The spectogram work had been described to them in an unrelated teaching session on Post Traumatic Stress and Dramatherapy; however, although aware of the fact that it often provided powerful insights, two participants found it affected them quite deeply and time needed to be spent in assisting them to explore what the spectogram had meant to them and ensuring they had de-roled the figures afterwards and were able to leave the session feeling safe and knowing where to seek further assistance if they wished. As with any training that enables the participants to experience for themselves therapeutic methods, the facilitator has a responsibility to create a safe container for what may be produced. The trainee also needs to know the potential power as well as usefulness of the methods so they treat them with respect and not as a 'box of tricks'. The group considered that the mirroring work described helped them to feel closer and that they were all therefore working towards the same purpose. It also lightened the situation with some humorous poses! When they separated to go their individual ways

they said they still felt a sense of support for one another and acceptance of each other.

Session 4

This session begins by discovering if there are any particular things to share or ask following the last one and asking how people hope to use what they have learnt in the workshop with individuals or groups.

PUTTING IT INTO PRACTICE

The therapists have to consider whether group or individual work is indicated.

GROUP THERAPY

This offers the following advantages:

1. A supportive atmosphere where participants come to realize that they are not the only one with the difficulties.

2. Ideas and suggestions from one another in answer to specific problems a person may experience.

3. Challenges to a person's denial or behaviour.

4. Numbers to aid in the development of creative activities such as psychodrama, drama, dance, story telling, etc.

5. An economical use of resources and thereby wider availability of help.

Disadvantages:

1. The person may be too physically weak to participate.

2. A group should be aware of its selection process. I once facilitated a group where a new member turned out to be trying to sell a famous dietary regime! (This did not match the disruption caused in an initial session in one group setting in a hospital when a vendor knocked on a door and asked if anyone wanted to buy a pasty! It was later a subject of group laughter but I think the man must have wondered what he had said!)

3. Some individuals are in such a vulnerable state that in a group they may take on other people's symptoms.

4. Gender – although an increasing number of males have eating problems, resistance to mixed groups is immense.

INDIVIDUAL THERAPY

This can lead to group work or self support groups.

Advantages:

1. The person may find it easier to disclose at an earlier stage and therefore the therapy may be of shorter duration.

2. It does not exclude those with severe related physical weakness.

3. The therapist can use the dynamic of working in partnership to address the issues of control.

4. Gender – males may find individual therapy more accessible.

5. A more individually planned and tailored programme relating to the client's needs can be given.

Disadvantages

1. Feelings of isolation may be maintained.

2. Only the therapist's perspectives are available to the client during therapy.

3. Fewer people can be seen and it may be more costly.

Further issues

The possibility of other issues being involved is discussed within the training group and the need to be aware of initial ambivalence in people seeking therapy. More often than not the person suffering from an eating disorder is well read about their illness, and has had at least a few bad experiences of 'help'. Non attendance should not be seen as a reason for not offering further appointments or preventing readmission to a group. It is often a 'testing' and may be the person's movement towards asserting or trying out self-empowerment. If possible, a creche should be made available as many attenders are women with young children. Supporters/carers may feel confused and left out, and if this is ignored they may inadvertently disrupt the therapy. A monthly carer/supporter group to provide information on the latest development in the treatment of eating disorders (with the prerequisite that it is not a place to discuss individual sufferers) is extremely useful.

Supervision

Working alongside people suffering from eating disorders can be challenging and, as in any therapy, the therapist must ensure that they receive regular clinical supervision, preferably from a supervisor with a good knowledge of

the issues surrounding working with people with eating difficulties. This should be a time during which the therapist can reflect on their clinical practice and their own responses to clients they are working with. Issues over nourishment and the rejection of it can stir up personal material for the therapist and these and how they relate to the clients and future work may need to be explored. If the client or group are resistant, how does the therapist feel about the rejection of her nourishment?

When issues of control are paramount, the therapist has to take care to avoid being drawn into the battle and becoming yet another person to fight against. The supervisor needs to be alert for any signs that this is occurring and give feedback to the therapist.

Conclusion

There are other therapies that have proved effective in the treatment of people suffering from eating disorders, for example behaviour or cognitive approaches. Some clients have found these helpful and have been able to embrace them, once more gaining control of their lives and learning how to ask for what they want, without needing to resort or retreat in to their focus on food and/or body image.

Many people who I see have not been successful with this (although I readily and gladly concede many others have). Those who cannot resolve their conflicts in this way will say that, intellectually, they know what to do but just cannot accept it or make the shift deep within themselves or on an emotional level.

The use of dramatherapy and other creative methods has the following benefits:

Many of the techniques described in the staff training are projective and can be readily adapted to user groups. Very often the person with an eating problem is used to keeping things deeply buried and pushed down inside them. This is done symbolically with food: in cases where the person starves, they ignore the hunger 'pains' deep within; if they vomit or purge, then the material quickly disappears from them. The projective techniques described focus the person away from their preoccupation with food, calories and weight and allow them to start to open themselves to creativity – to nurturing, nourishing and growing in a new way or rediscovering what has become buried in the description to be in control. Instead of being bogged down, heavy, stuck, the person can begin to explore options and alternative ways of being, taking tentative steps towards the risks and rewards of freedom.

Often a client will say that everything else in their life is beyond their control and they discovered that the one thing they could control was their food, until that took control of them. Even with that acknowledgement (which, with its recognition of the problem, is an ideal starting point to the partnership), the first steps towards recovery can seem an immense struggle. Creative methods can help lift the mood and give a sense of achievement even on the early stages of the journey.

Due to the distancing in the techniques used (i.e., the therapist is not dealing directly with the eating and food problems), paradoxically the client and therapist are able to enter more deeply into the underlying difficulties that have manifested in an eating problem. There has frequently been a history of competition and conflict during previously experienced treatment. It should be remembered that the person with an eating disorder is usually an expert on their problem – has often read more books and researched the subject more thoroughly than 'professionals'.

Whatever way you and the client or group decide to work together, work at achieving a partnership, harness their experiences and knowledge of how it is for them, and create the sense of journeying towards a shared goal together. It is important for the therapist to keep this goal in mind as the main disadvantage of such therapy can be the loss of direction. The therapist and sufferer may use the time as a diversion and avoidance of the reason why they are there. This brings me back to the importance of supervision: the supervisor can guide and challenge the therapist over what can be difficult territory, but which, when surmounted, can open up new horizons and opportunities as the clients become free and the therapists mature as journey persons.

Reference

Hutchinson, M. G. (1985) *Transforming Body Image.* Freedom, CA: The Crossing Press.

IV
Psychodrama

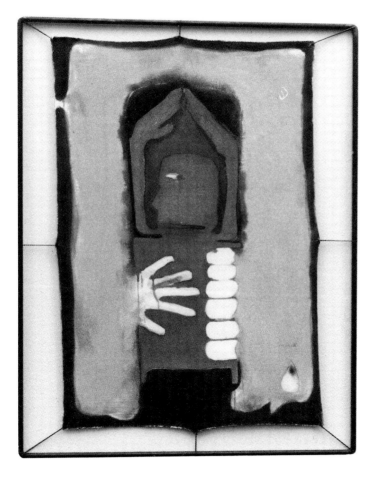

A Circle of Conversation

But you don't understand
Then explain
You box me up and then spit me out at your nearest convenience
That's not true we want to help
Then leave me alone
Do you want to return to college?
Of course I do
Then you have to eat
You tear me apart and expect me to heal myself
Why won't you eat?
Fuck off, leave me alone
Are you hungry?
You have absolutely no idea what I go through
Then tell me
Why waste your time with me go and help the others
At the moment I'm here for you
Do you really want to know what it's like?
Yes
Then you're mad
No, I want to help
Do you think I will get well? Promise me that I will get well
I can't do that, I don't know
Do other people get better?
Yes they do
How long does it take?
That depends
On what?
When they start to eat again
There has to be another way
There is no other way
It's not fair. when will I be better?
I don't know
will I get better?
I don't know
Fuck off then and leave me alone.

Elise Warriner

*This poem is based on a conversation that I had over and over again with
one of the nurses whose particular job was to help me get better.*

Art Therapy and Psychodrama with Eating Disordered Patients
The Use of Concrete Metaphors for the Body

Mary Levens

This chapter is based on my work over the last nine years as both an art therapist and a psychodramatist, within a specialist Eating Disorders Unit at Atkinson Morley's Hospital, London. Patients admitted to the unit may be suffering from anorexia, bulimia or compulsive eating. The fact that they are admitted for the intensive in-patient treatment programme implies they have already undergone an out-patient assessment, after which only the most severely disturbed patients are admitted. Others are offered out-patient treatment. The group I refer to throughout this chapter are, therefore, at the most severe end of the spectrum. I emphasize this, as many of the ideas I will be discussing in relation to this degree of disturbance are not necessarily intended to address the core issues of less ill sufferers.

Patients are admitted to the unit for an eighteen-week in-patient treatment programme which includes a two-week assessment period, followed by up to fifteen weeks of day-patient attendance. The general approach is psychodynamic, with patients attending group and individual therapy, family therapy and art therapy and psychodrama. However, occupational therapy and the nursing programme are also essential parts of the overall programme, focussing more on functional skills and eating behaviour. Patients attend art therapy and psychodrama from the start or from very early on in their treatment, although the way in which they are able to make use of these sessions varies according to their stage in treatment. Very low weight anorectics are seen for individual art therapy for the first few weeks of their admission, and may not be emotionally ready to join the psychodrama group

until they have started gaining significant weight. Patients are rarely excluded from these forms of therapy, unless they are particularly over-aroused.

Psychodynamically, many of the concepts I will be referring to are relevant to patients who exhibit an underlying borderline personality organization, rather than a higher level neurotic organization. The term borderline personality organization should be distinguished from Borderline Personality Disorder (American Psychiatric Association 1980); the latter is a psychiatric diagnostic category, which is dependent upon a cluster of symptoms of behaviour. These include:

- impulsive behaviour
- intense and unstable relationships
- difficulties with anger
- identity disturbance
- self harm
- chronic feelings of emptiness and boredom.

The former term is a psychoanalytic one, and is not dependent upon symptoms, but rather describes the degree of disturbance within the patients own ego, in their capacity to relate to others, and the type of defences predominantly used. Those who have an underlying Borderline Personality Organization (BPO), rather than a more developed neurotic organization, often have great difficulty in sustaining any sense of stable self; they are liable to feel as if they are about to fall apart, and often turn to a range of destructive behaviours, partly in order to hold themselves together. They experience disturbances in their capacity for object constancy, meaning that they cannot rely upon their image of themselves or another person to be sustained in any predictable way. This makes the world a very threatening place.

The deficit in this capacity (or more accurately the interference with it), leaves the individual reliant upon actual tangible evidence of emotional states. In the same way as the young child, who feels she has been totally abandoned when mother leaves the room until she is able to recognize that mother continues to exist when outside her own range of vision, the disturbed adult may turn, for instance, to food to fill the empty space when left.

These patients tend to perceive their world quite simplistically in black and white. This split is to do with the earliest perceptions of the mother, who is divided into good and bad. Further along in their development, something of each is present in the same person, forming the beginnings of a 'Whole Object'. Other crucial developmental processes occur in relation

to this; the individual's experience of their own body boundary develops, so that they can recognize more accurately what is inside them (a feeling or a thought) and what belongs to the external world. This is part of the infant's developing recognition of separateness from others and location of themselves within their own body space.

Until this is well accomplished the infant or, in later life, the disturbed adult, demonstrates a failure to 'mentalize his own feelings and thoughts'. This is a concept discussed by Fonagy (1989) with particular reference to the thought processes of borderline patients. The difficulty in establishing a sense of difference between self and other is related to a confusion between inside and outside and, most important, between thought and action. The two may feel the same because, as Fonagy describes,

> 'The capacity to conceive of the concepts of one's own mind or those of another's mind is a vital pre-requisite for normal object relations.' (Fonagy 1989)

For the disturbed patient, these contents are not experienced as thoughts or feelings, but as concrete reality, which makes it terrifying, for instance, to think murderous thoughts. I will go on to describe more characteristics of BPO further on, but I have selected these few very important concepts in order to suggest a hypothesis.

That is that, due to the fact that patients functioning at this level are living in a world which is dominated by 'Concrete Objects', and that the representations of themselves and of others lack integration and are in fact conceived of as many quite separate selves,

> **psychodrama and art therapy have a most particular role to play, and may even be therapies of choice, as they are uniquely able to work within the world of concrete objects and, by doing so, meet the patients in a way which feels genuine and authentic in order to facilitate their emotional growth.**

For those patients whose self-destructive behaviour is dominated by an eating disorder, we see how psychological conflicts are not experienced as such, but rather are enacted concretely through the individual's use of food and her own body. Many of our patients are suffering from a range of associated 'impulse disorders', and have been described as suffering, from a 'Multi-Impulsive Personality Disorder' (Lacey and Evans 1986 p.641). This describes a cluster of symptomatic behaviours which are commonly associated with each other, such as alcohol or drug abuse, self mutilation, repeated or compulsive over-dosing, shoplifting or gambling and sexually disinhibited behaviour, for which the patient herself feels guilty and ashamed.

For those unfamiliar with art therapy, I should first introduce it. As with psychotherapy, it can be used at very many different levels, according to the capacities of any client group. The style of art therapy I work with is very influenced by psychoanalytic ideas, particularly object relations theory, although this is not necessarily representative of a wide range of styles of art therapy being practised. This approach accepts that thoughts and feelings derived from the unconscious often reach expression in images rather than words, and that these images can be understood as communicating something of the internal object world of the patient to the therapist.

Art therapy can allow this to be expressed as an alternative language, perhaps when words are too restrictive or, more commonly (certainly in relation to articulate patients), when words may be used defensively or, most important, without meaning attached to them. The art therapist explores elements of the art work itself with the patient, such as the colour, the space used, the content and form of the imagery and the patient's own associations to their work. They also explore what thoughts and feelings occurred to the patient whilst they were involved in the actual making of the work and also when it is being re-looked at, after its completion.

Through this means of externalization, it is possible to recognize aspects of oneself and one's relationships, whilst relating through an image and using the art image as a transitional object. Often, denied or repressed aspects of the self can first be faced in an image. A very depressed patient who had internalized her rage, and consciously could not recognize it at all, painted a wild animal with bared teeth as a self-portrait, while she described herself as mild and placid. When the contradiction between her image and her words became evident, she began to be more able to own some of her underlying feelings. In groups, any individual's art work can be used by the whole group, rather like a group metaphor; however, I particularly encourage patients to relate to the images not only verbally, but also visually or kinesthetically. In other words, is there a discrepancy between the feel of an individual's words and that of their image, or what did it feel like to produce this work. How is it that one very withdrawn passive woman is able to relate so strongly to an image which was made by tearing paper up and stabbing at it with crayons and yet cannot identify at all with words which hint at any suggestion of violence.

In this case, rather than encourage fantasies about content of the image, I would suggest that the passive patient imagined what it could have felt like for the producer of the picture to have made it. This demands the focus to be placed upon thinking about behaviour and feelings, particularly in the

actual making of an image, rather than on a symbolic interpretation of the content.

Art therapists are trained to facilitate their patients' spontaneous expression in a variety of media, for instance paint or clay, and it is within the context of a therapeutic relationship that problems are worked with, either individually or in groups. It is by examining the process – that is, the gradual build up of shape and colour and the use of space, and particularly the order in which images are created – rather than just the end result, that art therapy functions. It is through this process that it is possible to build up some picture of the patient's symbolic or representational world. Or, as I will be suggesting with disturbed character disorders, the most useful focus may not necessarily be on symbolic content, however appealing their often colourful and supposedly symbolic marks seem to be. One bulimic patient was very deceptive. Her complicated, multi-coloured, packed-full paintings gave an impression of layers of meaning. However, when one listened to the way in which she related to her own images, it became clear that she was not able to make use of her images symbolically. It is not the images themselves which contain the symbolic meaning, but the patient's relationship to them and use of them.

Freud described the first ego as a body ego, and that is really the starting point for the work that I am doing, as one sees that that these patients are using their own bodies as a transitional object. They are using bodily metaphors as opposed to psychological ones. They are functioning at a very concrete level. It is because of these issues that it is so important to understand the nature of the eating disordered patient's experience of her body. For many, the body is not only a hated object to be controlled, but a constant reminder of their experience and that they have something missing. This deficit pathology is well described by Gottlieb (1942) and is very relevant to her own group attempts to prevent her sense of bodily fragmentation. The body, identified with the maternal object, is experienced in a persecutory way, which has to be controlled, lest it devour the patient.

Such patients have failed to separate in all senses, cognitively and psychically, from the maternal object, leading to a narcissistic fixation on their own body rather than reaching out to objects in the wider world, through the use of external transitional objects. This has profound consequences as regards the self–other boundaries and the process of individuation. One patient painted an image of two female figures, overlapping each other. When asked which one represented her, and which was her mother, she replied 'It doesn't matter, you can choose!' The two figures were interchangeable for her. To make them into separate figures, by differentiat-

ing them in her painting, would have threatened the wished for merger and fusion. This therefore became the subject for discussion in the session: what was being defended against, by not painting the figures with any distinguishing features.

One can see the use of art as an external transitional object to be used to promote the capacity for symbolization. These patients experience the intake of food as the enhancement of their bodies, but this occurs at the expense of the self. This is based on the deep split between mind and body, a body being a thing. Therefore, the patient is fighting against being a thing, so that even contained within the violent self attack can be found an attempt at survival of an inner self. Because of the level of her experience, she is restricted to using concrete means in order to fight her battle. An anorexic patient portrayed this quite literally, with an image of herself, made up entirely from different types of food. An orange was placed in the position of her head, a loaf of bread for her body, sausages for arms and so on. Her experience of eating was that the food was taking over and replacing what had been her core self. I have not described this by saying 'The orange represented her head'; she was not purely symbolizing parts of her body by the food images, but conveying the actual concrete sense she experienced of being replaced.

So the territory of the battle is in her own body. The intensity of this battle is because the body doesn't only contain the bad object. In order to contain something inside oneself, there has to be a sufficiently developed sense of what is inside and what is outside. Body boundaries are dependent on the concept of inner and outer; this is a prerequisite, as it were, to conceptualizing a boundary between self and other. These in turn are dependent upon the concepts of space and limits. What I am particularly interested in is the way in which these basic concepts can be worked on, through art in the sense of 'giving form to something'.

For these patients, many thoughts are too difficult to bear and have to be evacuated, got rid of through actions. Often, because the symbolic nature of a thought cannot be considered, thoughts frequently become too terrifying, and the more they have to be abolished, the more the actual thinking apparatus becomes disturbed. The use of art has a particular role here, in the creation of a concrete space, and in the absence of a mental space to allow for thoughts.

Psychodrama is a form of group psychotherapy, although in each session, only one individual works on their chosen issue, facilitated by the therapist who is known as the director. Presenting issues often include hatred of the body, fear of sexuality, family relationships or conflicts around food. The

initial scene may be diagnostic. A contract is made between the individual chosen to work (the protagonist) and the director. Other members of the group are selected to play significant roles, as the first scene concretizes the presenting issue.

Object relations theory describes our internal world as existing through a series of inner relationships. Our perception of parents and others have been internalized and we are constantly playing out our internal mini-dramas, which effect our overt behaviour. We also have a variety of self-perceptions which effect these internal interactions. For instance, Kate's perception of herself as a rejected child, who relates to a rejecting other, unloving other than inside her own mind, often manages to evoke the exact response in her external world to fit her internal drama. These internalized figures are not replicas of the original external figures. They may have gone though a series of distortions to arrive at their present day form; however, it is these characters (including the self) who reign all powerful and tyrannize the patient's actual interactions. It is these *internal* figures who need transformation. Often these previously unrealized internal dramas or interactions can now be externalized, made conscious and, it is hoped, modified through the psychodramatic process.

As we all know, reality can be hard enough to bear when one is aware of what it *actually* involves, but these patients have little hope of learning to face their real life issues, whilst they are dominated by their damaged and distorted internal world view.

Working with eating disordered patients, I lay great emphasis on their relationship with their bodies and ownership of their own thoughts and emotions. Any of these aspects can be externalized. Clare may be chosen to play Susan's anger, which she can not yet express; Louise, to play Susan's wish to be dependent. Each session, lasting two to two and a half hours involves approximately four to six different scenes. The intention of each is to deepen the exploration of the last. This is done by the director closely observing the person working and paying particular attention to their body language, in order to follow what has been termed, their 'emotional smoke'. When the protagonist tightens her jaw, taps her foot or speeds up her breathing as, for instance, they challenge their father in a scene, the director asks them what other, earlier memories are evoked by this scene.

Many memories are stored in the body and re-called at a pre-verbal level, which can then be made conscious. By my paying attention to their body signals, so their body consciousness is also increased. Psychoanalytic theory suggests that the infant accurately perceives and then responds to their own

body stimuli as a result of their mother's appropriate responses to them. The relevance of this to eating disorders goes without saying.

The scenes follow each other, tracking the presenting problem further and further back into the patient's history. Fantasies of the future may also be enacted; for instance, one anorectic enacted a number of future scenes which might be realized, were she to stay ill. Each scene was a further projection in time, allowing her to experience, in a most powerful way, the possible outcomes of her deterioration, ending with a hospital scene, where she knew she was about to die, speaking to, and being spoken to by her parents. Through this she could access the underlying rage towards her family and the hollow triumph she would feel at proving their powerlessness over her.

Frequently these patients' true, authentic self has been suppressed, denied or obliterated. It needs to be re-discovered, so that they can say the words that were never said, or experience the emotions which were never felt, often because the unhappy family situations so many of our patients grew up in could not in any way provide a safe enough setting for the child to experience a normal full range of feelings and learn to survive them without disastrous consequences. So often there *were* disastrous consequences to ordinary healthy feelings, sexual interest met with seduction, anger with abandonment, sadness with neglect. In psychodrama, the authentic 'I' can be re-discovered, an experiential self, who owns her body and feelings. She can then, but only then, distinguish her needs from those of others – again highly relevant to eating disordered patients.

As the scenes continue, the other members of the group are actively involved, by coming up and speaking the protagonists unspoken thoughts. This is called 'doubling', and often helps to break through the protagonists' defences. Whilst she is meekly apologising to her mother, another patient comes up and asserts what needs to be said. The protagonist then accepts or rejects these doubles. The doubles are often doing their own work at these times, whilst identifying with the protagonist's situation. A patient who is not able to recognize something for herself, is often first able to recognize it through watching someone else's work. This is a fundamental concept in group psychotherapy.

Keeping in mind the title of this chapter, and the patient's use of concretization, we need to appreciate some of the issues involved in pre-symbolic thought. These ideas have relevance to the practise of both psychodrama and art therapy. Because of this, they frequently emerge in both sessions, or I may make reference to a theme in art therapy which emerged earlier that week in the psychodrama session. As the majority of patients,

after the first few weeks of assessment, participate in both, the group is able to carry certain themes between the sessions.

In my experience, the poorer the degree of self–other differentiation, originating in the mother–child relationship, the more difficulty the patient has in making use of one of the fundamental tools of psychodrama, that of 'Role Reversal'. This involves taking on the other person's role, thereby seeing oneself through another's eyes. The internal dramas are enacted externally, with the protagonist being directed throughout the session to move between significant roles. In this way she may ask of her mother 'why did you hate me so much?' In the reverse-role situation, she answers from her own perception of mother. For some patients, the lack of self–other differentiation is demonstrated by stopping mid-sentence to say 'I'm not sure if this is me or my mother speaking'. Although there are multiple reasons for this confusion, it may be that the patient is not yet ready to work on a dialogue necessitating two distinguishable people. The therapeutic task may be first to ask alternative techniques to facilitate a more secure sense of themselves.

This may also be demonstrated in art therapy. In one art therapy session, Jane, a young woman with a borderline personality disorder, and severe acting out behaviours, painted an image of a red circle with a black circle inside it. Opposite her at the art table sat Meg, who had finished her painting five minutes earlier. Hers was an exact mirror image of Jane's picture! When the group discussed Jane's work, Meg said she felt uncomfortable, as Jane had obviously copied her work, although she had reversed the black and the red. Jane was unaware of having seen Meg's art but got very upset at the accusation, accusing Meg of trying to set a trap for her. I suggested that we concretize Jane's image in some dramatic form. Jane agreed and, using the whole group, asked everyone to get into pairs.

Each pair were asked to stand with one enclosing the other with their arms around their partner's waist. Jane then stood in both positions in turn, describing the shapes she had created. The inner one was enclosed, trapped, constricted, the outer one was pulling, encasing. I asked her to describe the physical sensations of both positions, and she found it hard to differentiate the sensations. She wasn't quite sure who was meant to be pulling who, and which figure was holding on or trying to let go. She was expressing her confusion about who was really on the outside and who was on the inside of this shape (which she had unconsciously expressed by reversing the painting opposite her). Her confusion was to do with who was who and where were they both in relation to each other.

The first thing that Jane needed was help in clarifying these issues, before further work could continue, which it did in the following day's psychodrama session. In that group, Jane selected a photograph, which was part of the warm up exercise for the session. The photo was of a young boy, with a sack on his back, walking down a long road. She became the protagonist, and took on the role of this character, which led into a full psychodrama based on the theme of escape from entrapment. She had fantasized about this boy, that he was a traveller who never stayed in one town for long. Having set up this scene to explore it further, a scenario developed where the local inn keeper had an argument with the young lad about his having broken a commitment to stay in town for a week to play his flute at the inn. As the scene developed, the lad (Jane), became more and more anxious to escape. When we explored this fear through a number of scenes, having moved into her own personal world, she recognized that her fears of entrapment led to her always being 'on the run' in relationships, but that this disguised the other side of the coin, which was in fact her own immense desire to find someone for herself and to hold them captive so that they would never leave her, as she had been left in her early years. So the confusion was indeed valid, regarding who wants who. (Further reference will be made to this session.)

Examining this a little further, the concretization of the art image brought up technical issues for the psychodramatist concerned with the needs of the whole group, not purely the protagonist. Jane's fantasy of the contact between each set of pairs was that they would be very entwined and almost symbiotic. The anxieties of the rest of the group had to be considered, particularly with reference to very close physical contact as, for this group, issues of breaking personal boundaries and fears of being invaded predominate. So together we created an alternative means of producing the image, using patients' hands and arms only. The important point was to find a way of concretizing the image, which could then be linked to the physical sensations, which could then be expressed in some way. But this had to be a process which could not be cut short by an accurate verbal interpretation, because the words may well have rested neatly at an intellectual level of understanding, and reached no further.

One reason why it is so important to find ways of concretising the internal images of these patients is because of the way in which they will use bodily metaphors instead of psychological ones. Their distress is expressed directly through their bodies (and in this area, they may well have certain features in common with psycho-somatic disordered patients). Although the therapeutic aim is to enable the development of psychological thoughts to occur,

it seems absolutely appropriate to meet patients functioning at this concrete stage of body experience at the right level. They may not yet be able to make use of the symbolic concept that they are cared about unless the care is demonstrated physically and literally, or they feel that their inner emptiness is connected to lack of care or love. It is then a denial of their true physical level of experiencing and understanding the world if the therapist brushes too lightly over this concrete thinking and, too quickly, makes a symbolic interpretation, which is only academically correct. Psychodrama has a particular capacity, by its very nature, to help them develop a symbolic capacity from first having their real internal experience understood concretely.

Goldman and Morrison in their book *Psychodrama: Experience and Process* (1984) state

'The protagonist is using symbols and metaphors throughout the session that apply directly and concretely to his life. These symbols are ones that are called into use for concretization...'

and, further on,

'[it is] important to make use of the protagonists' most significant and evident symbols. As the concretization is being structured we clarify the symbols we have been given.'

Blatner and Blatner (1988) say of concretization

'Psychodrama works in part by helping patients to convert their abstract statements into something more concrete because vagueness is a major way of avoiding dealing with issues directly... Another way of concretizing issues is to convert metaphors into actualities.'

The point I would add to this is that, when working with people whose thinking is predominantly influenced by concretization rather than symbolic thought processes, the work of psychodrama is rather to enable them to find a means of representation of their inner world of concrete objects, rather than assuming that what is being dramatically represented is in fact of a different order from their experience. The tools of psychodrama lend themselves particularly well to helping disturbed patients find the building blocks upon which to build their sense of self and other.

This was highlighted in a session with a patient working on her separation difficulties from her mother. She literally could hardly bear to be any distance away from her, which was threatening to disrupt her opportunity to have help from the in-patient treatment programme. No amount of interpretations about her unconscious fantasies of what might happen were

they to be separated, touched this patient. However, a significant turning point in these early days was her willingness to use a psychodrama session, in which she created an umbilical cord between herself and her mother. It was through the concretization of her actual experience and the relief in managing to express literally and visibly what her connection to her mother ready felt like, that we could at least make a start.

With this patient as well, these very primitive bodily experiences were reflected in her art therapy sessions. Up until that point she had sat staring at her blank sheet of paper in the sessions, feeling she had absolutely nothing inside her, of her own, out of which to make any image. I suggested she make an image from the psychodrama session, and the umbilical cord then evolved in different stages into a creature with many tentacles. This image then provoked fantasies to do with her sense of herself as a 'primitive life form' with no distinct bodily shape. This creature was floating in the water, not attached to the sea bed or rocks, and in a part of the sea which was otherwise uninhibited. These associations led us to explore her fears of separating from her mother, and being left totally un-anchored, unattached to anyone or anything.

In both art therapy and psychodrama the form of the session may be of more therapeutic importance than the content. Another example of this may be when one considers the underlying issues which these patients have in common, their poor sense of self, problems in differentiating themselves from another, lack of autonomy and the particular types of defence mechanisms they rely upon. There are a number of ways in which the psychodrama session can work directly and actively with their personality structure, bringing the concrete nature of their style of thinking to life in a session, by dramatising it. The IT may not be the content brought to the session to work on, for instance getting sacked, the IT may be the particular way in which they experience ANY conflict. The splitting processes which dominate the borderline's thinking, keeping good and bad experiences as far apart as possible, can be pychodramatically expressed

This process of splitting occurred in my own group in one particular session, when the protagonist quite dramatically shifted her attitude toward the work, toward me and toward the auxiliaries. One moment all seemed to be going well, with the protagonist well engaged, and then suddenly she stopped, turned to the director and said 'This is a load of rubbish, I'm not going on, you can stuff your psychodrama'. In that instance another patient managed to stop her leaving the room, and we halted the session to talk about what had happened.

The borderline patient's lack of consistent ongoing sense of herself means that she also experiences the rest of the world as equally unstable, and in fact often provokes extreme reactions from others. At these points, where there is almost a loss of touch with the external reality of the situation that there may need to be a calming down period, or a re-integration time, to enable the protagonist to regain their grip on reality once more. When they feel safe enough, then the psychodrama may continue.

Jefferies (1991) considers the issues involved in actually losing control:

> 'If I lose control, what then?... Their (the prisoners) inability to control their violence brought them into prison... Experiencing emotions that have not been dealt with before raises anxiety as to whether the whole group – protagonist, director and the other members – can survive the emotions that need to be expressed.'

The patients I am referring to, whilst rarely having committed violent crimes towards others, have, during their impulsive and out of control acts, constantly been engaged in exactly that form of violence towards their own bodies. The issue of stepping over the boundary that demarcates fantasy from reality is of extreme importance, both with regard to working with patients who 'act out' their emotions, and the use of active techniques which invite patients overtly to express, through some kind of action, their inner world. For these reasons I would like to explore the issue of 'acting out' a little further here.

Many of these patients, including those who have committed violent crimes, may have stepped over the boundary that demarcates fantasy from reality, and this is a very important point to bear in mind with regard to protagonists' quite reasonable anxieties about loss of control. Loss of control for the better-integrated person may involve fears of breaking down into tears or getting really angry but, for many of this group, it may be equated with becoming violent to another person or to themselves, it may mean becoming actively psychotic, damaging objects at random or other dangerous and frightening events which have to be taken seriously. This may mean selecting carefully the use of psychodrama props, depending on the protagonists' potential for loss of control, or protecting auxiliaries from a protagonist who is liable to switch their mood in an instant. For instance, in pub scenes, plastic beakers may be used instead of glass tumblers, expression of anger may be facilitated by punching cushions, making loud noises on the piano or stamping feet rather than using hard objects.

I particularly emphasize to each new patient, and often to the protagonist of each session, that they are in control of the session, that they need to feel

able to stop or slow down at any point and trust that I will not push them into areas they cannot handle. Without this sense of mutual co-operation, this type of patient will easily walk or rather run out of a session and perhaps start smashing up the pottery in the room next door.

Understanding these patients' excessive needs for control of both their own feelings, behaviour or thoughts and those of others, has much to do with the earlier discussion on concrete and symbolic thought. For the patient who cannot readily differentiate between thought and action, certain thoughts must not be had. To experience one's murderous thoughts may be much too close to the actual act where the thought in a magical way may lead to the other's death. The protagonist feels all-powerful in a terrifying way. This may often be one motivating factor in certain patient's resistance to action in both art therapy or psychodrama. Through an inhibited use of their body and voice, they display very clearly a sort of emotional and physical straight jacketing.

In one psychodrama session, we invented an 'anger dial' on the protagonist's back. I suggested it could be set between nought and one hundred, to allow for a range of expressions of anger; nought represented a tiny whisper. We agreed throughout the session, what number the dial should be set at, and at one point when the patient suggested a high number, I argued for a lower one. The group joined in with humour, but the method did create a feeling of safety for the protagonist, as a result of which I believe she dared to engage more with her aggression within this session than she might otherwise have done.

The clinical expertise of the director is called for at these times in making a judgement as to whether the use of certain psychodramatic methods to facilitate the patient's expression of their feared impulses is in fact what is therapeutically called for, or whether at this point for the protagonist to feel a loss of control which might in certain instances actually be unmanagable would increase their level of fear and be harmful. I think the director's own degree of comfort with these issues and perhaps also with a particular protagonist has an important bearing on how much can be safely contained within a session.

Within the psychodrama session, Blatner and Blatner (1988) make an important statement; although they refer specifically to psychodrama, their comments apply equally to all expressive forms of psychotherapy.

> 'We must differentiate the concept of enactment, or therapeutic acting out, from the non therapeutic or antitherapeutic forms of acting out. When behaviour is encouraged and subject to the influence of the group and the therapist, self-expression can include in turn both

regressive tendencies and their corrective alternatives. The context's capacity to go along with the behaviour subtly generates a degree of role distance that calls into operation the patient's observing ego.'

The authors go on to compare the use of the patient's act hunger to the principles underlying the Japanese martial art of aikido: the psychodramatist allows the act hunger to be fulfilled, the wish to act is not constrained, or blocked, so that a transformation can be facilitated during the actual process. Adding some of my own thoughts to those of these authors, I have suggested that the elements which help to create this transformation and which therefore differentiates the act from the previous typical forms of destructive 'acting out' behaviours in both techniques appear to be the following.

1. Awareness of the context the behaviour is occurring in.

2. Awareness by the patient of the symbolic nature of the act, or of the image.

3. Understanding of the patient that in this setting there do exist actual limits to the behaviours, therefore the original impulse (i.e., to kill) has to be modified or symbolically translated into an acceptable means of expression.

4. By maintaining a link at crucial times with the therapist, the patient is helped to maintain her grasp (be it a fragile one) on reality.

5. By this occurring in a therapeutic context, as Blatner and Blatner suggest, a greater awareness of the patient's own observing ego is developed.

6. The symbolic expression of the act can reinforce awareness of the possibility of the patient making use of sublimatory channels of expression.

7. That the patient is aware that what is occurring is in the service of her own development rather than her previous acting out behaviours which served to prevent any growth.

8. The need for the therapist to be aware of her own personal wishes for feelings to be expressed which she may otherwise unconsciously provoke the patient into acting out on her behalf.

In essence then, this way of conceptualizing the form of acting out in psychodrama or art therapy allows for the original behaviours not to be in any way re-inforced or stimulated, but uses part of that energy for a process which may be transformative.

This discussion relates closely to our theme of patients with severe eating disorders having such difficulty in symbolically transforming their intensely felt needs. One of the dominant features of these patients' disturbance rests upon their great difficulty in being able to delay gratification. When they experience a wish, it is difficult for this to be differentiated from an acute need, which is perceived as having to be met immediately, if not yesterday! All frustrations and tensions must be abated as quickly. Learning to wait and to contain a reasonable amount of tension is a vital part of healthy adult functioning.

The implication of this is not a suggestion to ignore the protagonist's wishes to express destructive feelings by any means, but for the director to be aware of the counter-aims which may sometimes be present in facilitating the patient's capacity to bear tension. This same issue arises frequently in art therapy sessions, with a style of art painted by the bulimic patients which I have called their 'vomit pictures' (Levens 1987 p.2). These are out-pourings, simple attempts to empty themselves of unwanted feelings, but with no working-through having occurred in the process. In an art session, I would intervene, and help them to create some form out of the chaos, to give the picture some structure; in other words, to aid the development of thought, where none was intended to be. This is often resisted, as it is not as gratifying in the moment as 'letting rip', discharging violent feelings on impulse.

Drawing to the end of this chapter, I hope to have partially explored certain dynamic issues relevant to working with this group of patients, when using art therapy and psychodrama. I have paid particular attention to their most primitive levels of disturbance, and have considered ways in which these therapeutic techniques may be of particular value in aiding the development of the sense of self, both in mind and body. These patients who come to our unit feeling quite fragmented and with a lack of ownership of their own bodies and minds, need first to build the necessary foundation stones which have been so massively disrupted, before they can begin to conceive of engaging in healthy relationships with others.

Their abandonment of thinking and reliance on concrete expression of their distress progressively leads them to further disintegration. Through these techniques I believe they have a unique opportunity to build a relationship with themselves and experience themselves as inhabiting their own bodies. So many self-mutilating patients have described how easy it is to attack this object called their body, but which to them represents a lump of flesh, which could be hanging in a butcher's shop. They describe, in vivid ways, their lack of concern for themselves, and lack of self-recognition. Psychodrama and art therapy are powerful methods to facilitate their self

awareness in a total way, so that they can then begin genuinely to relate to others. The emphasis I have placed upon concrete versus symbolic thinking is of great importance and seems particularly to offer itself up as an issue which can be so well highlighted and worked with through these forms of creative therapies.

References

Blatner, A. and Blatner, A. (1988) *Foundations of Psychodrama: History, Theory and Practice.* New York: Springer Publishing Co.

DSM III. Diagnostic and Statistical Manual of Mental Disorders. (1980) Washington, DC: American Psychiatric Association.

Fonagy, P. (1989) On Tolerating Mental States: Theory of Mind in Borderline Personalities. *Bulletin of the Anna Freud Centre,* 12, part 2.

Goldman, E.E. and Morrison, D.S. (1984) *Psychodrama. Experience and Process.* Dubinque. Iowa: Kendall/Hunt Publishing Co.

Gottlieb, S. (1992) Failures of The Transformational Object. *British Journal of Psychology,* 8(3), 253–265

Jefferies, J. (1991) In Ed. P. Holmes, M. Karp *Psychodrama, Inspiration and Technique.* London: Tavistock/Routledge

Lacey, J.H. and Evans, C.D.H. (1986) The Impulsivist: A Multi-Impulsive Personality Disorder. *British Journal of Addiction,* 81, 641–649

Levens, M. (1987) Art Therapy with Eating Disordered Patients. *Inscape: Journal of Art Therapy,* Summer, 2–7

The Use of Psychodrama in the Field of Bulimia

Sandra Jay

Psychodrama is a form of psychotherapy which enables an individual to explore relationships and different aspects of their life through enactment rather than by simply talking. It is a powerful therapeutic tool which can be used in many different ways and can be adapted to the needs of the group which it serves.

In this chapter I will be describing my use of psychodrama with a particular group of women who suffer from bulimia and use external sources to manage internal struggles. I will discuss my understanding of the dynamics that evolved during the course of the group and the specific defences that were commonly used in relation to this eating disorder. The examples given are real but certain details have been changed in order to preserve anonymity.

Bulimia is described by French (1987) as an eating disorder characterized by uncontrollable bouts of over-eating followed by self-induced vomiting and\or laxative use to expel the food. Men suffer from bulimia but not as commonly as women. Throughout the chapter I will be referring to women, as my experience has been with women, although some of the points will also be relevant to men.

Setting up the group

In October 1991 I was asked if I would be interested in setting up a psychodrama group for women with bulimia. The request came from a local GP who also had medical responsibility for one of the colleges in Oxford. I had past experience of working with people with eating disorders and found the idea both interesting and challenging.

Within two weeks of the request, hundreds of posters were displayed around the colleges. Posters were left in the female toilets, where women could read the details at their leisure without the fear of being seen. Within a fortnight I began getting telephone calls from women, all of whom expressed concern about exposure. These concerns varied from 'what if I know someone in the group' to 'what if my problem is worse than anyone else's?'.

All the women needed to be seen by the GP. This was to ascertain the diagnosis of bulimia and also to identify any medical complications resulting from the condition. I would then meet with each woman individually to assess suitability for joining a psychodrama group; this could include a full account of their family history, medical and psychiatric details, current lifestyle and support network. I would also take a comprehensive account of their eating problems, including the current level of insight, ability to acknowledge that bulimia may be related to other areas of distress than maintaining/losing weight, and by the end of the session I would hope to have a clearer idea about their level of motivation to change. By the end of this process, four women were suitable to join the group.

It was striking how much the women had in common regarding their earlier experiences in life and the particular roles they played within their family. It was not uncommon for the women to have taken on the role of the 'responsible child'. This often included taking on what are generally considered parental tasks, for example looking after younger siblings or having considerable responsibility for the running of the home. Generally, these tasks held a lot of responsibility, but ultimately the child had little control. At this stage, the child learnt how to look after others' needs and during this process began to suppress their own. The more the child fulfilled this role the more skilled she became at suppressing her own needs.

The women had real difficulty in consciously acknowledging the anger surrounding how the role of 'responsible child' developed, as this would have meant recognizing their own resentment toward their parents, particularly their mother, whom they had always tried to protect against any emotion perceived as negative.

Another familiar role described was that of the 'good child'. This role is not necessarily 'responsible' but the expectation was that the child did not cause any problems. Much emphasis had been put, by the parents, on praising the child for being 'good' which made it very difficult for the child to act differently without feeling that she was letting them down. For example, 'You are such a good girl. If it weren't for you I don't think mummy could

cope.' This again reinforces the belief that to be acceptable one does not express anything that the parents perceive as 'bad' or 'needy'.

If the family have a lot of problems or another sibling is causing concern, then the child, who later goes on to develop bulimia, may be relied upon to behave properly and not cause any additional problems. Once given praise for being the 'good' child, it may be difficult to express other aspects of herself without feeling she is letting her parents down. If the child lives within a world that describes things as 'good' or 'bad', then the child may use this framework to view herself, thereby suppressing the 'needy' part of herself in order to continue gaining her parents' approval.

She is then only able to experience 'her self' through one of these polarized positions. Therefore, integration of the vulnerable and strong aspects of herself do not take place. Her bulimia could therefore be seen as a displacement used to keep the unacceptable aspects of herself in an external position (food) so she does not have to recognize them as aspects of herself. Even though food is seen as something outside of herself, it is still directly responsible for controlling the way she feels about herself. Therefore, on a 'good' day when she eats 'good' food she can allow herself to feel 'good' as a person, until the time when she eats 'bad' food and then the pattern reverses. This obvious lack of self-esteem seems to be carried into adulthood where self-worth as a person only seems to exist if it is validated by an external source (Bauer, Anderson and Hyatt 1986).

Most people like to be in control of their lives, but for these women it is of particular importance. It may not be restricted only to the areas of eating and weight control. Actually accepting that they are not always in control seems a very difficult task. This would become apparent when exam time was getting nearer and their work would fall behind or through the experience of financial hardship. Their eating would become very chaotic and even though they would feel very low and in desperate need of support they often found it incredibly difficult to admit that they might be out of control.

Most bulimic women have experienced someone else's need to enforce control and therefore they operate almost from the basic belief that relating from the passive stance is the best way to survive in relationships.

Within the context of the therapy group, it was often very difficult for the women to acknowledge that they did not have to relate to each other from this passive stance. Many of the group exercises would be focussed on personal empowerment and helping each member learn to value their contribution. Feeling more in control of what happened in the group as

opposed to being a passive recipient helped the women realize that they can effect what happens in their environment, if they chose to do so.

When talking with someone who has bulimia, it is striking how many 'shoulds' and 'should nots' occur during the conversation. Therefore, if she eats something she 'should not' because it is 'bad' then she automatically feels 'bad' about herself for failing. The only way to feel 'good' again is to break this cycle and eat in a way perceived as 'good'. This transaction may take some time to achieve, so in the meantime the guilt will perpetuate a binge that will possibly continue until she is so full she has to vomit. These binges may occur several times a day or only at particular times of the week, depending on the severity of the bulimia.

Because of their high need for approval, and their constantly falling short of their own standards, many bulimic women experience difficulties in relationships. They tend to oscillate between partners who need taking care of and partners who have a tendency to rescue. Finding a balanced relationship can sometimes be very difficult. Because of the woman's low self-esteem it is hard for her to acknowledge the fact that someone may find her attractive as a person and a woman. She may experience difficulty in sexual encounters due to her rejection of her own body and may use alcohol or drugs in excess to help her deal with this difficulty. Some women find it hard to tell their partner about their bulimia as they may believe that he/she will be disgusted or that this may mean that the partner will be keeping a careful eye on them, creating as much anxiety as the original secret.

Keeping emotional control is an important issue for women with bulimia. Actually acknowledging that things may be out of control can be a big step forward. Joining a group is often very anxiety provoking as this may be the first request for external support.

Psychodrama

Psychodrama is a form of psychotherapy that uses action to help an individual explore past and present events and relationships that have psychologically affected them. It also encourages the exploration and expression of unspoken thoughts and feelings. It enables the individual to encounter people, events and fantasies from the past, present and future. Psychodrama usually takes place in the context of a group. A typical session would involve three stages:

Warm Up

Action

Sharing

The aim of the 'warm up' is to help the group get in touch with particular feelings. This could be achieved by structured means, for example trust exercise or splitting the group into couples to discuss the worst/best incident in the week, relating to food. It might simply involve talking to each other about the week since they last met.

Usually someone in the group will then decide to look at a personal problem in more detail. Sometimes there are several people who put themselves forward. There are many different ways of choosing who will work. In this group I always encouraged members to choose, for reasons I will describe later. The person chosen, who I will now refer to as the 'protagonist', will then go on to the next phase, referred to as the 'action'. During this phase, the protagonist will explore some aspect of her life. This may involve returning to a family scene from the past in order to try and understand how what happened then affects the way she is now, or it may begin with a problem she had to face that day.

One of the important techniques used in psychodrama is 'role reversal'. This is where the protagonist changes position with another person in her life in order to get a deeper understanding of how that person might think and feel. Role reversal is also used when trying to explore the protagonist's relationship to herself. In order to explore this more fully she will ask other group members to represent certain aspects of herself (when a group member takes on a role they are referred to as an auxilliary), for example one group member can represent the 'sad' part, another the 'angry' part. She can then role reverse with each part in turn. This will not only give the auxiliaries a better understanding of what they are portraying but it will also help the protagonist understand this aspect of her self better.

The psychodrama may help the protagonist understand a particular relationship more fully, facilitate the expression of feelings that were otherwise unacknowledged and therefore suppressed, and go on to generate a richer level of insight.

Often the women put a lot of energy into gaining the approval of others. So I tried to help the women recognize that gaining their own approval and increasing their self-esteem is of utmost importance. This process can be started by getting the women to meet aspects of themselves that they like. Other members of the group can help by playing the different roles chosen by the protagonist, for example 'loving sister', 'loyal friend' or 'hard working student'. By helping the protagonist acknowledge the aspects of herself that she likes, we are creating a more balanced view of herself as a whole as opposed to just the 'bad' or bulimic aspect presented originally.

After the psychodrama, the members come together for 'sharing'. This refers to the latter part of the session where people can identify with the protagonist from experiences in their own life. It is not a time to analyze what has just happened. It enables auxiliaries to 'de-role' from parts they may have been in and helps the protagonist to feel part of the group again.

The group

I am now going to focus more on the particular issues that evolved within the group. As you will see, many of the dynamics that evolved in the group were mirror images of those experienced in relation to food.

Clarity of boundaries was of utmost importance to evoke safety within the group. In the first session we discussed confidentiality and timekeeping. The group was to be a slow, open one, allowing new members in at the beginning of each term. We would meet weekly for two hours and each member made a commitment of one term.

In the early stages of the group the women looked to me for guidance and structure. I needed to find the balance between offering it and leaving enough flexibility to work spontaneously with what the group brought each week. A recurring issue was for the group to want me to become their 'provider' or 'good mother' and take away their emotional discomfort. They found it very difficult to contribute to the group without a lot of encouragement from me and it took some of the women many months to feel safe enough to look to each other for support.

A phenomenon that often occurred was the group's need to please me. This was displayed by making me coffee and always agreeing with things I said. This role of 'good child', as described earlier, was established in relation to their natural mother, when much of their time had been spent looking after her needs and denying their own. Having to look after mother may evoke anger in the child and since the expression of anger is unacceptable to families of bulimic women these feelings would be expressed and enacted through the bulimia. Psychodrama can help explore these feelings and begin to help the women get in touch with the anger and grief that had been carefully 'packed away' as unacceptable.

Case Study

When Jane was ten years old, her mother went into hospital, returning with her baby brother. From this time on, Jane was expected to look after her siblings. When she expressed her frustration she was sent to her room, soon learning that to express anger was not acceptable. She

developed anorexia a few years later as a way of regaining some control over her life and identity. In the psychodrama group Jane was unable to recognize her anger, so through the use of empty chairs she was asked to describe all the emotions she experienced at this stage in her life. She placed one emotion in each chair, she was then asked to 'role reverse', with each emotion (this was to try and help her understand more about her inside world and help her get in touch with all those feelings she may have been suppressing). In the role of 'anger' she was able to express herself to her mother and acknowledge that she was not happy looking after her siblings all the time but needed someone to look after her.

A few weeks later, I suggested to the group that we try out a new exercise. Jane stated that she didn't think it was a good idea and made an alternative suggestion. This was the first time she had ever disagreed with anyone in the group and she had obviously found sufficient self-esteem to look after her own needs rather than look after someone else's.

It seemed that the more aware the women became of their suppressed emotions the more able they were to assert themselves within the group. In the first few weeks of the group, the members tended to focus mainly on their eating difficulties. This process of identification was essential before any level of trust could be established. All the women had kept their bulimia a secret from most (if not all) family members and friends. The realization that they were not the only ones suffering from this socially isolating condition seemed to be most therapeutic. Yalom (1975) describes 'universality' as one of his curative factors in group therapy and in my experience of working with bulimic women, it seems very important for them to realize that they are not unique in their problem. The self-disgust promotes the secrecy and therefore creates isolation. Therefore, breaking out of this cycle can be most liberating.

The group needed a helping hand to move into identifying issues from areas of their lives other than eating. This was achieved by facilitating structured exercises to help the women explore their feelings that lay behind the eating. The therapist might say to the group: 'Let's put the eating to one side for a moment and think of two feelings you often experience. Become that feeling and introduce yourself to your partner'.

By such means the group were able to identify feelings rather than just discuss their eating behaviour. This enabled a much deeper identification between members. Occasionally, the atmosphere in the group seemed

relatively light and spontaneous. This was usually when something positive had happened to one of the women. However, I noticed that each time I tried to encourage this spontaneity it only evoked guilt and feelings of being irresponsible. Offering structured exercises sometimes helped as this gave the group the permission it needed to play. In my experience of working with bulimic women it seems that to act spontaneously is a common difficulty. A lot of preparatory work on self-esteem and trust within the group is required before anyone feels safe enough to risk being spontaneous. Some of the 'warm up' exercises can help with this. The group seemed more able to relax when the exercise had a lot of structure; they were not expected to talk about anything too difficult, and physical contact was minimal. Over the weeks they were able to develop in these areas but this was only possible on a gradual basis.

Before individuals could feel fully accepted by others in the group they felt the need to enact aspects of their bulimic behaviour on the psychodrama stage. This would vary from individual to individual but would often include powerful symbols such as their fridge or favourite binge foods. By means of using these metaphors, one group member would re-enact her secret behaviour in front of the group and get a deeper understanding of her relationship to food by the use of role reversal. She would take on the role of her binge food and, with the help of the therapist, get a greater insight into her use of her bulimia. For example, if the food was filling some form of void in her life then she is more likely to acknowledge this when playing the role; Louise, for example, would always binge to excess on a Saturday night. Ice-cream was the food she always associated with bingeing. In reverse role with the ice-cream she was able to connect the fact that it was only on Saturdays that she was left on her own for hours because her house-mates were out with their boyfriends. This then enabled her to look at her distress about not being in a relationship.

It took the group several weeks before the members began identifying with each other in areas other than eating. This ranged from avoidance of college work to feelings of isolation and loneliness. Actually acknowledging feelings and learning to express them in a way other than eating was very painful for all involved and the women would often fall back into the familiar pattern of discussing behaviour. The method of psychodrama can help by allowing individuals to use a chair to represent the 'behaviour' and a chair to represent the 'feelings'. The woman will then role reverse with each of these aspects to get a greater understanding of what they are and how they function.

In the role of 'behaviour', Angela was very articulate and felt in control. When role reversed with 'feelings', she got in touch with her despair and emptiness, something she had not felt since she was six years old when her father had left the family home. Many of the women had experienced 'the need to be strong for parents'. Some of the group had experienced the 'responsible child' role from an early age and it seemed that the parents had been unavailable for one reason or another, thus leading to the suppression of needs and denial of anger.

The women in the group seemed to find it difficult to accept anything for themselves and if they did discuss a personal problem this would inevitably end in them feeling guilty. This would seem to relate back to their childhood, where much of the family interaction and personal acceptance had been conditional on being 'good' and caring for others.

Yalom (1975) describes 'altruism' as one of his curative factors in groups, and anyone who has ever worked with women who have bulimia will realize that they have no problem in giving to others but immense difficulty in receiving. Psychodrama can help the group experience how it feels to receive from each other unconditionally and help individuals explore and contain the guilt this evokes. One woman found it hard to accept that she could cry without being rejected, which had been her experience as a child.

As the group progressed, the members were more able to tolerate a loosening of the structure and they began spontaneously to discuss difficulties as they arose without needing me to take the lead. Some evenings we would spend a lot of time talking before moving into action. The group would always choose the protagonist. This was mainly to ensure we worked with the issues the group felt comfortable with, but also to reinforce that it was their group and they had some power in deciding the content of the evening. It was very difficult for some individuals to put themselves forward as protagonist, this being a strong reflection of their difficulty in acknowledging and expressing needs. Before long it became a group norm to help individuals express their need. I felt that this was a major step forward as it demonstrated or enacted the support of another's need as well as reinforcing the message to those giving the support. Most of the women felt they had difficulty expressing anger directly and agreed that lack of acknowledgement and expression of this and other feelings would often result in an increase in the binge/vomiting behaviour.

Case Study

Sarah had recently returned from abroad where she had spent several days with an ex-boyfriend. They had got on extremely well and on her return she felt very happy and content with life. The relationship had felt complete and there had been no sexual inhibition. In the group she discussed how her vomiting had increased since her return and how she could not understand why. Psychodramatically, we looked at her behaviour (eating and vomiting) and her feelings (unsure what to put in this chair) by asking her to place each of these aspects onto separate chairs. In reversed role with her behaviour, she described herself as 'repulsive' and 'greedy' and proceeded to show the group how she behaved during this binge. A group member then took on this role and Sarah observed. This technique, which involves the protagonist watching someone else imitate them, is called 'mirroring' and can create a powerful way of receiving feedback. She said this made her feel angry and she was then able to place herself in the role of 'feelings'. Through the use of role reversal and support from other group members, she was able to see how much she had suppressed since her return. This relationship had been the first time she perceived her partner as strong and able to meet some of her needs. In previous relationships she had been the strong one, which had been a continuation of her role within her family. She was the eldest daughter and had always been relied on to be strong and had never had her needs met by her father.

The above example occurred after the group had been meeting for several months and highlighted to me how much trust had been formed between the women, therefore allowing Sarah to experience and express this pain within the group, which was very supportive and accepting of her distress. As a result of Sarah disclosing these feelings, the other women were enabled to share from their own life situations what elements had left them feeling very vulnerable.

Case Study

Jane is a very bright, articulate woman who comes from a family who rely a lot on her ability to cope. She has held the 'responsible child' role from a very early age and had always been there to rely on in times of stress. One week she came to the group quite distressed. Her mother had asked her father to leave the marital home and he had asked Jane if he could stay with her. She had put him up temporarily

and was helping him find a more permanent solution to his accommodation problem. They had both been staying in the same room. The desire for her father to move out created much guilt as she had been conditioned to believe that her own needs came last. Jane's position within the family was that of surrogate mother. Her parents had had a large family and when she was ten years old she was given the task of looking after her siblings. Her mother had a lot of emotional difficulties and Jane was also expected to look after her mother. She held a lot of unexpressed anger towards her father and it was clear that Jane's role had been abused within the family, giving her no space for her own needs to be met. She found it easier to feel anger towards her father as his way of communicating was far more direct than her mother's. She perceived her mother as helpless, pitiful and incapable and therefore it was impossible to feel anger without guilt.

In the group Jane explored the current situation but it was noticeable that whenever confronted by her father she would fall back into the 'selfless daughter' role. In order to gain some objectivity, I needed to create another dynamic to this relationship. I asked if there was someone (past or present) who was able to be clear about his/her own personal boundaries. She said that she had always admired that trait in her grandfather. We repeated the scene where Jane was feeling completely responsible for her father's future and she observed this interaction from the role of her grandfather. He (played by Jane) became very agitated, so I asked him to verbalize his thoughts. He was not only clear about what Jane could do to help her father but he was also able to articulate what was not her responsibility. Jane was reversed back to self and heard this message from her grandfather. She became very tearful as this was the first time she had ever heard anyone say 'this is not your responsibility'. We returned to the current scene of her father in her one room bedsit and she was able to acknowledge that this situation was not acceptable due to the complete invasion of her personal space. She was able to say that she was not her father's wife but his daughter and that living within this close proximity to each other was not acceptable. Jane was able to experience what it was like to be clear, set limits and project back the responsibilities that she had always carried. Jane has since stated that she still feels guilty when setting limits with her father but now she feels more able to say 'no' and look after her own needs.

After several weeks there seemed to be an atmosphere of tension which eventually surfaced. The group members had a belief that they each were expected to take turns to be protagonist, even though this had never been made explicit. Bearing in mind that the group was also relatively small, this was creating enormous tension. Sometimes group members did not turn up and often those who did would avoid eye contact, thinking it was their turn to 'perform'. The women seemed to believe that the only way to be in this group was the 'all or nothing' way, thinking that when you are protagonist you take it all, leaving nothing for others and if it wasn't your 'turn' then you would not be missed if you did not turn up. This starve/binge cycle was thus re-enacted within the psychodrama group instead of food. When I realized what was happening we spent a whole session exploring these feelings about being greedy in the group when being the protagonist, and with the help of structured warm ups they also recognized what each individual brought to the group and what value that held for others. From then on we did not always focus on one classic psychodrama session, as described earlier, but would spend some evenings providing time and space for several women to look at a brief piece of work, providing the group with a sense of sharing without their having the experience of being greedy by taking all of the time. This issue lasted throughout the duration of the group.

Women with bulimia often have difficulty in dealing with distressing feelings and resort to bingeing and vomiting as a way of dealing with them. Psychodrama can help the individual face the distress and teach her new skills in how to deal with the situation. It can also address underlying conflicts behind the bulimia in an environment that is supportive. Jane went through a very difficult few weeks when her family were making unreasonable demands on her. Instead of eating she would bring the feelings to the group and was more able to share her distress with others as opposed to her usual pattern of isolated bingeing.

Through physical re-enactment of situations, the group member can step outside the situation and observe her own behaviour objectively and get a greater understanding of the cognitive processes that occur during binges. This insight may then be acknowledged and modified the next time the urge to binge occurs.

The session may also be used to practise more assertive behaviour for expressing needs or looking at alternative ways of dealing with stress and anxiety instead of bingeing. Actually setting up the scene that occurs before a typical binge and going through it step by step can help her acknowledge warning signs and practise alternative coping behaviours. (Binge eating is a very effective method of dealing with stress. This is especially true if vomiting

occurs after the binge. There are a variety of reports that cite stress as a trigger (Hamburger 1951).)

The power struggle between mother and self is apparent with many bulimic women and this is often shown in the role reversal that so often takes place between mother and daughter in real life. Julie's mother had developed a disabling illness when Julie was in her teens. Julie found it impossible to express any of her own needs to her mother.

> 'My worries seem so small in comparison with what mum has to put up with. She needs me to be strong for her.'

Through talking with the 'strong' part of her mother, Julie was able to get in touch with her grief (and later her anger) at having lost most of her childhood by having to look after her mother and having no one to look after her. The unmet needs of her 'inner child' were often suppressed, only to be indicated later through the aggression of her bulimia. Through splitting the 'strong' and 'weak' part of mother into two separate parts she was able to get in touch with her anger without the fear that this may destroy her mother as a whole. Later in the session she was then able to re-integrate both parts and recognize that it is acceptable to feel anger and love toward the same person.

Psychodrama can enable the protagonist to express feelings in a more direct way than is usually acceptable in everyday life. Yalom (1975) talks about the importance of catharsis. However, although pure catharsis may feel very liberating, there is little evidence to suggest that it has a lasting effect on insight or long term behavioural change. It is the task of the psychodrama therapist to try to help the women make links between the emotion and its origin. The next stage is to help challenge and explore the nature of the belief, for example, is the child who suppresses anger really a better child than the one who screams?

Case Study

> Jane often came to the group very tearful and feeling vulnerable. This made her feel 'weak and pathetic' as she could not understand where these feelings came from – reinforcing her feeling of being out of control. All the other women were very caring and would often encourage Jane to cry. Looking after Jane made it a lot easier for the rest of the group as not only was this a role they were used to but whilst looking after Jane's vulnerability they did not have to address their own. It felt important to help the women acknowledge their own vulnerabilities so they did not completely suppress their own needs

and repeat the pattern which so often occurs in families of women with bulimia.

Conclusion

At the end of the group all the women were more able to describe, discuss and express emotions that had previously felt too difficult. They were also more able to acknowledge their change in mood in relation to what was happening in their lives as opposed to reacting to what they had eaten. Their eating patterns were still occasionally chaotic but the binge/vomit syndrome became less frequent as they learnt new ways of coping and expressing uncomfortable feelings.

As the group reached its last few weeks, the women began to get in touch with their familiar defences as a way of preparing for their everyday worlds. My hope is that the journey through the group has allowed each woman to explore, adjust and experience her inner world in a way that feels less destructive and more nurturing. I hope, too, that I have shared with the reader some of my experiences in running a group for women with bulimia as I believe that psychodrama is a very useful way to help people explore their relationships to food, other people and, most important, themselves.

References

Bauer, B.G., Anderson, W.P. and Hyatt, R.W. (1989) *Bulimia – Book for Therapist and Client.* Indiana: Accelerated Development Inc Publishers.

French, B. (1987) *Coping with Bulimia.* London: Thorsons Pub. Ltd.

Hamburger, W.W. (1951) *Emotional Aspects of Obesity.* Medical Clinics of North America.

Yalom, I.D. (1975) *The Theory and Practice of Group Psychotherapy.* New York: Basic Books.

Further Reading

Blatner, H. Adam (1973) *Acting-In. Practical applications of psychodramatic methods.* New York: Springer Publishing Co., Inc.

Blatner, Adam and Blatner, Allee (1988) *Foundations of Psychodrama.* New York: Springer Publishing Co., Inc.

Goldman, E.E. and Morrison, D. (1984) *Psychodrama: Experience and process.* Dubuque, Iowa: Kendall/Hunt Publishing Co.

Holmes, P. (1992) *The Inner World Outside: Object Relations Theory and Psychodrama.* London: Tavistock/Routledge.

Starr, A. (1979) *Psychodrama – rehearsal for living.* Chicago: Nelson-Hall.

V
Dance Movement Therapy

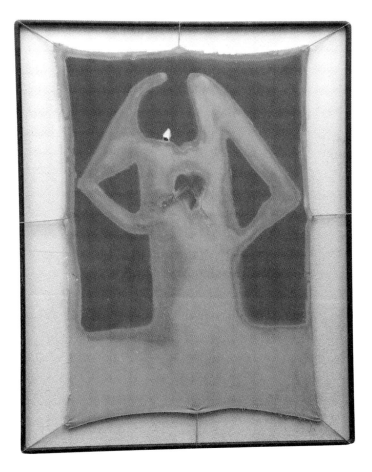

Hopeless Hope

Fuck you doctors with your hoping
I know the damage of my ways
I know life is leaving and time is slowly ticking
and yet there is a freedom to the blackness of your fears
Do you think that I don't know that my body is now dying?
Just because I do not tell you of the pain of which I feel.
You promise me the summer sun that sits inside your hand
and your willing me to reach for the life that you say is mine
Yet you're blind to all the chains in which mentally I am tied
Do you think that I am happy now I know that I will die?
Do you think I enjoy all the anger and the pain?
But do you think that I have the will to try to live again?
No, don't, I know what you're going to claim.
You string me up with all your tubes and drugs to keep me sane.
As if I am a puppet you leave my dignity at bay.
Save your hope for those behind me
and leave this body to decay.

Elise Warriner

A New Way of Working with Body Image in Therapy, Incorporating Dance/Movement Therapy Methodology

Sally L. Totenbier

Body image

It is commonly acknowledged that a primary symptom associated with most eating disorders is body image disturbance (Cash *et al.* 1990). Body image is a complex concept. Schilder (1950) states 'the image of the human body means the picture of our own body which we form in our mind…the way in which our body appears to ourselves' (p.11). The formation of this image is based on reception of sensations coming from skin, viscera, muscles; also on a sense of body unity, including awareness of position and posture. Together, this creates a tri-dimensional image or body schema. Fisher and Cleveland (1968) defines body image as a 'psychological experience…[which] focuses on the individual's feelings and attitudes toward his own body. It is concerned with the individual's subjective experiences with his body and the manner in which he has organized these experiences' (p.x). Fisher (1990) emphasizes that it is not a single image but a composite that changes according to time, place, and situation. Like personality, it is a multi-layered feature of humanness, not an experience which can be quantified or measured comprehensively.

Body image and eating disorders

Body image disturbances in people with eating disorders are divided into two categories: distortion and dissatisfaction (APA 1987). When the body

image is distorted, an individual believes his/her body's shape, structure, or weight differs significantly from the image seen by other people or in a mirror. Since other perceptual abilities tend not to be affected, it is a distortion of self-image, rather than a cognitive problem. A number of studies have examined the extent and type of distortion in eating disorder clients (Rosen 1990). Although the studies lack a conclusive finding, distortion is found more often as a symptom in anorectics than bulimics. Also of note, many 'normal' women overestimate their size; some of them may have sub-clinical eating disorders.

In contrast to those with body image disturbances, a client with body image dissatisfaction accurately assesses body size, but experiences extreme dislike for his/her body as a whole, or with specific features or body parts. This is characteristic of most bulimics, and is experienced by many anorectics; it also is a common feature in any psychological disturbance with lowered self-esteem, especially depression.

Dance/movement therapy and body image

Dance/movement therapy is a form of psychotherapy in which movement is the primary form of intervention. The Association for Dance Movement Therapy[1] defines it as 'the use of movement and dance as a medium through which the individual can engage creatively in a process of personal integration and growth' (1990, p.1). A basic premise is that there is a mind-body connection, hence, a change in the mind results in a change in the body, and vice versa. The dance/movement therapist, in the context of the therapeutic relationship, helps the client identify and interpret the emotional associations to movement experiences and sequences created by the client. Because the body or the actual self is the therapeutic tool, change, exploration, and growth are felt concretely. There are thus immediate effects on both body image and self-esteem, for clients constantly immerse the total self in the process of change while experiencing movement. The therapist creates the facilitating environment, and helps the client process and incorporate the feelings stimulated by the movement experience (Totenbier *et al.* 1988).

In the following model for Body Image Therapy, the basic focus is clarification of the client's body image, followed by change resulting from body exploration. Since movement is a primary influence on both development and change in body image, dance/movement therapy is particularly suited to this work. Touch of others and of self, important in formation of body image, can be a difficult tool for therapists to utilize (McNeely 1987); dance/movement therapists are uniquely trained and experienced in this area. In addition, by virtue of their psychotherapy training, dance/movement

therapists are better equipped than those trained only in massage or other body manipulations to handle the emotional issues, including transference and countertransference, which arise with intense body work. Hence, dance/movement therapy is uniquely suited for this therapeutic model (Stanton-Jones 1992, Stark *et al.* 1989, Rice *et al.* 1989).

Background

Body Image Therapy was developed by the author in the early 1980s, in response to a request from a multi-disciplinary eating disorders team in a psychiatric hospital. Their clients worked with the psychotherapist, participated in the group milieu, received nutritional counselling, had individual Body Image Therapy sessions 1–2 times weekly, and occasionally had group Body Image Therapy sessions, dependent on census.[2] Length of hospitalization varied from six weeks to nine months; generally, anorectics were in treatment longer than bulimics because of the need to stabilize weight at an acceptable level in addition to addressing psychological issues. All clients were engaged in out-patient treatment following hospitalization; however, this did not include Body Image Therapy, due to the conditions of the employment contract. The eating disorders team reviewed the case load weekly, coordinating focus for a given client's treatment. Team members also attended daily treatment team meetings for the clients' unit, ensuring that all disciplines were aware of the progress in each treatment modality, allowing co-ordination in approach.

The first client to undergo this programme, an anorectic female in her early twenties, is presented in this chapter as a case study. The method subsequently has been applied in both in- and out-patient settings; with individuals, small, and large groups; with clients ranging in age from 12 to mid-forties; and with two male clients. All hospitalized clients diagnosed with eating disorders were referred to Body Image Therapy in the two hospitals where this approach was offered. In addition, clients complaining of body image dissatisfaction were referred to the programme.

Case study

'T' was a 22-year-old anorectic female, 5' 1/2" tall, weighing 35.5 kilos; her highest previous weight was 55.5 kilos. T was described as a classic anorectic: immature, with thinking and affect like that of a pre-adolescent, in an enmeshed relationship with her mother. T attributed all her weight loss to diet. She denied bingeing, vomiting, or fasting. Initial complaints were irregular menstrual periods, consti-

pation, abdominal pains, dry skin, difficulty sitting or lying down, problems sleeping and concentrating, feeling cold, and losing her hair. She also had lanugo over most of her body. Her measured body fat was three per cent.

The team put T in the day treatment programme when she failed to gain any weight during a month of twice weekly out-patient sessions. She attended all in-patient groups, and was supervised during meals. The decision against full hospitalization was made because of T's high motivation and cooperation, and because of her financial needs. The author was asked to develop a treatment regime based on dance/movement therapy principles and focusing on body image. The programme had to comply with weight-related activity restrictions. Details of T's experience are presented below, along with the methodology.

T remained a day treatment patient for three months. Three months after discharge T began missing her weekly psychotherapy sessions. About a year later, she married and moved from her mother's home, and reported that things were going well.

Methodology

Overview

Body Image Therapy begins by leading the client through a guided imagery experience, visualizing looking at herself[3] in a mirror; then drawing a picture of herself. This defines the body image, providing a reference point for all future work. All activities are designed to increase body awareness, with the intention of turning the body image from a distorted or unknown entity into something familiar and thus increasingly comfortable for the client. Clients verbalize their feelings about these experiences, and are encouraged to connect their understanding with concurrent personal and group therapy work.

Following is a description of the methodology. It is recommended that the initial session begin with *Mirror Image* and *Self-Portrait*, setting a framework and evaluation tool for subsequent sessions. A highly successful closing activity is described, which reviews progress. Use other techniques in the order most relevant for a given client. Special considerations and precautions are provided with the activity description.

Mirror image

In this activity, the client is asked to imagine looking at herself in a mirror. Although many eating disorder clients spend excessive time staring at themselves in the mirror (APA 1980), they typically do not view all parts of the body, consider the body as a whole, or view varied angles. This method encourages the client to gain fuller awareness of her body in entirety, and helps both therapist and client see how the client actually views her body.

First, the therapist helps the client achieve a relaxed state (see below, *Relaxation*). The therapist directs the client to imagine standing in front of a full length mirror, far enough away from it to see her entire body. The client is asked to imagine looking at her whole body as a unit. She then is to imagine turning to the side, and looking at her whole body from the side, then repeat on the other side and from the back.

Next the client is asked to imagine moving towards the mirror until she is almost touching it, and holding her right hand so that she can see it in the mirror. She imagines looking at the hand in the mirror, moving it around to see every view. Repeat with the other parts of the arm. The client then views the right arm as a whole. Repeat the entire process with the left arm. Direct the client to continue the imaginary viewing process with one leg, beginning with the foot, and then the other leg; followed by the torso, then the head and neck. It is important to view each section as a unit, following investigation of the individual parts, so that the view of the body will not remain fragmented. The client then imagines stepping back from the mirror to again view her body as an entire unit, and is directed through viewing her body from front, sides and back as before. Then guide her out of the imaginary activity and into discussion. Consider the following: Was the activity difficult for the client…why…which parts? Were certain body parts or views more difficult to imagine? What feelings were brought up? Were any memories or associations aroused?

This exercise encourages the client to experience the entire body, not just the parts that the client dislikes. The client hears the names of all parts of her body, and becomes used to dealing with the body in the presence of the therapist. No part of the body is left unconfronted, so there are no secrets or hidden areas. T stated that this exercise was much less distressing than actually looking at herself in the mirror.

This time consuming activity takes 45–60 minutes for the visualization, and additional time for relaxation and processing. This activity, or other guided imagery experiences, is not advisable for psychotic clients or those with psychotic tendencies, as it can result in depersonalization or even psychotic episodes in such individuals.

Self-Portrait

The client is asked to draw a picture of herself. Emphasize that artistic ability is not required: she will be given the opportunity to write about anything that she does not draw correctly, that is, she can write 'my head should be larger in proportion to my body'. This allows the client more confidence in drawing, and allows the therapist to determine if proportions represented were actually intended. Next the client lists in one corner the inaccuracies she feels are present in her drawing. In another corner she lists any aspects of her appearance with which she is unhappy. In a third corner she writes at least three things she likes about her appearance.

The *Self-Portrait* provides material for future sessions. It should be available in all sessions, and referred to regularly. Explain that it serves as a record of her body image. Explain the goals as moving items off the dislike list, and increasing the length of the like list. Disliked features gradually need to become accepted features; as the client becomes more comfortable with her body image, she will find more parts of herself that she enjoys. Entire sessions can revolve around discussing and processing the like and dislike lists. An important part of dealing with dislikes is separating what can be changed from what cannot be altered. Some clients benefit from discussions on camouflaging disliked features. More important are discussions on highlighting liked features, for it increases confidence more significantly than covering up perceived flaws. Such discussions educate clients about realistic ways to work with appearance, rather than unhealthy methods like dieting, purging. It teaches a different way to take control.

Each session, ask the client if she is ready to remove any items from the dislike list. Most clients gain great satisfaction from drawing lines through these items. One bulimic woman who was not sure about her valuations used pencil, so she could remove the line if she changed her mind. It was a significant achievement when she crossed off items with a thick black marker. Clients should also be asked each session if they want to add to the like list. It is recommended that a self-portrait always is drawn, compared, and discussed in the final session to review the treatment process.

For her self-portrait, T selected a pale peach colour, barely allowing her figure to be seen. Looking at this picture just before discharge, she commented 'I'm almost not there, it's like I couldn't see myself.' She had so little self-awareness that she could hardly put herself on paper. In her final drawing, she used bold, dark lines and drew a smiling face. This was the only picture on which she felt no need to indicate that she had shown inaccuracies; she finally felt able to represent herself accurately.

Caricature

The client selects one item from the dislike list. Direct her to imagine looking at herself in the mirror again, focusing on the disliked feature. Warn the client that this is likely to be an uncomfortable process, and provide support as needed. The client then draws a picture of herself, grossly exaggerating the feature in the form of a caricature. The client then moves as though she had this exaggerated feature. Direct her to try a wide range of movements, including walking around the room, performing actions of daily living. Suggest that the exaggerated feature is growing/increasing, and have her adjust her movements accordingly. Sometimes the therapist moves with the client as though she has the same deformity.[4]

After moving, process and discuss. How would life be different if the client actually had this abnormality; what adjustments would she make, what assistance would she need? She then compares this to the reality of her own body. About 70 per cent of clients state that their situations are not as bad as previously perceived; they now can develop more realistic perspectives on these features of their appearance. Caution must be exercised when using this activity with a group of mixed diagnosis eating disorder clients, as it can be a cruel experience for a compulsive over-eater to watch underweight women acting as though they are carrying excess weight.

At the beginning of this session T announced 'I really am too skinny, I'm beginning to notice that.' She focused on aspects of her appearance related to weight loss: facial lines, bony chest, flat buttocks. After exploration she realized these features were under her control, subject to change if her eating behaviours changed.

Ideal self drawing

This activity is similar to the *Caricature*. The client draws a picture of herself, accentuating the aspects of her appearance which she likes, based on the *Self-Portrait* list. The valued features can be highlighted by use of colour, detail, written labels, and so forth. Often, these pictures become caricatures of a positive nature. The client also can engage in movement exploration. By highlighting accepted parts of their appearance, clients can decrease the energy spent dwelling on unsatisfactory parts; this begins the process of liking their bodies as a whole. It also encourages self-care and nurturing, usually diminished or lacking in this population.

In T's *Ideal Self Drawing* she showed jewellery highlighting her accepted features. She had stopped wearing jewellery due to her weight loss: it was too heavy and cold. She missed wearing it, and so was encouraged gradually

to add jewellery. In subsequent sessions, her weight gain and related feelings were assessed according to the amount of jewellery she wore.

At the end of treatment, compare the *Ideal Self Drawing* with the final self-portrait. T had admired her *Ideal Self Drawing*: it was the body image she wanted. She had drawn a large, almost grotesque smile and a tiny waist. When comparing it to her final drawing, however, she found it superficial and exaggerated, preferring the new, healthier image of herself. It helped her recognize the importance of a body image that was whole, yet integrated positive aspects of her appearance. She felt similarities in the ideal and real drawings showed that she had reached some of her goals.

Relaxation techniques

Most patients with eating disorders have difficulty relaxing. They have lost touch with their internal sensations, in order to control their eating habits, and consequently have lost sensitivity to their musculature. They typically fail to recognize varying degrees of tension in their bodies.

There are therefore several steps to teaching the client to relax. First is identifying tension. Ask her how she recognizes tension: are the muscles hard, does stretching hurt, is there associated pain? Does the degree of tightness vary by situation or mood? This helps the client evaluate tension in her body, practise the techniques needed to re-learn hunger sensations, and re-develop body awareness. The client should touch tight body parts, and touch other body parts for comparison. She should create tension in her muscles by contracting a muscle group, feeling this muscle move in and out of contraction. The second step follows the same process, now identifying relaxed muscles. Techniques inducing relaxation include stretching, vigorous shaking of body parts, or massage.

The third step is learning and practising relaxation techniques. Relaxation methods involving movement rather than imagery work best in the early stages. Yoga, deep breathing, stretching sequences are all effective. Movement methods allow the client to identify gradual shifts in muscular states. After the client achieves some mastery of moving relaxation, more traditional imagery methods, including progressive relaxation or guided imagery can be taught and practised.

Anytime a client is tense, upset, or unable to handle difficult material, relaxation offers an alternative or a preparatory activity. One anorectic client started each session with a therapist-assisted stretch for her back and neck, reinforcing not just relaxing, but bonding with her therapist.

Kinaesthetic / Tactile / Sensory exercises for body awareness

It is valuable to set aside time to focus only on body awareness. This is facilitated by such activities as breath work, touch and massage, and movement of body parts. Virtually any form of deep breathing is valuable to this population, which tends to breathe shallowly (Rice *et al.* 1989). Deep breathing not only improves circulation and lung capacity; it helps the client gain awareness of the body's interior. Breath work is an excellent early approach to relaxation.

Touch and massage encourage attention to both the outer surface of the body, in particular the body boundaries,[5] and the internal, kinaesthetic sensations. Often these individuals have issues regarding touch, fearing others will discover how horrible their bodies are. Safe approaches to touch include wrapping the body in blankets,[6] touching the body with tactile objects, functional activities such as applying body lotion, or pressing body parts against other surfaces.

Once the client is comfortable with stimulation of her skin, introduce her to massage. The easiest approach is teaching the client how to explore and massage her hands. Encourage this as a self-care technique, a way of showing respect for one's own body. The next step is therapist demonstration of basic massage movements: tapping and kneading his/her own leg, with the client mirroring this. This gives the client the basic skills to use massage as needed, to relieve tension in herself or others.

Being touched by others was very frightening for T; she was more receptive when allowed to perform a touch experience on the therapist before the therapist touched her in a like manner. Therapists must recognize the implications of touch: misused, it can be interpreted as sexual or aggressive. Receive consent from the client each time. Avoid touching sexually charged body parts. Touch also significantly impacts transference and counter-transference; keep this in mind when using contact interventions (McNeely 1987).

Anything which draws the client's attention to the functioning and existence of her body assists in improving her body awareness. Try moving body parts in isolation, identifying the sounds of the body, or what the body is contacting (clothing, furniture, etc.). Books (Kramer 1981) can provide pictorial vehicles for discussions on body functions, systems, or processes. T was among the clients who were amazed to realize that the stomach is temporarily, not permanently larger after consuming a meal; that the lack of fat padding the abdomen causes the faecal bulk to be visible as bulges. She was greatly reassured when she understood the process of metabolism, and what her body was experiencing with weight gain.

Body tracing

Body tracing and body map techniques, often used with eating disorder clients (Hornyak *et al.* 1989), are expanded and used frequently in the Body Image Therapy approach. This typically arouses significant anxiety, so it is not done until the client trusts the therapist and can respond to relaxation techniques. The client wears a swim-suit or leotard and tights, so the body contours can be accurately outlined. If the therapist is similarly attired, it reduces the client's anxiety level. Before doing the body tracing, the client draws a life-sized outline of what she guesses her body tracing will be like. Then she lies on her back, and the therapist outlines her body. Hold the marker perpendicular to the paper, following the outermost body part while tracing, to reinforce body boundaries. The marker's diameter makes the outline about 1/2" larger than the actual body; advise clients of this. The client then views her tracing from all angles, making comments.

Do a second tracing, with the client lying on her side, arms positioned away from the torso. This crucial tracing provides a view of the abdomen, buttocks, and breasts, areas of sexuality and weight gain which are not reflected in traditional body tracings. Again the client should view the tracing and comment.

At this point some clients like to trace the therapist's body. Compare the tracings, unless the client is significantly heavier than the therapist, leading to an unfavourable comparison for the client.

The client may colour or decorate her tracing; or cut out her tracing, creating a life-size paper cut-out. Wonderful work in self-acceptance and nurturing can occur if the client moves with this cut-out. She can partner her cut-out in a dance, introduce herself to others, and help herself perform actions of daily living. Another approach is to create a body map, indicating areas of pain, pleasure, fear, dislike, and so forth. (Rice *et al.* 1989, Bartal *et al.* 1993.). Tracings can be used again for re-tracings, as the client gains or loses weight. Typically, weight fluctuations show up more clearly on the side views. Patients' fears about weight gains are often eased when they see how little a gain of 3–5 kilos actually impacts total body shape or size.

T had little reaction to her tracing until she traced the therapist. T was one inch shorter than her therapist; she admired the therapist's figure, and had once been similarly proportioned. She was shocked to see the straightness of her body compared with the therapist's. In the side tracing, T had no abdomen, buttocks, thigh, or calf curves. She found this lack of curves disappointing: 'I can't believe how I don't have any shape or figure.' This first confrontation with her destruction of her femininity led to exploration of related issues in future therapy sessions.

Posture

Our society grossly undervalues the impact of posture and alignment on appearance. A person with good posture exudes a sense of self-confidence, energy, and aliveness – qualities which are transferred to the individual's sense of well-being. Improved posture makes a better presentation of any body, and is the fastest way to change appearance.

It is extremely valuable for clients to examine images of women promoted by society (Fallon 1990, Wolf 1990). Encourage the client to collect advertising images which she finds appealing. The therapist should have a collection of pictures displaying women's and men's bodies from different time periods and cultures. Compare and contrast in discussion and movement. Clients should try these postures; therapists can demonstrate them. It quickly becomes apparent that one reason models, for example, appear slim and attractive is that they hold postures never practised in real life. Clients discover they can assume a very different appearance both by exaggerated poses, and with correct alignment. Working this way with posture and images helps the client identify sources of her desire for a certain appearance, while actively working on improving her appearance and sense of self.

Comparison with therapist's body

The eating disorder client often idealizes the therapist's body. When there is trust in the relationship, the client believes the therapist has control of his/her body, wishes to have this control for herself, and hopes that the therapist can impart some of this 'magic' to the client. A useful technique is working in front of a mirror, with the therapist standing in front of, then behind the client, seeing which figure obscures the other at which points. Comparing body proportions is achieved in this manner, or by holding body parts next to each other. T, like many anorectic clients, was shocked to discover that her emaciated image was completely obscured in the mirror when standing behind the idealized therapist's body. This was the first time T realized how distorted her perception of her body size had become. She wanted to be as thin as the author, who was 13.6 kilos heavier.

Touch and contact with the therapist's body is very helpful. Part of the educational process is understanding the difference between muscles, fat, and sagging skin. A male anorectic, athlete and teacher, would pinch skin folds, claiming they were evidence of weight gain. He overcame this illusion by pinching fat, skin folds, and loose and contracted muscles on his therapist's body, then trying to locate similar areas on his own body.

In all techniques requiring contact with or examination of the therapist's body, it is essential that the therapist has worked through his/her own issues about touch, and that the therapist has a healthy attitude towards his/her own body. Otherwise the therapist models unacceptable behaviours, both consciously and unconsciously. This is an important area to address in both supervision and personal therapy before attempting the work with clients.

'I was...I am...I will be...'

This activity works extremely well as a closing activity in the final session. It also may be used earlier as an assessment and review tool. The directions given to the client follow:

> 'Complete the following statements:
>
> I was...
>
> I am...
>
> I will be...
>
> 'Each statement should be completed verbally, and with movement. Take a few minutes to complete the statement, to develop the corresponding movement, and to practice. You will show this to the therapist/group. If you wish, someone else may read for you while you perform the movement, or you may share the words before or after sharing the movement. The time framework for 'I was...' is anywhere in your past, 'I am...' is about your present state, 'I will be...' addresses some point in your future.'

After the client completes and shares her sequence, discuss the work. Find out why she made the selection of time, issue, movement. The therapist or a group member performs the piece for the client, both allowing the creator to view her work, and giving the performer a chance to experience another's position or bodily experience. What qualities will have to be developed to reach her future goals: strength, reduced anxiety, freedom, etc.? How does the mood/movement of the past differ from the present? The client may repeat or expand a section that seems to hold important material.

T presented a moving piece. 'I was always fussing around, worrying, organizing, cooking food. I couldn't be still,' she said, with incomplete movements miming these activities. Both watching and performing this movement caused tension and anxiety. 'I am calm,' she said, standing on the spot and slowly moving her arms downwards. 'I will be someone who can achieve, have dignity, and move around,' she said, and she started to locomote. The same grace and ease previously seen in her arms now showed

throughout her body, and she pushed her arms with strong, circling movements. Afterwards she felt fatigued, realising she did not yet have the physical or emotional endurance required to sustain the free, confident state: but she had tasted the feeling, and was motivated to work towards achieving it. She stated she would perform her movement sequence periodically, to assess her work towards her future goals, and to remind her of her past.

Conclusion

A new and different approach to healing body image disturbances has been presented, which relies heavily on movement experience. This is of particular value since movement impacts significantly on the formation and alteration of the body image. The basic premise of the work is that looking at, examining, and experiencing the body/body image makes it more realistic and better known, hence less frightening and more acceptable. The method is a series of activities which may be conducted in varying order based on the needs of the client, so that the exact format depends on the client and therapist. All techniques can be used in individual work; many are also appropriate for groups. The basic principles addressed could be met with a range of additional dance/movement and other art experiences, depending on the expertise and interest of the conducting therapist.

This approach to treatment is most useful when applied in conjunction with a full treatment programme for eating disorders, as it addresses only some of the many behaviours and emotional issues. It allows for structured focus on the body, which is reassuring to the client; while allowing this work to occur outside of therapy sessions dealing with or focusing on behaviours directly related to eating, family problems, and so forth. It also is useful for assessment of and monitoring change in self-image. One potential problem is that the positive transference to the Body Image Therapist can be quite strong; if this is not acknowledged and addressed by the treatment team, splitting can result. For example, one anorectic client caught repeatedly purging began requesting meal time supervision from the dance/movement therapist. It was later discovered that she had hoped the trusted therapist would let her consume less food, and would not know she used tricks to hide food.

There are a number of potential developments for this method. It could readily be researched, as it contains measurable and objective features. It could be used in prevention, treating clients who show symptoms related to eating disorders. Putting these clients through Body Image Therapy would allow work on one of their presenting problems, helping them build a better self image. This programme is also valuable for on-going maintenance and

support for clients who complete treatment programmes. Body Image Therapy Support Groups would be effective out-patient resources. The model is easily applied to other populations with body image disturbances. Community groups could be held on body image, for personal growth work, to help counteract the negative influences of the media on our cultural body images: any developments which help our culture deem a wider range of bodies acceptable will help reduce the incidence of psychiatric disturbances related to body image disturbances.

Notes

1. The Association for Dance Movement Therapy promotes, develops, and sets standards for the use of dance/movement therapy throughout Great Britain. For information write: ADMT, c/o Arts Therapies Department, Springfield Hospital, Glenburnie Road, Tooting Bec, London SW17 7DJ.

2. Larger, regular group sessions were not conducted until Totenbier began work at a different hospital, serving a larger number of eating disorder clients. This facility offered a weekly group for current inpatients combined with out-patients, which focused on body image issues. Many of the techniques described in this chapter were used in this setting.

3. As the majority of eating disorder clients are female, the feminine pronoun will be used for the client throughout this section, to avoid the awkward use of s/he in an attempt to achieve non-sexist language.

4. This is similar to an exercise for actors, described in detail by Dezseran (1975, p.40), who suggests many other activities good for developing body awareness.

5. For an excellent series of activities focusing on body boundary exploration the reader is referred to Stark *et al.* (1989, p.133–135).

6. Dance/movement therapists often use a 'stretch cloth', a large piece of lycra fabric, approximately three yards square. The stretchy quality of the fabric allows it to be pulled as well as draped around the body, providing surface contact and tension on more body parts.

References

Association for Dance Movement Therapy (1990) *General Information.* London: ADMT.

American Psychiatric Association (1980) *Diagnostic and Statistical Manual of Mental Disorders* (3rd ed). Washington, DC: American Psychiatric Association.

American Psychiatric Association (1987) *Diagnostic and Statistical Manual of Mental Disorders* (3rd ed, revised). Washington, DC: American Psychiatric Association.

Bartal, L. and Ne'eman, N. (1993) *The Metaphoric Body: Guide to Expressive Therapy Through Images and Archetypes.* London: Jessica Kingsley Publishers.

Cash, T. and Pruzinsky, T. (eds) (1990) *Body Images: Development, Deviance, and Change.* New York: Guilford Press.

Dezseran, L. (1975) *The Student Actor's Handbook: Theatre Games and Exercises.* Palo Alto, CA: Mayfield.

Fallon, A. (1990) 'Culture in the mirror: Sociocultural determinants of body image.' In Cash, T. and Pruzinsky, T. (eds) *op.cit.*

Fisher, S. (1990) 'The evolution of psychological concepts about the body.' In Cash, T. and Pruzinsky, T. (eds) *op.cit.*

Fisher, S. and Cleveland, S. (1968) *Body Image and Personality* (2nd ed, revised). New York: Dover.

Hornyak, L. and Baker, E. (eds) (1989) *Experiential Therapies for Eating Disorders.* New York: Guilford Press.

Kramer, A. (ed) (1981) *Woman's Body: An Owner's Manual* (revised ed). New York: Simon & Schuster.

McNeely, D. (1987) *Touching: Body Therapy and Depth Psychology.* Toronto: Inner City Books.

Rice, J., Hardenbergh, M., and Hornyak, L. (1989) 'Disturbed body image in Anorexia Nervosa: Dance/movement therapy interventions.' In Hornyak, L. and Baker, E. (eds) *op.cit.*

Rosen, J. (1990) 'Body-image disturbance in eating disorders.' In Cash, T. and Pruzinsky, T. (eds) *op.cit.*

Schilder, P. (1950) *The Image and Appearance of the Human Body.* New York: International Universities Press.

Stanton-Jones, K. (1992) *An Introduction to Dance Movement Therapy in Psychiatry.* London:Tavistock/Routledge.

Stark, A., Aronow, S., and McGeehan, T. (1989) 'Dance/movement therapy with bulimic patients.' In Hornyak, L. and Baker, E. (eds) *op.cit.*

Totenbier, S., Olivera, B., and Borczon, R. (1988) 'The expressive therapies in mental health.' *Psychiatric News Network 2* (1) 6–9.

Wolf, N. (1990) *The Beauty Myth: How Images of Beauty are Used Against Women.* London: Vintage.

Eating Distress, Women and Integrative Movement Psychotherapy

Helen Payne

Outline

This chapter is concerned with describing the first stages of an extensive, systematic inquiry with a focus on extracts from the preliminary fieldwork group sessions. The approach uses integrative movement psychotherapy with women survivors of eating distress. The programme breaks new ground as a community-based project offering an opportunity for change to long-term sufferers of this ever-increasing problem.

Definitions

Before embarking upon the descriptive sections I feel it is important for the reader to understand my definitions of the two major terms used in this piece.

Eating distress

What is it that I understand by the term 'eating disorder'? At its simplest, an eating 'disorder' is a reflection of a person's degree of unhappiness with themselves. I prefer the term eating 'distress' since it is less clinical and undermining. Many individuals with an eating distress are restricted in emotional expression and receive their self image entirely through others. They perform for others, yearn to be recognized and attempt to be perfect. Experiences of working with such sufferers in group and individual approaches has highlighted these clients' obsessive vigilance about their bodies, calorific intake and how they appear to others. They need to experience the reality of their body through becoming actively involved in

therapeutic exercises to change body image attitudes and behaviours (Rosen *et al.* 1989). They do not have an accurate or distinct mental representation of their body, and have negative perceptions, thoughts and feelings about their bodily experiences (a negative or distorted body image). The body image distortions in many eating-distressed clients are promoted by their eating preoccupation, exercise routines and dieting attempts.

Anorectics, bulimics and compulsive over-eaters often experience their bodies and themselves as easily invaded, exploited and overwhelmed by external sources. Therefore feelings around the issue of control is also a recurring theme which is well documented in the literature. It is also acknowledged that body image experiences are intertwined with feelings about the self. An approach which uses the body-self may develop a more integrated sense of identity and lead to an efficacy of a new treatment possibility.

Recent research exploring the effects of medication on body image showed group psychotherapy alone (as compared to medication) reduced body dissatisfaction (Mitchell *et al.* 1989). Other research literature has shown that group experiential approaches have been found to be helpful in decreasing body-dissatisfaction for women with bulimia nervosa (Wooley and Kearney-Cooke 1986). Self-help groups for sufferers of anorexia and bulimia have also been the subject of inquiry with resulting positive outcomes (Deeble *et al.* 1990, Deeble and Bhat 1991). Other literature such as Orbach (1978) and, more recently, Richards and McKisack (1993) support the use of experiential group therapy. In the latter description the approach was found to raise self-esteem and decrease body-dissatisfaction scores as well as reduce re-referral rates for undergraduates. If an effective treatment for eating-distressed clients is found they will no longer need to be required to take medication or become hospitalized.

Integrative movement psychotherapy

Integrative movement psychotherapy is a development from dance movement therapy and, in common with many other body-orientated therapies, uses movement and the body as the focus for change (Reich 1942, Feldenkrais 1973, Lowen 1975, Pesso 1969, Rolf 1980, Levy 1988). It is a process which furthers the physical and psychic integration of the individual. In particular, movement psychotherapy employs verbal integration of the body-focused experience. For example, in therapy groups the clients are encouraged to reflect on their week in the initial section of the session. They may also raise issues emerging from the previous week's session. In one group the scenario went as follows:

'Karen was absent as well as Jennifer; Nicola had forgotten Jennifer was going to be absent this week, thought it was to be next week. A long silence followed this focus. I remembered my fantasy from earlier in the group time that the group members who were now present would not come at all. They arrived about five minutes late. Absence was not unusual; on several occasions members had failed to arrive, sometimes without any prior message. They were also late at times. As I waited I considered the emptiness of the seats. Perhaps these feelings of loss I was experiencing were just those feelings the group experienced.

'I heard a noise outside and two members arrived in a flurry, giggling like naughty schoolgirls. In a previous session there had been a connection by the group between "fat" and "naughty girls". As the silence continued I decided to comment on the difficulty of beginning today and whether they had reflected on last week. The silence felt like a neediness and a withdrawal, perhaps in relation to the previous session in some way. Nicola said she had not thought about it at all. She had denied Jennifer's absence as well; did she also deny her neediness in other ways? Jackie said she had felt things had shifted a bit for her last week, she felt good about herself this week. They went on to speak about their obsession with weightwatchers and books about dieting. The overwhelming desire to eat, unable to give it up because of the need to live. I suggested they might be feeling an insatiable neediness in the group as a result of the absence of two members, the need for the group to "live on" and an anxiety it may not. The previous session had revolved around the theme of their needs never being fulfiled, and the difficulty in getting any needs met because of other people's demands upon them.

'It seems as though the group is following through on this theme now in their responses to absences and their needs in the group being met/unmet this week.'

In combination with the words, movement and a focus on the body is considered a practical tool for the client to use, if they wish, when considering their feelings about their body and life experience. A basic assumption is that movement or posture is an important personality component (North 1972, Geller 1978). The most direct experience of the self (and the various sub-personalities, Rowen 1989) is available through the body; the awareness of the relationship between emotional and bodily experience is primary in the approach. This relationship has been found to be helpful in treating a

range of psychiatric and learning disorders. Krueger and Schofield (1987) give an overview of dance movement therapy with eating disordered patients in general. Literature has documented the use of dance movement therapy with anorectics (Silberman-Deihl and Komisaruk 1985, Burn 1987, Rice *et al.* 1989, Franks and Fraenkel 1991) and bulimic survivors (Stark *et al.* 1989); little is known about the efficacy of the approach to date. However, Fisher's (1986) review supports the position that body-orientated approaches have the potential to offer a positive effect on psychological well-being.

I have coined the term 'Integrative Movement Psychotherapy' more recently because I feel it more accurately describes my work now. It captures the notion of the use of movement (to include dance at times) and that of psychotherapy. It is important to distinguish the latter from 'therapy' as in art therapy or dance movement therapy which may be informed by psycho-therapeutic concepts but which does not offer the depth, techniques or artistry normally associated with psychotherapy, apart from when used as brief therapy. The approach in integrative movement psychotherapy aims to synthesize transpersonal, analytic and humanistic psychotherapeutic frame-works in an active, experiential methodology. Of course, the belief that everyone is basically 'OK' is fundamental to the approach, hence the refusal to call the person a patient but rather client or group participant. It also shares with other holistic approaches in that it follows the energy whether ex-pressed physically, spiritually, emotionally or intellectually. John Rowan, an authority on integrative psychotherapy, states that an approach is integrative when it: 'unifies the three basic legs on which psychotherapy stands: the regressive, the existential and the transpersonal' (Rowan 1992 p.119).

In a practical way the approach works with the client's past as relevant to the present, for example by taking a detailed case history at the initial interview and then connecting this with the client's material as expressed in the group where appropriate. For example:

> 'Joan's gesture was an anxious pressing of her hands together; behind this was a vacant space, she said. It reminded her of a long train journey alone when she was three and a half years of age, 'being left' I suggested. She cried and then expressed anger. I knew from her history that she had been sent away from her home as a three-year-old to live with her aunt. Her mother had left her father, who had set the house on fire after coming home drunk. She was put on a train and someone going that way had been asked to look after her. She returned to live with her mother and father again at eight years. This was the first of three separations from her parents. She had been divorced five years prior to the group commencing and had recently experienced the

death of her youngest child. So loss was an important issue for this woman. I got the impression that she re-experienced the absence of mother in this hand gesture. I went on to speak about my understanding of her feelings in relation to her early childhood experiences and current life experiences.'

It also works with the 'here and now' as reflected in the current experience of the client's world, for instance:

'A woman brought a dream of seeing herself as a fat sow with hundreds of piglets suckling from her. She had seen this once in her childhood. In the previous week's session we had moved the "mask which covered the secret" and then drawn the mask, that which is used in public. Kathy's gesture for what was really going on behind the mask was concerned with self-supporting contact. This was associated with her need to lean on her husband more, feeling more needy. She said she does not find this at all comfortable. She had expressed her acknowledgement of vulnerability because she now had three children and could not do everything for them, needing to rely on her husband to do some things; for example, to ferry them around in the car because she could not drive. She expressed the wish to do everything on her own as she had in the past. The meaning of this dream could be interpreted in many ways. She had seen the dream as being about the current enormous demands made upon her by her children and her response to those demands as becoming fat in order to give more. With a previous session's notion of "nurture others, deny self and eat to compensate" together with the disclosure's from last week in mind I suggested she may feel the need to satisfy all the children's needs and her own inner child totally from her own resources. She may resent the current situation in which she experiences herself as having to rely on her husband, or another, as this may highlight an awareness of her own vulnerability.'

Or it may be expressed in the dynamics between group participants. In the preliminary fieldwork this was illustrated by the following:

'There seems to be some transference for Kathy, Jackie and Nicola in relation to siblings. For example, Nicola's sister was anorectic, is this why she is so angry with Wendy (who was my apprentice and thin)? Kathy's sister was clever and given all the attention because of that, she felt, again, Wendy is seen to be clever and given extra attention by me, maybe because of her role. Nicola's anger with Wendy could be linked to her relationship with her sister, her need for mother's

attention, perhaps. So the group is not expressly angry with mother but with each other. Deprivation, anger and mother seem linked today. Displacement of anger onto another in the group, who is aligned in some way with mother. My impression is that they feel anxious in expressing it directly to me because they feel I control them and they can never be good enough to receive my unconditional love; it is never unconditional for them in the transference, always conditional. When told by mother not to eat, they eat; told what to eat by mother, they do not eat, they said; the word rebellion was also used today. I suggested the group may be expressing a need to 'get back' at mother by 'hating/envying' a sibling. A sense of wanting mother all to themselves, as individuals at this early stage of the group.'

The group-analytic model is brought into play here whereby interpretations are made at the group level rather than related to individual clients.

Finally, in the transpersonal the approach emphasizes the future or the higher self whereby a person gains a greater perspective through a spiritual insight. In this aspect the intuition of the therapist is drawn into play, a facility of the higher unconscious which is beyond the ego boundaries.

By inviting work with metaphors and images the approach brings the realm of the transpersonal into focus. For example:

'Just before a session commenced I had been talking about house cleaning; it was the third session before the end. In the session a lot of guilt was expressed around not being good enough for 'mother' but also a sense of disappointment in mother (perhaps they are beginning to get in touch with feelings that mother has let them down). An anger with mother but as they cannot tell her this they feel guilty instead. One member was concerned her mother was "too old" to do the cleaning in her house, although she welcomed her help. They all said they had "dirty" homes. There was a sense of "dirty" representing the "bad" parts of themselves they did not want to face. "Can they allow themselves to leave this group without feelings of guilt?" I said. "Is mother in the wrong place?" I thought. Either they deny the messiness or have mother look after it, yet now are anxious she may not be able to. They can begin to speak their dissatisfactions about mother, or their fears of being "let down" in the future by mother (the ending, mother being too old – nearing death?). With this in mind we used imagery to move a structure concerning "guilt" this week. The "guilty" part of Alison was represented in her move-ment where she felt like an old man trudging up a hill with a large

weight on his back, she then became a light fairy offering him help which he rejected. In her movement Sara became the chained man from the story *A Christmas Carol* (she could not remember the name). She found it difficult to dialogue with the beautiful, slim woman who shut her ears to his pleading to take some of his burden from him. The first archetype is of the burdened, suffering one who is offered help and rejects it because of the guilt which is believed to be deserved and held onto. The second wants to get rid of the guilt burden to the perfect one who denies its very existence. In each case they choose to hold onto their guilt, and this was suggested to them. In this way the collective unconscious may be witnessed by the therapist and symbolic experiences actioned by clients.'

I have found the development of my work into an integrative approach has provided me with a greater flexibility to adapt the intervention to the situation, be more spontaneous and less hide-bound to a given theoretical model or rules. Practice informs theory not the other way around and we ought to recognize the need for dialogue between the two.

The groups were a pilot for the following proposed research project which I outline below.

The inquiry

Background

This project is conceived under the auspices of the Institute for the Arts in Psychotherapy, a local group of arts therapists based in St Albans and has already received enthusiastic support from two consultant psychiatrists, a clinical psychologist and local GPs.

The inquiry approach consists of action research into an innovative approach for psychotherapy with women in the community with an eating distress. The second part of the Government's White paper on the Health Service, which came into effect in April 1990, stresses the re-shaping of the role of the General Practitioner whereby they become the manager and budget holder of health care. This initiative bears in mind recent government initiatives since these changes will affect the use of arts therapies in the community and in particular the role of integrative movement psychotherapy with eating distressed people. Therapeutic work with this population is necessarily long term since most are chronic sufferers and therefore expensive and many GPs may feel they cannot afford to offer 'treatment' themselves.

Projects within primary care are required to help in the development of services for eating distressed people, who are on the increase and unable to

be treated indefinitely in hospital. The voluntary sector, such as charities, may become more involved as partners in care and service provision. This project is open to the collaboration of both the primary care sector of the NHS and the Mental Health Foundation in providing financial resources for this service.

In this inquiry we aim to document the therapeutic experience first from the therapist's and later from both the therapist's and clients' perspective. In this way we aim to explore whether an emphasis on movement as a therapeutic approach could help to unlock some of the barriers to change, allowing for a less destructive, more positive and healthier attitude towards the body and the self.

Aims of the research

1. To explore the clients' perceived value of the approach.

2. To offer the opportunity for primary care teams of the NHS to collaborate with the Institute for the Arts in Psychotherapy in providing this service for the NHS as part of community development in service provision.

3. To set up and implement a series of short term ten-week preliminary programmes to explore the implications of the proposed inquiry.

4. To develop and pilot a systematic research approach over a period of 21 weekly group movement psychotherapy sessions for five to eight local women with a chronic eating distress.

The inquiry methodology

Over the past year, by collaborating with GP surgeries in the locality of St Albans, referrals have been made for three weekly short-term (10–12 weeks) groups and individual treatment programmes in integrative movement psychotherapy for women suffering from bulimia, anorexia and compulsive over-eating.

The project will be a pilot, following on from this preliminary fieldwork, operating for 21 weeks with a total of an additional three months for the setting up, follow-up interviews and write-up periods. This will provide further data for a longer research project at a later date. Attention will be given to the needs and effectiveness of the service as part of primary care for this population during the pilot fieldwork.

Primary health care workers, especially doctors, find it difficult to help these people; more medication in the form of physical treatment is not always appropriate.

Therefore several preliminary programmes have been undertaken which resulted in the following protocol being decided upon for a pilot research project. The descriptive case study is from one such programme.

The inquiry will focus on an analysis of the multi-faceted realities of all stakeholders in the inquiry process, at whatever level or stage. Recent initiatives in the medical field show that co-operative approaches to inquiry, from the emerging paradigm, offer a greater validity to research (Reason 1988). These research methodologies have a foundation of established work in the fields of education, management, psychotherapy, and social work. In the light of these findings it is this participatory action research approach that the project has adopted. The research does not seek to be a straightforward evaluation of the project, but aims to engage participants in evaluative approaches. I have developed my expertise in this during prior projects discussed elsewhere (Payne 1993). Outcomes of the approach adopted will yield:

1. Working with body image through the medium of movement and stillness is potentially an effective way of working with eating distress because it addresses the pattern leading to the symptom.

2. A refinement of the method for the field of somatopsychic therapies.

3. Potential benefits for the funders, the clients and the GPs.

Research tools

Journals, semi-structured interviews and regular de-briefing meetings will be the main research methods employed. Clients' perceptions of the treatment process will be elicited through their personal journals, which they will be invited to keep throughout their treatment. Journals will include comments on aspects of the approach such as techniques, strategies, facilitation and the therapeutic process, under headings such as 'helpful/ unhelpful'. These comments will be analyzed by myself and/or clients themselves, after the research programme. All participants would be given complete anonymity in the write-up and publication of findings. A code of ethics concerning confidentiality will be negotiated with participants early in the research process.

Interviews will also form a major tool for eliciting information from stakeholders. In the light of my previous experience in this sensitive area

where the therapist is a key player in both the research and the therapy, an interviewer will need to be employed to undertake these.

Pre- and post-programme semi-structured interviews with clients (by the outside interviewer) will provide for data on assumptions and reflections about the programme and on the research process. GPs will also be invited to comment through interview before, during and after the programme implementation. These interviews will be recorded and transcribed. Then the participants will be invited to analyze their own transcriptions to arrive at significant themes and contradictions. Together with myself, decisions will be made about the future design and outcomes of the research.

Group debriefing meetings with myself will be held independently for both the GPs (eight in total) and the women clients at regular intervals to enable reflection on the research process in general and to encourage greater authority and self-directed roles.

Final reports will be shared with all participants and comments invited. One report will provide an evaluation of the treatment since it is considered an essential part of the project for the following reasons; services in the community require rigorous, systematic implementation if further work is to be cost effective; feedback would aid the development of the project itself and the practices/charitable association involved. The complete results and implications will be documented in the relevant journals to provide a wider dissemination of the project and a greater understanding of the ideas inherently involved. The collaborating funding organization, and GPs will also be invited to comment on final reports and to contribute to the writing. In addition, there may be several short reports written for each player in the project.

My previous experience in evaluative and research initiatives using interviews and journals (Payne 1987; Payne 1990) will enable a high quality pilot project to be undertaken, part of which will entail a detailed and thorough evaluation. The identification of major stakeholders such as the GPs, the women and funders enables criteria for success to be identified by them in their own terms.

Outcome would be related to the stakeholders themselves, whereby they contribute to decisions about the conclusions. For example, GPs may wish to know if the service is cost effective, women participants whether they will become less anxious about their bodies and the funding body whether the project was effective in terms of satisfying the families/carers of the survivors. The inquiry will seek to elicit information from all these stakeholders and collate, analyze and interpret the findings.

Through this participatory approach, where the women participants and GPs have a voice in the process of the research as well as the evaluation, the research hopes to contribute to and support the therapeutic objectives which aim to facilitate the womens' experience of increased control over their lives. In this way there is a consistency in the therapeutic and research philosophy.

Supervision

On-going clinical supervision for myself as the therapist is available with an experienced analytical psychotherapist. A provisional monthly arrangement for the research aspect of the project has been made with a woman member of a University department which has expertise in the methodology and previous experience of action research in collaborative inquiry.

The role of the Eating Disorders Association

This organization is enthusiastic about the project so far and wants to advertise it in their magazine. It is not involved day-to-day and its role is a supportive one since it does not have the funds to sponsor research. I have consulted with its managers and this is the way they wish to be involved.

Costing

The budget has included a range of materials, expertise and time costs. For example: expenses for the programme, interview costs and materials, transcribing expenses, report writing costs, equipment costs (tape-recorder and tapes), project supervision, travel costs, clinical supervision, subsistence and travel expenses for GPs (eight) meetings (eight). Cost of the hire of space will need to be met out of contributions from the group participants. Sessions take place at the clinic at the Institute for the Arts in Psychotherapy.

The research would require the employment of a skilled interviewer to interview the patients and GPs before and after the programme and a follow-up interview three months after the programme. I would be involved with the clients in collating and analyzing data from journals, de-briefings and interviews, liaising with other players in the project and incorporating their views. The documentation will include one outcome case study evaluative report and three smaller reports. GPs will be invited to eight de-briefing meetings where lunch, tea and coffee will be available. The purpose of the meetings is to monitor the study from their perspective.

Overall duration for pilot

After the setting up of the project, the first six weeks will be spent liaising with GPs and selecting participants. The programme will then run for 21 consecutive weeks, apart from breaks at holiday periods. After this final report writing stage will begin in earnest. The follow-up interview with client participants together with the collection of thoughts from other collaborators will conclude the fieldwork.

A case study

The following description of a group is extracted from my notes during the process and is from my perspective only. It concerns a ten-week closed group of self-selected clients and formed part of the preliminary work for the inquiry described above.

Therapeutic aims

1. Development of a healthier body-image and less dissatisfaction with the perceived body.

2. Increase of clients' control over their lives.

3. Provide for generative change.

Therapeutic tools

Since I have experience and training in approaches to psychotherapy involving humanistic, transpersonal and analytic approaches these strands are integrated together with movement and body image techniques whereby a process and experiential model of therapy is employed. The sessions were of one and a half hours duration weekly. Clear therapeutic boundaries were maintained throughout.

Population

The women for the programme were be drawn from the practice lists of the participating GP surgeries and self-selected for group or individual treatment in consultation with their GP. Self referrals were encouraged in which case liaison was sought with the GP with the patient's consent. An advertisement for the group was placed in a therapy journal, local paper and a flyer distributed.

Referral procedures

Before setting up the programme the following criteria were helpful for professionals in the primary care team to consider when making referrals.

- Those needing an alternative to hospitalization and physical medicine
- Those needing a reduction in, or alternative to, physical treatment approaches
- Those in a period of transition from in-patient care to the community
- Those who seem to be isolated
- Those stuck emotionally.

Selection

There was a maximum of six and minimum of three places. For the pilot project informed and free access to the idea of the research project will be given to all those considering participating. In this way GPs and patients will be aware from the beginning of the related research project and that their co-operation will be sought. They may choose to play a strong or weak role in the research as it progresses.

An assessment interview was undertaken by the therapist prior to offering the client a place on the group. The aim of this is to create a positive expectation before the onset of the group, to give information on the facilitation, approach, and aims (to correct any prejudgements of the group) as well as to elicit a personal history and clarify issues such as confidentiality. For the pilot study the research project will also be discussed at this interview to engender a favourable conception of this too. These pre-group interviews are offered to women on a first come first served basis. Only a small charge is made for the interviews and for the group as a whole in recognition of the client's time input to the project.

Places are normally offered to those who seem to fulfil the following criteria:

- High motivation for a group approach to therapy
- An insightful attitude (such as self-disclosure and ability to introspect) towards their problem or the potential to develop such an attitude
- Acknowledgement of eating distress
- Chronic suffering over more than two years

- Demonstration of some understanding of a psychotherapeutic approach
- A hopeful though not unrealistic attitude towards the possibility of change
- Supportive family relationships
- A favourable attitude towards the use of body image and non-verbal interactive structures as well as words.

Criteria for exclusion, some of which are based on Yalom's (1985) recommendations, include the following:

- those who are diagnosed as having a learning difficulty, depressed or suicidal
- acutely psychotic, sociopathic, paranoid, or hypochondriacal
- those addicted or using drugs or alcohol
- those under the age of 18 years
- those in the midst of an acute life crises
- those who may not attend regularly
- severe body image disturbance.

There follows an extraction from my notes of one of these preliminary sessions. As in the examples above any identifying features have been disguised to protect the anonymity of the women participants.

'Daphne and Wendy absent. Daphne owes final part-fee payment. Members arrived together a little late. I acknowledged Wendy's planned absence and raised the possibility of Daphne's absence. The contact between the two group members who were present was sensitive and empathic after a brief period of withdrawal when I acknowledged absences. Smoking was discussed early on in the session. It was felt that this was another "obsession" and "secret" like eating. Laura said she'd noticed Rosie smoked. Rosie said she "only did it when away from everyone else". Did she also only eat when out of others' view I thought? Perhaps she'd been "caught" in being noticed as a smoker by Laura; the secret was out! Interestingly, it was after this discussion that some dreams were shared. It was as if secrets, including the secret world of the unconscious, were now able to be acknowledged out in the open and now could be explored in their therapy.

There followed a period of reflection on their week which included the dream – sharing. Rosie's was about being fat and naked and winning the swimming race. She interpreted it as still being able to reach her goals even though she felt overweight. I suggested she was also naked in the dream, did she perhaps wish to acknowledge her vulnerability in this? I asked. No comment. The first of Laura's dreams concerned her being told she was to make her own music at the opera. There was a man with hoods on his head which she repeatedly pulled off, she said this man was not her husband. There was no interpretation of this dream at this time. The second dream she shared was about a church basement (where the group was held in actuality) in which people were "not whole" and bathed in a mystical light. There was a voice saying "give up your pain". They both felt this second dream was very much about this group and its purpose.

They wanted to do an exercise I suggested which used imagery, movement and drawing to imagine the body as a creature moving or still in a particular environment which then meets another creature/person/object and interacts or not. I led them through the structure which lasted about 20 minutes. The movement experience was followed by a short transition period of drawing time prior to any words being expressed.

Laura's animal was a fawn which met a lady who placed a golden cord around its neck. Then there was a huntsmen who said to the lady "that's OK I won't hurt it any more now". Laurie spoke of the image as relieving her of some of her suffering. I said if this had been my experience I would have felt the lady was rescuing and protecting the fawn from the huntsman yet also capturing the fawn by putting it on a magical lead. Laurie then spoke of a second image which emerged in the exercise of a chocolate box pig trying to escape from being trapped. She said she identified with the first image rather than this one though. I was unsure of the precise significance of this second imagery but it seemed to be concerned with her need to become less trapped.

Rosie's image had been of a horse galloping freely which met a chicken with some eggs. She said her parents had kept chickens when she was a child. She had loved to play with them and felt a loss when they had to be destroyed. Her expressed need for wild, unharnessed energy and freedom in opposition to her current experience as a "mother hen" with her eggs seems apparent here. Does she, in her

experience of being a mother, deny herself her wild, free part? This loss she then refers to explicitly in her association of a childhood loss. Later in the next week she telephones me to say she does not feel able to attend the group this week but will be there the following week. Her children are returning from being away and she wants to be there for their return. They said she should go to her group but she feels she wants to be there for them arriving home. I suspect her need to be in control of her "eggs" is restricting her attempts to become freer. She restricts herself even further by denying herself her own therapy – the very pathway to her freedom!'

The above reflection illustrates the power of movement in an integrated approach utilizing metaphor to elicit and connect with inner worlds. Restriction and control and freedom and rescue emerge as working themes, tempered with an acknowledgement of suffering, vulnerability and the desire for protection.

Conclusion

In this chapter I have described how integrative movement psychotherapy can be adopted for women suffering from eating distress to facilitate exploration and understanding of the conflicting feelings and issues experienced.

The pilot groups have given a clearer picture of how a co-operative inquiry may be undertaken which involves the clients themselves as actors in the research through playing a part in the design, journal-keeping, interview, and commenting on transcriptions. The aims include: to facilitate change in a group of women suffering eating distress, a refinement of the brief therapy approach, and an opportunity for collaboration between the NHS and a voluntary body. It is an approach in which all can participate in inquiring into the therapeutic process, whereby their perceptions are engaged with. Research as part of therapy and therapy as part of research.

From the preliminary study it is recommended that care is needed in defining clear criteria for the assessment and selection of clients. Pre-group consultations are essential in clarifying both the nature of therapy and how the research project inter-relates with it. Referral procedures are needed for primary care teams to consider and self referrals encouraged. There is a requirement to engage an outside interviewer to ensure clear role boundaries for the therapist, and involve participating GPs in sharing their views.

Finally, I can see a good future for this form of therapy for two reasons. First, it offers a movement/body focus as well as talking in a synthesized

approach which has special advantages for women suffering with eating distress. Second, the interpersonal and common nature of the group is a powerful means for promoting understanding and change. Third, the integrated model of psychotherapy facilitates exploration of pre-personal, personal, inter-personal and transpersonal experiences.

References

Burn, H. (1987) The movement behaviour of Anorectics: The control issue. *American Journal of Dance Therapy 10*, 54–76.

Clare-Baker, N. (1987) *The construction of the self: An art therapy approach to the use of body image.* MA dissertation, Hertfordshire College of Art and Design (now University of Hertfordshire).

Deeble, E.A., Crisp, A.H., Lacey, H.J. and Bhat, A.V. (1990) A comparison between women seeking self-help and psychiatric treatment in anorexia nervosa and bulimia. *British Journal of Medical Psychology 63*, 65–72.

Deeble, E.A. and Bhat, A.V. (1991) Women attending a self-help group for anorexia nervosa and bulimia: Views on self help and professional treatment. *British Review of Bulimia and Anorexia Nervosa 5*, 1.

Feldenkrais, M. (1972) *Awareness through Movement.* New York: Harper and Row.

Fisher, S. (1986) *Development and Structure of Body Image.* Hillsdale, NJ: Erlbaum.

Franks, B. and Fraenkel, D. (1991) Fairy tales and dance movement therapy: Catalysts of change for eating disordered individuals. *Arts in Psychotherapy 18*, 311–319.

Geller, J.D. (1978) The body, expressive movement and physical contact in therapy. In: J.L. Singer and K.S. Pope (eds) *The Power of Human Imagination: New Methods in Psychotherapy.* New York: Plenum Press.

Hornyak, L.M. and Baker, E.K. (eds) (1989) *Experiential Therapies for Eating Disorders.* New York: Guilford Press.

Krueger, D. and Schofield, E. (1987) Dance movement therapy and eating disordered patients: A model. *Arts in Psychotherapy 13*, 323–331.

Levens, M. (1983) Magical control of the body and psychic cannabilism. MA dissertation, Hertfordshire College of Art and Design.

Levy, F. (1988) *Dance Movement Therapy: A Healing Art.* Virginia; NDA and AAHPRD.

Lowen, A. (1975) *Bioenergetics.* New York: Penguin.

Mitchell, P.B. (1988) The pharmacologic management of bulimia nervosa: A critical review. *International Journal of Eating Disorders 7*, 29–42.

North, M. (1972) *Personality Assessment through Movement.* London: MacDonald and Evans.

Orbach, S. (1978) *Fat is a Feminist Issue.* London: Arrow Books.

Payne, H. (1979) Body image boundary and its relationship to the social adjustment, self concept and self actualization in a group of emotionally disturbed children.

Unpublished dissertation submitted in part fulfilment for PGDip. Cambridge Institute of Education, University of Cambridge.

Payne, H. (1987) The perceptions of male adolescents labelled delinquent towards a programme of dance movement therapy. M.Phil thesis, University of Manchester.

Payne, H. (1990) A dance movement therapy group experience as an integral part of learning on a training course in Higher Education. Proceedings of the First Arts Therapies in Education Conference; Our European Future, Hertfordshire College of Art and Design. (now University of Hertfordshire) St Albans.

Payne, H. (1992) *Dance Movement Therapy: Theory and Practice.* London: Tavistock/Routledge.

Payne, H. (1993) (ed) *A Handbook of Inquiry in the Arts Therapies: One River, Many Currents.* London: Jessica Kingsley Publishers.

Pesso, A. (1969) *Movement in psychotherapy.* New York: New York University Press.

Reason, P. (1988) (Ed) Whole person medical practice. In: P. Reason (Ed) *Human Inquiry in Action.* London: Sage.

Reich, W. (1969) *Character Analysis.* New York: Farrer, Strauss and Giroux.

Rowan, J. (1989) *Sub-personalities: The People Inside Us.* London: Routledge.

Rice, J.B., Hardenbergh, M. and Hordyak, L.M. (1989) Disturbed body image in anorexia nervosa: Dance movement therapy interventions. In: L.M. Hornyak and E.K. Baker (eds) *op.cit.*

Richards, C. and McKitsack, C. (1993) Group therapy for women with eating problems. *The Journal of the British Association for Counselling 4*, 4, 270–271.

Rolf, I. (1980) Structural integration. In: H. Herink (ed) *The Psychotherapy Handbook.* New York: New American Library.

Rosen, J., Srebnik, D., Salzberg, E. and Wedndt, S. (1989) Cognitive behaviour therapy for negative body image. *Behaviour, Research and Therapy 23*, 349–360.

Silberman-Deihl, L. and Komisaruk, B.R. (1985) Treating Psychogenic Somatic Disorders through body metaphor. *American Journal of Dance Therapy 8*, 37–45.

Stark, A., Aronow, S. and McGreehan, T. (1989) Dance movement therapy with bulimic patients. In: L.M. Hornyak and E.K. Baker (eds) *op.cit.*

Waller, D. (1980) Body image disturbance as observed in paintings by persons with eating disorders. Proceedings of Conference G and I Champernown Trust.

Waller, D. (1981) Art therapy and eating disorders. Proceedings of Art Therapy symposium and International Conference of the British Psychological Society.

Wooley, S.C. and Kearney-Cooke, A. (1986) Intensive treatment of bulimia and body image disturbance. In: K.D. Brownell and J.P. Foreyt (eds) *Handbook of Eating Disorders: Physiology, Psychology and Treatment of Obesity, Anorexia and Bulimia.* New York: Basic Books.

Yalom, I. (1985) *The Theory and Practice of Group Psychotherapy.* New York: Basic Books.

Young, M. (1985) The use of dramatherapy in the treatment of eating disorders. Dissertation for PGDip, College of Ripon and York St John.

VI
Music Therapy

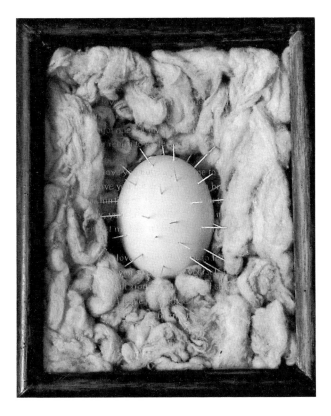

Letting Go

I love you but don't ask me to eat
I love you but don't ask me to fight
my hunger is of a making just beyond my reach
but I cannot quench my thirst with mothering milk
nor return to a life rejected in youth.

I love you but don't ask me to live
I love you but don't ask me to breathe
this hurting of life is not for you to heal,
this body, your creation, is not yours now to feed
you set me free at birth, set me free now.

You love me so allow me to leave
I love you so please let yourself free
I wear your guilt around my neck and slowly I drown
as I leave my embodied life behind
my soul begins to fly.

Elise Warriner

Towards Autonomy and a Sense of Self

Music Therapy and the Individuation Process in Relation to Children and Adolescents with Early Onset Anorexia Nervosa

Jacqueline Z. Robarts

'Music is a strange thing…it stands half-way between thought and phenomenon, between spirit and matter, a sort of nebulous mediator, like and unlike each of the things it mediates – spirit that requires manifestation in time, and matter that can do without space.'

(Heinrich Heine, 1832)

Introduction

The paradoxes of music and its mediating power may offer some initial clues as to the relevance of music as therapy for young people suffering from the condition anorexia nervosa. Can the paradoxes of music address the paradoxical psychosomatic phenomena of the anorexic condition? Can music mediate the 'mind/body split', the dichotomies of denial and disturbed self-perception associated with anorexia? How can music used in therapy bring about integrative processes of individuation, basic psychological and physical well-being? Heine's thoughts on music conjure up parallels with the paradoxes of Winnicott's (1971) transitional space or intermediate area of experience, 'Me and Not Me', and other creative phenomena of human experiencing. ('Experiencing' conveys the dynamic, vital quality of sensing the here and now, the simple (or, equally, highly complex) 'Is-ness' of being in the flow of time. 'Experience' is abstract, referential, distanced, fixed in time.)

The paradoxes of our deepest sensibilities, which seem to lie beyond the grasp of the intellect, assume a particular significance in the music therapy process: spirit and matter, time and space, inner and outer reality – not dualities, but two aspects of human experiencing, held in a perpetual dynamic interplay. These experiences are intrinsic to music therapy and the ways in which it can help to open the door, not only to the domain of 'being', but 'being-with' that lies at the heart of human experiencing and creative personal growth in all its mystery and its mundane reality.

This chapter explores the improvisational music therapy process and its relevance in individual music therapy for child and adolescent patients suffering from early onset anorexia nervosa. Theoretical and clinical perspectives of music therapy with anorexic children will be discussed, illustrated by detailed case material of 13-year-old 'Melanie'.

Music therapy: its role in the multi-disciplinary team

In-patient treatment on a child and adolescent psychiatry unit of the general children's hospital where I work involves a multi-disciplinary team of nurse therapists, family therapists, psychiatric social worker, dietitian, psychologist and psychiatrists. Music therapy is valued particularly for children who present psychosomatic symptoms or emotional and behavioural difficulties relating to dysfunctional family background, early childhood trauma, abuse or neglect.

Clinical and theoretical background

My work is based on a psychodynamically-informed Nordoff-Robbins approach,[1] which has gradually incorporated a developmental self and object relations perspective, my main influences being Alvarez (1992), Masterton (1985), Stern (1977, 1985), Trevarthen (1974, 1993a) and Winnicott (1971) and, above all, the many young people referred to the music therapy department. This orientation has developed over 13 years of working in both a psychiatric and a child development multi-disciplinary team. As well as children and adolescents with widely varying psychiatric disorders, children with autism and learning disabilities are also referred to music therapy. Thus, a fascinating psychological continuum or matrix of self and object relations has been central to the perspectives I have formed. As regards the complex needs and psychosomatic phenomena presented by young people suffering

1 The Nordoff-Robbins approach focuses on a clinical and creative improvisational use
 of music, founded on the work and research of Paul Nordoff and Clive Robbins (1971,
 1977).

from anorexia nervosa, concerns of ego-deficit, impaired self-identity and sense of autonomy, issues of separation and individuation predominate. The 'non-verbal', musically-supported expression of feelings and the dynamics of the musical relationship are all-important factors both in assessment and treatment. Verbal and imaginal self-expression are also supported and developed directly through the music, keeping in touch with the underlying feelings in the 'here and now' of the music therapy situation. The creative use of musical silence as much as sound is also vital in assisting self and relational processes.

Bruch (1990) writes: 'The therapeutic task is to help the anorexic patient in her search for autonomy and self-directed identity by evoking awareness of impulses, feelings and needs that originate within herself'. Bruch's recognition of a developmental basis to anorexia nervosa, the anorexic patient's inadequate and defective self-concept, the need for patient and therapist to be *active participants* in therapy, in order to engender the processes of active participation in life, is confirmed in the improvisational music therapy process with my patients described later in this chapter.

Early onset anorexia nervosa

Of the thirty or so children and adolescents with whom I have worked, who have eating disorders, there have been seven with early onset anorexia nervosa (i.e., onset between 8 and 14 years). Lask and Bryant-Waugh (1993) give an extensive account of early onset anorexia nervosa, examining the multidetermined aetiology and its various interacting components: genetic, biological, psychological, family, socio-cultural – and, increasingly, a history of sexual abuse in childhood. They point out that case definition is problematic, where the strict criteria for defining anorexia nervosa cannot apply, for example amenorrhoea, and body weight in relation to height and age (due to low food intake affecting growth rate). This is further complicated by the occurrence of atypical eating disorders in childhood. Bryant-Waugh & Kaminski (1993) provide the following diagnostic checklist for this younger age group.

Great Ormond Street Diagnostic Checklist:

1. Determined food avoidance
2. Weight loss or failure to gain weight during the period of pre-adolescent growth (10–14 years) in absence of any physical or other mental illness

3. Any two or more of the following

 (a) preoccupation with body weight

 (b) preoccupation with energy intake

 (c) distorted body image

 (d) fear of fatness

 (e) self-induced vomiting

 (f) extensive exercising

 (g) purging (laxative abuse).

Another difference between early and later-onset anorexia is highlighted by Irwin (1984), particularly emphasizing the role played by depression, which he reports usually accompanies the severe emaciation of later stages of the illness in older individuals. He links the early appearance of depression of the younger anorexic patient with the difference in distribution of adipose tissue in children and older individuals with anorexia. A study by Fosson *et al.* (1987) shows a significant incidence of depression in children with early onset anorexia nervosa. Moreover, depression and onset of anorexia below 11 years are noted as pointers to a poor outcome (Morgan and Russell, 1975, cited in Lask and Bryant-Waugh, 1992). Otherwise, the psycho-pathology of early onset anorexia is said to be similar to that of older age groups, the key features being 'pre-occupation with body weight and shape, a stated belief of being larger than in reality, low self-esteem and a tendency toward depression and perfectionism'.

The 'bodily ego': implications for developing autonomy and sense of self

The early histories of my anorexic patients highlight the complex aetiology of the disorder, especially when viewed in terms of the child's developing autonomy and sense of self: in addition to the prevalence of family history of depression as a psychological factor, each of my anorexic patients had adverse physical, or possibly genetically-based, factors affecting their earliest development. These included febrile convulsions, epilepsy, cerebral palsy, and, in one case, a family history of obsessive-compulsive disorder; in other cases, sexual abuse in early childhood by a significant family member. Such afflictions can be assumed to have a significant impact on the developing *bodily* sense of self, rendering the early sensory-affective-perceptive schema or self-organizational processes vulnerable within the dynamics of early attachment relationships. A developmental and psychoanalytic framework,

informed by infant development research, provides valuable insight into issues concerning self-concept, autonomy and control which present so dramatically and paradoxically in people with eating disorders. For those individuals suffering from anorexia nervosa the early affective processes which form the core sense of self, the 'bodily ego' which Freud (1961) describes, are directly implicated. As both the *medium and mediator* of early object relations processes engendering individuation, creativity and healthy symbolic functioning, improvisational music-making can be an appropriate primary therapeutic intervention.

A developmental perspective on self-processes and object relations in music therapy

Infant development research has yielded rich and fascinating documentation describing the dynamic forms of mother–infant communication, which is highly relevant to an object relations music therapy approach. The infant's earliest expressive-responsive behaviours manifest tonal and rhythmic elements in sophisticated, complex fluency. Indeed, musical terms are frequently used to provide an adequate, appropriate vocabulary for this domain of psychology. Sometimes termed 'proto-conversation' (Bateson 1979), early infant communication and expression would seem to be a musical field, a musical spectrum of temporal organization (pulse, pattern, phrasing, silence/rests), fluctuations of tonal-rhythmic intensity (volume and pace – increasing/decreasing), of tempo (speed), melodic-rhythmic contour (as in prosody), and so on. Stern (1985) refers to such musical phenomena when he describes the 'vitality affects' of mother–infant communication, and the importance of 'affective attunement' as a fundamental psychological building block in the child's development.

Micro-analytic studies of mother–infant interaction have shown in detail the features and infrastructures of early communication, the emotional reciprocity or intersubjectivity of mother and infant *both* adjusting 'the timing, form and energy of their expression to obtain intersynchrony, harmonious transitions and complimentarity of feelings between them in an emotional partnership or 'confluence' (Trevarthen 1993a). Like Trevarthen, Beebe (1986) emphasizes the formative, self-organizing principles of early communication as being 'a "temporal pattern of connectedness" (which) becomes a context for the emerging self- and object-representations'. Beebe continues: 'Because the behaviours of each partner are potentially so intimately temporally meshed with those of the other, one aspect of what will become internalized is this temporal pattern of connectedness of mutual responsivity'. She acknowledges other relevant parameters of intensity,

complexity, novelty and timing of *both* mother and infant, although her research focuses on variations in maternal timing. Moreover, the early communication of primary relatedness assumes universal forms which are cross-cultural and, moreover, are intrinsic to communication between people of any age (Trevarthen 1993b).

Early object relations may, therefore, be described in terms of musical introjects, which are demonstrated to begin before the baby is born (De Casper and Carstens 1981). From a psychoanalytic viewpoint, Maiello (1993) refers to the sound and silence (presence and absence) of the mother's voice as the basis of a 'pre-natal proto-object' or 'sound-object'. From this sound basis, therefore, the primary relationship develops into the organizationally more sophisticated and complex duets of emotional communication, which lead from pre-symbolic to symbolic expression. Infant psychology researchers have used the descriptive terms, 'reciprocity envelope' (Brazelton and Cramer 1991) and 'proto-narrative envelope' (Stern 1994), which convey an image of the containing, holding attributes of early communication. It is both aspects of this 'reciprocity envelope' that I term 'musical dynamic form'. In the music therapy relationship, the musical dynamic forms of interaction symbolize some of the fundamental aspects of self–other representation in early object relations. From these mutual resonances arise transitional and metaphorical phenomena. I believe this adds an important dimension to a psychoanalytic understanding of music therapy process, and points to the phenomenological basis of music therapy's 'reconstructive' and recreative potential.

Breakdown or deficits in the harmonious attunement and contingency responsiveness of the mother–infant relationship have been the subject of research by Murray and Trevarthen (1985) and Murray (1992). They observe that infants of depressed mothers fail to thrive, affecting later cognitive development. In a recent study of depressed mothers' speech to their infants, Murray *et al.* (1993) report that the speech of depressed mothers expressed more negative affect, was less focused on infant experience, and tended to show less acknowledgement of infant agency. In other words, the self-organizational processes of early object relations are adversely affected by a poorly attuned, poorly cathected, non-empathic primary relationship, however satisfactory the external, physical aspects of parental care. In Winnicottian terminology, this may result in the child's development of a 'false self' (Winnicott 1960). The significance of this is borne out in the case material of my anorexic patients.

Increasing emphasis is nowadays being given to the 'here and now' of the therapeutic process, much akin to the value Bruch (1985, 1990) set on

empathic modes of interaction and 'positive affect' as *active* components of the therapeutic process, the therapist responding as the auxiliary or helper ego (Emde 1990, Goodsitt 1985). Child psychotherapist Anne Alvarez's (1992) theory of ego deficit and reclamation offers a clinical and theoretical perspective which also has particular application to music therapy process. Alvarez emphasizes the significance of mothers' function as 'alerters, arousers, and enliveners' of their babies, also recognising the 'quasi-musical', affective nature of the mother–infant interaction and its function in ego development. She perceives this as a valid extension of the therapist's function: to be 'animate, live company', in order to provide the necessary holding, to act as a container/transformer (Bion 1965) for those children who have disturbed or insufficient ego development.

Musical dynamic form

Let us now examine in more detail the musical-emotional-structural and self-organizational complexities of the improvisational music therapy process which appear to have such direct correlations with the communicative infra-structures of the primary relationship. Nordoff and Robbins (1977) give a succinct and clear description:

> 'A thorough examination of music and of the experiences individual-ized musical activity can bring to children shows what an enormous and potentially unlimited range of *active*, self-integrative experience is available for therapeutic use: the vast range of *emotional experience* possible – in addition to the "conventional" range of emotions, all kinds of moods and nuances of feeling can be realized, all subtleties and progressions of change, all degrees of intensity. There are experiences of *form* and *order*, from the minute to the extensive, the simplest to the highly complex; there are pre-determined forms that induce stability into activity – and the forms that are creatively, expressively realized. There are the basic elements of *tempo* and *rhythm*, fundamental to music and fundamental to our extramusical organization and life. The *melodic* element contains all the above as well as the evocative concurrences between speech and music – these also make directly possible in *song*, the setting and expression of thought forms and ideas that have personal significance for a child. All this is inherent in the relationship between man and music, all this is available for creative therapy with the Music Child.'

Nordoff and Robbins define the concept of the Music Child as that which denotes

> 'an organization of receptive, cognitive, and expressive capabilities that can become central to the organization of the personality in so far as a child can be stimulated to use these capabilities with a significant extent of self-involvement. Such an involvement, creatively and responsively fostered, induces the functions of recognition, perception, and memory; intelligence, purposefulness, confidence come spontaneously into expression as the child becomes deeply, personally involved. He becomes emotionally involved, not only in the particular music or in his activity in it, but also in his own self-realization and self-integration within all the therapy situation holds for him.'

This postulates a reconstructive therapy through the agency of music itself. Music is described by Aldridge (1989) as 'a powerful and subtle medium of communication which is isomorphic with the process of living... If musical elements are essential to communication, then the improvised musical playing of people may make manifest both underlying pathology and possibilities for growth and change.' Nordoff and Robbins (1971) indicate music therapy's diagnostic potential: 'In their individual character, children's musical responses are descriptive of their pathological and developmental condition. Both progressive attributes and pathological factors are revealed. Forms of musical response hold diagnostic implications'. To some extent, Nordoff and Robbins' claims are now supported by Perilli's (1993) research on subjective tempo, which emphasizes the role of the temporal and rhythmic elements of music in diagnosis of certain psychiatric disorders. Further research into improvisational music therapy as an effective intervention shows improvement in affective states of adults suffering from schizophrenia and depressive illness (Pavlicevic and Trevarthen 1989).

Musical symptoms of anorexia nervosa

Musical expressive characteristics which seem to manifest the psychopathology of anorexia nervosa have been described in detail by Robarts and Sloboda (1994). Musical symptoms which were evident in our patients' playing included: lack of structure *or* conversely, tight, rhythmic structures (i.e., amorphousness *or* excessive control); no 'spaces' or rests; preference for high-pitched tones, also revealed in their speaking voice; lack of flexibility (in speed and dynamics – loud/soft – of playing); above all difficulty in empathic interaction with the therapist, either playing in a flat, affectless,

rather cut-off, 'one-dimensional' way *or* following every nuance of the therapist's playing in a symbiotic compliance.

The paradoxes of compliance and control form a musical 'minefield', in terms of therapeutic intervention. The 'communicative matching' of which Masterton (1985) writes (and warns) so easily can lead the music therapist into confirming and compounding the 'false self' by empathising or else by literally playing into its deficits. The lack of spontaneity and lack of vitality of my young patients' playing frequently made me feel that my music must compensate for this in some way. Yet, at times, animating their responses in a way that facilitated movement, particularly pulse, was sometimes a necessary foundation for expression of anger rather than repressed, depressed feelings. To enhance, support, and allow the patient's being and playing to develop musically and with sufficient autonomy required the utmost care in listening to each emergent related moment: carefully providing the right amount of 'space' or silence, at the right time, with the right amount of preparation/anticipation/resolution, while judging the properties of harmonic progressions and tonal colour that would be most helpful. Then there arise the fleeting moments of initiative and novelty in the child's playing, micro-shifts of tonal inflection, for which the therapist can provide musical contexts (silence as much as sound) as the nurturing environment for the tiny first seeds of spontaneous self-expression.

Case study: 'Melanie'

The following case material focuses on the ways in which a 13-year-old girl, whom I shall call 'Melanie', used the music therapy sessions. I will describe in some detail the function and process of musical dynamic form in improvisational music therapy. In the light of the preceding material regarding depression in early onset anorexia, it is significant that Melanie's illness was eventually understood to be linked with the effects of chronic depression, spanning two generations in her family.

At the age of eleven and a half Melanie was admitted to the unit with symptoms of anorexia nervosa, but her parents took her home immediately she had attained a safe weight. One year later, she was re-admitted, suffering from severe symptoms of anorexia nervosa and depression. Her weight had decreased to 35kg and then to 31kg, necessitating bed-rest and a re-nutrition programme. Family and individual therapy did not begin until a safe weight of 45kg was attained. This took five months and was carried out on a contract basis with Melanie.

Melanie's prognosis was poor. The severity of her condition was compounded by an extensive history of unacknowledged (and untreated) depres-

sion in the family, and a particularly enmeshed, symbiotic relationship with her mother. Her case notes raised concern regarding the paucity and isolation of Melanie's play when she was a young child. The unit's therapeutic work was to focus on helping both Melanie and her mother to 'grow up' and to individuate; and helping Melanie's father, also a depressive and a rather remote man, to take a more active, supportive role in the family.

Melanie came for once-weekly music therapy sessions lasting 45 minutes each for nearly a year (46 sessions in all), finishing shortly prior to her discharge from the unit. Descriptions of the sessions demonstrate the significant aspects of the music therapy process which reflect and promote change in Melanie's emotional-physical and psychological states.

Early sessions

In the initial sessions Melanie seemed depressed, yet she played spritely hornpipe tunes (with her right hand only) on the piano in a rigid unvarying tempo and 16 bar structure, which were played 'without taking a breath' and somewhat superficially, without any instinctive gusto and verve. She allowed barely a pause before introducing the next tune, and the next – an example of the rigid music control and avoidance of 'spaces' or rests, which were referred to earlier as pathological musical symptoms of anorexia. At times I accompanied her playing, endeavouring to slow down at the final cadences, create spaces for her, changing to more sonorous harmonies to bring about change of mood, increase/decrease tension, extemporize the theme playfully – all to no avail. I felt breathless and puppet-like, with a sense of myself being controlled by external forces, namely Melanie's relentless, inflexible succession of notes. I felt urged to 'do the right thing' for her. I quickly learned to attend to these feelings arising in the counter-transference. Musically, this required my absolute attention to the quality and tiny dynamic (loud/soft) shifts of her *sound* rather than to the outer, more overt features of her playing, such as its on-goingness. Was this the only way Melanie could experience 'going-on-being'?

Melanie looked lifeless, very thin, with pale skin and hunched shoulders. Her thin, high-pitched voice was hardly audible; she moved slowly and seemed to glide along as opposed to walking on the ground; she was very pale. The overall impression was that of a ghost. Sometimes she played a bass metallophone, while I provided sparse, but sustained harmonies on the piano, rather than matching her perpetual motion. Sometimes Melanie's spritely, but mechanical-sounding hornpipes would give way to an amorphous succession of notes; as before, there were no spaces or pauses in her playing, which was bland, listless and showing no natural rise and fall of

expression or inflection. Melanie's playing then seemed to depend on mine, following every pattern and nuance. This was symptomatic of her behaviour in general: at that time she wanted everything done for her in the unit, including help in getting dressed in the morning.

Being and being-with

By Session 8 I had begun to introduce a gentle syncopated (off-beat) pulse to create a sense of dynamic interplay, *two*-dimensional rather than one-dimensional: working towards self and self-other awareness and independence of expression in the music-making. The use of pulse, in various ways, was integral to providing both a supportive framework and a dynamic for change throughout the course of therapy. I discovered that the sparseness of my music, in every respect (structure, texture, harmony, dynamics) was essential, in order not to overwhelm Melanie as she began to gain some awareness of herself in the musical relationship with me.

Later in the same session Melanie chose to join me at the piano, sitting at the treble end, shoulders hunched, and using one hand only to play. Her manner of playing continuous tones on the piano, mostly stepwise or using intervals of a 5th or 6th was similar to her playing of the metallophone. In addition to the off-beat pulse, I offered a further musical intervention, moving into atonality, away from Melanie's familiar territory (the white keys of C major and of the Aeolian mode – she had a piano at home, but had had only a few lessons). The all-important pulse maintained a frame of mutual reference, Melanie sometimes joining me *on* the beat, several times in succession. The joining or sharing of the beat is an intuitive universal element of mother–infant interaction (Trevarthen 1990). This was in retrospect a pivotal session, in which a strange harmonic mixture of tonal and atonal music formed the emotional 'landscape' for evoking expressive freedom and a new self- and self-other awareness – akin to Balint's (1968) idea that the therapist should 'allow his patient to live with him in a sort of "harmonious" mix-up', a kind of facilitating or nurturing environment for the patient to form a new sense of self.

Two sessions later Melanie was beginning to initiate brief moments of more focused and assertive dialogue in the atonal and 'harmoniously mixed-up' improvising together. After such moments she would revert to her characteristic, paradoxical rigidity, amorphousness and control, playing incessant melodies in a fixed tempo, complying with anything I played that differed from her music. However, in Session 10, there occurred a split-second shift of texture and tempo in Melanie's playing: instead of her customary linear melodies, she chanced (?) to play two notes together, a major third

apart. In that fleeting moment she expressed spontaneity and something that I can only describe as verve. It represented to me a chink in her armour or, equally, a first, fleeting glimpse of her inner self. I took a risk and responded in that split-second with a couple of minor 2nds in quick succession, followed by some gentler major or minor 3rds using very short 2 beat phrases to interject with Melanie's bland, habitual playing. (Would this prove too overwhelming and squash this new life, or did this slight change in Melanie's self-expression need acknowledgement, some kind of *resonating-with*?). There developed, however, much more spontaneous playing together, reminiscent of mother–infant 'chase and dodge' games, which Beebe (1986) describes as containing and integrating the negative feelings and projections of the infant. The increase of rhythmic and harmonic tension encouraged Melanie to respond more actively and dynamically, initially through identifying with my music, then spontaneously initiating her own ideas. This episode culminated at the cadence in a spontaneous solo flourish from Melanie, playing a fast ascending chromatic scale. It felt like a first experience of the freedom of which she wrote some years later after the leaving the hospital.

At this time Melanie's target weight was increased by 1 kg., since she had been able to sustain her safe weight now for two and a half months in the unit's therapeutic and management programme.

Increasing intensity and freedom of self-expression

Melanie began to express stronger feelings and emotional intensity, often 'provoked' by my musical interventions to her habitual ways of being. Listening intently to every nuance and texture of her playing was essential for me to gauge the moment and the musical form of intervening in Melanie's defensive, very limited (and limiting), habitual forms of self-expression. This aspect of the music therapy intervention and the music therapist's clinical awareness-cum-musical resourcefulness is crucial; otherwise there may arise the danger of colluding with 'false self' processes.

After Session 10 Melanie was reported to be expressing anger at her mother and having temper-tantrums in the family therapy sessions; moreover, so was Melanie's mother. This gave the unit team considerable insight into the nature of the symbiotic relationship and psychological enmeshment of mother and daughter. Melanie's increasing sense of herself and her developing autonomy marked the beginning of separation and individuation. Melanie's mother showed that she was not (and never had been) sufficiently emotionally available for her daughter; moreover, it emerged that Melanie's maternal grandmother suffered from depression, culminating in her seeking treatment for the first time. This coincided with the onset of Melanie's

anorexia. The impact of maternal depression in two generations was reflected in the dynamics of the music therapy and family therapy sessions: Melanie's compliance, over-dependence and lack of autonomy was shown in her limited range of self-expression and difficulty in initiating her own ideas. In this regard, the potential of the music therapy process takes on a new significance as a container *and* transformer (Bion 1965) and highlights the appropriateness of a music therapy model that uses musical dynamic form as 'both the medium *and* mediator of...self-organization and personality inte-gration' (Robarts 1993), a model in which new healthier self-structures are mobilized and internalized.

Later sessions

Melanie's feelings ranged from anger to joy, delight and then sadness during the ensuing sessions. This was clearly expressed in the music-making and the more spontaneous, inventive forms this took, culminating in a jazzy improvisation on the strings of the grand piano. Tight, conventional rhyth-mic patterns would give way to syncopated and pointillistic innovation. At other times Melanie would ask me to play the piano keys while she aimed for the exact strings of the notes I was sounding. This produced a distorted, jagged, off-key gibberish, a highly satisfying development of our earlier 'chase and dodge', and this time at Melanie's instigation. On the ward and in the family therapy sessions Melanie was likewise showing more assertive-ness, although often at an infantile level, which needed careful support and management. Both her mother and her father were now venting strong emotions in the family therapy work. They were also weary of all the pressures and commitment of therapy. They were encouraged to take a holiday on their own during the summer, leaving Melanie on the unit.

Separation and the continued struggle towards individuation and autonomy

Melanie lapsed into a long period of depression, commencing with her parents' two-week absence, which overlapped, unavoidably, with my one-month summer vacation. When therapy resumed in the late summer, Melanie's playing once again showed almost total dependence on the therapist's musical support. Her playing and demeanour was that of 'little girl lost'. However, this process of separation, although painful, led gradually to much more individuated self-expression than before. Melanie's personality began to blossom. She began to talk about her first musical instrument (a wind instrument) and about earlier experiences of playing. In the early

autumn, she brought it to successive music therapy sessions. She tended it lovingly, polishing it before playing. She had begun taking much more initiative in our piano duets, even playing a second piano in the room. This seemed further evidence of her capacity to separate and establish a sense of herself in her playing. Now, on her own instrument, she took the lead, creating a slow, lyrical, rather mournful melody, followed by a spritely, humorous playful one, in which she enjoyed and invited lively interaction from the therapist. The long sustained tones encouraged intensely self-expressive playing. A warm, fun-loving personality was beginning to replace the pale, lifeless 'ghost' of six months previously.

These developments in music therapy – when Melanie was beginning to present a new sense of self, creativity and personal autonomy – seemed tenuous, however, as they coincided with her beginning to self-monitor her weight maintenance on the unit. She found this difficult to cope with emotionally. The containment of her anxiety and maintaining connectedness with the 'here and now' became the focus of the sessions. At times I instigated a fast tempo, with an insistent pulse and Stravinsky-like vitality in the music, as if offering some form of physical life-force to support and animate her sufficiently to express her feelings. Creative and destructive feelings were jointly coming to the surface in Melanie, both inside and outside the therapy sessions, as she became more connected with her emotions. The oral experience of playing her own instrument, too, seemed directly related to forms of expression of early infancy and elicited primitive emotions. Her whole body had to make a great effort to produce each note. At times it was as if her internal battle was being sounded through this instrument, on the in- and out-breath as she endeavoured to sustain a tone. Interpretation or metaphor seemed superfluous to the immediacy and impact of this basic discovery of herself, her physical and emotional being in her playing. The warmth and poignancy of sustained major 10ths and 9ths in E flat major supported her self-expression, without intruding on her self-experience. When her playing became fragmented or disjointed, I introduced structures and dynamic forms of the musical improvisation to contain and to connect these emotionally fragmented episodes, as if they were fragmented parts of her self. In improvisational music-making Melanie became able to function at a very early level of emotional sensory-affective self-expression and be supported musically towards a cohesive, integrated experience of herself.

Creativity and individuality

As cohesiveness and creativity of playing began to develop, Melanie's solos became increasingly sad, soulful, and reflective. She said she had never played her own instrument like this before; she had never 'made up' her own music. She seemed to be exploring her sadness with a new depth of self-expression, often leading the improvisations throughout the entire session. She also became the instigator of creative playing, no longer reliant on my supportive techniques of the past. She now played with the pulse of the music, passing it from one to the other in a two-way communication. In one of the final sessions she introduced the theme of 'Au Clair de la Lune', which then formed a refrain shared several times during our improvisation. Listening to this music now, its deep sadness still touches me. Melanie's free extemporizations of the theme are testimony to a new, more robust sense of self, her playing showing emotional depth, flexibility and subtlety of expression – but, above all, individuality.

Melanie's behaviour generally began to show more emotional stability, without her previous anxieties or depression. She was able to maintain a safe weight independently. She left the unit and continued her education in a small residential school. Two years after her recovery from anorexia, Melanie wrote:

> 'I was able to see the world with new eyes…a world where you could laugh, sing, smile and be free…to be free is to live.'

Conclusion

Music therapy can offer a particularly appropriate treatment for people suffering from anorexia nervosa. The paradoxical phenomena of early self and self-in-relation experiences can be expressed in musical dynamic forms, symbolically akin to those of the mother–infant relationship. Improvisational music therapy offers a potential space for feelings to be expressed in the dynamic forms of musical improvisation. In this way, the defective self-organizational constructs of the primary relationship can be contained and transformed, while simultaneously the fragile inner self is nurtured. This is particularly vital for children with early onset anorexia nervosa, where the earlier appearance of the severe stages of the illness, including depression, renders the child especially vulnerable.

Clinically-oriented improvisational use of music as therapy can engender the processes of ego maturation, self-identity and personal autonomy. This enables the true self to begin emerging in '"lived" or "experienced" time (of music)…measurable only in terms of sensibilities, tensions, and emotions…'

(Langer, 1953). Such metaphysical concepts take on new meaning in music therapy with young people with anorexia nervosa.

References

Aldridge, D. (1989) A phenomenological comparison of the organization of music and the self, *The Arts in Psychotherapy, 16*, 91–97.

Alvarez, A. (1992) *Live Company*. London: Routledge.

Balint, M. (1968) *The Basic Fault – Therapeutic Aspects of Regression*. London: Tavistock/Routledge.

Bateson, M.C. (1979) 'The epigenesis of conversational interaction: a personal account of research development'. In M. Bullowa (ed) *Before Speech: The Beginning of Human Communication*. London: Cambridge University Press.

Beebe, B. (1986) Mother–infant mutual influence and precursors of self- and object-representations. In J. Masling (ed) *Empirical Studies of Psychoanalytic Theories*, Ch.2, 27–48.

Beebe, B., Jaffe, J., Feldstein, S., Mays, K., and Alson, D. (1985) Interpersonal timing: the application of an adult dialogue model to mother–infant vocal and kinesic interaction. In F.M. Field and N. Fox (eds) *Social Perception in Infants*. Norwood, NJ: Ablex.

Bion, W.R. (1965) *Transformation*. London: Heinemann.

Brazelton, T.B. and Cramer, B.G. (1990) *The Earliest Relationship: Parents, Infants and the Drama of Early Attachment*. London: Karnac.

Bruch, H. (1985) Four decades of eating disorders. In David M. Garner and Paul E. Garfunkel (eds) *Handbook of Psychotherapy for Anorexia Nervosa and Bulimia*. New York, NY: Guilford.

Bruch, H. (1990) *Conversations with Anorexics*. D. Czyewski and M.A. Suhr. (eds) New York: Basic Books.

Bryant-Waugh, R. and Kaminski, Z. (1993) Eating disorders in children: an overview. In B. Lask and R. Bryant-Waugh *op. cit.*

De Casper, A.J. and Carstens, A.A. (1981) Contingencies of stimulation: effects on learning and emotion in neonates, *Infant Behaviour and Development, 4*, 19–35.

Emde, R.N. (1990) Mobilizing fundamental modes of development: empathic availability and therapeutic action, *Journal of American Psychoanalytic Association, 38*, 4, 880–913.

Fosson, A., Knibbs, J., Bryant-Waugh, R. and Lask, B. (1987) Early onset anorexia, *Archives of Disease in Childhood, 621*, 114–118

Freud, S. (1961) The ego and the id. In J. Strachey (ed. and trans) *The Standard Edition of the Complete Psychological Works of Sigmund Freud* (Vol.19, pp.3–66). London: Hogarth Press. (Original work published 1923).

Goodsitt, A. (1985) Self psychology and the treatment of anorexia nervosa. In D.M. Garner and P.E. Garfinkel (eds) *Handbook of Psychotherapy for Anorexia Nervosa and Bulimia,*. 55–82. New York: Guilford Press.

Heine, H. (1832) Über die französische Bühne. Neunter Brief. Quoted in P. Nordoff and C. Robbins (1977) *op. cit.*

Irwin, M. (1984) Early onset anorexia, *Southern Medical Journal, 77,* 611–614.

Langer, S.K. (1953) *Feeling and Form: A Theory of Art.* London: Routledge Kegan Paul.

Lask, B. and Bryant-Waugh, R. (1993) *Childhood Onset Anorexia Nervosa.* London: Karnac.

Maiello, S. (1993) Interplay: sound-aspects in mother–infant observation. Paper presented at Infant Observation Conference, Tavistock Clinic, London.

Masterton, J.F. (1985) *The Real Self: A Developmental, Self, and Object Relations Approach.* New York: Brunner/Mazel.

Morgan, H.G. and Russell, G.F.M. (1975) Value of family background and clinical features as predictors of long-term outcome in anorexia nervosa: four year follow-up study of 42 patients, *Psychological Medicine, 5,* 355–371.

Murray, L. (1992) The impact of postnatal depression on infant development, *Journal of Child Psychology and Psychiatry, 33,* 543–561.

Murray, L. and Trevarthen, C. (1985) Emotional regulation of interactions between 2 month olds and their mothers. In T.M. Field and N.A. Fox (eds) *Social Perception in Infants, 177–197.* Norwood, NJ: Ablex.

Murray, L., Kempton, C., Woolgar, M. and Hooper, R. (1993) Depressed mothers' speech to their infants and its relation to infant gender and cognitive development, *Journal of Child Psychology and Psychiatry, 34,* 7, 1083–1101.

Nordoff, P. and Robbins, C. (1971) *Therapy in Music for Handicapped Children.* London: Gollancz.

Nordoff, P. and Robbins, C. (1977) *Creative Music Therapy.* New York: John Day.

Pavlicevic, M. and Trevarthen, C. (1989) A musical assessment of psychiatric states in adults, *Psychopathology, 22,* 325–334.

Perilli, G.G. (1993) Subjective Tempo in Adults with and without Psychiatric Disorders. Paper based on Ph.D. thesis Dept. of Educational Sciences, University of Rome.

Robarts, J.Z. (1993) Facilitating Basic Emotional Communication in Creative Improvisational Music Therapy with a 4 year old Autistic Boy. Paper presented at VII World Congress of Music Therapy, Spain.

Robarts, J.Z. and Sloboda, A. (1994) Perspectives on Music Therapy with People suffering from Anorexia Nervosa, *Journal of British Music Therapy, 8,* 1, 7–14.

Stern, D.N. (1977) *The First Relationship: Infant and Mother.* Camb.Mass: Harvard University Press.

Stern, D.N. (1985) *The Interpersonal World of the Infant.* New York: Basic Books.

Stern, D.N. (1994) One way to build a clinically relevant baby, *Infant Mental Health Journal, 15,* 1, 9–25.

Trevarthen, C. (1974) The psychobiology of speech development. In E.H. Lenneberg (ed) *Language and Brain: Developmental Aspects.* Neurosciences Research Program.

Trevarthen, C. (1990) Signs before speech. In T.A. Sebeok and J. Umiker (eds) *The Semiotic Web, 1989.* Berlin, New York, Amsterdam: Mouton de Gruyter, 680–755.

Trevarthen, C. (1993a) The function of emotions in early infant communication and development. In J. Nadel and L. Camaioni (ed) *New Perspectives in Early Communication and Development.* London: Routledge.

Trevarthen, C. (1993b) The self born in intersubjectivity: the psychology of an infant communicating. In U. Neisser (ed) *Ecological and Interpersonal Knowledge of the Self.* New York: Cambridge University Press.

Winnicott, D.W. (1960) Ego distortion in terms of true and false self. In *The Maturational Processes and the Facilitating Environment.* (1990). London: Karnac.

Winnicott, D.W. (1971) *Playing and Reality.* London: Penguin.

Individual Music Therapy
with Anorexic and Bulimic Patients

Ann Sloboda

In this chapter I will give an account of individual music therapy work with several people suffering from eating disorders. Before presenting detailed case material, I will describe the setting in which the work was done, the influences on my way of working, and put forward some ideas as to why I consider music therapy to be an effective form of treatment with this client group.

All the clinical work took place in NHS settings, in units where I was the only music therapist, working for one day per week as a member of a multi-disciplinary team.

The majority of my experience in this field has been at an in-patient psychiatric unit (only one patient was seen as an outpatient in a community setting). The in-patient unit is an acute psychiatric ward in a large general hospital. It specializes in both eating disorders and affective disorders. Eating-disorder patients initially stay in the unit full-time, and participate in feeding programmes alongside other therapeutic input. The ward does not use force-feeding procedures, and each patient's participation in devising their own programme is seen as essential. The process of discharge happens gradually, with people attending the unit as day-patients on weekdays, and finally as out-patients for specific sessions only.

The role of the arts therapies at this in-patient unit has been discussed by Dokter (1992). She describes how the art therapist, dramatherapist and music therapist (myself) designed an integrated arts therapies programme with a joint system of referral.

Although each were employed for only one day per week, we liaised closely with each other and with the rest of the staff team.

As music therapy was new to the ward programme a set of instruments, (a piano and a selection of pitched percussion) needed to be purchased in order to conduct the music therapy sessions. None of the arts therapists worked exclusively with the eating-disorder patients, and we divided our time between them and those with affective disorders. Typically, I would be working individually with two or three eating-disorder patients at any one time. During my three years of working in the unit, twelve people received individual music therapy.

Influences

My understanding of eating disorders was deepened by exploring the literature on the subject, where the self-hatred that is so central to anorexia and bulimia is well documented. Orbach (1986) uses the term 'self-hate' rather than 'low self-esteem' in order to convey the strength of negative feelings observed in her anorexic patients. Lawrence (1987) quotes an anorexic woman who described herself as 'a parasite, a worthless thing with nothing to give to anyone'.

For many sufferers, their only sense of self-esteem is derived from controlling their human appetites, restricting their intake, reducing themselves (in a very concrete way) and withdrawing from contact with people. Orbach (1986) describes how 'the institution of rules and regulations, exercise, habits of work or study' are used to create 'a self-image which can counteract the horrible, worthless meaningless person she feels herself to be'. Orbach viewed this as an example of Winnicott's concept of the 'false self' – a protective defence that covers these feelings of worthlessness and vulnerability.

The books of Jungian analyst Marion Woodman (1980, 1982, 1985), a Jungian analyst, has addressed the issue of obesity in addition to anorexia and bulimia. She argues that obesity and anorexia are two extreme physical symptoms of the general repression of feminine nature in our culture, and women's' own identification with 'male values – goal-oriented lives, and compulsive drivenness' (Woodman 1980). The vivid case studies show her analysis of dreams, fantasies and myths in helping women to develop a closer and more accepting relationship with their bodies. In posing the question 'what does fat symbolize?', Woodman makes use of mythical imagery, as well as data from her own research studies with eating-disordered women. Sufferers' associations with 'fat' (eg. loss of control, neediness, greed,

depression) and 'thin' (eg. self-control, success, efficiency, self-sufficiency) are documented.

From my own observations I share the view that people suffering from eating disorders find the experience of psychological or emotional pain intolerable. Their disturbed eating behaviours had become the primary focus of their lives, demanding continual planning and self-discipline, and predominating over all other forms of activity. This obsessive preoccupation serves as a defence against experiencing painful emotions, and represents a striving for external perfection, in an attempt to compensate for profound feelings of inferiority.

In both anorexia and bulimia (although most visibly so in anorexia) the body is treated with brutality and contempt by the sufferer, through starving, bingeing, or purging. At the same time, the body is used as a manifestation of distress; in other words, the sufferer who does not have the capacity to bear the full experience of emotional pain can act it out physically.

When I began this work in 1990, I found hardly any literature on music therapy approaches with this client group. This might be due partly to the fact that very few music therapists in the UK are employed to work exclusively with people with eating disorders, (although many encounter them in adolescent or adult psychiatric units).

In a recent chapter (Sloboda 1993) I referred to the work of American music therapist Paul Nolan (1989). Whilst he deals only with bulimic patients in a group setting, I found his ideas on the particular value of music useful. He viewed music's ability to elicit extra-musical associations as its most important contribution to work with this client group. Through these associations the emotions expressed in spontaneous improvisations could be brought to greater consciousness.

I found this idea relevant for all the patients mentioned in this chapter. The music they played in sessions elicited a variety of associations and images, and it became possible to 'link the quality of their own improvisations with aspects of their internal world and everyday relationships' (Sloboda 1993).

It may be helpful at this point to give an idea of the way the music therapy sessions are conducted, and mention some techniques used. The sessions involve both verbal discussion and musical improvisation. Free improvisation is most often used, sometimes based on a theme, such as an emotion or a particular person. The theme may be chosen by the patient, or suggested by the therapist, inspired by material discussed in the session. 'Musical role-play' is sometimes used, (described in the case material below). Interestingly, pre-composed music was only once requested by a patient and hardly ever

used. Musical improvisations were often recorded, and then listened to during the sessions. This provided an opportunity for patients themselves to comment on the sounds they had made, their own role in the interaction between us, and any thoughts or images that occurred to them whilst listening to the music.

Case material

All the cases mentioned here have involved the use of free improvisation followed by discussion of the images arising from it.

Neither of the first two patients had any previous musical experience, and both found free improvisation difficult at first. The technique of using musical instruments to represent a concrete theme or idea was most successful in engaging them. The patient's own family was the most frequently used theme.

The first example is that of an adolescent girl whose stay in the unit was too brief to engage in individual therapy. However, even when patients are on the unit for only a few weeks music therapy can still be useful, as the process of improvising can arouse powerful emotions. A patient's response in a session offering a non-verbal medium may well differ from their behaviour in a purely verbal situation, and thereby provide valuable information for the rest of the staff team.

Case: 'Karen'

Karen was seventeen, and lived with her parents, although she attended a boarding school. Her mother had suffered from mental health problems in Karen's early teens, and Karen felt that her mother had 'lost interest' in her from this time onwards. She had attempted to rebel by breaking school rules, but was not treated severely by the school, as other pupils had committed more serious (and illegal) offences at the same time. Karen felt she had been ineffective in everything, even in her attempts to rebel. She was, however, effective in reducing her food intake until she developed anorexia. Unlike her other protests, this was taken seriously by school staff and she was admitted to hospital as an in-patient.

Karen spent six weeks there, and attended four individual music therapy sessions. She quickly regained some weight, but felt unhappy about this. She explained that she had felt 'important' when very thin, and felt insignificant now that she was less thin. On first meeting she appeared subdued and depressed, and spent the therapy session sitting with her head hung, remaining silent for long periods. She did briefly mention her family, stating

that they were a problem, but in a flat monotonous voice conveying little feeling. In her next session I suggested that she explore her feelings about her family using the musical instruments. Karen chose a wooden xylophone to represent her mother, and played persistently and relentlessly for ten minutes without stopping. I tried to support her with piano accompaniment, but she gave no indication of having heard me. When I paused, or left some silence, that had no noticeable effect on her playing either.

When she had finished playing, Karen said that she felt this to be an accurate 'musical picture' of her mother. I wondered what effect this had had on Karen, so, before any further discussion, I suggested that she play on the theme of herself. She chose the largest drum, and began playing – slowly and quietly at first, but soon increasingly loud and fast. She persisted with insistent drumming for five minutes. It could be heard all over the ward.

Karen's musical expression was powerful and eloquent – in contrast to the difficulty she experienced in communicating feelings through words. On the xylophone, she had depicted her mother taking up all the space. After improvising together I was able to comment on my experience in our duet; that it had not felt like a dialogue, and that I had been unsure if she had heard me playing the piano. Karen likened this to the experience she had with her mother saying: 'She never listens to me'.

Her subsequent expression of violent rage and frustration on the drum surprised everyone, including Karen herself. It was the first time since her admission that she had expressed any anger. Karen was soon referred on to a psychiatric unit for adolescents, which fortunately had a music therapy group that she could attend.

Case: 'Brian'

Brian, a bulimic man in his mid-thirties, had felt dominated by his mother and elder brother since childhood. Open conflicts within the family were rare. Brian used food as the arena in which to express and act out his conflicts. He took refuge in food, and would over-eat for comfort. He then used self-induced vomiting as a means of covert rebellion and self-punishment. His use of musical instruments to depict himself within the family setting helped to increase his awareness of his own passive role. For example, his improvisations would be dominated by the themes of his critical mother and brother, represented by relentless, aggressive drumming, while Brian played tentatively on quieter instruments to represent himself. After eleven months of therapy he also became more aware of his own internal critical 'voice' in perpetuating the situation. As he began to acknowledge that some of the anger that was projected onto his family was also his own, a change of

attitude (and, ultimately, behaviour) became possible. A detailed account of this case forms the basis of another chapter (Sloboda 1993). Some of the techniques used here have much in common with Priestley's analytical music therapy techniques, in particular the 'splitting technique', used where a person has 'projected part of herself (eg. anger) onto another character and, in doing so, lost the emotion invested in this person' (Priestley 1975).

Both the client themselves and the other character are used as themes for musical improvisation and role-play. Therapist and client might take turns to play both roles, giving the client a chance to get in touch with the emotion they had projected.

Reflections on the value of music therapy

The cases of Brian and Karen illustrate some of the major themes that have arisen in my encounters with eating-disordered patients. For both, their disorder had functioned as a passive but powerful protest (a literal hunger strike). The immediacy of the experience of free improvisation helped them become more conscious of their emotional state.

The tendency to withdraw from emotional contact with others is recognized as a feature of the disorder for many anorexia and bulimia sufferers. Close contact with another person (eg. musical interaction, discussion, and reflection with a therapist) may put people in touch with their own neediness, pain and vulnerability. For those who have been 'practising the self-denial of dieting and living out the life of a person with no needs' (Orbach 1986) the experience of improvising in music therapy could seem raw and intimate.

I can recall at least three patients who, after talking at length about their difficulties in a somewhat distant way, began to play the instruments (while I provided gentle imitative support on the piano) and after less than a minute, began to weep. It did seem as if these women had been touched at a very different level by the music; a level they found difficult to experience through speech.

Setting up an improvised 'duet' on musical instruments can, as described above, allow patients to feel 'held' and supported. Having experienced that closeness, it could then be discussed with reference to significant people in their lives. Equally, where improvisations were characterized by other dynamics (eg. extreme loudness, or a lack of any rhythmic synchrony) an awareness of patterns of relating in their musical interaction could help patients gain a greater awareness of the way they interact with other people.

I see it as significant that music making is a physical activity, involving the body in movement and rhythm. It therefore offers possibilities for people to explore their relationship with the body they despise and have made such

strenuous efforts to control. A recent paper (Robarts and Sloboda 1994) describes how the rigid control exerted by many eating-disorderd patients their bodies was also displayed in aspects of their musical improvisation: (eg. tight rhythmic patterns, a difficulty in slowing down, a lack of phrasing, flexibility, or variation in rhythm and volume). I noticed that some patients seemed to approach improvisation as if it were a test of physical endurance:

- Brian, (mentioned earlier) would drum relentlessly until exhausted; saying afterwards 'I felt I ought to keep going'

- Sandra, a bulimic woman, would play in a similar manner until her arms ached, and said 'I didn't want to give up too soon.'

The freely interactive nature of music therapy gave people the experience of non-verbal imaginative play, thereby providing a positive and confidence-building encounter with another person.

Equally important was the role of making music together (and reflecting on it) in awakening peoples' creativity, enabling them to use and value their own imagination. This could be a very strengthening experience. I found Rosemary Gordon's (1989) words on the nature of creativity most relevant here:

> 'Creativity involves play and paradox, and depends on a person's capacity to tolerate contradictory – and yet also complementary processes…a person who would be creative must be available to freely moving oscillations between, for instance, control and surrender of control, to periods of conscious work and effort, to periods of passivity waiting and surrender.'

The process described above requires the very attitude which was most difficult for eating disorder sufferers. Whether anorexic or bulimic (or both) all were striving to exert total control over their bodies, appetites and needs. The idea of losing control was terrifying, and any encounter involving food aroused this fear. In an encounter with musical instruments, it was possible to explore the idea of relinquishing control, to consider that there might be some value in this, and to lose some of the fear associated with it.

The stage at which I met anorexic patients was usually one at which they had gained a certain amount of weight, and had some insight into their condition. However, they often felt despairing and trapped. Whilst recognizing that continued weight loss would, ultimately, lead to death, weight gain could not be viewed as anything other than shameful; a humiliating surrender. Bulimia sufferers felt equally humiliated, and trapped in their vicious circle of starving, bingeing and purging.

Both the anorexic and bulimic patients whom I encountered spoke of lacking a sense of aliveness – they disliked their own bodies, and felt they did not deserve nourishment. This was evident in the case of Sandra, a bulimic woman, whom I saw as an out-patient in the community for twelve sessions of individual music therapy.

Case: 'Sandra'

Sandra was thirty-three, and had a busy, 'high-pressure' job in an advertising agency. She had approached her GP for help because she felt unable to control her eating, and alternated between binges and periods of starving herself. The GP referred her on to the local Community Mental Health Resource centre, which offered a variety of out-patient services to people with mental health problems. It was staffed by a multi-disciplinary team which included sessional input from the arts therapies. The referral for music therapy came from a psychiatric nurse, who had conducted Sandra's initial assessment.

At first, Sandra expressed surprise that the therapy she had been offered was *music* therapy, and wondered what she would be expected to do in the sessions. I explained that I was a music therapist with some experience in eating disorders, and that we could use musical instruments where appropriate to explore Sandra's difficulties. In our first session Sandra stated that bingeing was her only problem, and that her efforts to stop it always failed. If she could only find a way to exert complete control, this, she felt, would be the solution to all her problems.

Later, she began to show more ambivalence; describing herself as 'split down the middle'. She felt torn between a wish to control herself and her eating, and a desire to break out of the constraining stereotype she had adopted as her professional identity. (The image she aspired to was that of the slim, ambitious, career woman.) Her work seemed to take all her energy.

When Sandra played the percussion instruments, her movements were stiff and tightly controlled. I suggested she choose an instrument to depict her work life. She chose a hollow wood block which she scraped slowly and without any animation. I commented that her playing sounded hollow. Sandra agreed that for much of the time she felt hollow and empty, and that she found her 'glamourous' job superficial. The only times she recalled feeling genuinely alive was when she was cramming herself with food. In a later session she depicted herself as a 'sad, caged, bird – stuck, and going round in circles'. She played the glockenspiel in a mechanical way that reminded me of a musical box.

In an attempt to find some meaning in her compulsive eating, Sandra tried to remember the feelings she experienced when she binged. She concluded that eating was one of the few means of giving herself comfort or pleasure. An additional by-product was the feeling of heaviness it gave her; causing her to slow down physically, and rest.

I commented that she did not allow herself much rest, and she agreed that this was so. Sandra had a mental list of 'forbidden' activities, which in addition to 'eating naughty foods' included; 'sitting doing nothing', and 'relaxing.'

She recalled the 'caged bird' imagery of earlier sessions, and realized that her time at home; supposedly her 'own', was actually highly regimented. The vital step was Sandra's own recognition that her restrictions were largely self-imposed and that, far from needing to exert further control, her internal images indicated a need for freedom.

A change became evident in her musical improvisations. She played more vigorously, swinging her arms, and using her whole body. She said: 'I just let myself go'. Whilst playing, she said she was imagining 'nature...trees... freedom'. She derived great satisfaction from these images, and began to consider ways in which she could allow herself to have this sort of experience in her life.

The only other experience of 'letting herself go' that Sandra could recall was that of bingeing. She began to understand the function of her eating disorder. The intervention with Sandra was brief, but gave her valuable insights. In her final session she said she had 'realized that I have been stuffing myself to fill the void of emptiness, dissatisfaction, and meaninglessness.'

The bulimia and anorexia sufferers that I worked with seem to share a conviction that they did not deserve nourishment, although bulimics were often overwhelmed by a voracious desire for food. Anorexia sufferers had successfully avoided food for so long that their whole identity was based on this. I became convinced that what was needed was to contact and utilize that spark of creativity that could lead sufferers towards a desire to feed themselves and live, instead of starving themselves to death. By participating in the process of creation in music, they might begin to listen to and recognize the rhythms and needs of their bodies rather than denying and despising them.

In Sheila McLeod's (1981) account of her own anorexia, response to poetry provided this sort of experience. The author recalls an event when, at a dangerously low weight, she heard her mother quoting 'The Sunflower'

by Blake. She was taken aback by the strength of her response to the words, and the realization that

> 'although I, like the sunflower and all organic things, was living out a natural cycle, I had somehow shut myself out, cut myself off from nature.' (McLeod 1981)

This marked her sudden awareness of her closeness to death, and her deep sense of isolation.

> 'I was cold, untouchable, and in my grave, where I didn't want to be. I wanted to be warm…a part of normal life rather than apart from it.' (McLeod 1981)

She describes feeling a faint hope that she might be capable of 'harmony and wholeness' followed by a painful sense of isolation and a desire to weep. She considered this experience a vital precursor in her decision to resume eating and begin her long, painful recovery.

I have quoted McLeod so extensively because she provides such an eloquent example of the process I mentioned above. In the final case example I aim to demonstrate how music was used in this way, as a powerful agent in the painful 'thawing out' process of recovering from anorexia.

Case: 'Joanna'

Joanna, a post-graduate student, was admitted to hospital with acute anorexia. She spent two months on a re-feeding programme before she was considered strong enough for any other therapy. The referral for music therapy came from nursing staff, who felt it might help Joanna get in touch with her emotions. She was very articulate, and showed insight into her condition, but often seemed remote, and over-intellectual.

At her initial session, Joanna was highly sceptical about the idea of music therapy. She eyed the percussion instruments with disdain, saying: 'I can't see how banging these things is going to help me'. She did not play any of them in this session.

In discussion, I noticed how much of her time she spent criticizing herself, often with bitter sarcasm. It seemed difficult for her to receive sympathy or support – if I made a sympathetic comment she would respond with a self-deprecating quip.

Joanna spent her first session discussing her eating disorder and the feelings associated with it, but she gave the impression that she was talking about someone else. She did mention that she played the violin, and that she

used to express herself by playing Brahms. Since developing acute anorexia, however, she had felt 'blocked' and unable to play.

Joanna agreed to return for further music therapy sessions on the condition that I accompanied her playing Brahms' violin sonatas. This was, in fact the only time that anyone on the unit had requested pre-composed music in an individual music therapy session. In general, I avoided the use of such music, partly because of its associations with the need to conform to a preordained ideal of perfection. For people who had so little sense of valuing what came from inside themselves, improvisation seemed most helpful in enabling them to use the medium for self-exploration. In Joanna's case, I agreed to the request, as the music of Brahms held great emotional significance for her. In the event, she was able to create her own music on the violin, and Brahms' help was not necessary! We worked together for six months.

Joanna had never improvised before, but, with a little encouragement, was able to do so with an intensity that surprised me. Her improvisations on the violin had a characteristic, individual quality that was remarkably different from her verbal expression. An extract from her third session is given below in Figure 16.1.

Joanna played long sustained notes in the lower register, her bow rarely leaving the string. There was little movement, either in rhythm or pitch, but she showed deep involvement in her playing. At this stage there was little sense of musical interaction between us, but she was able to use my support on the piano. I considered my musical role to be one of a witness and a guide, who could frame and amplify Joanna's encounter with herself.

Whereas in the previous case material significant family members had been most useful as initial themes for improvisation, in Joanna's case, it was her relationship with herself that formed the subject matter. In the earliest improvisations she asked me to suggest a subject, and I asked her to play on the theme of 'This is who I am'. She produced music similar to that in Figure 16.1, and returned to this theme repeatedly over the next few weeks. Her first comment on listening to the music was that it was sad, and that sadness was something she had been anxious to avoid feeling. She recognized that in so drastically reducing her food intake, she had been able to restrict the extent to which she experienced her feelings.

As the sessions progressed this music came to represent a previously despised and repressed part of herself, that needed nurturing. In her own words, two contrasting images or metaphors emerged (images that could be represented visually or in sound).

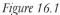
Figure 16.1

The first, her anorexia, was described as dry, tense, lifeless, rigid, brittle, restless, and rejecting all contact. Joanna improvised on percussion depicting her 'anorexic self' as a 'lifeless skeleton, with rattling bones'.

In this piece she avoided all the resonant instruments, making dull or scratchy sounds, and switched rapidly from one instrument to another.

The other image was associated with emotion, and was always represented by violin and piano improvisations. Joanna described this music as 'fluid, flowing, alive, emotional, resonant, full.'

We discussed the characteristics of these two musical metaphors: the lifeless skeleton, and the life-giving flow. It was possible to reflect on the paradox that, while Joanna greatly preferred the latter, all her self-esteem, identity and confidence had become attached to the former. Joanna identified the deep, resonant qualities of her violin music with the emotional, vulnerable parts of herself that she had 'put on ice'. It was as if she had found a new voice, that she needed to explore and get to know. The violin music served to articulate emotions which Joanna had not yet found words to express.

Rosemary Gordon's words on the need to create seem to describe the process at work here:

> 'There is in man a need to externalize and "em-body" images that emerge and have their being inside him.'

> '...We also want to see in a tangible form our own changes, movement and growth that might be happening in our inner and secret world, in order that we might become acquainted with it and recognize it as being...a part of ourselves' (Gordon 1989)

Over the weeks, her weight increased, and menstruation resumed. Joanna experienced a flood of confusing and painful emotions.

She acknowledged that in many ways she had been 'hardly alive', and now struggled with the challenge of becoming fully involved in her life and relationships. Joanna began to consider her capacity to relate to others, within the music therapy sessions as well as outside. Having withdrawn from contact from others for so long, she could now imagine a way of being that was more receptive, in which she might 'take things in', and respond spontaneously, without being overwhelmed. Earlier, I commented on the lack of interaction in our violin and piano improvisations. In the final month of therapy, Joanna herself observed that she hadn't really been listening to the piano.

The final extract (Figure 16.2) is a later violin and piano improvisation, from her penultimate session. It shows similarities in style to the first example, but also striking differences in the nature of Joanna's interaction. She imitates material played by me, but also initiates her own. Rather than the violin being supported by the piano, the two 'voices' interact together on a more equal level.

Figure 16.2

Of the patients discussed in this chapter, Joanna was the only one that possessed a high level of technical skill on a musical instrument. However, none of them had improvised before, and, despite the differences in the length and intensity of their therapy, all were able to engage in free improvisation. In my view, it was this that enabled them to experience their own emotional state, develop confidence and strength of expression, and engage in an interactive dialogue.

Acknowledgements

I am grateful to Charlotte Roberts and Julian Raphael for transcription of the musical examples, and to Rachel Stubley and Rick Bolton for their supportive criticism of the text.

References

Dokter, D. (1992) 'Tolerating Chaos – Dramatherapy and Eating Disorders', *Dramatherapy ,14*, 1.

Gordon, R. (1989) 'Reflections on Creativity and the Psyche' 'Harvest', *Journal for Jungian Studies, 35.*

Lawrence, M. (1984) *The Anorexic Experience.* London: The Women's Press.

McLeod, S. (1981) *The Art of Starvation.* London: Virago.

Priestley, M. (1975) *Music Therapy in Action.* London: Constable.

Nolan, P. (1989) 'Music Therapy improvisation techniques with bulimic patients'. In E.K. Baker and L.M. Hornyak (eds) *The Handbook of Techniques in the Treatment of Eating Disorders.* New York: Guilford Publications.

Orbach, S. (1986) *Hunger Strike.* London: Faber.

Robarts, J. and Sloboda, A. (1994) 'Perspectives on music therapy with people suffering from anorexia nervosa', *Journal of British Music Therapy, 8,* 1.

Sloboda, A. (1993) 'Individual Therapy with a Man who has an Eating Disorder.' In M. Heal and T. Wigram (eds) *Music Therapy in Health & Education.* London: Jessica Kingsley Publishers.

Woodman, M. (1980) *The Owl was a Baker's Daughter: Obesity, Anorexia Nervosa and the Repressed Feminine.* Toronto: Inner City Books.

Woodman M. (1982) *Addiction to Perfection: The Still Unravished Bride.* Toronto: Inner City Books.

Woodman, M. (1985) *The Pregnant Virgin: A Process of Psychological Transformation.* Toronto: Inner City Books.

Sexual Abuse and Eating Disorders
A Possible Connection Indicated
Through Music Therapy?

P.J. Rogers

This chapter reviews the literature on music therapy and eating disorders and suggests possible connections between sexual abuse and eating disorders. It does not propose that there is a direct link between the two phenomena, rather it questions the effects of sexual abuse on the survivor's sense of living in his or her own body, and by extension of living in the world – the abuse survivor's experience of embodiment – and draws parallels with the distorted body image and hatred for the body found in so many eating-disordered clients. It illustrates similarities in the improvised music of sexually-abused and eating-disordered clients.

A sense of self, as suggested by Mahler (1975) and Stern (1985) develops in the context of a child's most intimate relationship with its crucial caretakers, notably the mother. Disruptions in this relationship are possibly at the heart of what makes incest so traumatic for a child and ultimately lead to an abused child's inability to develop stable capacities for the modulation of feelings or for the ability to trust. Stern (1985), in providing a detailed summary of developmental research, notes that prior to the emergence of the verbal self in the second year of life, our lived and remembered experiences (including experiences of our bodies and our 'core' selves) are primarily sensuous; as rich in emotion, perception and cognition as our later experiences. Whilst language allows us to understand and communicate some of our pre-verbal experiences, much remains unsaid or inadequately described when using language alone. 'Such experiences then continue underground to lead an unnamed (and to that extent only, unknown) but

nonetheless very real existence' (p.175). Stern observes that it is through the sharing and modification of feelings by parent and child that the sense of the subjective self is formed.

The verbal self links us to the world of others; it makes us comprehensible to others by making us comprehensible to ourselves. Our pre-verbal self remains, made up of those thoughts, emotions and sensations which resist encoding in language or which contradict the reality of our emerging inter-subjective selves. These emotions often remain fragmentary and elusive, inaccessible to language and lacking in coherence or continuity (Young, 1992). Young hypothesizes that traumatic events which occur in early childhood may be encoded in our psyche in a primarily non-verbal modality. When these emotions, perceptions or events are re-experienced, they thus have a similar non-verbal quality. As a music therapist working with abused children and adolescents, I have often noted that clients who are otherwise articulate, verbal and highly intelligent literally have no words with which to describe their traumatic childhood experiences.

Music therapy, and indeed all the arts therapies, offer a voice or expressive medium for non-declarative or procedural memories; thus its use in the therapy of abused or eating-disordered clients may provide an understanding of the inner psychic and physical experience of the client.

Udwin (1993), in a detailed literature review of work with memories for traumatic experiences, notes that a tendency to enact or portray in drawings both 'unremembered' and remembered early traumatic experiences is well documented in research examining the behavioural and psychological se-quelae of traumatic experiences (Terr 1988, Burgess and Hartman 1993). Moore (1994) notes that it not only the content of a child's drawing but also the drawing process which 'may reflect specific procedural memories of early childhood trauma'. Udwin (1993) reports that traumatic experiences (such as sexual abuse) stored within declarative memory can be consciously recalled, verbalized or represented in a drawing, and by implication in an improvisation. Where trauma has been defensively forgotten (Clark 1993), repressed or dissociated, there may be no declarative memory. Thus the memories will be stored in non-declarative (including procedural and im-plicit) memory stores. Such non-declarative or procedural memories cannot be articulated verbally and could be described as non-conscious. They may however be expressed in play or in a musical improvisation and include both symbolic and non-symbolic elements.

Sloboda (1993) and Smeijesters and van den Hurk (1993) refer to the texts of Loos (1989) and Maler (1989) in discussing whether anorexia may be linked to a disturbance in the balance between symbiosis and individu-

ation or a lack of 'knowing where to draw the line'. The role of music therapy in facilitating individuation is well documented (Frohne 1986) and it is interesting in this context to note that such features may be represented in the musical playing of anorexic and bulimic patients.

Music therapy and eating disorders

Little has been written on the application of music therapy to clients with eating disorders; indeed, it is notable that the few available references to work with eating disorders have all been published since 1988. No specific evaluation of work with this client group has been reported. With the exception of Parente (1989), the literature available suggests that the use of music therapy improvisation techniques offer clients with an eating disorder an opportunity to explore and express emotions in a non-verbal manner, and that musical expression acts as a bridging process to the conscious – and possibly verbal – expression of feelings.

Tarr-Kruger (1989) argues that music therapy offers the bulimic patient 'an alternative means of expression, of experiencing and re-owning one's body, so that the deficient self can be strengthened and renourished and a new beginning is possible'. In her interpretation, bulimia is the search and hunger for expression and resonance.

Nolan (1989a) states that music therapy 'improvisation is useful in facilitating psychotherapy because it stimulates the awareness and expression of emotions and ideas on an immediate level' (p.167). He describes the theoretical concepts which underpin his work in group music therapy with a bulimic population. He argues that group music therapy process brings about awareness of feelings and behaviours in the here-and-now with musical experiences and subsequent verbal processing, providing excellent opportunities for patients to experience and integrate areas of conflict as well as ego strength. In a second paper Nolan (1989b) expands the theoretical foundations for his clinical work, hypothesizing that musical improvisation functions as a transitional object (Winnicott 1951) which enables the interruption of the binge/purge cycle in bulimic patients.

A similar theme is developed by Sloboda (1993) in a detailed single case study of a man with an eating disorder, who had suffered from both bulimia and anorexia. The paper describes individual therapy and is notable in providing a description of the changes in the musical processes and interaction which occurred over a period of 40 sessions. Sloboda discusses the function of an eating disorder as a 'visible symptom of painful feelings, but a defence against experiencing them' (p.105). Sloboda appears to concur

with Nolan's (1989a p.174) view that music therapy acts as a bridging process between musical expression and the conscious expression of feeling.

Smeijsters and van den Hurk (1993) describe music therapy research in practice with a client having the symptoms of anorexia nervosa. The clinical work described is based on the psychoanalytically informed methods of Preistley (1982), Bonny (1989). In addition techniques from client-centred approaches (Perls, 1985) and the principles of gestalt therapy, such as an unconditional positive regard, are melded into the treatment philosophy, producing an eclectic and flexible approach. The paper describes the resulting therapeutic process in detail and draws comparisons between the client's musical behaviour and her anorexic symptomatology.

Improvisation techniques are recommended by Goiricelaya (1988) as being ideal for working through issues of perfection and control and illustrating a client's lack of spontaneity and creativity. The author recommends that improvisational techniques are used in parallel with song writing and the exploration of the images and moods evoked from music to explore some of the psychological issues surrounding eating disorders.

A somewhat esoteric approach is proposed by Parente (1989) who argues that clients with 'anorexia can use music as a bridge to verbal therapies. Feelings, attitudes and perceptions can be recognized, acknowledged, clarified and tested through music before exploring them in verbal therapy' (p.326). She describes a specific community model of music therapy: 'process theatre' which she has developed in which each member of her troupe is an anorexic client, whilst she acts as both therapist and 'troupe director'.

The only known previous reference to work with a client with a learning disability and an eating disorder is made in a paper by Heal and O'Hara (1993) in which they describe work with a client with Down's Syndrome. (See Chapter 18 of this volume.)

Sexual abuse and eating disorders

The apparent sequelae of sexual abuse include a wide range of psychological impairment and distress: eating disorders, dissociation, drug and alcohol abuse, self mutilation, suicidal ideation and suicide, multiple personality disorder, sexual disfunction or disinterest, depression, anxiety, rage, poor self esteem, vulnerability to re-victimization, enhancement of learning disabilities (Sinason 1992), social isolation, mistrust, helplessness, difficulties in forming relationships and guilt (Rogers 1992).

There is growing evidence that the most serious long-term effects result from highly intrusive sexual abuse, such as oral, anal, or vaginal penetration, abuse that is violent or sadistic in nature, continued over many years – and

intrafamilial abuse, particularly where the perpetrator is a parent, step-parent or parent figure (Browne and Finklehor 1986). In recent years, research studies and clinical observations have shown that childhood physical and/or sexual abuse is reported in the histories of nearly two thirds of adult female psychiatric patients (Bryer, Nelson, Miller *et al.* 1987). Recent clinical studies have suggested that severe childhood trauma can be correlated with disso-ciative symptoms, post-traumatic stress symptoms and the disruption of personality development and maturation – as seen in borderline personality disorder (Chu 1992).

Sexual abuse has frequently been described as important or causal in the development of individual cases of anorexia and bulimia nervosa (Sloan and Leichner 1986). Oppenheimer *et al.* (1985) suggested that sexual abuse may cause disgust with femininity and sexuality, which ultimately manifests as concern with body image, leading to an eating disorder. Support for this hypothesis has predominantly been derived from two sources – first from individual case studies (Sloan and Leichner 1986) and second, a study by Calam and Slade (1989) which demonstrated an association between abnor-mal eating attitudes and unwanted sexual experiences in the normal popu-lation. The apparent association between sexual abuse and eating disorders has been challenged by Finn *et al.* (1986). They suggest that the apparent association of sexual abuse and eating disorder may be coincidental rather than causal, given the prevalence of both eating-disordered women and sexually-abused women in the general population.

More recent research has shown that the 'coincidence hypothesis' is inadequate. First it has been shown that the prevalence of reported abuse is higher in women with bulimic symptomatology and no history of anorexia, than in women with bulimia with a history of anorexia or anorexia of the bulimic subtype. It was further concluded that reported sexual abuse was rare in women with restricted anorexia (Waller 1991). Second, it appears that the nature of reported abuse is more severe in the eating disorders than in the 'non-clinical women' (Waller 1992, Calam and Slade 1991). Whilst the results of neither of these studies is compatible with the 'coincidence hypothesis', it cannot be assumed that all cases involve a causal link, given the prevalence of the two phenomena in the general population and the current lack of understanding of the psychological mediators between eating disorders (particularly bulimia nervosa) and sexual abuse.

Waller, Ruddock and Pitts (1993) report that approximately 40–50% of eating-disordered women describe some sexual abuse in child or adulthood, and that at a general level, reported sexual abuse does appear to be associated with eating disorders – in particular bulimic eating disorders – with the

frequencies of binging and (to a lesser extent) vomiting being related to the presence and nature of abuse. Waller (1991) reports that

> 'the frequency of binging is particularly high where the woman reports being abused by a relative in a way that involves force, or before the age of 14 years. These women are also likely to vomit more frequently if the reported abuse was intrafamilial'. (p.91)

The links of meaning between sexual abuse and bulimic symptomatology are not as yet clearly understood; it is likely that these links will require a multi-causal model of the aetiology and maintenance of eating disorders (Smolak *et al.* 1990, Waller 1992).

Finally, the studies which examine possible connections between sexual abuse and a subsequent eating disorder remain inconclusive, as they are dependent on the eating-disordered client holding a conscious memory of the abuse and a willingness to disclose it. It is only recently that the effects of forgetting the trauma of sexual abuse have been studied (Clark 1993).

It is commonly reported that guilt, self-blame, low self-esteem and a dysfunctional family environment are common factors in child sexual abuse (Furniss 1991, Rogers 1992). It is worthy of note that these same factors are also cited in the development and maintenance of eating disorders (Waller 1991). Palazzoli (1974) suggested that a dysfunctional family background is relevant in the aetiology and maintenance of eating disorders. Similarly, both Bentovim (1988) and Furniss (1991) have stressed the need to consider the dysfunctioning family system which exists for the sexually-abused client, rather than focusing solely on the abused–abuser relationship. Waller (1992) notes that three of his patients reported involuntary or self-induced vomiting after enforced fellatio. For these patients, who undoubtedly did feel sick, the vomiting provided a degree of control by annoying the abuser. Whilst individual case material may provide some clues to possible links, as yet such material remains anecdotal. The difficulties of researching such links are discussed by Waller (1992) and Finklehor (1986).

The development of body image is affected by traumatic events such as sexual abuse or surgery. Kearney-Cooke (1989) notes that in a survey of 75 consecutive bulimic patients treated at the University of Cincinnati's Eating Disorders Clinic, more than half the respondents had been sexually abused. It is logical that a disturbance in body image can result from sexual abuse, as the body is the site of the original trauma. Guilt, shame and a sense of dirtiness frequently remains when the abuse ends and may persist into adulthood. The need to get rid of the body may be a defensive way of handling these feelings. Kearney-Cooke (1989) suggests that bulimia may

become a ritual of self-purification, 'offering the hope that if the victim's body is perfect, she will be cared for and will no longer feel ashamed'.

One aspect of sexual abuse is the balance of power and powerlessness within the relationship between the abused and the abuser (Rogers 1992). Power and control represent an area of considerable vulnerability for the abused client. In today's western culture, where female success is associated with thinness and failure with fat, it needs to be acknowledged that the abused client may attempt to regain a sense of personal control through diet – with the obvious analogies of taking material in and out of the body.

Browne and Finklehor (1986) note that many researchers have found a high incidence of suicide attempts and self-destructive thinking and behaviour amongst the victims of abuse. One of the most striking features of such self-destructive behaviour is that it is carried out on the physical body. Young (1992) hypothesizes that the abuse survivor often feels her body has betrayed her through being small, vulnerable, the cause and carrier of pain and humiliation or by the experiencing of pleasure during the abuse. Thus the abuse survivor may simultaneously experience the wish to punish the body which betrayed her and to be rid of the body from which she feels dissociated. In maintaining an eating disorder, the abuse survivor experiences physical pain within her own body; such pain can be seen by the dissociated (abused) patient as confirmation that she is alive.

Clinical case material

Sloan and Leichner (1986) describe the coping mechanisms used by a raped female patient who

> 'dissociated herself mentally during the assault, and later by identifying herself with her mind, viewing her body as a foreign container of her bad sexual feelings, and proceeding to attempt to make the latter gradually disappear by starving herself.' (p.659)

Young (1992) suggests that many of the resulting long term effects of trauma and sexual abuse can be understood in terms of problematic embodiment and the formation of personal identity and psychological integrity. Such an account may provide an explanation for the resulting eating disorder described by Sloan and Leichner (1986), where the patient's attempts to starve herself (i.e., to starve the body which is not me) appears to be driven by the distorted logic that the foreign container (her body) is filled with all her bad feelings and sensations and then destroyed. She (her mind) is thus free from intolerable feelings and painful memories and safe from physical intrusion and harm.

Rogers (1992) describes a similar case in which a young abused woman was gradually able to explore her inner emotional world through music therapy. As a trusting relationship was slowly developed through the therapeutic process the client was able to acknowledge both her abuse and her preoccupation with her eating habits. These gave her something

'within her own environment which she could control, serving both to deny her sexuality – leading to the anorexic and thus desexualized female form – and reinforcing a belief that she would no longer be attractive to her abuser. the converse wish of the same client to continue to receive "love" (her word) from her abuser was also demonstrated in her need to control her eating habits...the client felt rejected and believed that her slimmer sisters received more affection from the family member who had abused her...thus she sought to emulate her sisters in the hope that the affection she had previously received through the imperfect but nevertheless existent relationship with her abuser would be reinstated. She therefore starved herself and was able to follow simultaneously two patterns of behaviour: the first attempted to deny her sexuality, and the second to gain the reinstatement of affection from the abuser. This ambivalence indicates the high degree of confusion and emotional anxiety felt by the client.' (p.12)

A detailed description of the processes in the music therapy of the above client is provided by Rogers. This example illustrates clearly the paradox which faces the therapist – the client feels the need to destroy her body in order to survive, but the process of destruction will endanger the client's survival. Such an explanation avoids the client's sense of reality that her body is no longer her own; that it is now outside her and hence not her, rather than being an essential part of her. Young (1992) suggests that it is only through the destruction of her body, which keeps the abuse survivor tied to a dangerous world, that she can survive. A second explanation is that, by avoidance of weight gain, the client is able to avoid the concomitant problems associated with psycho-sexual maturity (Crisp 1980). The anorexic symptomatology permits a regression to a pre-adolescent level in which issues of sexuality can be denied because of a 'child-like appearance', amenorrhea, absence of sexual impulses and prepubertal levels of gonatrophins.

Musical considerations

Sloboda (1993) suggests that the inability of her client to end an improvisation was symptomatic of his lack of awareness of the therapist or her music; whilst Smeijsters *et al.* (1993) assert that the eating-disordered client finds it

difficult to make contact, admit intimacy, emotion or equality into the relationship and lacks insight into whether or not they are making contact. Not 'knowing where to draw the line' (Maler 1989) was illustrated in the features of the musical improvisations through a lack of balance between order and chaos;

> 'Not being able to stop activities, the inability to break off relationships or to realize a balance of freedom and restraint in relationships...the client could not check herself when playing an instrument; ...vary the tempo, the dynamics, the musical motifs.' (Smeijsters *et al.* 1993 p.259)

She was 'unable to conclude her play and could not develop or conclude a worthy musical contact' (p.260). Many of the features noted by Sloboda (1993) and Smeijsters *et al.* (1993) are also apparent in the musical play of the following case study. The similarities in the described musical material beg for a detailed process research study to evaluate whether such features could be identified as being typical of a client with an eating disorder.

Theoretical models underpinning the music therapy process

The therapeutic relationship finds similarities with the mother–infant relationship within which the child experiences the mother as a container into whom a chaotic confusion of emotions and sensations can be put. The mother (therapist) uses her own reverie in order to metabolize in herself what the child is not as yet able to metabolize; ultimately, the process enables the child to create a space in which to think.

Winnicott's concept of 'holding' (Winnicott 1960) is often used interchangeably with Bion's model of the 'container-contained' (Bion 1959, 1962). Both refer to the attitudes required of a mother towards her newborn infant. They differ, in that they are each derived from different theoretical frameworks.

For Winnicott, the good enough mother adapts to and identifies with the needs of her infant through primary maternal preoccupation. The concept of 'holding' thus secures the infant a safe environment, free from external impingements, within which his natural maturational processes will enable him to develop and grow.

Bion acknowledges that the newborn infant will encounter frustrations and anxieties from the very beginning and will evacuate these feelings through projective identification (Klein 1964) with the mother. The mother's task is not only to identify with the projected feelings but, through her reverie, to process them, detoxify them and make them available for reintro-

jection. The mechanism of projection may arouse persecutory and paranoid anxieties, and thus negative aspects of the relationship between Bion's mother and baby are more prominent than with Winnicott's mother and baby. Bion's concept also suggests a more interactive process between mother and baby as it necessitates the projection–reintrojection of parts of the self.

Hinshelwood (1991) summarizes the distinctions between the two concepts:

> 'The function of Winicott's holding is to support the infant's unwavering belief in his own omnipotence; Bion's concept of reverie is the maternal attempt to provide a containing function of understanding the infant's reality in order to support his loss of impotence.'

Thus it can be seen that the therapeutic setting as a whole may be described as a holding environment: a safe, consistent and regular space with secure boundaries is offered within which the therapeutic work takes place. Within that space, active containment may also be demanded of the music therapist, who will inevitably be drawn into the workings of the defensive system and will need actively to offer insight and understanding.

Transference and Countertransference

Projective identification, particularly following Bion's discovery of its communicative potential (Bion 1959) has done much to advance out understanding of transference and countertransference. Joseph (1985) has observed the manner in which projective identification constructs the transference-countertransference relationship between therapist and patient. She describes transference as a living process in which

> 'everything of importance in the patient's psychic organization based on his early and habitual ways of functioning, his phantasies, impulses, defenses and conflicts, will be lived out in some way.'

The client, through projective identification, will unconsciously attempt to stimulate and provoke the therapist to behave according to his unconscious expectations and 'in this way, the history of the patient's object relations comes alive in the transference' (Joseph 1985).

The therapist's countertransference responses – the thoughts, feelings and behaviour stirred up, become a vital source of information about what the client is communicating about their inner world. It is the client's hope that the therapist will be able to contain that which has been projected, accept it, reflect on it and detoxify it, hence transforming it into something understandable and manageable. This process enables the client to take back

his projections, regain lost parts of the self and therefore modify the nature of his internal world and internal and external object relations.

Such processes will manifest themselves both verbally and musically within the therapeutic relationship; it is thus interesting to consider the clinical improvisation (usually recorded on audiotape) as providing a detailed record of the transference–countertransference process which is available for subsequent thought or clinical supervision.

The value of music therapy

Music therapy provides the opportunity for confused, aggressive or alarming feelings to be expressed without necessary resort to verbal language; thus, within the psychic space created in sessions

> 'the client is able to project his confused and chaotic feelings and experiences (which he can neither digest not control) towards the therapist. This enables him to bear what seem uncontainable feelings (projective identification).' (de Backer 1993 p.35)

The therapist may respond both musically or verbally to the client's expression. Music therapy offers the advantage that it can accompany the client's expression of emotions, offering the client the experience of being heard or listened to and simultaneously supported. Frequently, clients report that previously unacknowledged or unconscious emotions and feelings have been made pre-conscious or conscious through the process of clinical improvisation, with verbal discussion of the content of improvisations playing an important role in moving from symbolic levels of explanation to gaining insight and understanding.

Clinical improvisation provides an opportunity to express emotions and memories (particularly non-declarative, procedural or implicit memories) for which the abused client may have no verbal language. This is of particular relevance where abuse or traumatic events occurred in early childhood, where the primary mode of experiencing the world is not verbal or linguistic but sensorimotor; thus memories have not been encoded verbally and are consequently unretrievable using verbalization alone.

Process in music therapy

'Jill'[1] was a very small anorexic thirteen-year-old girl, with a short elfin hair cut. She was referred for music therapy from a residential adolescent unit, to which she had been admitted.

Although Jill was motivated to use the music therapy, she expressed anxieties that she would not be 'good enough' and would fail. This theme was to become a common expression during early sessions and were both an acknowledgement of her fears that the therapist would not be 'good enough' to deal or cope with her aggression and anger, and, subsequently her complete lack of self-esteem in which the only achievement she could find was that she could control what she ate.

Various factors were clearly visible from the first session. Jill isolated herself both musically and physically: she avoided eye contact and her whole body posture was turned in upon itself whilst she enveloped herself in a wash of sound, using a large paiste gong which effectively obliterated the therapist's supportive playing on a piano. She appeared to demonstrate little awareness of the therapist or the therapist's music, although she described the improvisation as providing her with a safe cocoon of sound. The improvisation ended abruptly and throughout the gong was played in an unvarying rhythm without pause or rest despite alterations in the therapist's music which included alterations in tempi, pitch and volume. Jill remain firmly seated or defensively rooted in one place during the first few sessions and initially found it difficult to reach out and use the space in the therapy room.

Subsequent clinical improvisations revealed Jill's chaotic and confused inner world. They were characterized by frantic and forceful rhythmical beating, sudden changes in the choice of instrument being used and a need to control the resulting improvisation. There was little use of physical space in the room and Jill frequently surrounded herself in a containing barrier within which she felt safe enough to acknowledge her confusion and aggression.

As a gradual sense of trust was developed, Jill was able to explore through the therapeutic process her inner confusion and chaos. The musical (and non-musical) therapeutic relationship served as a metaphor through which it was possible to examine and acknowledge her need to control her diet, for fear that there was nothing else within her environment over which she had any control. This was manifested within clinical improvisations by the lack of balance portrayed within the music. Jill either sought to control the evolving improvisation, leaving the therapist with a sense of being obliterated or rubbed out or, alternatively, she was effectively 'not there'. Her difficulties in stopping reflected her difficulties in maintaining a balance within her diet – the binge–purge cycle.

1 A pseudonym has been used to protect confidentiality.

Jill's use of the instruments was at times highly sexualized, reminiscent of a abused child (Rogers 1992). Improvisations gradually revealed increasing anger and self-hatred, directed towards her own body which she believed had enticed an uncle into a sexually abusive relationship which had ceased when he left the family home when she was about six years old. She had no memories of when the abuse had started. There existed pre-conscious and non-declarative memories of sexual abuse from which she had become dissociated.

As the therapeutic process developed, Jill's improvisations would include equally sudden changes in energy and dynamic, moving from the chaotic to the highly controlled and back again. Through the reflection of the client's playing and simultaneous consideration of the therapist's countertransference responses, the client's expressions were intensified and complemented by the therapist's own musical expression. The therapist and her music provided a containing function for the projected feelings of the client.

The therapeutic process revealed both to Jill and her therapist that underlying her anorexic and bulimic symptoms was a belief that the abuse had occurred because her own body had betrayed her by being too attractive or seductive, and that her eating disorder functioned to provide a means of denying her emerging pubescent body and sexuality. She had amenorrhea as a consequence of her eating disorder. The chaotic strands involved in understanding the eating disorder also emphasized a belief that she was in control of her eating disorder: of what was being put into and out of her body – with the obvious sexual symbolism.

The non-consumption of food was a secret (like the abuse had been) she managed to keep from her parents for many months. It had now become in many senses an addictive self-destructive process with the distorted and paradoxical belief that, if she could destroy the body which had betrayed her by being small and seductive, she could atone for her sense of guilt and shame.

The therapist attempted to facilitate Jill's musical expression and provide a space and time within which the feelings attached to transference, countertransference and the new symbols created through the therapeutic relationship could become meaningful. The musical expression itself was regarded as meaningful as Jill projected her chaotic feelings into the therapeutic space. The therapist acted as a container for what Jill experienced as uncontainable feelings (projective identification, Klein 1946). It was vitally important to Jill that the therapist was experienced as being able to contain these aggressive emotions and was not destroyed as she feared. The therapist was thus experienced by Jill as being a good enough mother, able

to contain both musically and subsequently verbally her confused angry and chaotic expression. That the therapist did not reject her helped Jill to acknowledge feelings of self-revulsion, poor self-image and sense of alienation. The duality of the resulting musical improvisation offered her the experience of being both heard and listened to, with the improvisation functioning as a transitional object (Winnicott 1951).

In revealing the underlying mechanisms which played some part in her present eating disorder, music therapy enabled Jill to explore and express her memories and emotions within a safe environment. In essence, she had focused much of her anxieties and rage on her own body. At times she became self-injurious, sinking needles into her arms and hitting her head against a wall. Yet during therapy sessions she would report that her injuries reminded her that she was alive through the sensation of pain. Like the client reported by Sloan and Leichner (1986), Jill's eating disorder can be seen as an attempt to rid herself of the foreign container (her body) into which all her 'bad' sexual feelings had been placed. Thus her eating disorder can be interpreted as a problem of embodiment.

Conclusion

In the above case study, music therapy enabled a client with an eating disorder to reveal an understanding of her inner psychic world and to express her emotions through a non-verbal medium. The drawing out of unconscious recollections and the facility for procedural and implicit memories to be portrayed through clinical improvisation enabled both client and therapist to gain an understanding of some of the mechanisms which led to the eating disorder. In the cases discussed, similarities in the musical playing of abused and bulimic clients and the function of embodiment for these two client groups are noted.

Whilst it is clear that as yet there is insufficient evidence to link eating disorders with a previous history of sexual abuse, clinicians providing therapy for an eating-disordered client, particularly one with bulimia are advised to consider whether earlier abuse has facilitated the current symptoms.

It should be stressed that whilst any evidence of past sexual abuse should always be routinely (and sensitively) enquired into, it is also known that the abused client may well be unable to disclose a history of abuse at the first opportunity (Rogers 1992). Such a history of abuse is likely to cause distress independent of any eating disorder, and that distress may warrant therapeutic intervention regardless of any link to the presenting problem – an eating-disorder. Whilst some clinicians will choose to focus on the more immediate

eating patterns, emotions and cognitions, others will focus on the antecedents of the eating disorder – the sexual abuse. Both the therapist's and the client's judgement will determine which approach should be used, although the therapist will need to consider the client's motivations for deciding that a previous history of abuse is relevant or irrelevant.

References

de Backer, J. (1993) Containment in music therapy. In M. Heal and T. Wigram (eds) *Music Therapy in Health and Education.* London: Jessica Kingsley Publishers.

Bentovim, A. (1988) 'Understanding the phenomena of sexual abuse – a family systems view of causation'. In A. Bentovim, J. Elton, Hildebrand *et al.* (eds) *Child Sexual Abuse within the Family.* London: John Wright.

Bion, W. (1959) 'Attacks on linking'. *International Journal of Psycho-analysis, 40,* 308–315.

Bion, W, (1962) 'Theory of thinking'. *International Journal of Psycho-analysis, 43,* 306–310.

Bonny, H.L. (1989) Sound as symbol: guided imagery and music in clinical practice. *Music Therapy Perspectives, 6,* 7–10.

Browne A. and Finklehor, D. (1986) 'Impact of child sexual abuse: A review of the research'. *Psychological Bulletin 99,* 1, 66–77.

Bryer, J.B., Nelson, B.A, Miller, J.B. *et al.* (1987) 'Childhood sexual and physical abuse as factors in adult psychiatric illness'. *American Journal of Psychiatry,* 144, 1426–1430.

Burgess, A. and Hartman, C. (1993) Children's Drawings. *Child Abuse and Neglect, 17,* 161–168.

Calam, R. and Slade, P. (1987) 'Eating problems and sexual experience: some relationships'. *British review of Bulimia and Anorexia Nervosa, 2,* 37–43.

Chu, J. (1992) The Therapeutic roller-coaster. Dilemmas in the treatment of childhood abuse survivors. *Journal of Psychotherapy Practice and Research, 1,* No.4, 351–369.

Clark, K. (1993) Season of light/season of darkness: The effects of burying and remembering traumatic sexual abuse on the sense of self. *Clinical Social Work Journal, 21,* No.1, 25–43.

Crisp, A.H. (1980) *Anorexia Nervosa: Let Me Be.* Toronto: Academic Press.

Finn, S., Hartmann, M., Leon G. *et al.* (1986) 'Eating disorders and sexual abuse: lack of confirmation for a clinical hypothesis'. *International Journal of Eating Disorders, 5,* 1051–1060.

Frohne, I. (1986) 'Music therapy in social education and psychiatry'. In *Music and Health,* Norsk, Musikforlag.

Furniss, T. (1991) *The multiprofessional handbook of child sexual abuse.* London: Routledge.

Goiricelaya, F. (1988) 'The role of music therapy in the eating disorders programme at St. Mary's Hill Psychiatric Hospital'. *Australian Music Therapy Association, Conference Proceedings.*

Heal, M. and O'Hara, J. (1993) 'The music therapy of a mentally handicapped anorexic adult'. *British Journal of Medical Psychology*, March, 33–41.

Hinshelwood, R.D. (1991) *A Dictionary of Kleinian Thought.* Second edition, revised. London: Karnac.

Hornyak, L.M., and Baker, E.K. (1989) *Experimental Therapies: The Handbook of Techniques in the Treatment of Eating Disorders.* New York: Guilford Publications.

Joseph, B. (1985) 'Transference: the total situation.' *International Journal of Psycho-analysis 66.* 447–454.

Kearney-Cooke (1989) 'Reclaiming the body: using guided imagery in the treatment of body image disturbances among bulimic women'. In L.M. Hornyak and E.K. Baker *op. cit.*

Klein, M. (1946) 'Notes on some schizoid mechanisms'. *International Journal of Psychoanalysis, 27, 99–110.*

Loos, G.K. (1989) 'Anorexie – eine Frauenkraheit – eine Zeiterscheinung'. *Musiktherapeutische Umschau, 10,* 105–131.

Mahler, M.S., Pine, F. and Bergman, A. (1975) *The Psychological Birth of the Human Infant.* London: Hutchinson.

Maler, T. (1989) *Klinische Musiktherapie.* Hamburg: Verlag Dr. R. Kramer.

Moore, M.S. (1994) 'Reflections of Self – the use of drawings in evaluating and treating physically ill children'. In D. Judd and A. Erskine (eds) *The Imaginative Body: Psychotherapy with Physically Ill Patients.* London: Whurr Publications. (In Press).

Nolan, P. (1989a) 'Music therapy improvisation techniques with Bulimic patients.' In L.M. Hornyak and E.K. Baker *op. cit.*

Nolan, P. (1989b) 'Music as a transitional object in the treatment of bulimia'. *Music Therapy Perspectives, NAMT 1989.*

Oppenheimer, R., Howells, K., A Palmer, R.L. *et al* (1985) 'Adverse sexual experience in childhood and clinical eating disorders: preliminary description'. *Journal of Psychiatric Research, 19,* 357–361.

Parente, A.B. (1989) 'Music as a therapeutic tool in treating anorexia nervosa.' In L.M. Hornyak and E.K. Baker *op. cit.*

Palazolli, M.S. (1974) *Self-starvation: From the Intrapsychic to the Transpersonal Approach to Anorexia Nervosa.* Haywards Heath: Human Context Books.

Perls, F. (1985) *Gestalt–Wachstum–Integration.* Paderborn: Junfermann Verlag.

Perls, F. (1992) *Mental Handicap and the Human Condition: New Approaches from the Tavistock.* Free Association Books.

Priestley, M. (1982) *Musiktherapeutische Erfahrungen.* Stuttgart: Gustav Fischer Verlag.

Rogers, P.J. (1992) 'Issues in child sexual abuse'. *Journal of British Music Therapy, 7,* 2.

Sinason, V. (1992) *Mental Handicap and the Human Condition: New Approaches from the Tavistock.* London: Free Association Books.

Sinason, V. (1992) The therapeutic roller-coaster. Dilemmas in the treatment of childhood abuse survivors. *Journal of Psychotherapy Practice and Research, 1,* No.4, 351–369.

Sloan, G. and Leichner, M.D. (1986) 'Is there a relationship between sexual abuse or incest and eating disorders?' *Canadian Journal of Psychiatry, 31,* 656–660.

Sloboda, A. (1993) 'Individual therapy with a man who has an eating disorder.' In M. Heal and T. Wigram (eds) *Music Therapy in Health and Education.* London: Jessica Kingsley Publishers.

Smeijsters, H. and van den Hurk, J. (1993) 'Research in practice in the music therapeutic treatment of a client with symptoms of anorexia nervosa'. In M. Heal and T. Wigram (eds) *Music Therapy in Health and Education.* London: Jessica Kingsley Publishers.

Smolak, L., Levine, M.P., and Sullins, E. (1990) 'Are Child sexual experiences related to eating disordered attitudes and behaviours in a college sample?' *International Journal of Eating Disorders, 9,* 167–178.

Squire, L. (1992) Declarative and non-declarative memory: multiple brain systems supporting learning and memory. *Journal of Cognitive Neuroscience, 4,* 3, 232 – 243.

Stern, D. (1985) *The Interpersonal World of the Infant.* New York: Basic Books.

Tarr-Kruger, I. (1989) 'Der hunger, das maß, die sinne: Musiktherapie bei bulimie'. *Umsch.10,* 135–143.

Terr, L. (1988) What happens to early memories of trauma? A study of twenty children under age five at the time of documented traumatic events. *Journal of the American Academy of Child and Adolescent Psychiatry, 27,* 96–104.

Udwin, O. (1993) Annotation: Children's reactions to traumatic events. *Journal of Child Psychology and Psychiatry and Allied Disciplines, 34,* 2, 115–127.

Waller, G. (1991) 'Sexual abuse as a factor in eating disorders'. *British Journal of Psychiatry, 159,* 664–671.

Waller, G. (1992) 'Sexual abuse and the severity of bulimic symptoms'. *British Journal of Psychiatry, 161,* 90–93.

Waller, G., Ruddock, A. and Pitts, C. (1993) 'When is sexual abuse relevant to bulimic disorders? The validity of clinical judgements. *European Eating Disorders Review, 1,* 3.

Winnicott, D.W. (1951) 'Transitional objects and transitional phenomena'. In *Playing and Reality.* London: Penguin.

Winnicott, D.W. (1960) The theory of the parent–infant relationship. In *The Maturational Process and the Facilitating Environment.* London: Hogarth.

Young, L. (1992) 'Sexual abuse and the problem of embodiment'. *Child Abuse and neglect, 16,* 89–100.

The Development of Symbolic Function in a Young Woman with Down's Syndrome

Margaret Heal

Introduction

Pioneering work in the psychodynamic treatment of people with learning disability has helped us to understand the emotional experience of handicap (Bicknell 1983; Sinason 1986, 1988a, 1988b, 1988c, 1992; Spensly 1985; Symington 1981). This chapter will describe the journey of Janet, a young woman who has Down's Syndrome (trisomy 21) and an eating disorder, and myself, her music therapist, as we struggled to explore and make sense of the link between her emotional world and her self-destructive behaviour. Throughout the three years of weekly, individual music therapy sessions, her willingness to use the musical instruments and the therapist to explore her own sense of self developed. This progress will be traced through the critical moments of the sessions, defined as moments in clinical improvisation which 'have special significance and represent the essential dynamic between the therapist and the client' (Pavelicevic 1988 p.31).

Diagnosis of an eating disorder presupposes that the patient have a distorted body image. As Janet had an IQ of only 50 (performance IQ=52; verbal IQ=53), tested on the Wechsler Adult Intelligence Scale, would she have a sense of her own body image? My clinical work with Janet led me to believe that she was acutely aware of her body and of how she appeared to others. I understood her illness as being of a 'deeper psychological disor-der…related to underlying disturbances in the development of [her] person-ality, with deficits in [her] sense of self, identity, and autonomy' (Bruche

1985). I know of only one other documented case of a woman with Down's Syndrome having an eating disorder (Cottrell and Crisp 1984).

The Standing Committee of Arts Therapies Professions (1991) describes music therapy as providing '…a framework for the building of a mutual relationship between client and therapist through which the therapist will communicate with the client, finding a musical idiom with which to reach, support and develop whatever potential there is'. It continues: 'The growing relationship allows changes to occur, both in the condition of the client and in the form that the therapy takes. By using skilled and creative musicianship in a clinical setting, the therapist seeks to establish an interaction, a shared musical experience, leading to the pursuit of therapeutic goals. These goals are determined by the therapist's understanding of the client's pathology and personal needs, in liaison with other members of the therapeutic team'. The main music therapy technique described here is that typical of British music therapy practice: 'free-flowing' improvisational music (Bruscia 1987). These musical improvisations could be described as the weaving together of sounds, silence and words to create a spontaneous sound tapestry.

The music therapy approach described in this paper is psychoanalytically-informed (Heal 1989a,b,c, 1992, 1993; John 1992; Priestley 1985; Rogers 1992; Sloboda 1993; Towse 1991) and is based on a mother–infant interaction model (Heal in press; Steele 1988). The sessions are held in the same room, at the same time each week, and are protected from interruptions and intrusions. Holidays are prepared for and their effects taken into account. It is through using these boundaries that a musical framework can be provided in the same 'hello' and 'goodbye' songs each session. The same choice of instruments is available in each session, although new instruments may be introduced.

As a music therapist, I try to understand what meaning is held for the client in the improvisations, their use of the musical instruments, and their physical movements. This is all within the context of our developing relationship. The emotional impact of the relationship on me is used as a tool in making sense of the client's internal emotional life. I seek to understand, to reflect and interpret musically, or verbally, therapeutic issues that have particular relevance for the client. This can also be described as trying to explore with the client the links between their feelings, fantasies and behaviour. This provides the opportunity for real change to take place.

The setting is a community services unit for adults with learning disability. The music therapy service provides music therapy assessment and treatment, consultation with families and other professionals, and input at multi-disciplinary meetings concerning clients.

Case presentation

Janet was referred by the Senior Registrar to music therapy. The referral mentioned Janet's numerous anorectic behaviours: poor appetite, vomiting after meals, highly selective food intake, avoidance of fattening foods, hiding behind her coat to eat, frequenting the toilets after meals, and vomiting into handkerchiefs and tissues. Her physical health had deteriorated to such an extent that she had been admitted to a residential unit for the mentally handicapped. The Registrar recognized that there was a link between Janet's feelings and the eating disorder, and hoped that the non-verbal medium of musical improvisation would provide her with a way in which to express and examine her emotions.

Janet was verbally able, but seemed to think concretely. A concrete thought is one that must be based in the 'here-and-now' sensory reality. One of the greatest capabilities of mankind is the ability to think abstractly. This allows us to be lifted from the present into a world of memories, dreams and reflections. Bower (1977) has commented on how any of us, when faced with an overwhelming situation, will revert to a reliance on sensory information, a concrete way of experiencing and understanding the world.

It is difficult to know whether this way of thinking was related to Janet's learning difficulty, to her eating disorder, or to both. Spensley (1985) comments that the slowness associated with learning difficulties 'may well be related to a diminished capacity for using symbolism which is as much a characteristic of psychosis as it is of subnormality or brain-damage'. Bruch (1985) has observed how people who suffer with eating disorders 'function with the morality and style of thinking of early childhood that Piaget has called the period of egocentricity, of preconceptual and concrete operations... The next step in conceptual development – that of formal operations...is deficient or completely absent in them' (p.11). Janet's use of concrete thinking was also apparent in the way in which she managed her emotional life.

During the music therapy sessions, seemingly intolerable situations quickly became a sore tummy or a sore head. This demonstrated Janet's inability to digest painful emotions as well as her overwhelming need to control her body. She did not have an effective way to deal with her frightening and unbearable emotions. Her use of the word 'hungry' for both 'hungry' and 'angry' and her writing of 'fatty' when she wanted 'frightened' supports this idea in a rather concrete way. How can the links between Janet's mental and physical states be better understood?

Bion's (1961) concept of a hypothetical matrix of the mind, the 'protomental system', where at a most primitive level the physical and mental are

undifferentiated, can help us to shed further light on Janet's behaviour. The tendency in this basic assumption state of mind is to action and not thought. When frustrations and mental pain are experienced as an uncontainable threat to psychic life, they are gotten rid of in a primitive way, through expression in physical illness. Sanders (1986) has provided a useful model of the application of this theory to patients in general practice.

This confusion between physical and mental processes can also be described as the psychological condition of alexithymia (Nemiah, Freyberger and Sifneos 1976), where a disorder in emotional processing results in an inability to distinguish between internal visceral and affective states. This has been described as a feature of women who suffer from anorexia nervosa (Bourke, Taylor, Parker, and Bagby 1992).

What issues underlay Janet's emotional difficulties? Janet, with her learning disability and the obvious physical features of Down's syndrome, had a greater burden of difference and therefore mental pain to bear. The first onset of the illness occurred around late puberty when her younger sister left home to marry. This provides us with a clue as to the underlying psychopathology. Sinason (1988c) has described vividly the learning dis-abled adult as feeling a 'part of something sexual that went wrong' (p.93). This underlying fantasy of damaged sexuality is pushed to the front of psychic life with the advent of puberty and the mature sexual relationships of siblings.

Janet had a splitting effect on the multidisciplinary team who worked with her. Not surprisingly, this seemed to be characteristic of the dynamics of her own family (Reder 1983). In order to develop good liaisons with the various people and organizations involved with Janet, multidisciplinary meetings were held monthly to review progress, to identify problem areas, and to establish clear roles and interventions for the workers involved. The thinking facilitated by these meetings increased our trust in each other and reduced the tendency to find blame with each other. We were able to separate out what was an external, real problem from the internal, emotional problems of Janet. We were then able to begin to work with the family to develop the most appropriate way forward for meeting Janet's needs. Eventually I was able to absent myself from these meetings and focus on the therapy itself.

Clinical material

The aim of therapy was to help Janet to deal with her emotions in a creative way. Would she be able to find somewhere in the music therapy sessions to project painful affects so that she would no longer needed to somatize them? Could she then take responsibility for these feelings? Would she be able to

use clinical improvisation to express and symbolize her internal confusion? The therapy will be described in stages through critical moments (Pavelicevic 1988), although Janet's development was not always sequential and involved several regressions before there seemed to be any real change.

Stage 1

In the early sessions, Janet tended to display two forms of interactive behaviours during shared improvisations at the piano. She did not improvise alone. The first type of improvisation seemed to me to feel hollow. It did not seem to have a sense of play but felt rather 'nice'. Janet's playing consisted of travelling up and down the keyboard, each time increasing the number of keys that she commanded and decreasing my area at the keyboard. She was not using the sound to negotiate our relationship, but using the physical area of the piano to take control of it. This was a concrete way of setting boundaries. It is interesting to note that when this improvisation is played back to people without an explanation of Janet's physical use of the keyboard, they hear a gentle, sweet, relaxing modal music well-contained in a 6/8 or rocking rhythm. It is only when told of Janet's use of the keyboard that they can hear her taking over the main territory of the instrument itself.

The second type of clinical improvisation felt more adhesive, with Janet attempting to mirror me, and to be the same as me in the music. We were like two players being so sensitive to each other that the duet could not survive, but would grind to a halt. There seemed to be a lack of play based on the individual initiative of two. An excerpt from the clinical notes of an early session will help to clarify this:

> 'Janet chose to share the piano with me. She sat in front of the treble and I sat in front of the bass. She looked down at the keyboard and then up at me, indicating that she wanted to play the piano but needed some sign of permission to be given.
>
> 'I played an open A minor chord in the bass. Janet rocked herself gently backward and forward twice and then began to play, using her right hand. The movement seemed to provide the momentum for her to play. She played three successive notes in a triplet rhythm and then stopped to look tentatively at me out of the corner of her eye. It seemed that Janet needed further encouragement to dare to sound more notes. I played an open D minor chord, trying to imply some movement but within an harmonic form or container. Janet played another three-note triplet up the keyboard with her right hand.

'I felt that I had to provide a strong sense of form and rhythm for Janet. I decided to continue in a simple four-bar chord progression, modally based (white notes only), which would provide clear structure for her. It was a struggle to play with her as she was following my rhythmic direction as strictly as possible. I felt uncomfortable. Though Janet was musically doing something different from me, it felt as if we were two accompanists sensitively striving to follow each other.'

The main aims in the music therapy sessions continued to be to provide some structure within which Janet would feel safe and somewhere for her to put her emotions where we could begin to examine them, and as an alternative to her continuing somatization.

Stage 2

Two months into therapy, Janet requested that we sing some of her favourite songs. These songs seemed to allow Janet to express with me ideas and feelings that were important to her. We were still together doing the same thing, but we were sharing songs that held words, emotions, and music. These songs seemed to be being used as what Winnicott terms transitional phenomena (Heal 1989a). Janet chose romantic songs. Interestingly, she called them 'automatic' songs. She sang them for all the women whom she had loved; and for the one whom she had great hopes of seducing into a physical relationship – me. They included: 'Sometimes When We Touch', 'Memories', 'The Way We Were' and 'You Light up My Life'. At times Janet would attempt to put her arm around me or would lavishly lay herself out on the piano bench.

Stage 3

All the music therapy sessions had been cassette-taped for the purpose of listening back to some of the music. Janet used these tapes in an unusual way. She was at first highly suspicious of the cassette recorder. This resulted in my giving her control of what we taped. The tapes were to be kept in the music therapy room. They were not for any other professionals that Janet knew.

Some tapes contained only talking, others only music. Onto some of the tapes Janet would list a catalogue of crimes that seemed to be upsetting for her, although she refused to accept any suggestion that she might be feeling angry or sad. As long as they were points that she could bounce off her fingers into the tape, she remained empty and happy, displaying what Sinason (1986) has called a stupid mentally-handicapped smile. As soon as

she was encouraged to expand on her offered points, Janet would develop a headache or a stomach cramp, or begin to cry with pain: 'No, that's not it'. I felt as if I were persecuting Janet. This helped me to understand how Janet felt.

Janet planted the tapes throughout the room. They eventually had four main homes, with several subdivisions. There were several that she wanted to throw out, but I insisted on holding them in my desk drawer until she felt more able to deal with them. She rearranged these tapes each week. This felt like a concrete attempt by her to order the thoughts in her mind.

At this time, staff at Janet's day centre, as well as her friends and family, commented on how much clearer Janet seemed in expressing herself verbally. She continued to gain weight.

Janet had been speaking into cassette tapes and rearranging them in a case as part of her sessions for over nine months. As explained above, they had held her confusion and many of her emotions. However, over time she had become more able to explain her anxieties: they were no longer limited to five points on the fingers of her hand, but had become stories that could change. She began to play out her stories in a physical way and would answer some questions about them. I felt that I was giving Janet some experience of having her emotions held and made manageable.

Stage 4

Janet could then begin to create musical stories; stories where the sound itself could express and hold her emotions. I was fed up with being supplanted by a machine, and decided to insist that we do more music: songs that she knew and liked, songs for which she had written the words (based on her taped experiences), mixed with attempts at free improvisation.

Janet began to compose songs for her favourite ladies. They were all the same, all girls together. She was still eroticizing her relationships, but was more able to create with me songs that related to her 'loves'.

An example of a song she composed reads as follows:

> 'She's got beautiful eyes,
> She's got beautiful hair,
> She's wonderful, sweetheart,
> She's a darling,
> so beautiful, so lovely.'

I tried to accompany her songs with music that transformed the seedy feel of her works to an emotional content that was loving. To facilitate this

transformation, I thought of a mother's eyes as she gazed at her infant: 'She's got beautiful eyes…'

Stage 5

In session 41, almost a year since we had begun, Janet decided that she wanted to play the piano by herself. She had a special piece to perform at the piano alone.

> 'This improvisation lasted over ten minutes. Janet used the entire range of the keyboard, contrasting the bass with the treble using contrary and parallel hand motion. She used all her fingers to play, sometimes one hand at a time and at other times with hands together. The dynamics varied throughout and supported the sense of phrase structure. Within the piece Janet both repeated notes and moved across them in a fanfare-like pattern. When her fingers found complex chords she would repeat them, seemingly appreciating their sonorous nature. The improvisation built up to a climax before finding an ending. The music felt intense, as if Janet were saying, "I have struggled but I will survive". She named the improvisation "The Olympics", and indeed it had sounded like an Olympic fanfare.'

I felt like a proud parent who had just witnessed the first steps of her child. Janet had named the improvisation 'The Olympics' as it reminded her of her competitive swimming days where she remembered herself as being successful. This very powerful improvisation expressed the struggle that she had had, and continued to have, in giving up something that mattered to her very much. It felt like a real step forward. I wondered if and when Janet and I would be able to improvise together in an attuned way.

Janet began to be far more open about thoughts that she had – thoughts to do with her sibling's marriage, the relationship between her parents, my refusal to be physical with her, her sickness, and issues that troubled her – mainly sex and smoking. Any discussion was slow-going, and required some guesswork on my part to make sense of her idiomatic, and at times concrete, language. As mentioned previously, she used the words 'angry' and 'hungry' interchangeably. The word 'mean' had only one definition for Janet. When people hurt her, she said that they were mean. It took time for me to make sense of her response to my question, 'What do you mean?' or 'What does that mean to you?'

With Janet, as with many of my clients with or without disability, a wished-for success can sometimes be imagined. I had a great deal of hope for success with Janet. She was just four days older then I and there were

many times when I thought of how we had been born with such different potentials. There were times when I fantasized about the perfect music therapy that would cure her. I had to accept the differences between us, just as she did.

After the session with 'The Olympics', Janet decided that she did not want to play the piano. There seemed to be something unbearable for her in what seemed to me to be a sign of her personal growth. However, Janet seemed to be slightly more able to tolerate anxiety. I could ask questions around her thoughts and she would be able to survive without the tape recorder for as long as ten minutes. I felt that there was some sign of progress when she brought her glasses. She wanted to see, and perhaps to hear.

However, her bulimia was getting worse. A friend had died recently in an accident and it seemed to have triggered a new assault on herself. She came back after the Christmas holiday in a confused state, wanting to have 'no more thoughts, no more dreams, just the music'. However, this state had resulted not in any weight loss but in a desire to improvise rather than a reliance on the tape recorder. I promised her that next week we would do only music if that was what she wanted.

Stage 6

The next week began with Janet asking for all the tapes to be put in just two locations. She improvised alone, and then we improvised together, a piece that felt interactive and playful.

Janet used both her hands together, as I did. We wove our sounds through and around each other's. There was turn-taking of different rhythms and motifs over a basic harmonic structure which I provided. Janet was able to imitate some of my rhythms at the keyboard within this piece and to provide some of her own. We found a mutual ending. This felt like an achievement!

'What shall we call it?' I asked.

'The Olympics,' replied Janet.

'But that music was different,' I said. 'You are Janet and I am Margaret. We are different but we could still be in the music together.'

'This was too much for Janet. She needed her tape recorder. She asked to tape some more confessions of cruelties meted out to her by staff members. She felt terribly persecuted. The idea of difference seemed just too painful for her. I really had hoped that Janet could stay with this idea. It was that part of me that hoped for some miracle cure. Janet

howled. She cried for the tape recorder. I felt that this was the time that I would insist on trying to hold and express her feelings.

'I improvised at the piano with Janet as she struggled with her feelings. I mirrored her anger in crashing atonal chords, in the hope that I would be able to hold her pain, and possibly modulate it into a form for which she could take responsibility. I mirrored her kicking feet with octaves playing in tremolo in the bass. I felt a strong temptation to stop and give her what she wanted, but knew that it was important for me to stay with her. I could not abandon her now. I moved into a modal structure when her frustration and anger began to feel more like sadness. The improvisation fell into phrases and slowed down in both tempo and pulse.

'Over my playing I began to vocalize what I felt she was experiencing: "Janet feels so sad. Janet is a piano player. She's been so brave sticking with those feelings. You've been holding them in your brain. You're playing much stronger." Janet moved onto the bench beside me and began to play with me, tentatively, but gaining strength as the improvisation progressed. When she hit a key that did not work I sang 'The piano still works, we can still make music with the missing note'. My thoughts were of her learning disability and her painful experience of what she lacked. She was able to continue playing after a momentary pause. We ended together and there was a warm, close feeling. We sat quietly for a minute. Janet then asked if she could listen a bit to the tape recorder.

'There were five minutes left. I put on the tape recorder for her to listen. She had been with me and her feelings for the first time.'

This session felt like a turning point. She had allowed me to give her the experience of someone able to bear her howling pain. Her feelings had been encased in sound and in words. After this successful abreaction, Janet had been able to join with me as an active partner in improvising.

Discussion

Each stage will be explored in terms of my thinking and reading after the sessions as I reflected on the improvisations, and our developing relationship.

During stage 1, Janet seemed unable to use the harmonic form that I had provided as a musical container for her expressions. I had begun to wonder how much of a containing relationship she had experienced in the past, and whether she felt that anyone would be capable of holding her. Perhaps her

emotions were so overwhelming that she feared no one could contain them, or so nebulous that she could not crystallize them into any form. I wondered what internal model of a mother she had: was this internal object capable of holding or containing and modulating into manageable form her explosive internal emotional life? Mothers of babies with a mental handicap do tend to experience greater difficulty in coping with their infants (Bicknell 1983, Solnit *et al.* 1961). They show greater stress than those with chronically ill and neurotic children, being more preoccupied with them and enjoying them less (Cummings *et al.* 1976).

Klein (1937) discusses the effect that the nature of the baby may have on its development. As mentioned previously, perhaps Janet had been a difficult baby with a limited capacity for tolerating the frustration of having to wait for her mother? She may then have been more inclined to develop defences that impeded her mental growth. One of these defences may be a regression to concrete thinking. Another may be an attempt to deny the separateness of the mother, and to feel that she herself is the mother or the container. Bion (1967) refers to this as identification with the container. Stern's (1985) idea of selective attunement supports the analytic theory of identification with, and internalization of, external objects in the development of an internal world. 'Through the selective use of attunement, the parents' intersubjective responsivity acts as a template to shape and create corresponding intrapsychic experiences in the child. It is in this way that the parent's desires, fears, prohibitions, and fantasies colour the psychic experiences of the child' (p.208).

Was Janet's need to be the same as the therapist in the music partly a denial of her handicap? Sinason (1992) has highlighted for us what the emotional experience of having a handicap might be. An intense denial of difference may be involved. This denial can be a difficulty in managing the envy of those more able. Turned in on the self, it can result in an attack of intact skills, the creation of an 'opportunist handicap'.

The eroticization described in stage 2 can also be understood as a defence against difference and in this case dependency – we are equals rather than a therapist mummy with a needy baby patient. Segal (1993) has written of the twoness in her relationship with an anorexic patient which did not include a space for threeness, and that in fact what was being avoided was an awareness of a triangular or Oedipal situation. During one session with Janet, two guitars leaning up against the wall had mistakingly banged together to create a sound. To my surprise Janet had howled out in extreme pain.

During stage 3 I described Janet's unusual use of the audio tapes. The difficulty with her use of the tapes was that they did not seem to serve as

symbols for the emotions. Had her emotions been symbolized, they could have been worked with and understood. At this time they were evacuated as anxiety into external objects. Janet was unable or unwilling to use me. She seemed to be personifying the tape recorder and, into it, in the form of her stories, pouring all her feelings. I was not experienced as someone who could modulate or translate Janet's overpowering anxiety into digestible bits.

This seemed related to Bion's (1962) idea of the mother providing an alpha function. The mother accepts the baby's overwhelming emotions and modulates them with the alpha function into a form that the baby can digest. The mother in her reverie intuits what to do as a result of unconscious thought. In effect, she acts as a container for the infant's feelings. This seems to be a similar concept to Winnicott's (1965) idea of the mother holding the baby and making emotions containable for it. Again I wondered at Janet's own mothering experience and her ability to make use of a good external figure.

In stage 4, Janet wrote songs for which I improvised the music. I felt that this was a step forward as we had worked together and spontaneously created something new. As well, through the use of my music I was able to marry her words to an emotional sound. This felt like a step towards abstract thinking.

Janet was able to be creative at the keyboard in stage 5. This ability to symbolize her feelings seemed a real development. As her playing had not felt excluding, I wondered if she had been able to internalize the idea of a container or an object that did take care of her, a good internal mother.

By stage 6, Janet was able to improvise with me in a playful and interactive manner. However, when faced with the idea of difference and the handicap of the piano (the 'missing' note), she had been unable to manage her emotions. Rather than my giving her up to the tape recorder and what would probably have been an evacuation of her feelings, I worked to act as a container for her feelings. I used my own emotional experience of her to create an improvisation which I hoped would reflect her feelings but in a digestible way. This was done intuitively with what I have described earlier as maternal reverie (Bion 1962), without conscious thought. Janet had been able to make use of this experience, and we had been able to come together symbolically in the sound.

Conclusion

In the opening paragraph I described Janet and I as making a journey together. The milestones of this journey do seem to indicate that there has been a development in her symbolic function. Janet in early sessions managed

to get rid of painful emotions, which she experienced as uncontainable anxiety, by evacuating them into a tape recorder. This was a concrete way of dealing with them. She was not able to use my skills for modulating her feelings, and would deny any difference between us. Her use of the precomposed songs, and then the songs we composed together, seemed to show a shift in her feelings about my usefulness to her. In improvising 'The Olympics,' Janet had been able to symbolize her feelings, and to demonstrate a budding creativity. She was later able to experience a playful improvisation with me. This culminated in Janet allowing me to hold and express her emotions.

I felt that in our work we managed to explore and find for Janet a more healthy way of being. With the impending end of therapy I am hoping that she will be able to maintain on her own what I see as a more creative way of being. Winnicott (1971) writes:

> 'It is creative apperception more than anything else that makes the individual feel that life is worth living. Contrasted with this is a relationship to external reality which is one of compliance, the world and its details being recognized but only as something to be fitted in with or demanding adaptation. Compliance carries with it a sense of futility for the individual and is associated with the idea that nothing matters and that life is not worth living.' (p. 76)

Perhaps Janet can begin to be less compliant in her dealings with the external world: perhaps she can begin to believe more strongly that life is worth living.

Acknowledgement

I would like to thank Dr Hyatt-Williams for his supervision of my case work.

References

Association of Professional Music Therapists (1985) *A Handbook of Terms Commonly in Use in Music Therapy.*

Bicknell, J. (1983) The psychopathology of handicap. *British Journal of Medical Psychology, 56,* 167–178.

Bion, W. (1961) *Experiences in Groups.* London: Tavistock Publications.

Bion, W. (1962) *Learning from Experience.* London: Heinemann.

Bion, W. (1967) *Second Thoughts.* London: Heineman Medical Books.

Bourke, M.P., Taylor, G.J., Parker, J.D.A. and Bagby, R.M. (1992) Alexithymia in women with anorexia nervosa: A preliminary investigation. *British Journal of Psychiatry, 161,* 240–243.

Bower, T. (1977) *The Perceptual World of the Child.* London: Fontana Paperbacks.

Bruch, H. (1978) *The Golden Cage: The Enigma of Anorexia Nervosa.* London: Open Books Publishing Ltd.

Bruch, H. (1985) Four decades of eating disorders. In D.M. Garner and P.E. Garfinkel (eds) *Handbook of Psychotherapy for Anorexia Nervosa and Bulimia.* New York: Guilford Press.

Bruscia, K. (1987) *Improvisational Models of Music Therapy.* Springfield, Maryland, USA: Charles C. Thomas.

Cottrell, D.J. and Crisp, A.H. (1984) Anorexia Nervosa in Down's Syndrome – A Case Report. *British Journal of Psychiatry, 145,* 195–96.

Cummings, S.T., Bayley, H.C. and Rie, H.E. (1976) Effects of the child's deficiency on the mother: A study of mothers of mentally retarded and chronically ill children. *American Journal of Orthopsychiatry, 46,* 246–255.

Heal, M.I. (1989a) The use of precomposed music with a highly defended client. *Journal of British Music Therapy, 3,* 10–15.

Heal, M. I. (1989b) In Tune with the Mind. In D. Brandon (ed) *Mutual Respect, Therapeutic Approaches to Working with People who Have Learning Difficulties.* Surrey: Good Impressions Publishing Ltd.

Heal, M.I. (1989c) Psychoanalytically-informed music therapy in mental handicap: two case studies. A paper presented at the Fifth International Congress: Music Therapy and Music Education for the Handicapped, Developments and Limitations in Practice and Research, Noordwijkerhout, The Netherlands, August 23–27.

Heal, M.I. (in press) A comparison of mother–infant interactions and the client–therapist relationship in music therapy sessions. In Wigram, West and Sapleton (eds) *Music and the Healing Processes.* Presented at the CIBA Foundation seminar of the Applied Psychology Research Group, 'The Evaluation of Music as a Therapeutic Tool', 30 November 1990.

Heal, M.I. (1991) The development of symbolic function in a young woman with Down's syndrome who suffers from eating disorders. Presented at the 5th Music Therapy Research Day Conference at City University, 16 March.

Heal, M.I. and O'Hara, J. (1993) The music therapy of an anorectic mentally handicapped adult. *British Journal of Medical Psychology, 66,* 33–41.

John, D. (1992) Towards music psychotherapy. *Journal of British Music Therapy, 6,* 1, 10–12.

Klein, M. (1937) Love, Guilt and Reparation. In M. Klein and J. Riviere (eds) *Love, Hate and Reparation.* London: Hogarth Press.

Klein, M. (1959) Our adult world and its roots in infancy. *Human Relations, 12,* 291–303.

Nemiah, J.C., Freyberger, H. and Sifneos, P.E. (1976) Alexithymia: A view of the psychosomatic process. In O. Hill (ed) *Modern Trends in Psychosomatic Medicine, 3,* London: Butterworths.

Pavelicevic, M. (1988) Describing critical moments. Published proceedings of the one-day conference jointly sponsored by the Association of Professional Music Therapists and City University Music Department: The case study as research, City University, London, 27 February.

Priestley, M. (1985) *Music Therapy in Action,* 2nd ed. St. Louis, MO: MMB.

Reder, P. (1983) Disorganized families and the helping professions: 'Who's in charge?'. *Journal of Family Therapy, 5,* 23–36.

Rogers, P. (1992) Issues in working with sexually abuse clients in music therapy. *Journal of British Music Therapy, 6,* 2, 5–15.

Sanders, K. (1986) *A Matter of Interest: Clinical notes of a psycho-analyst in general practice.* Perthshire, Scotland: Clunie Press.

Segal, B. (1993) Attachment and psychotic processes in an anorexic adolescent. *Journal of Child Psychotherapy, 19,* 2, 53–67.

Sinason, V. (1986) Secondary handicap and its relationship to trauma. *Psychoanalytic Psychotherapy, 2,* 131–154.

Sinason, V. (1988a) Smiling, Swallowing, Sickening and Stupefying: The Effect of Sexual Abuse on the Child. *Psychoanalytic Psychotherapy, 3,* 97–111.

Sinason, V. (1988b) Doll and Bears: From Symbolic Equation to Symbol, The Significance of Different Play Material for Sexually Abused Children and Adults. *British Journal of Psychotherapy, 4,* 4, 349–363.

Sinason, V. (1988c) Richard III, Hephaestus and Echo: Sexuality and mental-multiple handicap. *Journal of Child Psychotherapy, 14,* 2, 93–105.

Sinason, V. (1992) *Mental Handicap and the Human Condition: New Approaches from the Tavistock.* London: Free Association Books.

Sloboda, A. (1993) Individual therapy with a man with eating disorders: A case study. In M. Heal and T. Wigram (eds) *Music Therapy in Health and Education.* London: Jessica Kingsley Publishers.

Solnit, A.J. and Stark, M.H. (1961) Mourning and the birth of an effective child. *Psychoanalytic Study of the Child, 16,* 523– 537.

Spensley, S. (1985) Mentally ill or mentally handicapped? A longitudinal study of severe learning disorder. *Psychoanalytic Psychotherapy, 1,* 55–70.

Standing Committee of Arts Therapies Professions (1991) Artists and Arts Therapists: a brief discussion of their roles within hospitals, clinics, special schools and in the community. Pamphlet available from the Association of Professional Music Therapists.

Steele, P. (1988) Children's use of music therapy. Proceedings of the one-day British Society for Music Therapy conference: Music the cycle of Life, London, 17 November.

Stern, D.N. (1985) *The interpersonal world of the infant. A view from psychoanalysis and developmental psychology.* Basic Books: New York.

Symington, N. (1981) The psychotherapy of a subnormal patient. *British Journal of Medical Psychology, 54,* 187–199.

Towse, E. (1991) Relationships in music therapy: Do music therapy techniques discourage the emergence of transference? *British Journal of Psychotherapy, 7*, 4, 323–330.

Winnicott, D.W. (1965) *The Maturational Processes and the Facilitating Environment.* London: Hogarth Press.

Winnicott, D.W. (1971) *Playing and Reality.* Great Britain: Pelican.

Recovery

Cutting through forever, the scarred tissues of remembrance,
Unlayering the solitude that drowns me in its silence,
Spitting out the wasted words and memories lost in time,
Uncovering the wounded self that bleeds without a trace,
Unmasking all the sorrows that crawl beneath my skin,
Peeling off the childhood, out grown and left behind,
Unpacking all the burdened lies that tell me there's no hope,
Sawing through the chains of guilt that bind me to life's hate,
and allowing myself to breathe in life and spit out the decay.

Elise Warriner

The Contributors

Ditty Dokter, MSc, RDth, GAS is Senior Lecturer in Dramatherapy and Course Leader in Dance Movement Therapy at the University of Hertford-shire. Her clinical experience includes working with people with learning difficulties, adolescents with emotional and behavioural difficulties and in adult psychiatry. As part of her freelance practice she works both in the UK and abroad.

Margaret Heal, BA, BMus, LGSM(MT), RMT is Senior Music Therapist at Forest Healthcare Trust, Walthamstow.

Astrid Jacobse finished her training in dramatherapy in 1985 at De Kopse Hof, Nijmegen, Netherlands. Subsequently she worked for four years as a dramatherapist at the Endegeest Psychiatric Hospital in Oegstgeest, Netherlands. Here she developed a cognitive training programme for schizophrenic patients. Since 1989 she has trained therapists to use this programme. For the past six years, she has worked at the University Hospital of Utrecht, Netherlands, where she has specialized in treatment of anorexia nervosa and bulimia nervosa.

Sandra Jay, RNMH, RMN, DipPsychotherapy/Psychodrama lives in Oxford and is Clinical Nurse Specialist at the Department of Addictive Behaviour, Oxfordshire Mental Health Unit. Her job involves working with people who have problems associated with their use of drugs, alcohol and/or food, and she has a particular interest in working with people who have bulimia. She is a qualified as a psychodrama psychotherapist and is registered with the British Psychodrama Association and the United Kingdom Council for Psychotherapy.

Sue Jennings is Senior Research Fellow at the London Hospital Medical College and Visiting Professor of Dramatherapy at New York University. She is a prolific writer on dramatherapy and play therapy and is also a professional actress.

Mary Levens, MA, DipPD, DipATh, DipCOT, is Psychodrama Psychotherapist and Art Therapist at Atkinson Morley's Hospital, London.

Dr Paola Luzzatto, PhD, DipATh, is Senior Art Therapist at St Thomas' Hospital, London.

Helen Payne, PhD, CertEd, Laban Cert, PCDip, MPhil, Registered Psychotherapist (UKCP) is Director, Institute for the Arts in Psychotherapy.

Jacqueline Robarts, MA, ARCM, CertEd, DipMTNR, is Head Music Therapist at Cotswold House, Sutton Hospital, Surrey. She is also Lecturer in Theoretical Studies, Guildhall School Music Therapy Training Course and Senior Music Therapist, Nordoff-Robbins Music Therapy Centre, London.

Penny Rogers, MusB (Hons), LGSM(MT), MSc, RMTh, is a Research Fellow in Music Therapy, City University, London.

Mary-Jayne Rust has a Diploma in Art Therapy and an MA in Development Psychology. She is currently working in private practice and as a freelance lecturer.

Joy Schaverien is an art therapist and psychotherapist in private practice.

Ann Sloboda is a music therapist at Addenbooke's Hospital, Cambridge.

Sally Totenbier, MA, ADTR, is a member of Academy of Dance Therapists, Registered (this is the highest level of registry with the American Dance Therapy Association) and is a dance/movement therapist, at the Expressive Arts Therapies Department, Mental Health Centre, St. Joseph Hospital, Houston, Texas, USA. She has a private practice in dance/movement therapy and is an instructor at C.G. Jung Educational Centre in Houston, Texas. She is also a PhD candidate, Laban Centre, City University, London.

Diane Waller, MA(RCA), DipPsych, DPhil, RATL, is Head of Art Psychotherapy Unit, Goldsmiths College, University of London.

Linda Winn, is Team Coordinator/Clinical Specialist of the Community Treatment Team, Cornwall Health Care Trust. She is a Registered Mental Nurse, Registered Dramatherapist and Psychotherapy Supervisor, and is undertaking post-graduate research into post-traumatic stress disorder and dramatherapy at Exeter University.

Maggie Young is Senior Occupational Therapist for Community Health Sheffield (NHS Trust). This work was undertaken while she was an MA Student at the Centre for Psychotherapeutic Studies, University of Sheffield.

About the Artist

Elise Warriner was born in 1968 and started having serious problems with food at the age of eighteen. Her treatments have included in-patient treatments such as behavioural therapy, physiotherapy, psychotherapy, nutritional therapy and tube-feeding. Out-patient treatments have included support from physiotherapists, clinical psychologists, dietitians, many psychiatrists and art therapists.

During the second year of her degree course in illustration at the Norfolk Institute of Art and Design, she spent about five months in hospital. On her return to college in her third year she dedicated herself to communication of her experiences through word and image. The final result was an installation which focused on trying to make people look at food in a different light rather than just as something to eat.

This work included an edible carpet which consisted of transparent plastic tiles containing cereals, crisps and pasta, edible books including an edible dissertation and edible business cards. The table setting (see cover illustration) was made of liquidized paper and fruit skins. The table top was cling film and the chairs were barbed wire with no seats. The piece illustrates the frustration of anorexics when faced with the necessity of eating.

Her poetry also illustrates the condition and sheds an unique angle on what is often a much misunderstood illness. Much of her work represented in this book originated from work done during art therapy sessions.

Subject Index

References in italic indicate illustrations

Author Index